RAPHAEL

RAPHAEL

Leopold D. and Helen S. Ettlinger

PHAIDON · OXFORD

Phaidon Press Limited, Littlegate House, St Ebbe's Street, Oxford OX1 1SQ

First published 1987
© Phaidon Press Limited 1987

British Library Cataloguing in Publication Data

Ettlinger, Leopold D.
Raphael.
1. Raphael
I. Title II. Ettlinger, Helen S.
759.5 ND623.R2

ISBN 0-7148-2303-1

Printed in Great Britain by Hazell, Watson and Viney, Aylesbury

Frontispiece: Detail of *The Triumph of Galatea* (Plate 134).

Contents

To Linda and Peter,
with love and gratitude

Preface

For several years we have wanted to write a book about Raphael that would not be an art historical monograph or a complete catalogue raisonné. In the book that follows the reader may well miss well-known paintings, which are not illustrated or even mentioned. Our interest, however, is in Raphael in his world, among his patrons, his friends, and those who would have advised him about planning the often intricate programmes for his paintings. There is, consequently, in this book perhaps more history than conventional art history, and there is considerable discussion of theology, particularly in connection with the role of the Dominicans at the papal court. Most of this was prepared by Helen Ettlinger, who is writing a study of the problem. She also worked out the new interpretation of the perplexing iconography of the *Transfiguration*.

We have many people to thank. First and foremost is Alison Luchs, who was Research Assistant to the Kress Professor in Washington. She has contributed immeasurably, such as by finding obscure items for our research and studying Raphael's patrons in Città di Castello and Perugia, about whom she will publish a separate article. Indeed, without the facilities and assistance provided by the Center for Advanced Study, under the direction of Henry A. Millon, and the staff of the National Gallery of Art in Washington, much of this book could never have been written. It is impossible to thank each person individually, but two people must be mentioned: Tom McGill, who sought out rare books and transported innumerable tomes from the Library of Congress, and Starr Siegele, who was always ready to discuss problems about the engravings.

Other institutions also assisted us greatly. An ACLS grant contributed to the necessary travel. The unparalleled resources of the Vatican Library and the Biblioteca Hertziana in Rome made research there a pleasure, and Dr Fabrizio Mancinelli and the staff of the Vatican Museums opened otherwise inaccessible rooms. The British Museum, the Ashmolean Museum, and the Louvre were all most helpful over access to drawings. The Restoration Department of the Louvre kindly allowed us to see the *Madonna of Francis I* when it was in their laboratory, and we would like to thank Dr Hubertus von Sonnenberg of the Munich State Museums for letting us examine the *Canigiani Madonna*.

Among the many individuals who must be thanked for listening, discussing, and correcting are: Mme Sylvie Béguin, Tilman Buddensieg, Christof Frommel, John Gere, Charles McCorquodale, Henry Millon, Nelson Minnich, Michael Morris, O.P., Linda and Peter Murray, Loren Partridge, Kathleen Weil-Garris, and Matthias Winner. Finally, we must express our heartfelt gratitude to the staff of the Kunsthistorisches Institut, Bonn, who made books, facilities, and much else

available and were unfailingly helpful, no matter how outrageous the request.

We must also thank warmly Penelope Marcus, our editor at the Phaidon Press, who did so much to clarify our text. Dr. I. Grafe, as always, cast his eagle eye to good effect over the manuscript.

Leopold D. and Helen S. Ettlinger
Berkeley, California

Work on this book was completed in 1983, but publication has been unavoidably delayed. No subsequent alterations to the text have been made.

Introduction

Raphael's popularity in the twentieth century has never equalled that of his two contemporaries, Michelangelo and Leonardo da Vinci. The contents of art library shelves make this obvious. In contrast to volume upon volume that reproduce yet again detailed photographs of the Sistine Ceiling or Leonardo's drawings, the literature on Raphael, particularly in English, is limited to only a few books, which deal primarily with formal problems. Yet for over four hundred years the paintings of Raphael stood for perfection in art; they were studied avidly by artists and coveted by collectors. The loss of favour, which began at the beginning of this century, is largely the result of the anti-classicism of the present era. This was itself partly a reaction against the extraordinary eighteenth- and nineteenth-century adulation of Raphael, one example of which was the praise found in Lessing's *Emilia Galotti* that Raphael would have been the greatest of all artists even if he had been born without hands.

Typical of the reaction against Raphael is Somerset Maugham's perfectly serious comment that in Raphael's *Mass at Bolsena* it was already possible to see 'the vapidity of Bouguereau'. Nineteenth-century academic art had reduced the master's colouring and shading to slick vulgarity; the serenity of his images became suitable for the decoration of chocolate boxes. As Delacroix rightly pointed out, 'Raphael's pupils almost bring us to hate the very characteristics that from his own hand fill us with enthusiasm.' Even today the Gemäldegalerie in Dresden sells a postcard of that sublime masterpiece, the *Sistine Madonna*, with bright pink lips carefully added. Once Raphael's art had descended to kitsch the reaction against him was inevitable.

In recent years, however, many of Raphael's paintings have been cleaned and reveal once more the strength and splendour which must have impressed his contemporaries. The strong colours and the massive forms directly contradict the idea of Raphael as an artist who only painted sweet Madonnas for Florentine matrons. Raphael was capable of portraying both the erotic and the heroic, but never felt the need to seek the obscene or the horrible. Instead, he sought a perfect balance between form, function, and content. As Vasari stated, 'In truth, we have from him art, colouring, and invention harmonized and brought to such a pitch of perfection as could scarcely be hoped for.' It is worth distinguishing here between the goal of 'perfection' and that of 'idealization', because Raphael is so often treated as the Renaissance master whose achievement was to idealize the human figure. In fact, neither proportion nor the human body were for him ends in themselves, as they were for many other Renaissance artists. Rather, he strove towards the definition of beauty as given by Aristotle in the *Poetics*: 'In everything

that is beautiful, whether it be a living creature or any organism composed of parts, these parts must not only be arranged in a certain order but must also have a certain size.' It was the perfect beauty of the whole that was Raphael's ultimate goal.

Compared with those of Michelangelo and Leonardo, Raphael's life was uneventful. He was never forced to flee suddenly from a French invasion; he did not design weapons or traipse around Italy with Cesare Borgia; certainly, he would not have slammed a door in the face of the pope. Instead he spent most of his adult life as the favourite artist of the papal court, surrounded by lively and intelligent companions. The lack of drama in his life has led to the creation of one of the most enduring myths of any artist, that of Raphael's mistress, the so-called Fornarina. In an era when married men openly kept mistresses in lavish establishments, when cardinals associated with courtesans, and popes had illegitimate children, the fact that there is no indication whatsoever of Raphael's mistress in contemporary documents, salacious poems, or gossipy letters must be taken as indicating that she did not exist. Vasari's story that Raphael died after an excess of love-making has no basis in truth and has served only as the starting point for a number of interesting variations on the same theme. (The fiction was most fanciful in the nineteenth century when Ingres painted a picture of Raphael with the Fornarina on his knee, and a novel was written entitled *Raphael et la Fornarina*, in which the jealous black-haired daughter of Pope Alexander VI tries to poison Raphael's beloved blonde.)

A letter of 1514 written by Raphael to his uncle indicates that a marriage was being arranged between the painter and the niece of Cardinal Bibbiena, but apparently she died before anything could be finalized. Maria Bibbiena is buried in the Pantheon next to the tomb of Raphael, and the site is marked by a gravestone for which the artist paid. Vasari claimed that Raphael never married because he wanted a cardinal's hat but again, there is no evidence to support this.

Instead of indulging in such romance we should try to see Raphael through contemporary evidence. This shows him as an artist who was fascinated with the study of Rome and its environs, who was employed in doing exactly what he wanted to do, and — as we read again and again — was gentle, kind, courteous, and immensely popular both personally and for his artistic skills.

Aristotle stated that, 'Art must be an imitation of one thing entire, the parts of it being so connected that if any of them be either transposed or taken away, the whole will be destroyed or changed...' No apter characterization can be found of Raphael's work at its best. Nothing is superfluous or unbalanced. It was towards this end that he strove all his life, a goal summed up by his humanist friends in the epitaph for his tomb:

> Here lies Raphael. Living, great Nature feared he might outvie her works; and dying, fears herself may die.

1 *The Young Artist*

Raphael was born on 6 April 1483, in Urbino, the son of a local painter, Giovanni Santi, whose work, while provincial, was nevertheless competent. More important than the elder Santi's painting, however, is his *Chronicle* in verse about the reign of Federigo da Montefeltre, Duke of Urbino. This poem, in twenty-three books, is dedicated to Federigo's son and successor, Duke Guidobaldo, and tells us much about Federigo's court. That his father could write such an epic indicates the learned environment in which the young Raphael spent his first eleven years, for the work is modelled on both classical and Italian literature and displays an extensive knowledge of medieval and contemporary Italian history. In the prologue Giovanni is guided through the Elysian Fields by Plutarch, in much the same way as Dante was guided by Virgil in the *Divine Comedy*, meeting the famous men of the Middle Ages as well as the ancestors of the Duke. The poem then relates the history of Federigo and describes not only his exploits in battle but also his peacetime occupations, such as his pursuit of scholarship and his erecting of many beautiful buildings. Particularly interesting is the account of Federigo's participation in a disputation about art at the Court of Ferrara, during which the major artists of the fifteenth century and their technical achievements are discussed. Many of these men later had a great impact on the young Raphael. From the poem it is clear that Giovanni Santi was an observant and cultured man, an obvious model to his son of someone who took an interest, like his Duke, in his surroundings and all aspects of learning.

The Urbino of Raphael's youth was a political and intellectual centre of Renaissance Italy, and Duke Federigo was one of the great patrons and collectors of the period. A man of sophisticated taste and ideas, he took a leading hand in designing the spectacular palace, which still dominates the town (Plate 1). His patronage extended not only to prominent Italian artists such as Piero della Francesca, Melozzo da Forlì and Leon Battista Alberti, but also to the Flemish painter Joos van Ghent. Federigo's deep friendship with Lorenzo il Magnifico involved exchanges of artistic presents, and Lorenzo recommended Pollaiuolo to work for the Duke. Already in his own day Federigo's library was famous, and his bookseller, Vespasiano dei Bisticci (who also sold to Cosimo de'Medici), wrote that the Duke employed many scribes because he would not allow anything so vulgar as a printed book in his library.

Vespasiano claims that because Federigo could not find an artist in Italy who knew how to paint in oils, he sent to Flanders for someone to decorate his study — a somewhat exaggerated claim, as the painter subsequently employed, Joos van Ghent, was already in Italy. Joos executed the series of 'philosophers, poets and

doctors of the Church, Greek and Latin', in such a lifelike manner that, Santi tells us, they seemed to breathe. Equally impressive was the cycle of the *Seven Liberal Arts* by Melozzo da Forlì, whose abilities with perspective were also praised in Santi's poem. Further perspectival tricks were demonstrated in the magnificent intarsia work of the cupboard doors, which appear to be open revealing books, musical instruments, and even the Duke's armour ready to be put on. Mathematics and perspective were practised at the Duke's court by both scholars and artists. Alberti and Piero della Francesca were famous for their researches, and it is obvious that the Duke enjoyed the abilities of his artists to create a convincing illusion of the third dimension. In studying their work Raphael must have received his first intimations of what could be achieved with the illusion of deep recession.

The court of Urbino remained one of the leading cultural centres in Italy after Federigo's death in 1482 and throughout Raphael's childhood. Federigo's heir, Guidobaldo, was married to the intelligent and lively Elisabetta Gonzaga and maintained a court whose intellectual achievements were famed throughout Italy. During the 1490s, when the Medici were expelled from Florence and the Sforza driven out of Milan, Urbino remained a haven of stability and culture. It was in this environment that Raphael received his first artistic training, as an apprentice to his father. If his was a normal upbringing he would have begun at the age of seven to learn to prepare the pigments and formulas that were every painter's stock in trade. When Raphael was eleven, in 1494, Giovanni Santi died and the boy was left in the care of his maternal uncle, with whom Raphael maintained ties throughout his life. His apprenticeship probably continued under Timoteo Viti, an old family friend, who had recently returned to Urbino from Bologna. More important, however, at some time between 1495 and 1500, Raphael entered the workshop of Pietro Perugino in Perugia.

In the last decade of the fifteenth century Perugino was the most popular and most prolific painter in central Italy. His achievements in the decoration of the Sistine Chapel under Sixtus IV in 1481-2 had brought him many major commissions in Tuscany and Umbria, and his fame as a fresco painter was considerable. During the 1490s he commuted frequently between Florence and Perugia, and constantly received new commissions in spite of the political upheavals. To fulfil these numerous tasks he maintained a sizeable workshop, the most remarkable feature of which was that it was able with complete fidelity to reproduce the master's style.

Perugino was one of the first painters to appreciate the advantages of extensive standardization. Smooth-faced saints with eyes rolling upward to heaven and angels encircled by curling ribbons were produced in unending combinations. A patron could order two or four saints to stand beside a detached-looking Madonna and Child and be completely confident of the final result even before brush was put to panel. It was here that Raphael learned how to reuse designs, a practice which he later employed to great advantage in his own workshop. The other important lesson of the Perugino studio — the complete subjugation of a pupil's individuality to the style of the master — was one that Raphael could never apply successfully, for his extraordinary ability created too vast a difference between himself and his assistants. Attempts have been made to identify the hand of the young Raphael in various paintings by Perugino but nothing can be ascribed with any certainty. The use of pattern sheets for drawing figures precluded any variation or originality.

Raphael's complete assimilation of Perugino's style can be clearly seen in his early works. Vasari wrote of *The Crucifixion with Saints* of 1503 (Plate 2) that if it were not signed everyone would think it was by Perugino. This work, painted for the de Gavari family of Città di Castello, a town north of Perugia, is not only strikingly similar to a *Crucifixion* commissioned in 1502 from Perugino (Plate 3) but even

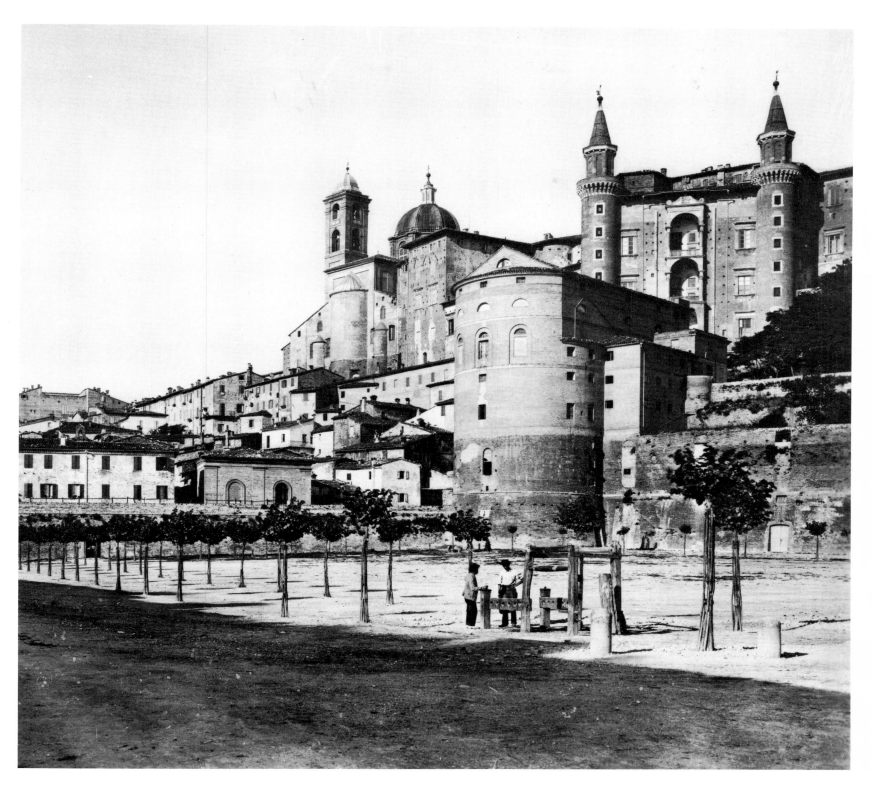

1. View of Urbino.
The silhouette of the town of Urbino has not changed significantly since Raphael's time. The most prominent building then, the ducal palace with its twin turrets, still dominates the town today.

makes use of the standard pattern in the Perugino workshop for the figure of St. Jerome. Yet Raphael's ability to enliven these routine figures is already evident. The angels balance on the toes of one foot and their sashes curl with a lively and rhythmical elegance. By raising the angels' legs high and pointing their toes Raphael has endowed them with an almost ballet-like quality so that they seem poised in the air rather than running along an invisible floor as do Perugino's angels.

Raphael's first independent commission seems to have been for a church standard (*gonfalone*) for the confraternity of the Holy Trinity in Città di Castello (Plates 4, 5). Such standards were traditionally carried in procession as invocations for

15

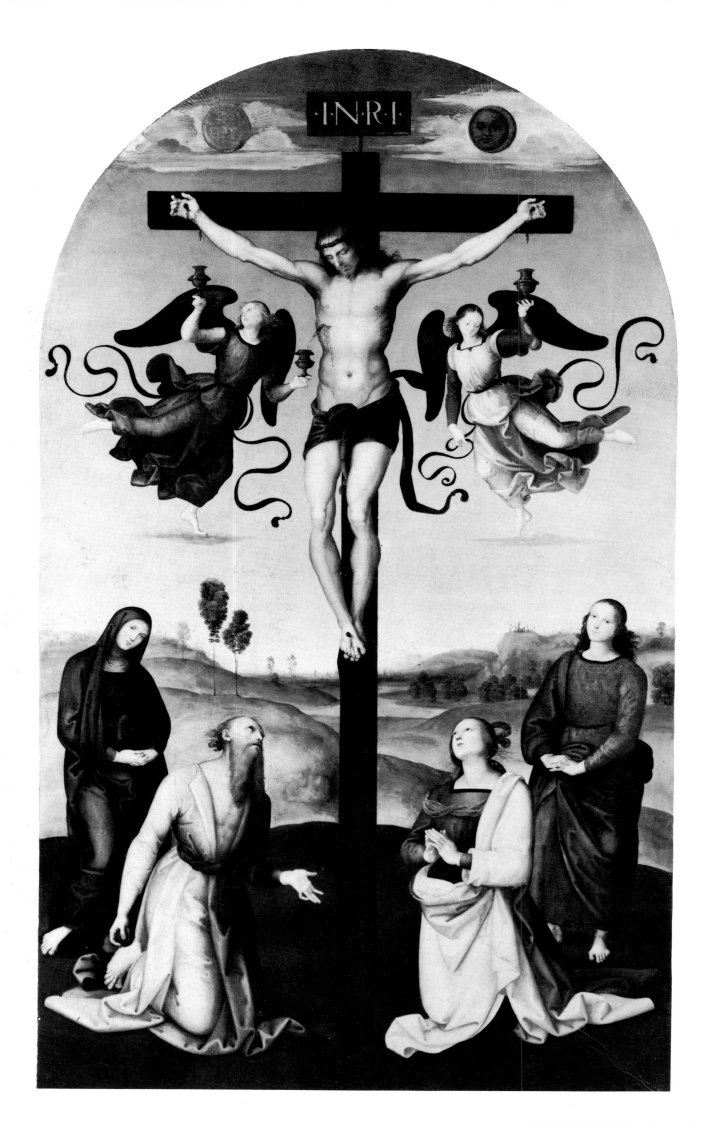

2 (left). *The Crucifixion with
Saints.* Panel, 280 × 165 cm.
Signed at the foot of the cross:
RAPHAEL VRBIN/AS/P. London,
National Gallery.
This picture, placed in San
Domenico in Città di Castello in
1503, shows how completely
Raphael had absorbed his master's
style. Vasari remarked that if it
were unsigned it would be
mistaken for a painting by
Perugino.

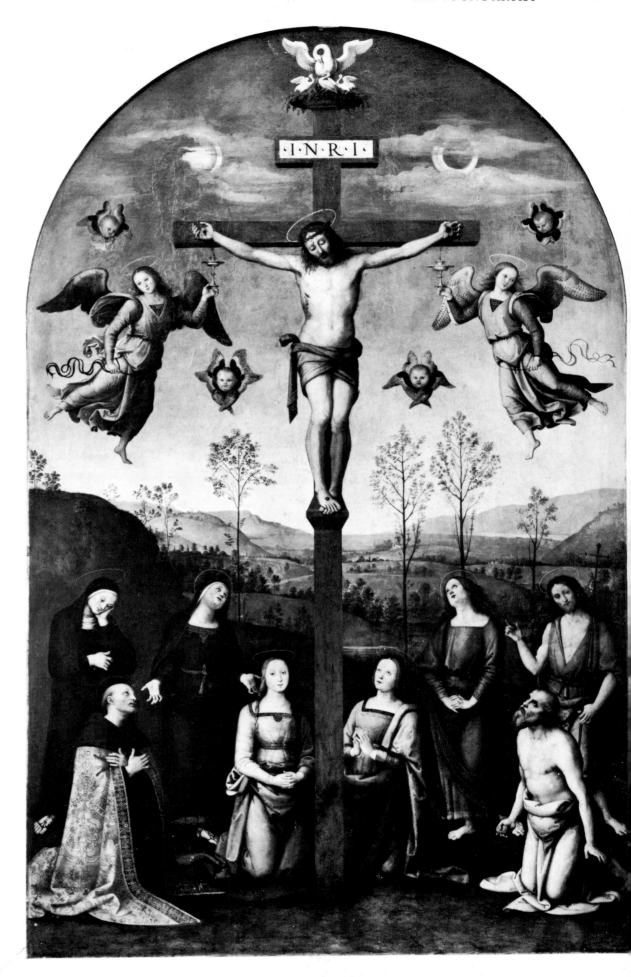

3. Perugino. *The Crucifixion.*
Panel, 400 × 289 cm. Siena,
Sant'Agostino.
Perugino received the commission
for this work in 1502 from the
Chigi family because they
considered him 'the best painter in
Italy'. It is a typical example of his
work, employing many of the
standard figures used in other
paintings. Agostino Chigi later
became Raphael's best secular
patron.

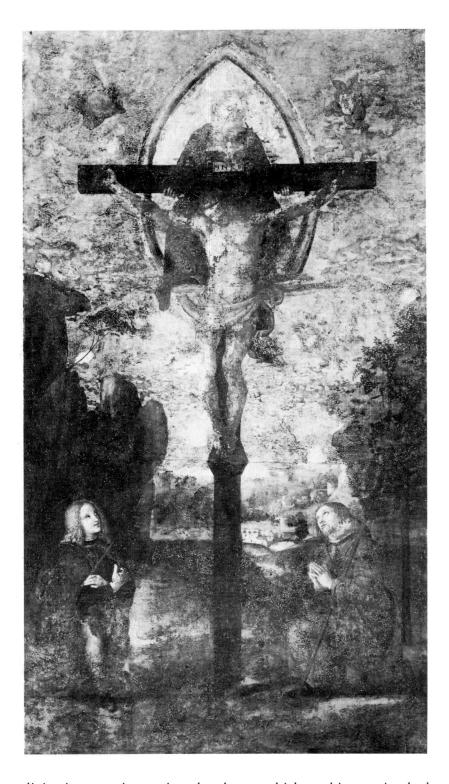

4. *The Holy Trinity with Saints Sebastian and Roch.* Canvas, 166 × 94 cm. Città di Castello, Pinacoteca Comunale. Commissioned as a *gonfalone* for the confraternity of the Holy Trinity of Città di Castello, this work was badly damaged during the seventeenth century. The two saints are seen appealing to the Holy Trinity for relief from the plague, which had struck the town in 1499.

divine intervention against the plague, which on this occasion had struck the town in 1499. To strengthen the prayers two plague saints, St. Sebastian and St. Roch, were included on the banner appealing to the Holy Trinity for relief from the terrifying pest. On the reverse, above the *Creation of Eve*, hover two Peruginesque angels. Raphael's authorship of this banner can be established from a drawing for the figure of God the Father (Plate 6). The presence of Raphael in Città di Castello is also established, for on the same sheet is a sketch of an archer taken from a painting of the Martyrdom of St. Sebastian by Signorelli, which is in the church of San Domenico there.

Exactly why a sixteen-year-old youth should have received an independent

5. *The Creation of Eve.* Canvas,
166 × 94 cm. Città di Castello,
Pinacoteca Comunale.
Painting on the reverse of Plate 4.

commission is not known. It is possible that the confraternity first approached Perugino, who may have been understandably reluctant to go to a city where plague was raging. Today the standard is too damaged to judge by, but Raphael may have collaborated with another artist on the contract, since his first documented commission, which is dated 10 December 1500, names him in conjunction with Evangelista da Pian di Meleto, both painters being called *magistri*. Evangelista, then forty-two years old, had been in the workshop of Giovanni Santi and was a witness to his will. He had also been employed by the dukes of Urbino. It was probably because of this partnership with Evangelista that Raphael was able to attain the title of Master at the unusually young age of seventeen.

Raphael's first documented commission was for a large altarpiece (390 × 230 cm) for the family chapel of the Baroncio in Sant'Agostino at Città di Castello, and represented the *Coronation of St. Nicholas of Tolentino*, a recently canonized Augustinian friar, who was particularly popular in Umbria and the Marches from where he came. The picture, smashed in an earthquake in 1789, survives only in fragments, but a good idea of its design can be obtained from a drawing by Raphael (Plate 7). This shows a typical quattrocento composition in two registers. God the Father, set apart in a mandorla, is flanked by the Virgin Mary and St. Augustine. All hold crowns over St. Nicholas who, accompanied by angels, stands on the

6. *Various Figure Studies.* Black chalk and pen, 25.4 × 21.6 cm. Oxford, Ashmolean Museum. This drawing for God the Father in the *Creation of Eve* establishes Raphael's authorship of the *gonfalone.* The torso and leg to the left are from a fresco, the *Martyrdom of St. Sebastian,* by Signorelli in Città di Castello.

7. Drawing for 'The Coronation of St. Nicholas of Tolentino'. Black chalk, 40.4 × 26.5 cm. Lille, Musée des Beaux-Arts.
The altarpiece, destroyed in an earthquake in 1789, was the first work of Raphael's for which the contract survives. The drawing shows that Raphael used a young man to model the pose for God the Father.

8. *God the Father*. Panel, 112 × 75 cm. Naples, Capodimonte, Museo Nazionale.
This is a fragment from *The Coronation of St. Nicholas of Tolentino* altarpiece. Once he had achieved the pose
he desired, Raphael painted a God the Father surrounded by cherubim that was typical of the Perugino school.

9. Perugino. *Studies for 'Tobias and the Angel'*. Silverpoint heightened with body colour (oxidized), 23.8 × 18.3 cm. Oxford, Ashmolean Museum. Despite the constant re-use of standard patterns, Perugino also used live models to study poses, as can be seen from this drawing.

defeated Satan. The poses and the faces, as can be seen in the surviving pieces, are characteristic of Perugino's workshop (Plate 8).

Although he relied on Peruginesque types, it is clear from the preparatory drawings that Raphael drew from life, and a young man in tights modelled for God the Father in the centre. The practice of posing models developed during the fifteenth century when patternbook types were not found adequate for the stylistic variety and freedom required by the new naturalism in art. Even Perugino used live models, as can be seen from a study of two apprentices posing for a *Tobias and the Angel* (Plate 9). For the *St. Nicholas of Tolentino* altarpiece there remain five

drawings, all life studies. Such careful evolution of composition was to remain characteristic of Raphael's method of working and caused Michelangelo to remark sardonically that Raphael's ability came only after long study.

Several drawings from life also exist for Raphael's *Coronation of the Virgin* (Plate 19) of *c.* 1503 for San Francesco in Perugia. Extraordinary care has been taken to pose the figures realistically and work out the correct foreshortening of the musical instruments (Plate 10). Only after Raphael had established the physical outline of the angel did he embellish it with fluttering drapery. Equally painstaking are the exquisite drawings for the predella, particularly that for the *Annunciation* (Plate 11), which is Raphael's first real attempt at constructing an architectural space

10. *Study for the angel to the right in 'The Coronation of the Virgin'.* Silverpoint, 21 × 23 cm. Lille, Musée des Beaux-Arts.
Once again Raphael has used a member of the workshop to pose. The legs were carefully drawn before the fluttering drapery was added.

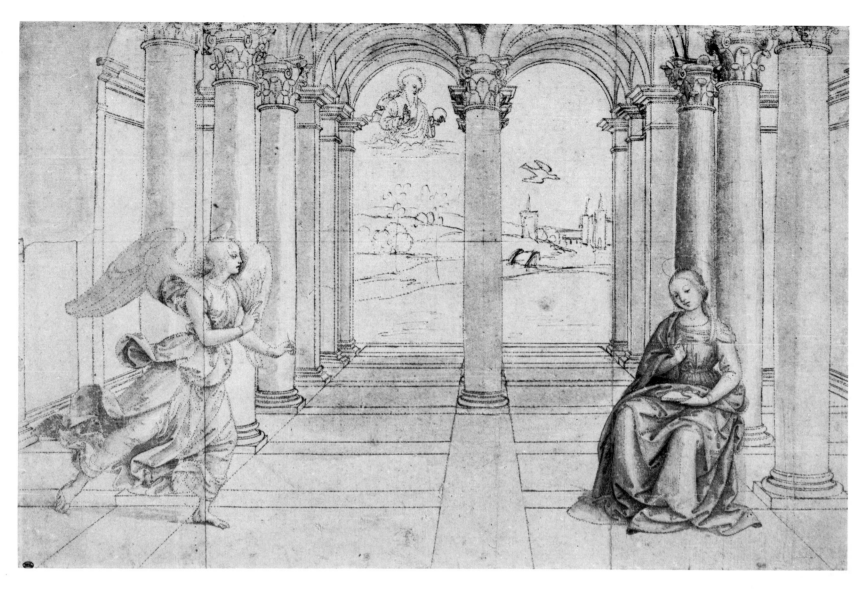

11. *Cartoon for 'The Annunciation'.* Brush drawing in bistre over silverpoint and pen, 28.4 × 42.2 cm. Paris, Louvre.
Here can be seen Raphael's first real attempt at depicting receding architecture. The drawing is pricked for transfer to the predella panel.

with deep recession. In his concern for perspectival accuracy he has allowed the architecture to dominate the figures in the final painting (Plate 12). A more balanced solution has been found in the *Presentation at the Temple* (Plate 13), where the figures have been better integrated with the complex architecture, and the tenderness linking Mother and Child that Raphael later perfected is first seen. Nevertheless, both compositions echo earlier works by Perugino, in whose shadow Raphael continued to work.

On the other hand, that so young a master could receive so major a commission as the *Coronation of the Virgin* from Maddalena degli Oddi, a member of one of the leading families of Perugia, shows that Raphael was establishing his own reputation. The constant and bloody battles between the Oddi and the Baglione, the other major family of Perugia, was one of the reasons why the city had never seriously rivalled Florence in the patronage of the arts (Plate 14). It had enjoyed a brief respite from strife after the Oddi were driven out in 1488, but they returned from exile in February 1503 under the protection of Cesare Borgia. Their triumph was short-lived, however, for in September they were forced to withdraw once again. Because the commission for the *Coronation* came from the Oddi, it is probable that it was ordered and installed in its intended chapel during these eight months. Between August 1502 and August 1503 Perugino was travelling to Siena to complete the Chigi altarpiece (Plate 3), and Pintoricchio, the other major painter

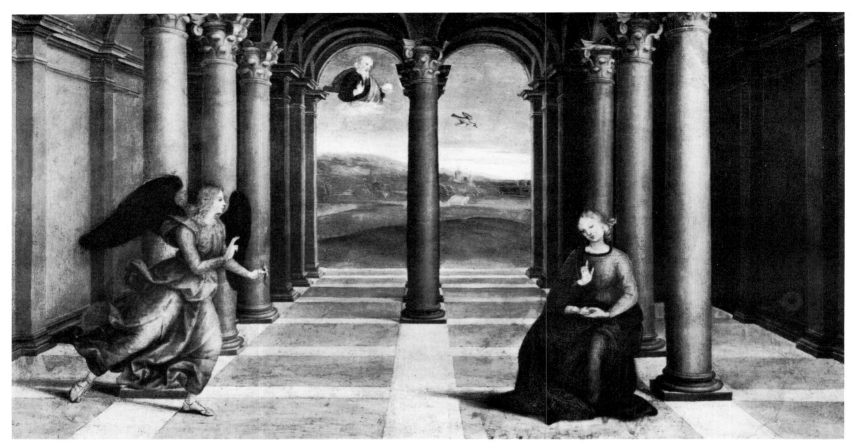

12. *The Annunciation.* Panel, 27 × 42 cm. Rome, Vatican Pinacoteca.
Predella panel for the *Coronation of the Virgin.* Placing the Annunciation in a receding arcade had a long tradition. In Perugia Raphael could have studied examples not only by Perugino, but also by Piero della Francesca.

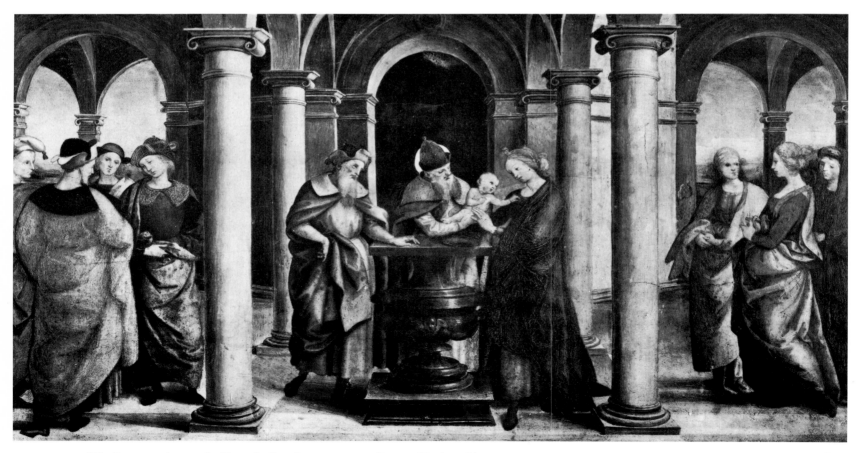

13. *The Presentation at the Temple.* Panel, 27 × 42 cm. Rome, Vatican Pinacoteca.
Predella panel for the *Coronation of the Virgin.* The tender relationship between Mother and Child for which Raphael was to become famous can be seen clearly here.

of Perugia, was also in Siena beginning the decoration of the Piccolomini Library. Thus, Raphael would have been the best painter available in Perugia.

The ravages of Cesare Borgia were not limited to that hill-top town. Departing from Rome in June 1502, and leading an army financed by his father, Pope Alexander VI, he seized the Dukedom of Urbino and expelled Guidobaldo. He then attacked Perugia, Città di Castello, and even reached as far north as Siena before the sudden death of the Pope in August 1503 put an end to his depredations. By November he had retreated from all his conquests and was suing for peace with the new Pope, Julius II, whose family, the della Rovere, had close ties with Urbino. These two years brought great political instability to the whole region, which restricted Raphael's movements somewhat. Artists often found it necessary to travel widely in order to obtain commissions, but it appears that Raphael's artistic employment during this period was limited to Città di Castello and Perugia, with possibly a brief trip to Siena.

The likelihood that Raphael went to Siena is based on the close correspondence, previously mentioned, between Perugino's Chigi *Crucifixion* and Raphael's

14. Circle of Perugino. Perugia. (Detail from *St. Jerome in a Landscape*.) Pen and ink. Oxford, Ashmolean Museum.
Sometimes attributed to Raphael himself, this view of Perugia in the early 16th century shows clearly the churches of Sant'Agostino (to the right) and Sant'Angelo (at the top of the hill) as well as the famous city gate built on ancient foundations.

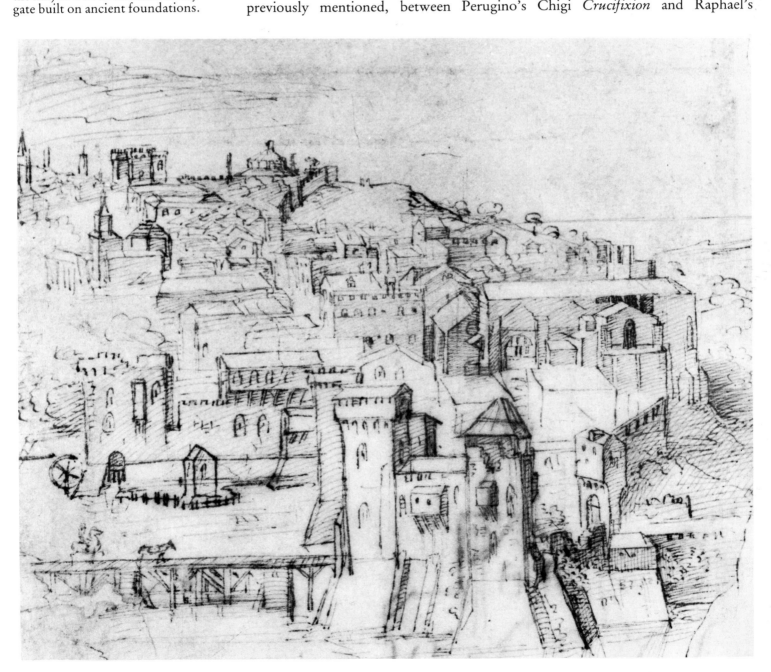

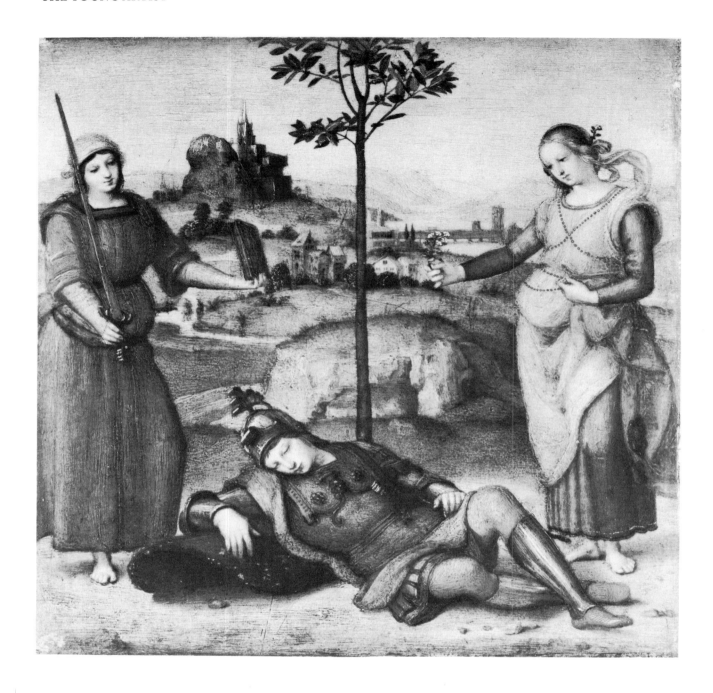

handling of the same subject (Plate 2) in the same year. It was perhaps then that he painted the charming *Vision of the Knight* (Plate 15) and its pendant, the *Three Graces* (Plate 16). Erwin Panofsky has suggested that this, the first commission for Raphael of a non-religious subject, may have come from the Borghese family in Siena, and that these allegorical paintings were a confirmation gift for Scipione di Tommaso di Borghese. Illustrating the classical story of the vision of Scipio Africanus, the London panel represents the choice between a virtuous or a dissolute life. To the left, Virtue, holding a book and a sword, offers the sleeper a difficult passage through life with the reward of eternal glory; to the right, Pleasure presents a posy as a seduction to the transient delights of this world. This kind of moral exhortation combined with the pun on the name Scipio makes this painting a typical example of Renaissance humanist thinking.

The companion panel of the *Three Graces*, whose composition is derived from a famous classical group in Siena, develops this theme further. The general concept of the Three Graces among Renaissance Neo-Platonists was that together they

15. *The Vision of a Knight.* Panel, 17 × 17 cm. London, National Gallery.

The scene is based on the story of the dream of Scipio Africanus and shows him being presented with the choice between a life of virtue and a life of pleasure.

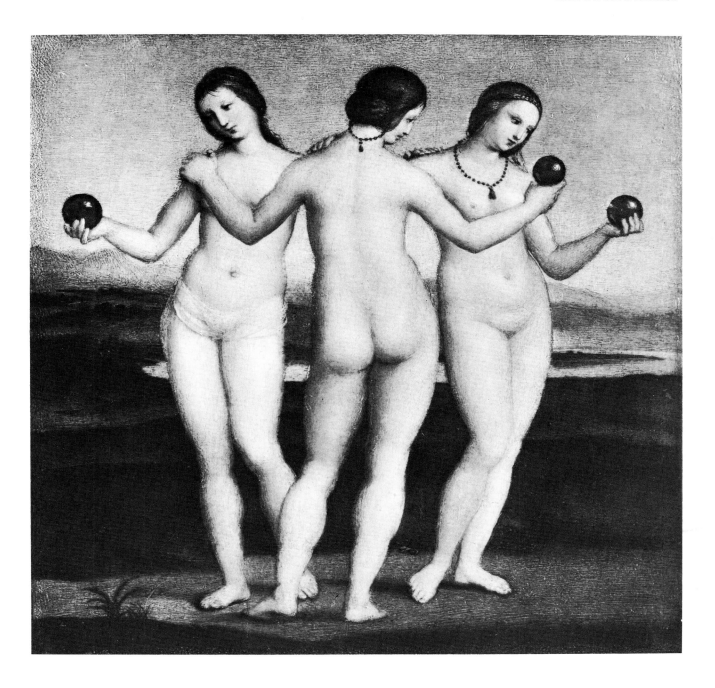

16. *The Three Graces.* Panel,
17 × 17 cm. Chantilly, Musée
Condé.
Formerly the reverse side of the
Vision of a Knight, this depiction
of the Three Graces is based on a
famous classical group in Siena.

comprised ideal beauty and that their Greek names could be interpreted as Splendour, Youth, and Joy. Youth referred to the love of colour and shape, Joy to pure delight, similar to that felt when listening to music, and Splendour to 'the charm and beauty of the soul which consists of the brightness of truth and virtue', in the words of Marsilio Ficino. All this added up to the love of contemplation and intellect, thus clarifying the proper choice for the young man.

During these early years Raphael also began to paint what remained the subject of his most popular works: the Madonna and Child. One of the earliest is the so-called *Solly Madonna* (Plate 17), which retains the quattrocento composition of the half-length figure of the seated Virgin with the Child on her lap. The painting shows the strength of the Perugino tradition in the serene Madonna with her face devoid of expression, her tiny mouth, and high forehead, such as is found in Plate 18. The great popularity of this type can be seen by the large number of surviving examples from the Umbrian school, some of which have been assigned to the young Raphael with more enthusiasm than judgment.

18. Perugino. *Madonna and Child*. Panel, 70 × 51 cm. Washington, D.C., National Gallery of Art.
Whether enthroned with adoring saints or just seated together, Perugino's Madonna and Christ
Child are always the same type with detached expressions, pinched mouths, and smooth faces.
There is never any attempt to establish an emotional bond between mother and child.

17 (left). *The Solly Madonna*. Panel, 52 × 38 cm. Berlin-Dahlem, Gemäldegalerie.
One of Raphael's earliest treatments of the subject, this Madonna and Child group shows him
firmly under Perugino's influence.

These pictures were produced to be hung in the homes of the middle and upper bourgeoisie as private devotional images. From inventories it seems that they were frequently placed in the bedroom, the most important room in the house. Here the marriage was consummated, the children conceived and born. Such pictures were piously associated with the life of the family for the Madonna was invoked as the protector of motherhood as well as intercessor in sickness and in the hour of death. It would be to her that the woman of the house would pray in her travail.

The patrons of Raphael's early period were very different from the great bankers and grand ecclesiastics of his Roman years. At the beginning of his career he was a typical young artist hard at work to establish a clientele among the leading merchant and political families of small towns in central Italy. While it is remarkable that he was called *magister* at the age of seventeen, it must not be forgotten that the commission was awarded jointly with an older painter. Raphael's technique during the first years of the sixteenth century was already extremely accomplished, but he had not as yet formed an individual style, and continued rather to use the best elements from Perugino.

In 1504 changes, which were to effect Raphael, occurred in central Italy. With the expulsion of the Borgia and the return of Duke Guidobaldo and his wife Elisabetta, the court of Urbino was soon re-established and became even more famous than before. This golden period was later immortalized in *The Book of the Courtier (Il Libro del Cortegiano)* by Baldassare Castiglione. He evoked an atmosphere of gentility and graciousness, and described how great scholars, beautiful ladies, and fine aristocrats would gather in the evenings to dispute elegantly about the qualities of the perfect gentleman. Many of the participants in this dialogue became Raphael's friends and patrons in the Roman court of Leo X, among them Castiglione himself, Bernardo Dovizi da Bibbiena, and Giuliano de'Medici, then living at the court of Urbino in exile. The Venetian humanist Pietro Bembo later recalled the six years he spent at the court from 1506 until 1512 as the best of his life. His friendship with Raphael certainly dates from this period, for in 1507 he acted as an emissary for the Duchess regarding a (now lost) painting by Raphael.

It appears that Raphael received his first commission from the Duke in 1504, a small diptych representing St. George and St. Michael (Plates 20, 21). The subject matter is a complete departure from the delicate altarpieces and small devotional pictures that had so far been the young master's main work. The pairing of these two warrior saints, each representing a chivalric Order, commemorated the close connection between the two men and their roles as warriors for the Church, and was probably ordered to celebrate contemporary political events in Urbino.

Upon the accession of Julius II in 1503, Guidobaldo had regained not only his dukedom but also his position as Captain of the papal troops. He was further honoured in January 1504 by being appointed to the Order of the Garter (whose patron saint is St. George) by Henry VII of England. Shortly after this the childless Duke agreed to adopt his sister's son, Francesco Maria della Rovere, as his own son and heir, an arrangement promoted by the new Pope, who was Francesco Maria's paternal uncle. The young man, later to become one of the great captains of Renaissance Italy, had found discretion the better part of valour during the Borgia papacy and had retired, with the aid of Cardinal Giuliano della Rovere, as Julius then was, to the French court where he had been made a Knight of St. Michael in 1503. In May 1504 the return of the exiles, the formal adoption of Francesco Maria, and the investiture of Guidobaldo as a Knight of the Garter were all celebrated with much fanfare in Rome, an occasion that was presided over by

19. *The Coronation of the Virgin.* Canvas, transferred from panel, 267 × 163 cm. Rome, Vatican Pinacoteca.
Commissioned by a member of the Oddi family of Perugia, this altarpiece was probably executed in 1503 when the family returned briefly to the city from exile. The format follows traditional quattrocento examples of this subject.

Julius II. The adoption ceremony was repeated for the people of Urbino in September after Guidobaldo and Francesco Maria had spent the summer campaigning together against the political enemies of the Papal States.

In the background of the St. Michael panel this theme is developed further. Two groups described in Dante's *Inferno* can be seen: to the left the cowled hypocrites, to the right the robbers. These may be not very subtle references to the previous Pope and his son Cesare. Using his papal office shamelessly to promote family interests, Alexander VI had even appointed the singularly unsuitable Cesare a

20. *St. George and the Dragon*. Panel, 31 × 27 cm. Paris, Louvre. Plates 20 and 21 were probably commissioned by the Duke of Urbino to commemorate the adoption of his nephew as his son and heir in 1504. Both show strong Florentine influences and may indicate that Raphael visited that city in winter 1504.

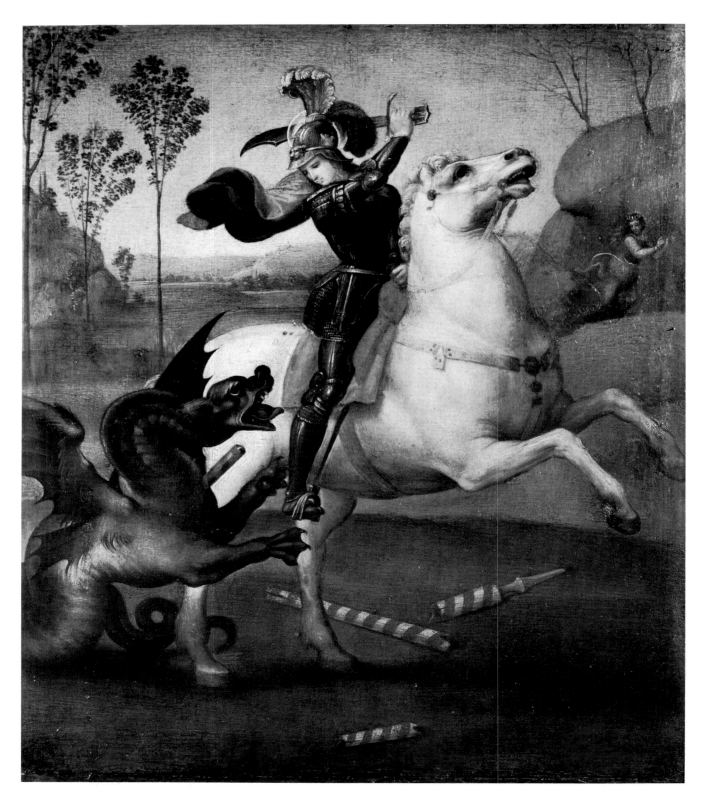

cardinal. After another of his sons was murdered Alexander briefly entertained thoughts of reform, but he soon reverted to his earlier ways. Cesare, released from his vows and supported financially and spiritually by his father, proceeded to rape and pillage the Papal States with the aim of setting up his own rule. It would not be surprising if the della Rovere and Montefeltre families, both forced to flee from these ravages, celebrated their own return to power as under the guise of Divine Vengeance. Raphael returned to this theme a few years later when he painted the Stanza d'Eliodoro for Julius II.

21. *St. Michael and the Demon.* Panel, 31 × 27 cm. Paris, Louvre. A diptych panel, together with Plate 20. It is painted on the back of a chess-board.

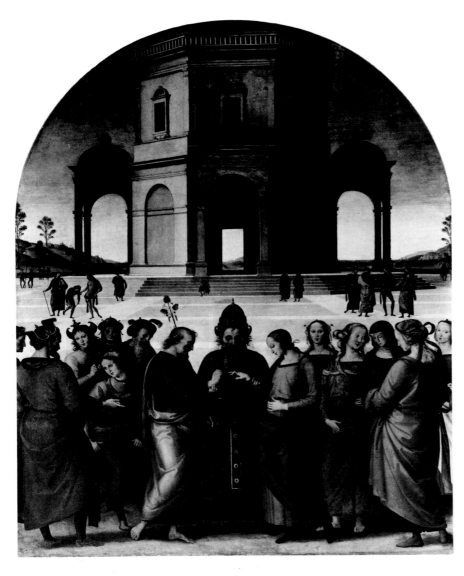

22. Perugino. *The Marriage of the Virgin.* Panel, 234 × 185 cm. Caen, Musée des Beaux-Arts. Commissioned for the chapel containing the relic of the Virgin's wedding ring in the cathedral of Perugia, the picture is composed in the isocephalic arrangement always employed by Perugino for crowd scenes. The figures remain coldly detached.

The last major work completed by Raphael in 1504 was the *Marriage of the Virgin (Lo Sposalizio)* (Plate 23), which is signed and dated. This perspectival *tour de force* was commissioned for the chapel of St. Joseph in the church of San Francesco, Città di Castello, by the Albizzini, one of the city's leading families. Raphael obviously conceived this work to rival Perugino's slightly earlier painting (Plate 22) of the same subject. Perugino's picture in fact was the more important commission, as it was intended for the chapel containing the relic of the Virgin's wedding ring, which had been stolen from the city of Chiusi in 1473 and now was installed in a newly built chapel of the cathedral of Perugia. The original commission to Pintoricchio in 1489 had remained unfulfilled and after ten years it had been transferred to Perugino.

The two pictures are startling in their similarity. Each is dominated by the large centralized building that traditionally represented the Temple in Jerusalem. The open door serves as the vanishing point for the pattern of the pavement, a device used by Perugino in the fresco of the *Giving of the Keys to St. Peter* in the Sistine Chapel (1481) and subsequently also employed by Pintoricchio. In Perugino's painting the figures are smaller than the Temple, and thus appear dwarfed by the imposing structure. Raphael, on the other hand, made his figures the same height as the Temple, thus giving the whole a tighter unity and better proportion.

An even greater difference between the two paintings can be seen in the portrayal of individual figures. Perugino's groups stand in a linear and isocephalic

23. *The Marriage of the Virgin.* Panel, 170 × 118 cm. Signed and dated on the Temple: RAPHAEL VRBINAS MDIIII. Milan, Brera. This extraordinary perspectival *tour de force* was Raphael's response to a slightly earlier work by Perugino (Plate 22). A subtle interrelationship is established in the central group by turning and tilting the priest's head.

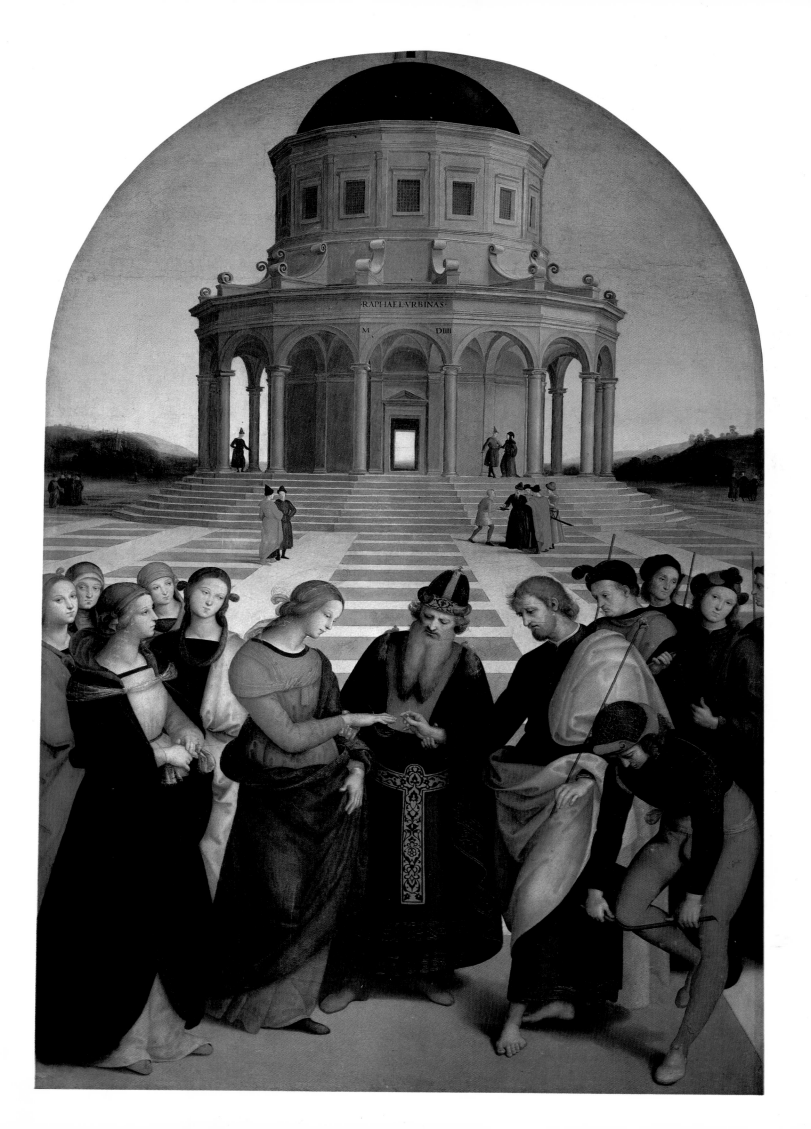

arrangement, and the two halves of the picture are separated by the sharp vertical of a fully frontal, and stiffly standing, high priest. The priest in the Raphael inclines his head and turns gently towards the Virgin, whose flowing grace was never rivalled by Perugino. Joseph's contrapposto is no longer the artificial pose of the Peruginesque type but rather that of someone standing comfortably. Finally, Raphael has placed great emphasis on the all-important central group of the priest, Mary, and Joseph by giving them more space than the bystanders clustered on either side. At last he has achieved the confidence and ability not to rely on but to compete consciously with his master. It is worth remembering that he was only twenty years old when he painted this masterpiece.

2 The Florentine Period

24. Workshop of Cosimo Rosselli (?) *Florence (The Chain Map)*. Engraving. Berlin, Staatliche Museen.
As today, the two architectural features that dominated late 15th-century Florence were the tower of the Palazzo Vecchio and the cathedral crowned by Brunelleschi's famous dome. The Ponte Vecchio is the third bridge upstream.

On 1 October 1504, Giovanna della Rovere, sister of the Duke of Urbino and mother of his adopted son Francesco Maria, wrote to Piero Soderini, the *Gonfaloniere* of the Republic of Florence: 'The bearer of this letter', she began, 'is Raphael, a painter from Urbino, who has much talent in his vocation, and wishes to spend some time in Florence to study.' This, however, may not have been the artist's first visit to the great cultural centre (Plate 24). In January 1504 a committee had been assembled to discuss the placing of Michelangelo's nearly completed masterpiece, the *David*, because the Arte della Lana, which had ordered the work, felt the stupendous statue should have a more prominent location than its originally intended site on one of the buttresses of the cathedral. This committee, composed of about thirty members, included many of the most prominent artists in Florence, among them Leonardo da Vinci, Botticelli, and Filippino Lippi. Perugino was considered either prominent or Florentine enough to be asked to serve. Since it appears that both Perugino and Raphael were in Perugia in November 1503, it may be that the ambitious youth accompanied his teacher to see this already renowned miracle of sculpture.

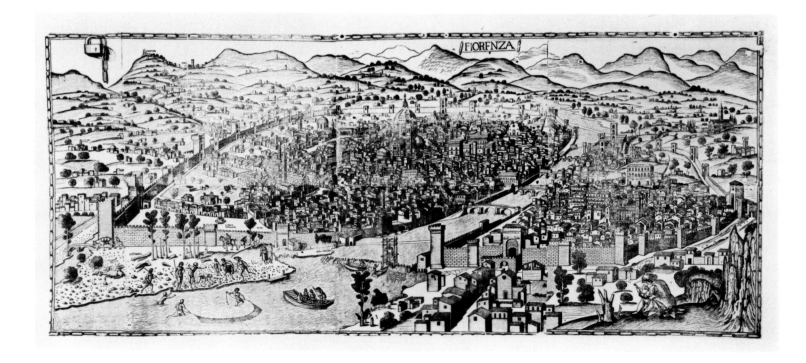

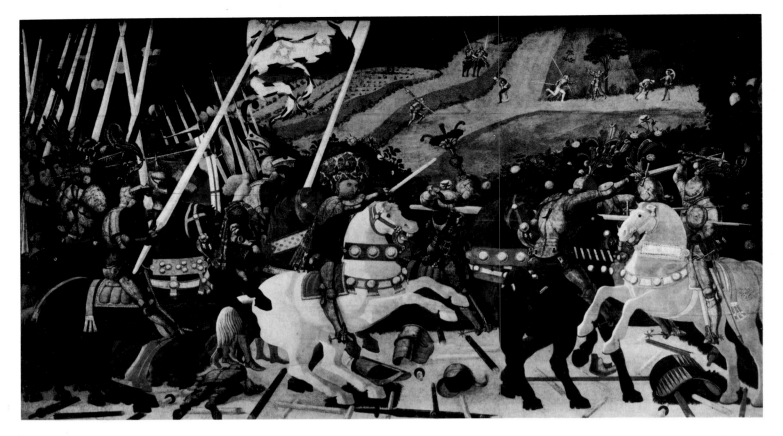

25. Uccello. *The Battle of San Romano*. Panel,
183 × 319 cm. London, National Gallery.
This painting is one of three depicting the Battle of
San Romano that hung in the Medici Palace. The
artificial arrangement of the broken lances may have
influenced Raphael's early painting of *St. George and
the Dragon* (Plate 20).

26. Botticelli. *The Mystic Crucifixion*. Canvas,
73 × 51 cm. Cambridge, Mass., Fogg Art Museum.
Raphael's painting of *St. Michael and the Demon*
(Plate 21) shares many elements with this painting,
most notably the flaming city in the left background
and the avenging angel.

27. *A Group of Warriors.* Pen, 27.1 × 21.6 cm. Oxford, Ashmolean Museum.
Raphael was deeply impressed by the numerous works of art he saw in Florence. In this drawing he has combined Donatello's statue of *St. George* with figures from classical reliefs.

28. Donatello. *St. George.* Marble, height 209 cm. Florence, Bargello.
Originally set in one of the niches on the exterior of the church of Or San Michele, Donatello's statue of this warrior saint was one of the most celebrated pieces of sculpture in Florence and was considered an example that artists should study.

There is stylistic evidence for his visiting Florence before the autumn of 1504. As previously discussed, Raphael had, in all likelihood, painted the diptych of *St. George* and *St. Michael* between May and September 1504. The position of St. George and his rearing horse echoes the pose of Niccolò Maurucci da Tolentino in Uccello's *Battle of San Romano* (Plate 25), which then hung in the palace of the exiled Medici. From the same source comes the artificial arrangement of the broken lance under the horse. The *St. Michael* on the other hand reflects ideas taken from Botticelli's *Mystic Crucifixion* (Plate 26), with its burning city and vengeful angel.

Whatever the date of his first visit, when Raphael arrived in Florence he studied with enthusiasm. The many drawings from the sketchbooks he kept during that period are evidence of this. Two themes seem to have fascinated him, Madonnas and the male nude. Interest in the latter has already been seen in his earliest known drawing, the copy of a figure by Signorelli, but in Florence Raphael was clearly overwhelmed by what he saw, and drew as if to absorb everything. Whether it was the works of his contemporaries or classical reliefs, he sketched, adapted, and worked out variations. A drawing in Oxford (Plate 27) shows Donatello's *St. George* (Plate 28) set among figures deriving from classical reliefs. Another, in

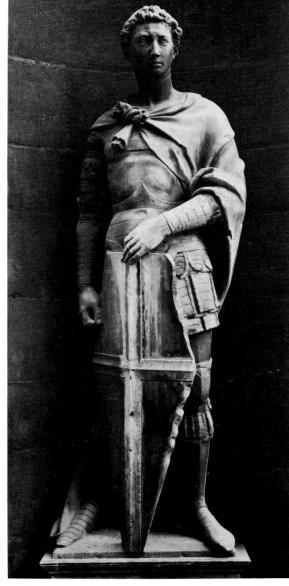

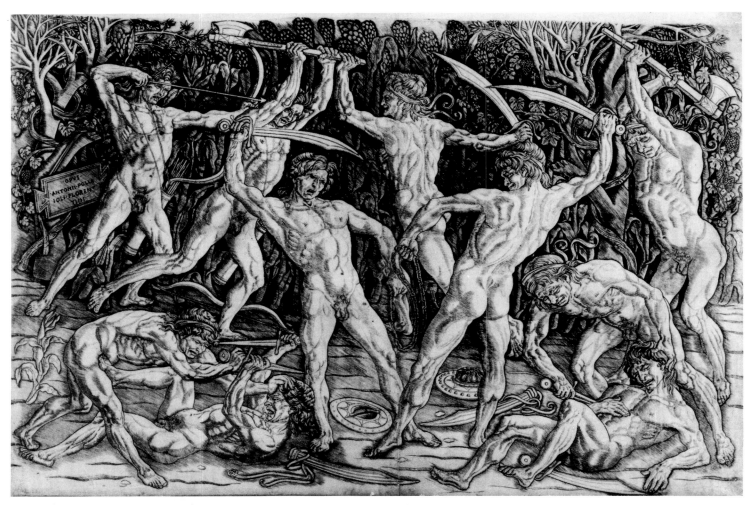

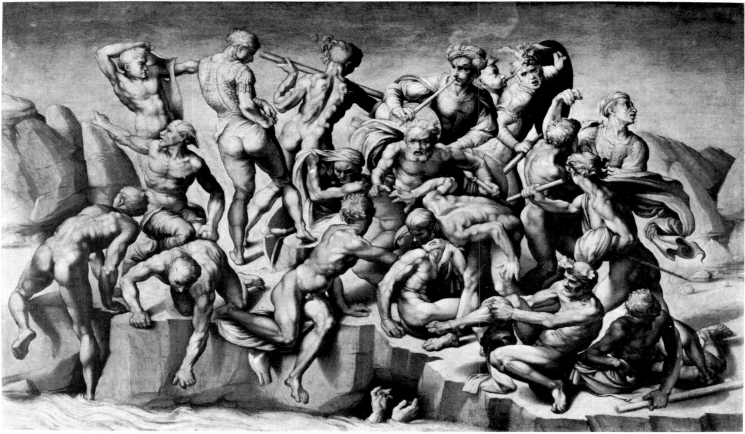

31. *Hercules Fighting Three Centaurs.* Pen and yellow-brown ink, 24.5 × 23 cm. Florence, Uffizi. The subject of Hercules as well as those battle scenes involving centaurs or horses were popular in Florence. This drawing reveals Raphael's careful study of Pollaiuolo.

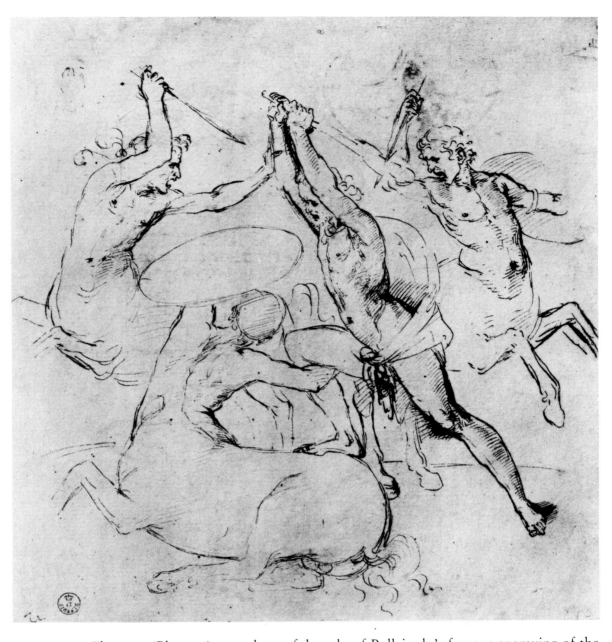

29 (top left). Pollaiuolo. *The Battle of the Ten Nudes.* Engraving, 38.3 × 59.5 cm. London, British Museum. Antonio Pollaiuolo produced this influential print at the beginning of the 1470s.

30. After Michelangelo. *Copy of the Cartoon for 'The Battle of Cascina'.* Panel, 77 × 130 cm. Norfolk, Holkham Hall. Raphael was only one of innumerable artists who studied and copied the unfinished work by Michelangelo. Echoes of it can be found in Raphael's work throughout his life.

Florence (Plate 31), reveals careful study of Pollaiuolo's famous engraving of the *Battle of the Ten Nudes* (Plate 29).

Not surprisingly, the two artists who had the greatest impact on him were Michelangelo and Leonardo da Vinci. Between 1504 and 1506 these two artists were striving to outdo each other in the decoration of the Sala del Consiglio in the Palazzo della Signoria. Although neither fresco was ever finished, Leonardo's *Battle of Anghiari* (for which Plate 33 is a drawing) and Michelangelo's *Battle of Cascina* (copy of cartoon, Plate 30) exercised tremendous influence even in their incomplete states. Artists sought admission to make copies (by 1516 Michelangelo's cartoon had been torn to pieces by eager students). Raphael must have made many drawings as well, for their impact on his work is readily apparent. The *St. George* of *c.* 1506 (Plate 34) combines Donatello's relief (Plate 32) with Leonardo's lunging horses from the *Battle of Anghiari*. Years later Raphael employed them again in his fresco of the *Repulse of Heliodorus*. Michelangelo's twisting and turning forms affected Raphael for the rest of his life, and quotations from the *Battle of Cascina* can be seen in such disparate works as the *School of Athens* and the tapestry cartoons.

43

32. Donatello. Detail of *St. George and the Dragon*. Marble relief, 39 × 120 cm. Florence, Or San Michele.
Located under the tabernacle, which originally contained the statue of St. George (Plate 28) this was the first relief to use perspective to create pictorial space.

33. Leonardo da Vinci. *Sketch for 'The Battle of Anghiari'*. Black chalk, 16 × 19.7 cm. Windsor, Royal Library.
Leonardo made many sketches for the never completed fresco of the Battle of Anghiari. His beautiful studies of horses in action greatly influenced the young Raphael.

34. *St. George and the Dragon*. Panel, 29 × 21 cm. Washington, D.C., National Gallery of Art.
This exquisite small panel shows the influence of both Donatello and Leonardo on Raphael's work. The saint's garter refers to the honour conferred on the Duke of Urbino, who was made a Knight of the Garter by King Henry VII.

While these battle studies became of use to Raphael only in his later, Roman, days, his paintings of the Madonna and Child served to establish his reputation. Many drawings show his constant preoccupation with this subject, his careful observations of how others had treated the same theme, and his working out of ever new variations and solutions to formal problems.

The earliest Madonna that was influenced by Florentine art is *The Madonna Terranuova* (Plate 35). Its tentative quality and chiaroscuro shows Raphael experimenting with some of Leonardo's innovations. The Virgin's left hand held in mid-air is a direct quotation from *The Virgin of the Rocks* (Plate 37), the kind of thing that occurs rarely in Raphael's work. The Child lying across her lap and the eye contact between Him and the little St. John the Baptist is a more successful

35. *The Madonna Terranuova.*
Panel, tondo, diameter 86 cm.
Berlin-Dahlem, Gemäldegalerie.
This is Raphael's first attempt to
make use of the popular Florentine
form of the tondo. Leonardo's
influence can be seen in the gesture
of the Virgin's left hand, in the
position of the Christ Child, as
well as in the pronounced
chiaroscuro.

37. Leonardo da Vinci. *The Virgin of the Rocks*. Panel, 198 × 123 cm. Paris, Louvre.
While Raphael was profoundly influenced by Leonardo, he never tried to create the same type of rocky landscape. The downward-glancing Virgin was to remain a favourite of Raphael's and reappears even in a late work, *The Madonna of Francis I* (Plate 182).

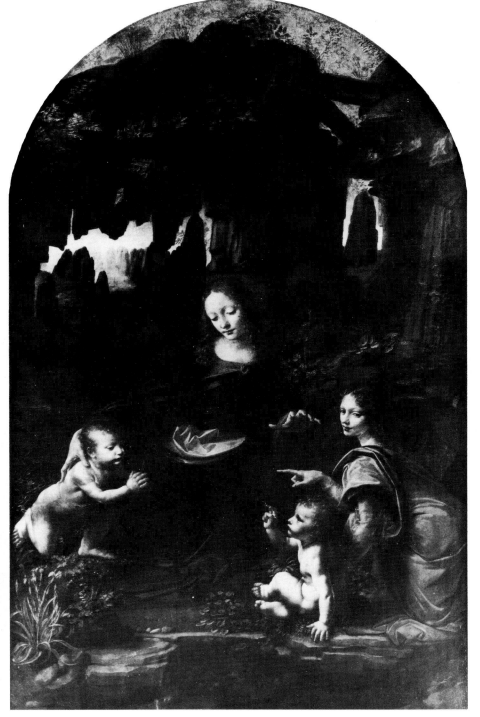

36. Leonardo da Vinci. *Cartoon for 'The Virgin and Child with St.Anne'*. Charcoal with white highlights, 159 × 101 cm. London, National Gallery.
Leonardo's motif of placing the Child across the lap of the Virgin was emulated by both Michelangelo and Raphael.

adaptation of the same motif in Leonardo's *Cartoon for 'The Virgin and Child with St. Anne'* (Plate 36). But in spite of these innovations the face of Raphael's Madonna retains a Peruginesque character. Furthermore, Raphael had not yet learned to adapt a composition to the form of the tondo, so that the picture remains essentially a square picture in a round frame.

A greater sensitivity to format is revealed in *The Madonna del Granduca* (Plate 39). A drawing (Plate 38) reveals that Raphael toyed with the idea of a round frame, but decided on an upright format to complement the elongated composition. There is landscape in the sketch, and the background of the painting may have been overpainted in the nineteenth century.

A more complex arrangement is reached in the slightly later *Small Cowper*

Madonna (Plate 40). The Child's head is now tilted more sharply and His leg pushes against the Virgin's arm. This gives the group more energy and liveliness. For this picture Raphael has seated the Madonna and placed her legs at an angle to the picture plane, in order to establish a spiral movement on a central axis, a device that Leonardo had invented in his *St. Anne* cartoon.

The composition with a standing Virgin was further developed in *The Tempi Madonna*, which was painted probably about 1508 (Plate 42). Vasari may have been referring to this picture when he noted that Raphael's earlier manner had changed from one close to Perugino to something 'much better'. Not only is the paint handled more loosely, but the entire body of the Virgin is placed at an angle to the picture plane, turning to the right. The Child clings closely to her. The painting

38. *Drawing for 'The Madonna del Granduca'*. Black chalk over stylus, 21.3 × 18.4 cm. Florence, Uffizi. Experimenting with the tondo form, Raphael sought to introduce stronger curves in the composition with fuller drapery and the tilted head of the Virgin. Both were changed in the final version, which was done on a rectangular format.

48

39. *The Madonna del Granduca.* Panel, 84 × 55 cm. Florence, Pitti.
This gentle rendering of the Madonna and Child is an important step away by Raphael from Perugino's colder treatment of this subject. Here the Child clings tenderly to his mother instead of sitting upright on her lap.

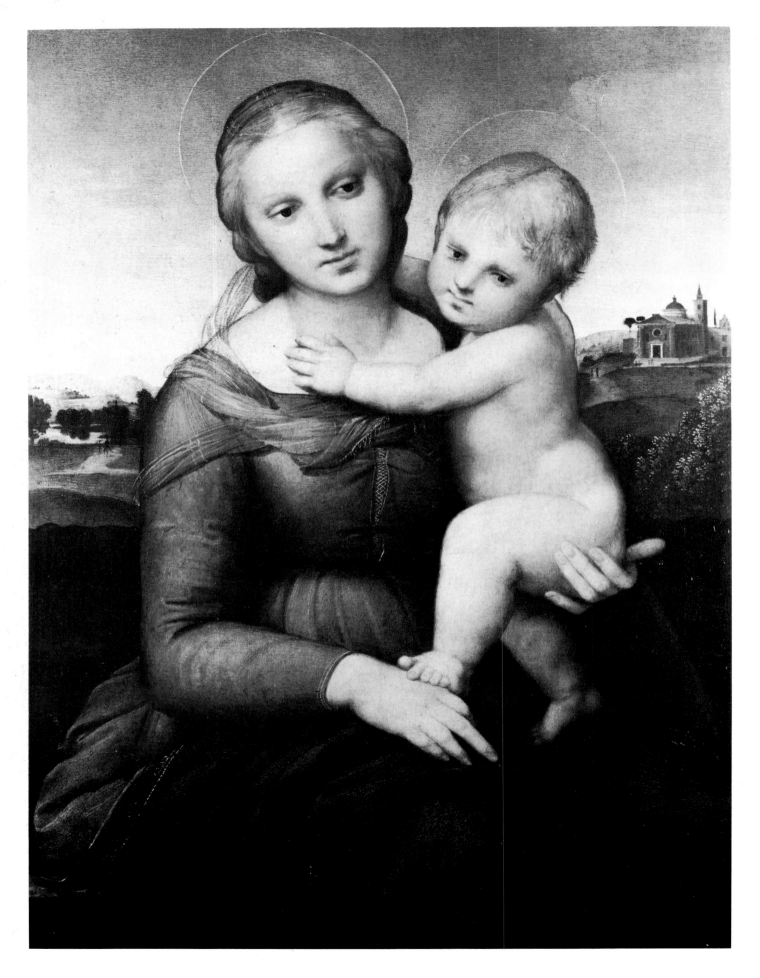

40. *The Small Cowper Madonna.*
Panel, 59.5 × 44 cm. Washington,
D.C., National Gallery of Art.
Slightly later in date than the
Madonna del Granduca, this
composition employs the more
pronounced tilt of the Virgin's
head in the drawing for the
Madonna del Granduca (Plate 38).
To balance this movement the
Child's head has been tilted in the
opposite direction.

42 (right). *The Tempi Madonna.*
Panel, 75 × 51 cm. Munich, Alte
Pinakothek.
One of the last of Raphael's
Florentine Madonnas. The loose
brushwork and the close
correspondence with a composition
by Donatello in Padua may
indicate that Raphael had travelled
to Venice in early summer 1508.

41. Donatello. Detail of the
Madonna and Child from '*The
Miracle of the Speaking Babe*'.
Bronze relief. Padua, Sant'Antonio.
Although there are other examples
of the Madonna and Child among
Donatello's work, none matches
any composition of Raphael's more
closely than this. More quotations
from Donatello's Paduan reliefs
appear in Raphael's frescoes for the
Vatican Stanze (see Plate 91).

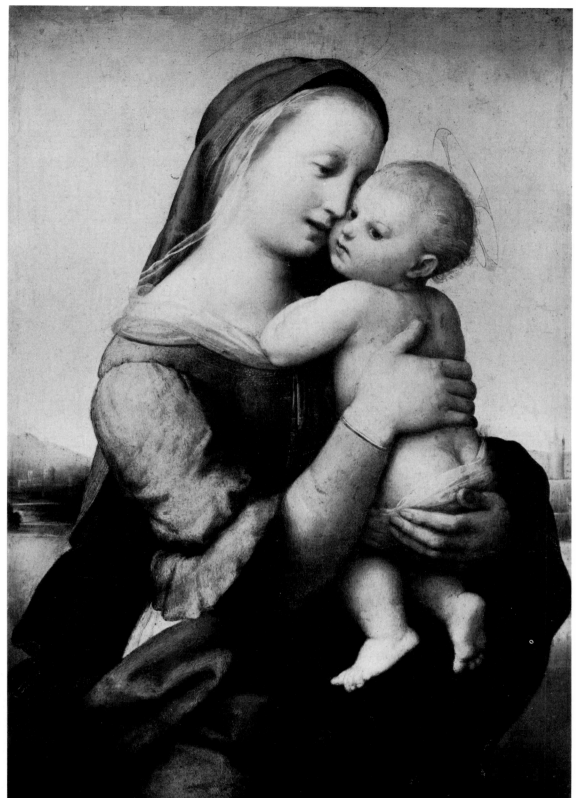

has a definite Florentine air and bears a striking similarity to the handling of the
same subject by Donatello (Plate 41).

Raphael also studied the variations that Michelangelo had introduced in his own
studies of Leonardo's work. *The Taddei Tondo* (Plate 48), carved for a patron of
both Raphael and Michelangelo, shows the Child's head turning inward to the
composition while His body moves outward, recoiling from the bird proffered by
the young Baptist. Raphael then experimented further with this complex
movement, turning the figures now towards, now away from each other in
contrasting twists (Plate 43). Numerous drawings working out these problems

43. *Studies of the Madonna and Child.* Pen and ink, 23.3 × 18.3 cm. London, British Museum. In Florence, Raphael also learned a freer drawing style. Following Leonardo's technique of trying different poses on top of one another, he has altered the Virgin's left hand so often that it has become illegible.

exist, and those solutions that pleased Raphael were painted. Closest to the prototype of the *Taddei Madonna* is *The Bridgewater Madonna* (Plate 61). Raphael has tightened the contact between mother and Child with the exchange of a glance. The psychological bond makes the image more self-contained and at the same time more human. This process is continued in *The Colonna Madonna* (Plate 46). Here the movement seems more natural and spontaneous. The knees of the Madonna, in the opposite direction from the previous painting, form a C-curve with her head and the body, and thus she envelops the clinging Child protectively. Experiment has given way to solution.

Another motif that Raphael took over from Michelangelo was that of the Child standing between His mother's knees, first introduced in *The Bruges Madonna* of *c.* 1505 (Plate 44). Raphael, who had formerly followed the convention of placing the Child on the Virgin's lap or in her arms, immediately adopted it (Plate 45). By

adding the young St. John, he developed a composition with a broader base, thus softening the stern hierarchical image produced by Michelangelo. This formula resulted in three of the most popular paintings Raphael ever executed and demonstrate the seemingly endless variety with which he could endow a given theme.

The Madonna del Cardellino (Plate 47) is the closest to Michelangelo's ideas, even using the St. John with a goldfinch from the *Taddei Tondo*. Rather than recoiling violently, however, Christ leans backwards towards it in a languid manner. An interesting note is that the Child's foot is placed on top of the Virgin's. This refers to a theological discussion regarding religious hierarchy. When Christ is placed on the Virgin's lap, He is necessarily above and therefore superior to her. Michelangelo had avoided the problem by making the Child stand on the Virgin's

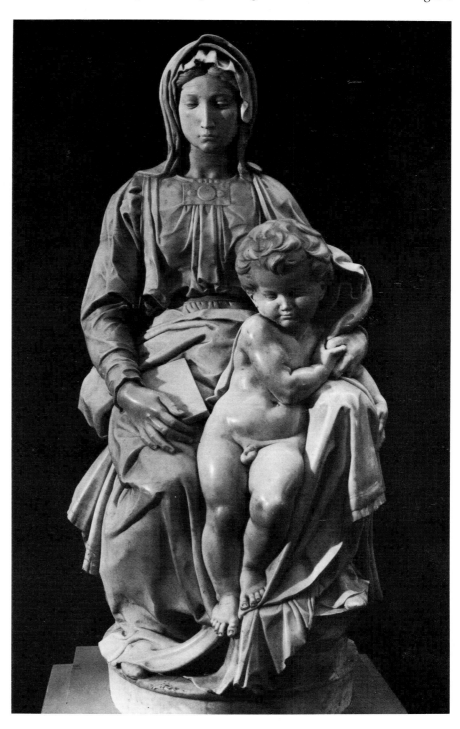

44. Michelangelo. *The Bruges Madonna*. Marble, height 128 cm. Bruges, Church of Notre-Dame. It is uncertain where Michelangelo carved this work, but documents indicate that it was probably made in 1505. Although Michelangelo cautioned his father in a letter to let no one in Florence see the statue, it is clear from Raphael's work that the motif of the Child standing between the knees of the Virgin soon became known.

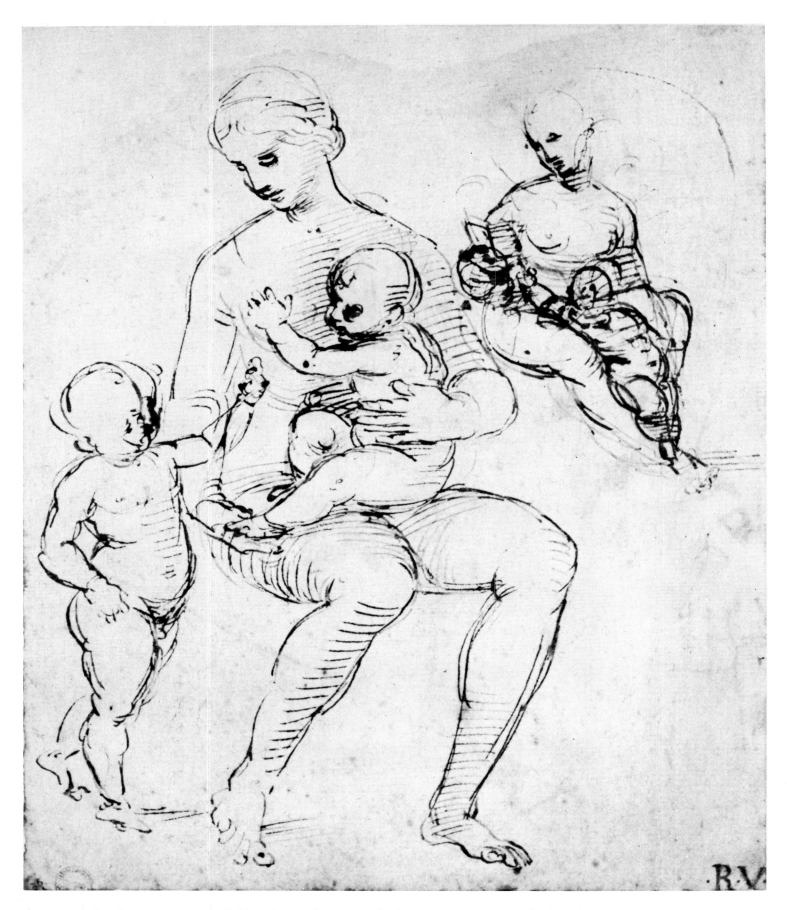

45. *Two Studies for a 'Virgin and Child with St. John'*. Pen and ink, 24.8 × 20.4 cm. Oxford, Ashmolean Museum.
Experimenting with a group of three figures, Raphael tried both seating the Christ Child on the Virgin's lap and placing him between her knees.

46. *The Colonna Madonna*. Panel, 77 × 56 cm. Berlin-Dahlem, Gemäldegalerie.
In this graceful painting Raphael has achieved a dynamic movement within a classic pyramidal composition. The gesture of the Child reaching for the Virgin's breast refers to her role as our intercessor with God. It is because she gave Christ milk when he became man that she can accept petitions on our behalf.

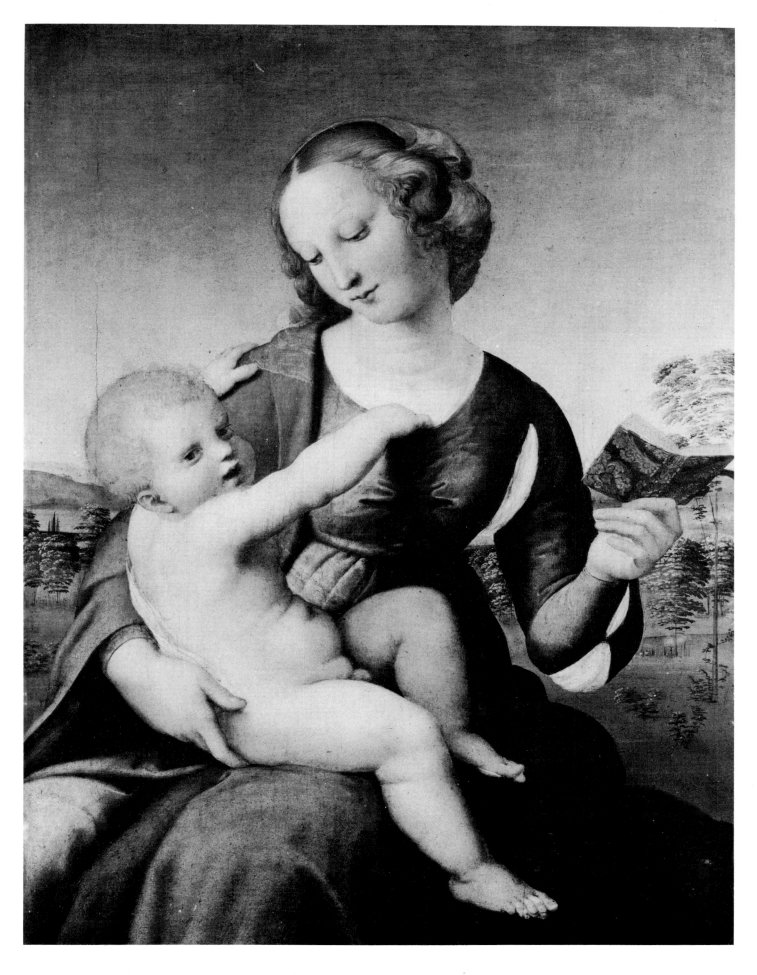

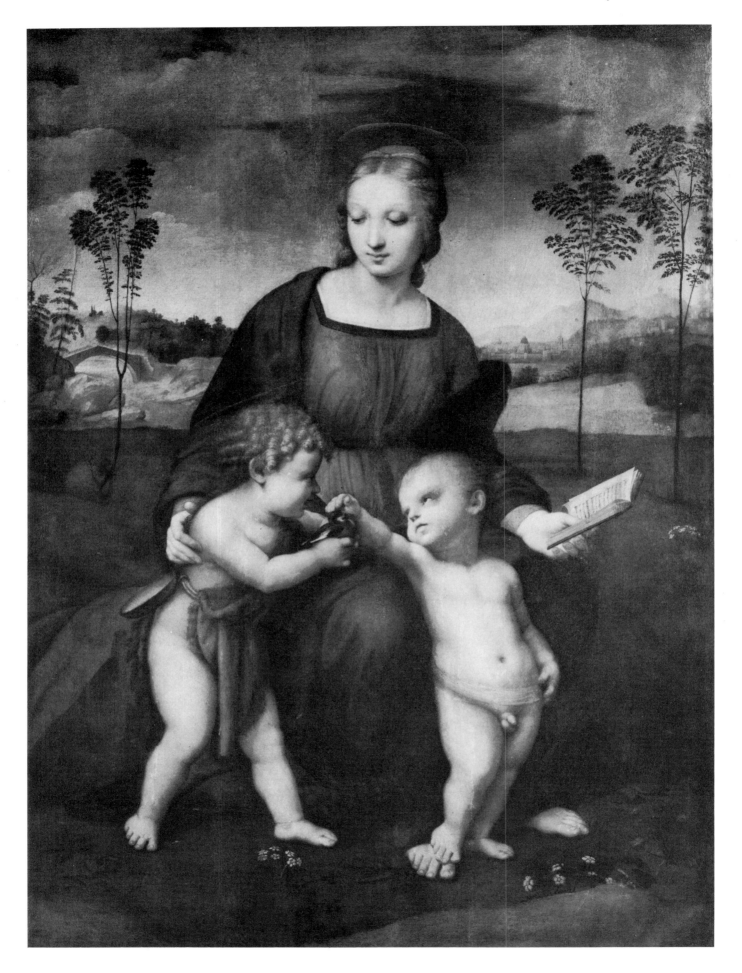

47. *The Madonna del Cardellino (The Madonna of the Goldfinch).* Panel, 107 × 77 cm. Florence, Uffizi.
The goldfinch held by the young St. John refers to the Passion of Christ as well as to the soul. The picture was badly
damaged in 1547 when a house collapsed.

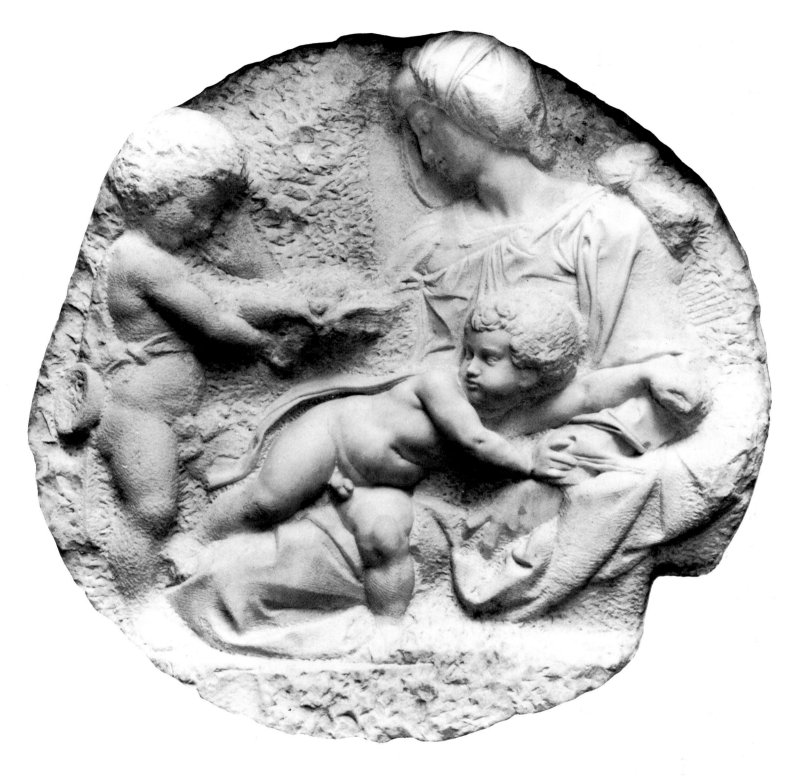

48. Michelangelo. *The Taddei Tondo*. Marble relief, diameter 109 cm. London, Royal Academy. This is Michelangelo's interpretation of the motif of the Child lying across the Virgin's lap from Leonardo's *St. Anne Cartoon*. Drawings show that Raphael studied this relief closely.

dress. But Raphael actually placed Christ on the ground and therefore was forced to establish His superiority to His mother in another manner. The same problem had arisen over the depiction of St. Anne and the Virgin as an adult with her Son. The result, as seen for example in the Leonardo cartoon for this subject, was to seat the Virgin on St. Anne's lap and then place the Child on top of her.

How Raphael laboured to find the optimum formal solution is clearly seen in a series of studies for *The Madonna of the Meadow* (Plate 49). The Virgin's position has been decided but not that of either child. Christ is turned in and out, looking toward or away from His mother. Even St. John can be seen kneeling in adoration or turning away, pointing in the opposite direction. The painted solution — one

of Raphael's most serene images — results in a series of interrelated and magnificently proportioned figures (Plate 50). The perfection of the image is such that in spite of its complex construction the figures seem completely unposed.

A squared drawing for the last of this series, *La Belle Jardinière*, reveals that Raphael conceived of the proportions of the figures as being such that the ratio of their height to their width was two to one (Plate 51). This was altered in the painting (Plate 52) by additional drapery, probably painted by Ridolfo Ghirlandaio. The increased sensitivity to format, seen in the rounding of the Virgin's pose to echo the rounded top of the panel, testifies to Raphael's growing maturity.

The Canigiani Madonna (Plate 54) adds St. Joseph and St. Elizabeth to the group and is the artist's most ambitious exploration of this type of grouping before his departure for Rome. A complex series of concentric half-circles and overlapping triangles can be traced inside the unifying pyramidal silhouette of which St. Joseph is the apex. The increasing ease with which Raphael could handle difficult figure arrangements is evident when this picture is compared with *The Holy Family with the Lamb* (Plate 53), signed and dated 1504. This latter was inspired by another of Leonardo's cartoons for the *Virgin and Child with St. Anne*, now lost. The cartoon had created a sensation when it was put on display in 1501 and showed

50. *The Madonna of the Meadow.* Panel, 113 × 88 cm. Vienna, Kunsthistorisches Museum. Dated on the neckline of the Madonna's dress M.C.V.I. As the Florentine year began on 25 March, the inscribed date refers to some time between the end of March 1506 and March 1507.

49. *Studies for 'The Madonna of the Meadow'.* Pen and yellow-brown ink, 24.5 × 36.2 cm. Vienna, Albertina. How carefully Raphael worked out his compositions can be seen from this drawing with four different poses.

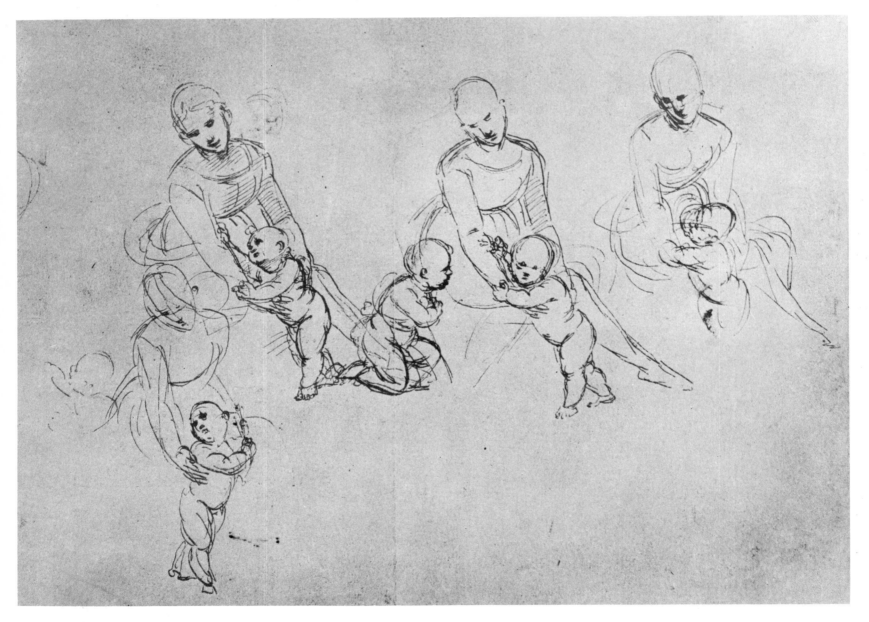

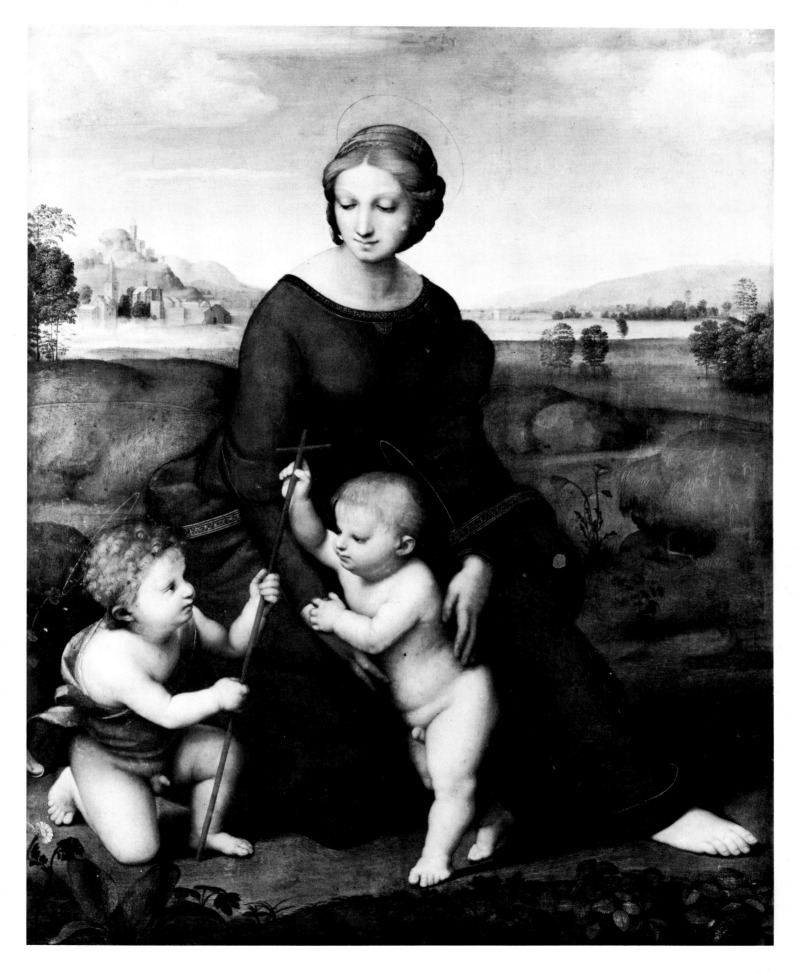

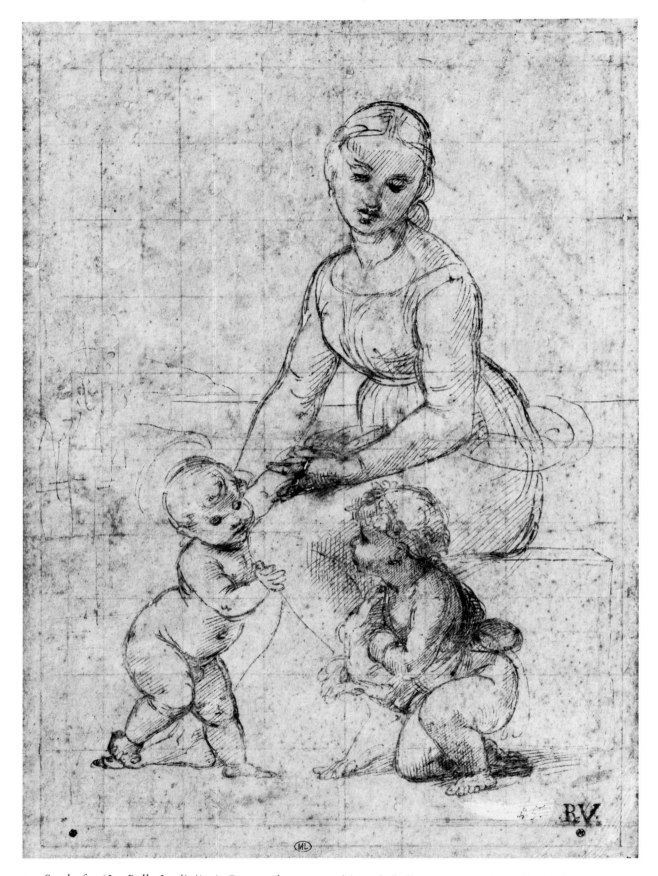

51. *Study for 'La Belle Jardinière'.* Over stylus, squared in red chalk, 30.2 × 20.8 cm. Paris, Louvre.
The squaring on this drawing shows that Raphael planned the proportions in a height to width ratio of
two to one. The lamb held by St.John was replaced by a reed cross in the painting.

52. *La Belle Jardinière.* Panel, 122 × 80 cm. Signed and dated on the seam of the Madonna's mantle:
RAPHAELLO VRB. MDVII. Paris, Louvre.
Vasari wrote that this picture was left by Raphael to be completed by Ridolfo Ghirlandaio. His
addition of the drapery to the right altered Raphael's carefully planned proportions.

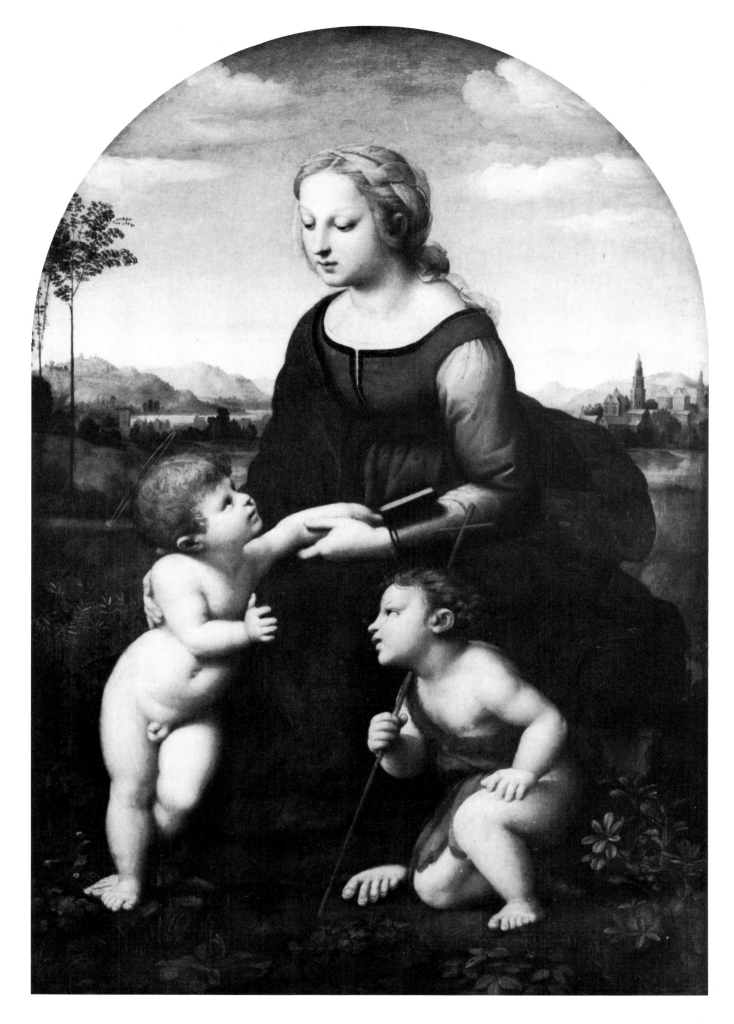

53. *The Holy Family with the Lamb*. Panel, 32 × 22 cm. Signed and dated on the Virgin's bodice: RAPHAEL VRBINAS AD MDIV. Vaduz, Private Collection.
This lovely little picture was one of Raphael's first Florentine works and drew its inspiration from Leonardo.

Mary, half-rising from Anne's lap, trying to draw Christ away from the symbolic lamb. Raphael has employed the same theme in the Vaduz picture but arranged the figures in a simple descending curve. By the time of the *Canigiani Madonna* he organized the figures into a much more complex relationship. He never forgot what he considered a successful solution, and over ten years later the same figures with only slight alterations were used again in the *Madonna of Francis I* (Plate 182).

Raphael did not spend the years between 1504 and 1508 only studying and working on formal problems in Florence. He received at least five large commissions from Perugia and must have travelled there to execute them. Two altarpieces of similar format seem to have been commissioned about the same time,

54. *The Canigiani Madonna*. Panel, 131 × 107 cm. Signed on the Virgin's neckline: RAPHAEL VRBINAS. Munich, Alte Pinakothek. Left unfinished by Raphael, the clouds and cherubim in the two upper corners were painted out in the early nineteenth century, thus destroying the tight composition and leaving large empty spaces of sky behind St. Joseph. The picture is currently being cleaned and restored to its original condition.

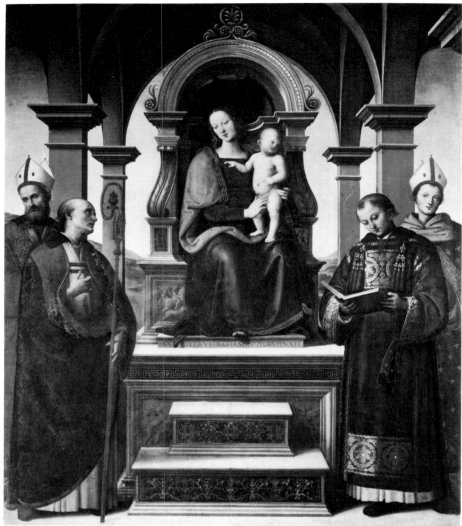

and one, *The Ansidei Altarpiece* (Plate 57), is dated on the painting 1505. This work required an upright panel, unlike *The Pala Colonna* (Plate 55), and therefore the Virgin is placed on a higher throne. Both use the classic *sacra conversazione* formula and rely heavily on Perugino prototypes, most notably on the *Pala dei Decemviri* (Plate 56) painted during the 1490s for the chapel of the Palazzo Pubblico in Perugia. Raphael had already been experimenting with the composition of the Madonna on an elevated throne under a *baldacchino* in earlier drawings (Plate 58), which are not related directly to either of the two altarpieces for Perugia.

While his paintings retained certain Peruginesque characteristics, most notably in the treatment of the Virgin, the impact of what Raphael had observed in Florence can be seen in the more massive drapery of the male saints as well as the subtler modelling of their faces. These ideas came from Fra Bartolommeo, whose use of colour and simplified monumental forms also greatly influenced Michelangelo and Titian.

The fact that Raphael did not make more use of what he was learning in Florence may have been due to the conservative taste of his clients. Perugino's static style continued to be popular throughout central Italy even though the exciting innovations were being introduced in Florence. The nuns who ordered the *Pala Colonna*, so Vasari implies, even specified that the Christ Child be clothed, contrary to late quattrocento fashion.

Such close control and old-fashioned preferences by patrons can be seen even

55 (left). *The Pala Colonna*. Panel, 169 × 168 cm. New York, The Metropolitan Museum of Art. Called after the seventeenth-century owners, this altarpiece was commissioned for the convent church of Sant'Antonio in Perugia.

56. Perugino. *Pala dei Decemviri*. Panel, 193 × 165 cm. Rome, Vatican Pinacoteca.
This altarpiece, for the chapel of the Palazzo Pubblico in Perugia, was the model for two of Raphael's works (Plates 55 and 57).

57. *The Ansidei Altarpiece*. Panel, 209 × 148 cm. Dated on the seam of the Madonna's cloak: M.D.V. London, National Gallery. Commissioned by Bernardino Ansidei for his chapel in San Fiorenzo, Perugia, this work is a successful blend of Peruginesque and Florentine elements. The magnificent head of St. Nicholas is one of Raphael's finest efforts.

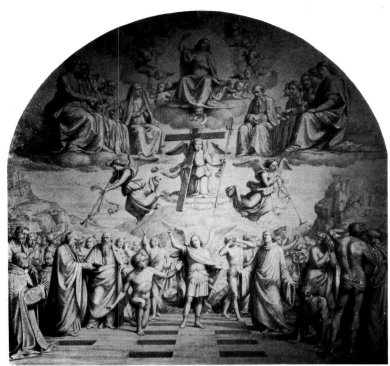

more clearly with the commission for the Monteluce altarpiece. In December 1505 Raphael was hired to paint the *Coronation of the Virgin* for the nuns of Monteluce near Perugia. The documents specify that the work was to be done jointly with another painter and that the model to be followed was Domenico Ghirlandaio's altarpiece of 1486, then in the church of San Girolamo in Narni. Raphael may have found such restraints stifling, for he never executed the picture. But the nuns were nothing if not tenacious, for they pursued Raphael to the end of his life and beyond, demanding that his heirs fulfil the renegotiated contract of 1516. The painting, finally delivered in 1525, was ultimately carried out by Gianfrancesco Penni and Giulio Romano.

The conservative nature of these altarpieces becomes apparent when contrasted with another of Raphael's commissions for a Perugian client, the unfinished fresco of *The Holy Trinity with Saints* in the church of San Severo, painted between 1505 and 1508 (Plate 60). In order to give the picture greater spatial depth Raphael used Fra Bartolommeo's innovative positioning of figures in his fresco of *The Last Judgment* in Santa Maria Nuova in Florence (Plate 59). The difference between the quattrocento and cinquecento conceptions of space becomes even more obvious when Raphael's portion is compared with the lower half of the fresco, carried out by Perugino after Raphael's death in 1520. Ignoring all the innovations introduced in the intervening fifteen years, the older master used the same isocephalic line of figures that he had employed since the 1480s, and the result was no different than if he had executed the scene in 1505-8. While Raphael had learnt the new ideas of the early sixteenth century in Florence, Perugino had not, and remained the quintessential fifteenth-century painter.

The most ambitious work that Raphael executed for Perugia is the famous *Entombment* (Plate 62), signed and dated 1507. Vasari tells us that Raphael received

58. *Enthroned Madonna and Child, with St.Nicholas of Tolentino.* Pen and brown ink with later retouchings in chalk or pencil, 23.3 × 15.6 cm. Frankfurt, Staedelsches Kunstinstitut.
While not related to any known painting by Raphael, this drawing shows how carefully he studied both the architecture and the throne of Perugino's *Pala dei Decemviri* without actually copying it.

59. After Fra Bartolommeo. *Engraving after the Fresco of 'The Last Judgment' in Santa Maria Nuova, Florence.* Florence, Museum of San Marco.
The formal composition of this fresco was used by Raphael not just for his fresco in San Severo but also for the *Disputa*, his first large work in the Vatican Stanze.

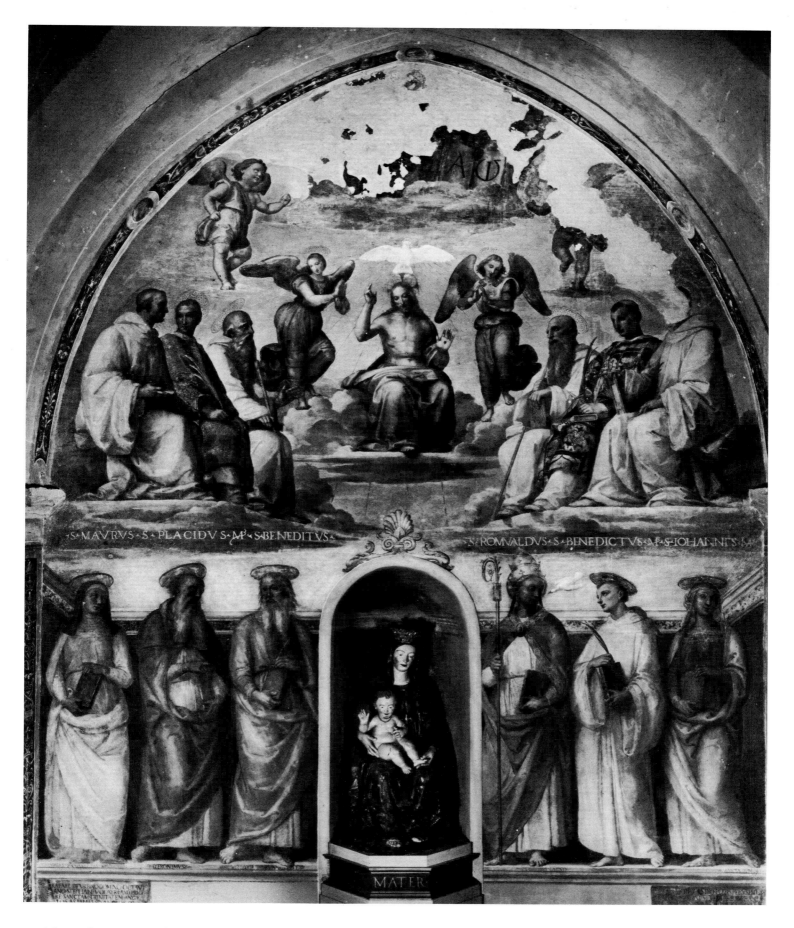

60. *The Holy Trinity with Saints*. Perugia, San Severo.
In spite of the fresco's poor condition, the sophistication of Raphael's rendering of receding space in the upper register is readily apparent when contrasted with Perugino's simplistic linear arrangement of the figures in the lower register, which he completed after Raphael's death.

61. *The Bridgewater Madonna.* Canvas, transferred from panel, 81 × 56 cm. Duke of Sutherland Collection (on loan to the National Gallery of Scotland, Edinburgh).
Instead of placing the Child across the Virgin's lap as Leonardo had, or turning only the head back, as did Michelangelo, Raphael has twisted the entire upper torso so that the Child actually curls back to the Madonna.

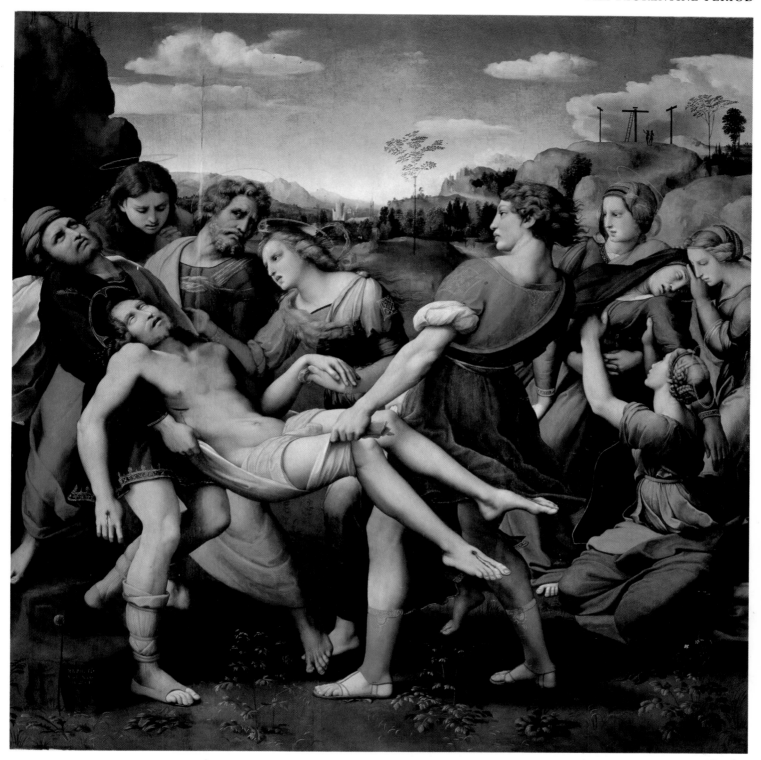

62. *The Entombment*. Panel,
184 × 176 cm. Signed and dated
on the stone step to the left:
RAPHAEL./VRBINAS./M.D.VII. Rome,
Villa Borghese.
This ambitious attempt by Raphael
to combine almost everything he
had learned in Florence never
coalesced into a unified
composition. Nevertheless, the
brilliant jewel-like colours and the
intensity of the emotion make it a
work of great beauty and feeling.

the commission, while he was on a visit to Perugia, from Atalanta Baglione for her
chapel in San Francesco al Prato; promising to return to complete the work, he left
for Florence, where he worked out the design. What makes this story credible is
that there remain many drawings showing that the painting, originally conceived
as a Lamentation roughly based on a Perugino composition (Plate 63), underwent
a metamorphosis. From its inception, however, Raphael was determined to use the
motif of Christ's dangling right arm, which so strongly conveys the lifelessness of
the corpse. The same pose occurs not only in Michelangelo's *Pietà*, already in
Rome, but in a number of drawings by Filippino Lippi and an altarpiece by
Signorelli.

The picture that gradually evolved is a highly emotional synthesis of almost

everything that Raphael had learned in Florence. The position of the human body while carrying a heavy object and the appearance of the dead weight of a corpse were both studied in great detail under the inspiration of Leonardo. The monumentality of the figures comes from the massive forms of Fra Bartolommeo, and the agitated movements of the women derive from Donatello and Filippino. Once again, too, the impact of Michelangelo is clear. Raphael sketched the unfinished statue of *St. Matthew* and then used it 'in reverse' for the bearer behind Christ's shoulder. More significant for his future work was the kneeling woman twisting back to support the swooning Virgin. Taken from Michelangelo's *Doni Tondo* (Plate 65), she reappears constantly in Raphael's subsequent work. Unfortunately, not even he could successfully digest so many divergent ideas at once, and the *Entombment* is a disjointed composition with individual passages of great power.

Atalanta Baglione, who commissioned this altarpiece, was a member of the ruling clan in Perugia. Her tragic life is the stuff of grand opera. Married briefly to a distant

64. Leonardo da Vinci. *Mona Lisa.* Panel, 77 × 53 cm. Paris, Louvre. Certainly the most famous and most influential portrait ever painted, the *Mona Lisa* had an immediate effect on Raphael's portrait style.

63. *Pietà.* Pen and brown ink, 17.8 × 20.5 cm. Oxford, Ashmolean Museum.
The first drawings for the *Entombment* show that it was originally conceived as a Lamentation over the dead Christ. Although here most of the figures depend on Perugino's prototypes, the dangling arm of Christ already shows Florentine influence.

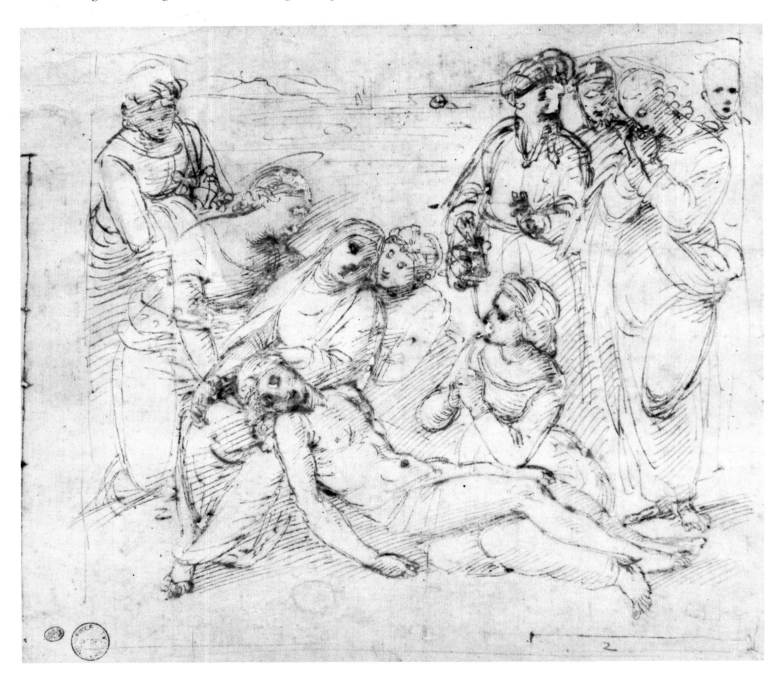

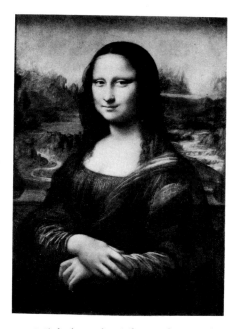

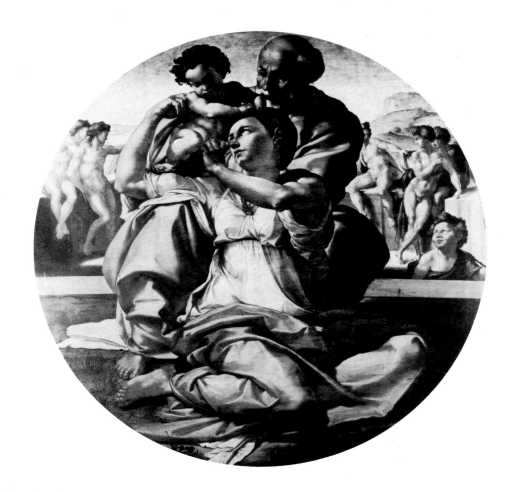

65. Michelangelo. *The Holy Family (The Doni Tondo)*. Panel, oval, 91 × 80 cm. Florence, Uffizi. Painted for Angelo Doni whose portrait Raphael later painted (Plate 67), this is a rare example of Michelangelo's paintings before he went to Rome. Raphael became fascinated with the pose of the Virgin and several variations of it can be seen throughout his work.

66. *Francesco Maria della Rovere*. Panel, 47 × 35 cm. Florence, Uffizi.
While this portrait has not been proved conclusively to be that of the future Duke of Urbino, the fact that it comes from the ducal collection argues strongly in favour of this identification. Probably painted around 1504, the sitter is placed in a pose used earlier by Perugino for his self-portrait.

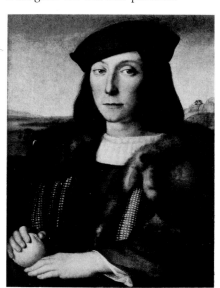

cousin, she bore a son, their only child, after her husband's death. This son, Grifonetto, tried to kill members of his own family during a power struggle in 1500 and was thus disowned by his mother. Shortly after, he was attacked by those seeking revenge and died in Atalanta's arms as she begged him to forgive his murderers. The great historian, Jacob Burckhardt, saw a connection between this traumatic event and the commissioning, seven years later, of the *Entombment*. Unfortunately the church of San Francesco al Prato was severely damaged by an earthquake during the eighteenth century and subsequently completely rebuilt, so there is no way of knowing if Atalanta intended her chapel to be used as a memorial for Grifonetto. Nor is it clear whether the *Entombment* was placed near Raphael's *Coronation of the Virgin*, which had been installed in a chapel in the church in 1503. What is certain, however, is that when Julius II came to Perugia in 1506 to establish a peace between the various warring factions, he celebrated Mass in this church. It would have been on the morning of 20 September that he first saw the work of the artist who would immortalize him in the first great papal portrait.

While Michelangelo principally influenced Raphael's treatment of the human figure, Leonardo changed his portrait style through the *Mona Lisa* (Plate 64). Its impact can be appreciated by comparing the portrait of Francesco Maria della Rovere (Plate 66) with the portraits of Angelo and Maddalena Doni (Plates 67 and 68). The pre-Florentine portrait is placed frontally, in a pose popular with the Perugino school, while Maddalena Doni's pose is taken directly from the *Mona Lisa*. The positioning of Angelo shows a greater independence, for the shoulders are placed at a definite angle to the picture plane as in Leonardo's masterpiece, but the left arm has been raised to rest on a balustrade, thus making the sitter appear more at ease. Raphael did reject Leonardo's limited tonal range, however. Throughout his life, his obvious preference was for strong colours, especially red.

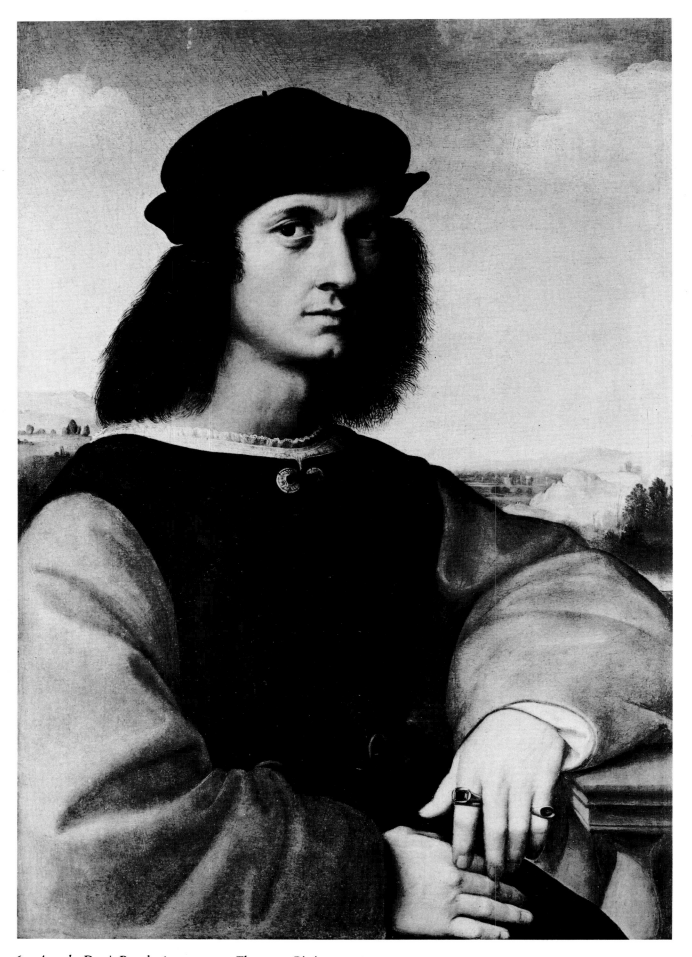

67. *Angelo Doni.* Panel, 63 × 45 cm. Florence, Pitti.

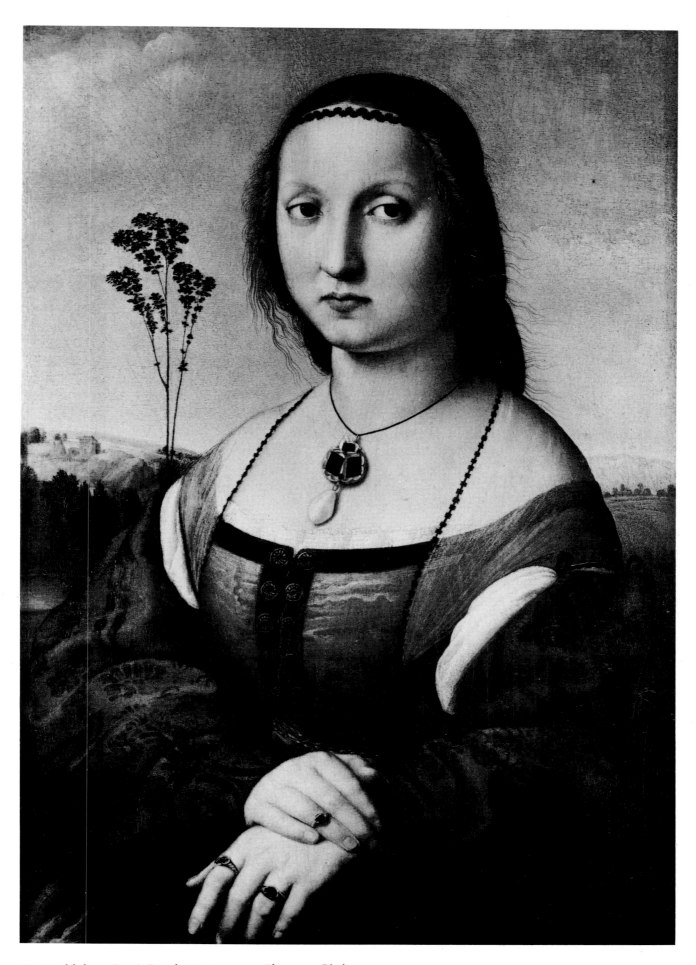

68. *Maddalena Doni*. Panel, 63 × 45 cm. Florence, Pitti.
Although he used *Mona Lisa*'s pose for Maddalena Doni, Raphael has rejected Leonardo's
limited tonal range and atmospheric background, preferring the bright colours and clear
landscape of Umbrian painting.

73

Angelo Doni is one of the few known patrons who employed Raphael in Florence. The son of a wool merchant, he was, according to Vasari, notoriously tight-fisted with money. His family had not been prominent in Florence in either politics or patronage, and the family home was only purchased by Angelo's father, which would indicate a recent rise in the family fortunes. The failure of the Medici bank and the exile of many members of the ruling families had created a vacuum, which allowed considerable social climbing, such as Angelo's marriage to a member of the venerable and powerful Strozzi family in 1504. Perhaps it was Maddalena who persuaded her husband to use some of his wealth for the purchase of art. The only other work, however, that he is known to have commissioned is the extraordinary tondo of the *Holy Family* painted by Michelangelo about 1504 (Plate 65).

Raphael shared another patron with Michelangelo. In contrast to the miserly Doni was the lawyer Taddeo Taddei, whom Raphael mentioned with great warmth in a letter to his uncle in 1508. Vasari claimed that the two men were such great friends that Raphael was often invited to dinner and that he painted two pictures for Taddei, generally assumed to be the *Madonna of the Meadow* (Plate 50) and the *Tempi Madonna* (Plate 42). Both men were friends of Pietro Bembo and may have become acquainted through him.

Raphael probably met Bembo in Urbino when the latter arrived there in 1506. The artist's presence at the court is indicated by the painting of St. George (Plate 34), which almost certainly was commissioned by Duke Guidobaldo, for St. George wears a garter, the symbol of the Order of the Garter, which the Duke received in 1504. Two other works painted at the ducal court at this time are known only from documents. One, a portrait of Bembo, has not been identified convincingly with any accepted portrait by Raphael. The second, an *Agony in the Garden* commissioned by the Duchess and carried by Bembo as a gift to a Camaldolese monastery, is lost. But the fortunes of the Duke at this time were not such as to allow for large-scale commissions, and while Raphael may have enjoyed Guidobaldo's personal favour, the lack of work and paucity of funds would have forced him to seek employment elsewhere.

Florence certainly provided several clients, even though there are no documented commissions. Two of the Madonnas of this period came from the houses of old and established Florentine aristocracy, the Salviati and the Niccolini, but it is not known if they were actually painted for these families. Another, the *Madonna del Cardellino* (Plate 47), is connected with Lorenzo Nasi by Vasari, for it was in the Casa Nasi when it was damaged by an earthquake in 1548. The Nasi, a family of some prominence, lived in the Santo Spirito quarter of the city, as did the Dei and the Canigiani, the patrons of the two largest works that Raphael painted in Florence. The Dei family commissioned the now ruined *Madonna del Baldacchino* (Florence, Pitti Palace) as an altarpiece for the family burial chapel in the newly rebuilt church of Santo Spirito, but the picture was far from finished when Raphael left for Rome in 1508, and subsequent overpainting has altered the original considerably. It may be that the Canigiani intended their *Madonna* (Plate 54) also for a chapel in Santo Spirito since Brunelleschi's innovative design for the church allowed for numerous small private chapels, and the size of this panel makes it unlikely that it was to be placed in a private house.

Not all Raphael's commissions came from Florence, Perugia, or Urbino. According to Vasari, *La Belle Jardinière* (Plate 52) was ordered by a client in Siena and, on Raphael's departure for Rome, was left with Ridolfo Ghirlandaio to be finished. This could explain why the name appears in the Italian form *Raphaello* instead of the Latin form *Raphael*, normally used by the painter himself. If Vasari

is right the year of 1507, also on the bodice, would then refer to when the picture was begun rather than the date of completion.

This painting entered the French Royal Collection from that of Filippo Sergardi, an apostolic protonotary from Siena who worked extensively for the papal banker and fellow Sienese, Agostino Chigi. Filippo was appointed executor of Chigi's will in 1519, which made him responsible for seeing that Raphael carried out the decoration of the Chigi burial chapel in Santa Maria del Popolo exactly as planned. Sergardi took his responsibilities seriously, because ten years after the deaths of Raphael and Chigi in 1520 he signed a contract for the completion of the chapel with Sebastiano del Piombo, which carefully specified all the subjects for decoration, including the altarpiece.

Raphael's relationship with Sergardi is unclear. They do not seem to have been friends during the years when they were both in Rome and working for the same men. However, Agostino Chigi was in Siena in 1507, and the talented young artist may then have come to his attention. Sergardi could have subsequently acquired the Raphael *Madonna* as a remuneration for serving as executor after Chigi's death when the family fortunes rapidly declined. If the notary was indeed Raphael's patron in 1507–8, it would have been Raphael's first job for a member of the papal curia.

That Raphael suddenly abandoned as large and important a commission as the *Madonna del Baldacchino* in order to go to Rome in 1508 indicates that he was sure of employment at the papal court. Julius II, on deciding to decorate the new papal apartments, had gathered together many prominent artists, among them Perugino. Perhaps Raphael's teacher suggested that his gifted pupil should be employed. It is possible that Julius II remembered the painting he had seen in San Francesco in Perugia, and acted of his own accord. Raphael could also have been recommended to him by his nephew Francesco Maria, now Duke of Urbino, his lawyer Sergardi, or even his banker Agostino Chigi, who had already lent him the services of the painter Sodoma. Vasari's claim that Bramante, Julius's architect for the new St. Peter's and the Vatican palace, suggested Raphael because they were cousins is not supported by evidence. Bramante was not related to Raphael and had left Urbino for Milan many years earlier. But for whatever reason Raphael went, it was the most important move of his entire life. In Rome he found not only permanent employment but also the perfect ambience for his talents and a pope whose demands for excellence in art brought Raphael's abilities to the fore. Apart from short excursions, he never left the city again.

3 *The Rome of Julius II*

Rome in 1508 must have been an extraordinary place. Michelangelo, having expelled everyone from the Sistine Chapel, had begun working on the ceiling. Old St. Peter's, the most venerated church in Christendom, was being rebuilt by Donato Bramante, who at the same time was remodelling large parts of the Vatican palace. To the south, on the same side of the Tiber, the foundations of Agostino Chigi's suburban villa designed by Peruzzi were being laid, and to the north, on the opposite bank, Andrea Sansovino was carving two magnificent funerary monuments for the newly constructed choir of Santa Maria del Popolo. A team of prominent painters including Sodoma, Perugino, Lorenzo Lotto and Bramantino had been engaged to decorate the papal apartments. One man was responsible for this phenomenal artistic endeavour: Pope Julius II.

Giuliano della Rovere, who took the name Julius II on his elevation to the papacy, has left an indelible stamp on Italian history and Roman culture. He was the nephew of Pope Sixtus IV and was appointed to the College of Cardinals in 1471 with the titular church of San Pietro in Vincoli. Constantly employed by his uncle on diplomatic missions throughout Europe, he developed a keen political sense and a driving ambition to become pope. These designs were thwarted three times by complicated political machinations before he finally achieved his goal, not entirely by honest means, in November 1503.

As a cardinal Giuliano had seen how skilfully his uncle used art to further papal propaganda. Sixtus built and decorated the Sistine Chapel as a manifesto of the pope's primacy, that is, his absolute leadership within the hierarchy of the Church. He renovated several Roman churches, with special attention to Santa Maria del Popolo to ensure that the first Roman church encountered by pilgrims from the north would impress them. Following Sixtus's desire to be 'humbly buried in the floor', Giuliano commissioned a free-standing bronze tomb from Antonio Pollaiuolo, the magnificence and size of which dispelled pretensions to humility on the part of the della Rovere family.

Julius was a pope driven by a vision. All his actions were aimed at securing the absolute power of the papacy and at protecting its independence against the challenges to his authority from councils, cardinals, and kings. To this end he sought to establish a state across central Italy as a safe territorial base for the papacy. He was utterly ruthless in achieving this goal and waged war up and down the peninsula, changing allies when required. His many detractors, among them Erasmus, depicted him as a proud egotist interested only in promoting his own glory. But Julius's intense commitment to his conception of the papacy was motivated by an appreciation of the dangers inherent in a second Schism or in a

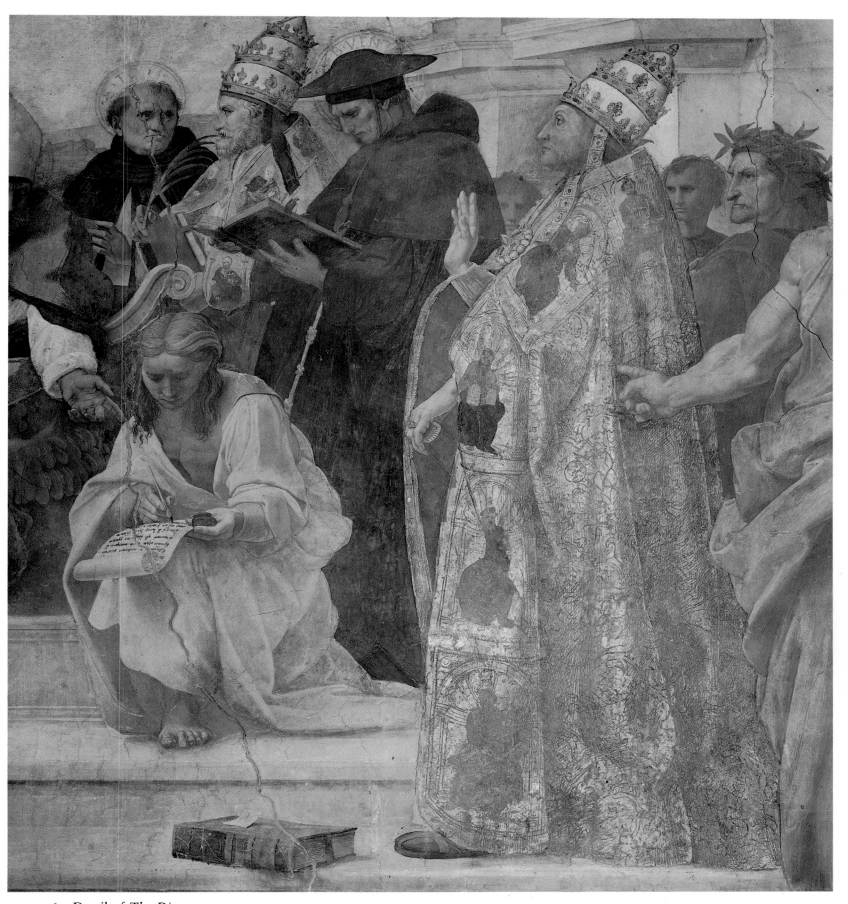

69. Detail of *The Disputa*.
Several figures in this fresco (Plate 80) can be identified. St. Thomas Aquinas and St. Bonaventura (dressed as a cardinal) have haloes with their names in gold lettering. Pope Sixtus IV stands next to Bonaventura, and behind him is Dante, the only person depicted twice in the room.

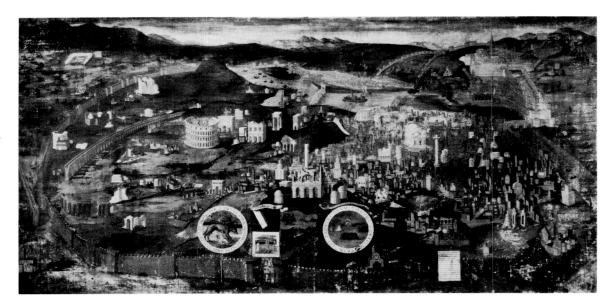

papacy subservient to a lay monarch, as had occured 150 years earlier during the 'Babylonian Captivity of the Church' in Avignon.

Julius's feverish rebuilding of Rome must be seen in relation to this. He sincerely wanted to create for Christendom a capital whose splendours would replace those of the pagan city (Plate 70). The strength of his determination transmitted itself to his artists, who for their part were inspired by the opportunities afforded them. The overwhelming personality of Julius, described during his lifetime as being endowed with *terribilità*, transformed the art of the High Renaissance.

Documents indicate that Julius had used two small rooms on the third floor of the Vatican palace for his living quarters from about 1505. These rooms, however, would not have provided sufficient space for the various ceremonial functions of the papal court or for a private study, for which the Borgia apartments on the second floor probably continued to serve. In November 1507 the Pope exclaimed that he could no longer stand the sight of his predecessor Alexander VI, whose portrait was included in Pintoricchio's colourful frescoes, and he transferred his entire household to the upper floor. (Today the room just behind the Stanza d'Eliodoro, which served as Julius's new *anticamera secreta*, houses a sales desk for reproductions and slides.)

This move made it necessary to remodel and redecorate the third floor in a manner appropriate to its new function as the official papal apartments. The first three rooms that received attention were those to the north of Julius's private rooms, and are today known as Raphael's Stanze. How these rooms were used during the reign of Julius II has been established convincingly by John Shearman. Nearest to the papal bedroom, the Stanza d'Eliodoro probably served as an audience chamber. Next to this, the so-called Stanza della Segnatura became Julius's private study, and the last room, the Stanza dell'Incendio, farthest from the private quarters, was originally intended as the meeting place for what was in effect the Supreme Court of the Church, the Segnatura. After Julius's death the rooms were put to other uses, and by Vasari's day the Segnatura had been moved into the room that today bears its name.

By October 1508 a team of artists had been assembled to paint these rooms. Of the early decorations only Perugino's ceiling in the Incendio remains, for all the rest were gradually redone after Raphael's talent became apparent. As the first documented payment to Raphael is dated January 1509 it is not clear whether he was included in the original group of painters.

Stanza della Segnatura

In 1509 the young master seems to have been working with the Sienese painter Sodoma on the ceiling of the Stanza della Segnatura. Evidence for the latter's participation in this part of the room is provided not only by stylistic considerations and payment records but also by the fact that Raphael included Sodoma's portrait with his own to the extreme right in the *School of Athens* (Plate 89). Such 'signatures' in frescoes were not unusual; both Perugino and Pintoricchio had included carefully framed self-portraits in fresco cycles, the one in Perugia, the other in Spello. Sodoma also had placed himself, wrapped in a conspicuous yellow cloak (which was part of his payment), in the foreground of his recently completed cycle of the life of St. Benedict at the monastery of Monte Oliveto outside Siena. (To ensure that his authorship of the *School of Athens* was obvious even though he had included Sodoma's portrait, Raphael printed the letters R.V.S.M. (Raphael Urbinas Sua Manu) (Plate 89) in the border of the tunic of Euclid, the bald figure leaning over in front of his portrait.)

As first shown by Wickhoff and von Schlosser in the 1890s, the Stanza della Segnatura (Plate 71) was planned as Julius's *studiolo* and naturally included a small library (not to be confused with the Vatican *biblioteca*, which was housed in another part of the building and was open to scholars). The purpose of the room is confirmed by the decorations, which follow the tradition of medieval and Renaissance libraries. Above each wall in a roundel on the ceiling (Plate 73) is a personification of one of the four faculties into which knowledge was divided in scholastic theory: Theology, Philosophy, Jurisprudence, and Poetry, the last having replaced Medicine in the thirteenth century. The system had been employed by Tommaso Parentucelli when he set up the libraries of the Dominican monasteries of San Marco in Florence and the Badia in Fiesole, at the behest of

71. The Stanza della Segnatura. Rome, Vatican Palace.
This room was originally planned as Julius II's private study, with book-cases probably located under the frescoes. The asymmetrical pattern of the inlaid stone floor indicates that Julius's desk would have been placed so that he had a view out of the window towards the Mons Vaticanus.

Cosimo de'Medici, as well as the private libraries of the then Count of Urbino and Alessandro Sforza. It would be surprising if Tommaso had not followed the same system when, as Pope Nicholas V (1447–55), he founded the Vatican Library. Julius was long familiar with the library which his uncle Sixtus had re-established after years of neglect — an event commemorated in a group portrait that included the then Cardinal Giuliano (Plate 183). Raphael too was acquainted with the division of faculties since his father, in his poem, mentions it when describing the Urbino library.

These faculties determined the subject matter of the wall paintings in the Segnatura. Traditionally, medieval thought conceived of the Universe as a closed system in which all things, visible and invisible, were interrelated. All knowledge, therefore, could be ordered into a comprehensive schema. Stemming from Divine Wisdom at the apex a complex system of divisions and subdivisions was worked out, beginning with Theoretical Wisdom, Virtue, and Necessity, and ending with the liberal and mechanical arts. This all-encompassing concept of knowledge was already worked out pictorially in the fourteenth-century fresco of *The Triumph of St. Thomas Aquinas* in the Chapter House of Santa Maria Novella in Florence (Plate 72). Here allegorical figures of the virtues, learning and the liberal arts are coupled with a historical figure that best exemplifies each concept. A simplified version of this was employed in the library of the Duke of Urbino. There portraits of great philosophers and theologians (including Sixtus IV) hung together with the enthroned seven liberal arts with kneeling supplicants. Alexander VI also had the enthroned seven liberal arts, with historical figures representing practitioners at their feet, depicted in a room in the Borgia apartments that may have been his study.

Thus, there was a long iconographic tradition upon which Raphael could draw. Although he chose to eschew the old hierarchical arrangement of stiffly enthroned figures and created instead realistic scenes, he preserved the basic concept. The four faculties in the ceiling preside over allegorical scenes in which the participants represent the various branches of knowledge. A modern variant of this concept may be found in many public libraries where the names of great writers and scholars are inscribed or their busts displayed along the walls.

73. Ceiling of the Stanza della Segnatura. Rome, Vatican Palace. The elaborate design with simulated mosaics defines the programme for the wall frescoes. The four faculties into which libraries were commonly divided appear in the large roundels, while in the centre putti painted by Bramantino hover around the papal arms.

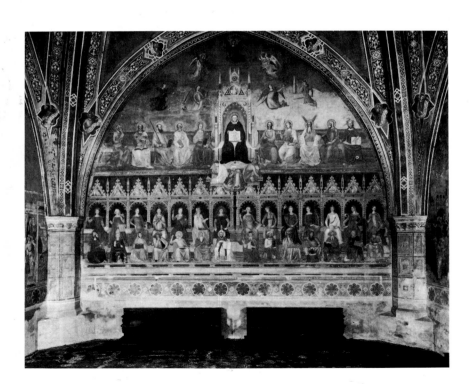

72. Andrea da Firenze. *The Triumph of St.Thomas Aquinas.* c. 1360. Florence, Santa Maria Novella, Chapter House ('Spanish Chapel').
Flanking the enthroned St.Thomas are saints and prophets. The allegorical figures of arts and sciences in the lower register have at their feet historical representatives of the various branches of learning.

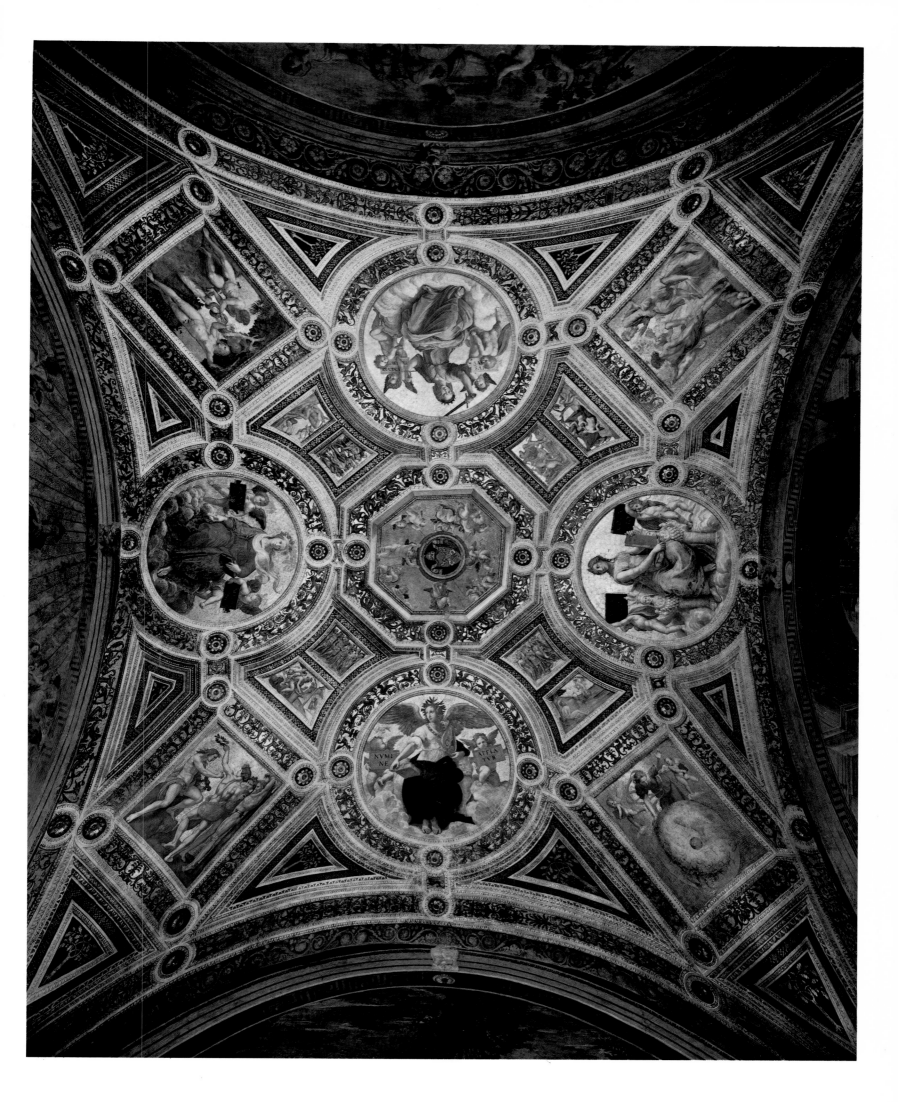

74. *Theology.* Rome, Vatican Palace, Stanza della Segnatura. Placed above the *Disputa*, this image of Theology is derived from Dante's description in the *Purgatorio*, XXX, 31-3. She is crowned with olive, and her clothes of white, green and red are the colours of the theological virtues, Faith, Hope and Charity.

The seated figures of the four faculties follow most closely the traditional arrangement of seated allegories. Each is given an inscription and attributes to identify her. Over the *Disputa*, *Theology* (Plate 74) is clad in the colours of the three theological virtues: red for Charity, white for Faith, and green for Hope. Her inscription reads, 'Knowledge of Divine Things'. Opposite her, above the *School of Athens*, reigns *Philosophy*, whose multicoloured gown, according to Vasari, refers to the four elements: earth, water, fire, and air. The accompanying inscription is 'Knowledge of Causes' (Plate 75). *Poetry*, winged and crowned with laurel and endowed with the quotation 'Inspired by the Godhead', floats above the

75. *Philosophy.* Rome, Vatican Palace, Stanza della Segnatura. Seated on a throne decorated with two images of the Diana of Ephesus, Philosophy holds books of natural and moral science. The many colours of her gown refer to the four elements, earth, water, fire and air.

76. *Poetry.* Rome, Vatican Palace,
Stanza della Segnatura.
Winged, crowned with laurel, and
holding a lyre, Poetry sits on
clouds. Her inscription is adapted
from Virgil's *Aeneid.*

Parnassus (Plate 76). *Jurisprudence* appears over the Justice wall wielding a sword
and carrying scales (Plate 77). Her tablets proclaim, 'To each one she assigns his
due'. These imposing figures, all from Raphael's hand, establish the theme of the
room.

Between the roundels, over the corners of the room, are rectangles with
individual scenes relating to the allegorical figure to the right. Thus, the *Fall of Man*
precedes *Theology, Apollo and Marsyas* appears before *Poetry, Urania as the
Primum Mobile* links with *Philosophy,* and the *Judgment of Solomon* accompanies
Jurisprudence. It is in these works that Sodoma probably assisted.

77. *Justice.* Rome, Vatican Palace,
Stanza della Segnatura.
The only one of these allegorical
figures not to hold a book, Justice
carries scales and wields a sword.
Both are her traditional attributes.

The first wall painting, *The Disputa* (Plate 80), received its name in the seventeenth century from Vasari's statement that the assembled men 'disputano' about the Host on the altar, meaning that they are having a lively discussion. The many extant drawings reveal how hard Raphael worked on the arrangement of the figures. Drapery, anatomy, gestures and poses were studied, drawn, and re-drawn (Plates 78, 79). The gradual evolution can be seen clearly in the finished work. God the Father is still of the Peruginesque type, as are the cherubim in the aureole behind Christ. As he worked down from the top to the bottom of the fresco (the normal direction in which frescoes are painted) Raphael became more confident. Already the saints and prophets seated on clouds in the second zone show a variety of natural poses. To the left, Adam sits with crossed legs engrossed in conversation with St. Peter (Plate 82), while St. Stephen points out a figure below to his companion who is half hidden behind the Virgin Mary.

The bottom register reveals Raphael's extraordinary ability, in that the first time he painted so many figures he did so in a clear and convincing manner. He has arranged individuals in small clusters, which he has then assembled to form larger groups. There is no tangled jumble of forms as seen in the *Entombment*. Instead there is an almost musical sense of rhythm and balance, which develops gracefully on each side towards the central altar. Gestures are varied but, like the arrangement of the figures, never unnatural or artificial. Nonetheless, for all its apparent ease,

78 (left). *Study for the man leaning over the balustrade on the right of 'The Disputa'.* Pen drawing over pencil sketch, 36 × 23.5 cm. Montpellier, Musée Fabre. Raphael worked hard on the different poses for the figures in this fresco. Here he has tried both raising the right hand and resting it on the balustrade.

79. Verso of drawing on Plate 78. Raphael tried various head and hand positions for the man. In the fresco it is his left arm that is elevated.

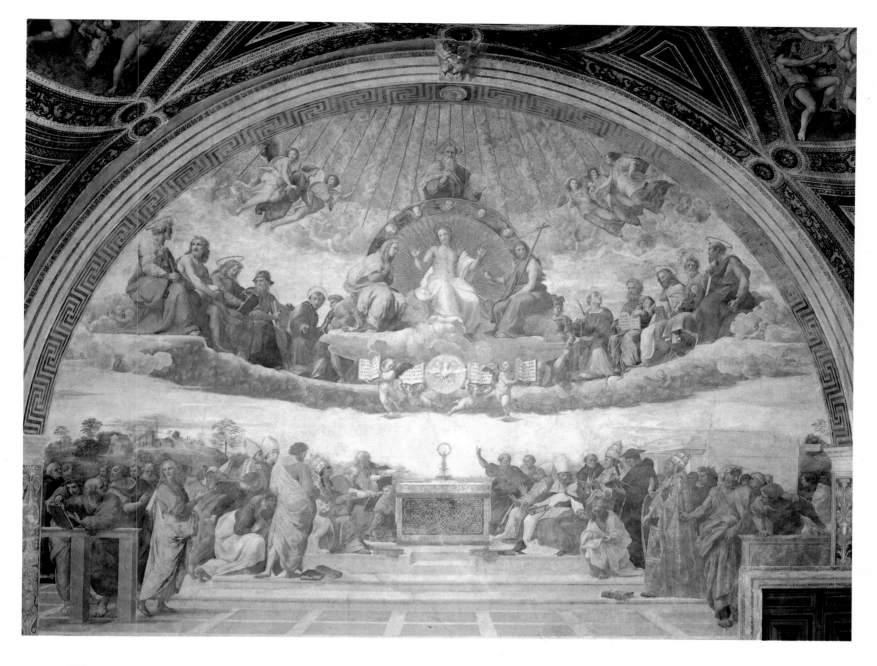

80. *The Disputa.* Rome, Vatican
Palace, Stanza della Segnatura.
The first of Raphael's great wall
paintings shows theologians
discussing the central mysteries of
the Catholic faith. The descent of
the Holy Spirit, represented by the
Dove, refers to the invocation for
wisdom pronounced at the
beginning of all great councils of
the Church.

81. Pollaiuolo. Detail of the *Tomb
of Sixtus IV.* Vatican, St.Peter's.
Commissioned by Julius II while
still a cardinal, the bronze tomb of
Sixtus IV is one of the most
impressive quattrocento
monuments. It was this portrait,
made from a death mask, that
served as the model for Raphael's
portrait of the pontiff in the
Disputa.

the fresco is so carefully constructed that the Dove of the Holy Spirit, from whom all Wisdom flows, is in the exact centre of the picture.

The prevailing influence on Raphael here is that of Fra Bartolommeo. The design again follows that of the Santa Maria Nuova *Last Judgment* and the monumental figures swathed in massive draperies are related to those in the Dominican's altarpieces. Particularly outstanding is the extraordinarily beautiful and subtle colouring of the frescoes (alas much faded), which, as Vasari already mentioned, Raphael also learned from the friar. But Raphael found other sources in Rome itself. The throne of St. Gregory the Great to the left of the altar is copied from the sixth-century marble throne preserved in San Gregorio Magno, and the portraits of Fra Angelico (to the extreme left of the picture) and Sixtus IV (the foremost pope on the right) (Plate 69) are taken from portraits on their tombs in the city (Plate 81). Perhaps the most amusing example of an adaptation from a classical model can be seen in a drawing in the Uffizi (Plate 83). A Venus Anadyomene has been clothed and transformed into the blond young man in the foreground to the left.

Six of the theologians in the *Disputa* are clearly identified by their names in gold letters on their haloes. Seated around the altar are the four Church Fathers: to the

82. Detail of *The Disputa*. Raphael broke down the traditional hierarchical postures of saints in this fresco. Rather than kneeling and adoring the central group, St. Peter and Adam are engaged in conversation. Next to them St. John the Evangelist writes and King David plays the harp.

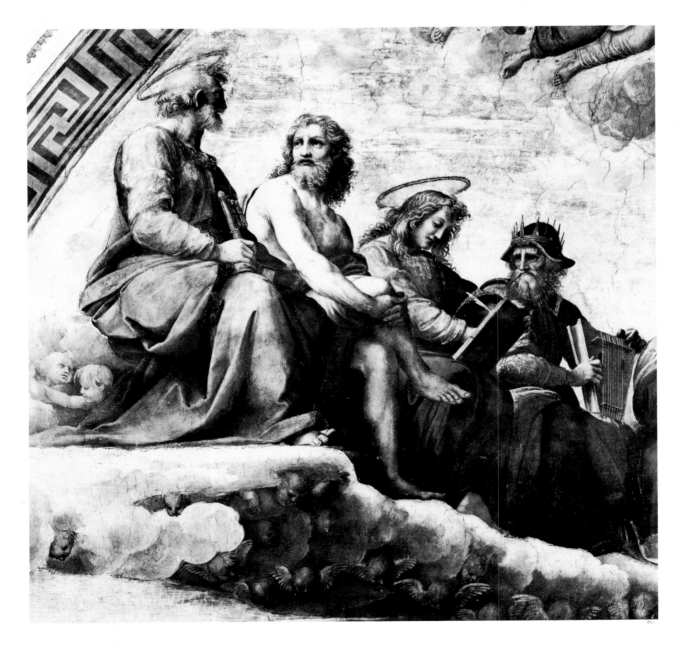

83. *Study for the blond youth to the left in 'The Disputa'* Pen drawing with lead pencil, 24.5 × 26.9 cm. Florence, Uffizi. Raphael has used the famous pose of a classical Venus as the starting point for his clothed young man.

left Pope Gregory the Great and St. Jerome with his lion, to the right the bishop saints Ambrose and Augustine. The books lying at their feet are not just seminal works of Christian thought but serve in addition as attributes for these figures. Before Augustine lies a copy of *The City of God*, accompanying Jerome are his translation of the *Bible* and his letters, and near Gregory is the *Moralia*. Behind Augustine stand the two greatest scholastic theologians: the Dominican St. Thomas Aquinas and the Franciscan Cardinal St. Bonaventura.

Sixtus IV stands next to Bonaventura. The inclusion of Julius's uncle in the fresco was not simply a conceit on the part of the Pope. As General of the Franciscans Sixtus had written a long treatise on the Holy Blood, a subject that relates to the Host on the altar. It is through the miracle of Transubstantiation that the eucharistic bread becomes both the True Body and Blood of Christ. Sixtus's position next to Bonaventura is also not fortuitous, for it was during his papacy that Bonaventura was canonized.

Of the other figures only Dante, standing behind Sixtus, and Fra Angelico to the extreme left, can be identified from known portraits. One of the Franciscans near the altar may be Duns Scotus, another eminent scholastic theologian, and the bald, elderly Dominican to the right is possibly Albertus Magnus, the teacher of Thomas Aquinas. The suggestion that the cowled figure next to him is the fanatic Dominican Girolamo Savonarola can be discounted. Led by the Cardinal Protector and the Master General, the Dominican Order itself brought charges against the monk,

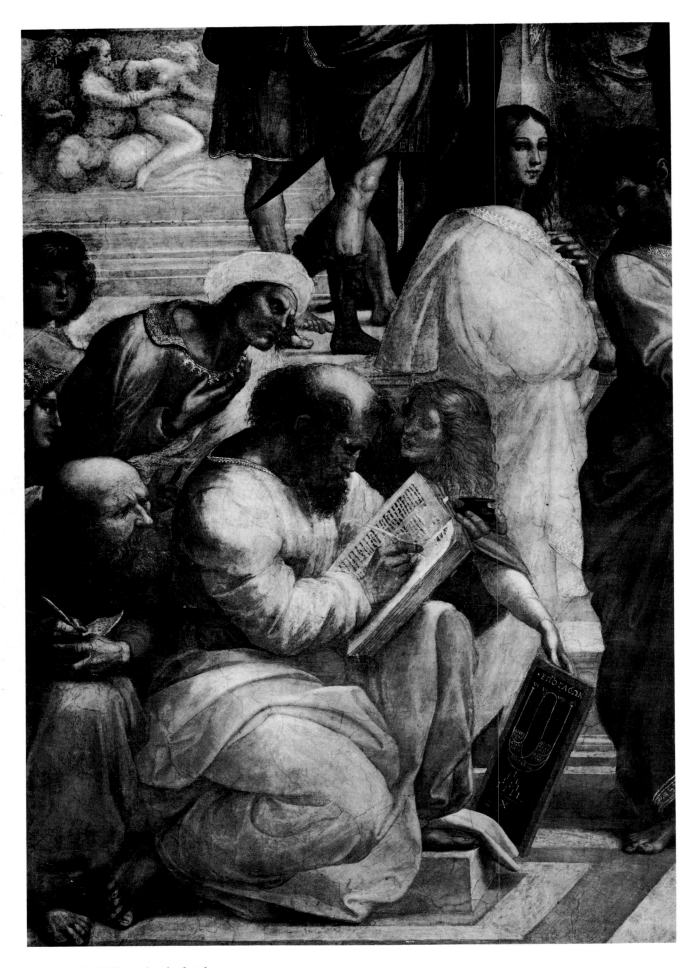

84. Detail of *The School of Athens*.
Pythagoras, representing Arithmetic and Music, demonstrates his system of harmonies on a blackboard. Behind him Raphael has placed his adaptation of the eldest Magus from Leonardo's unfinished *Adoration of the Magi* (Plate 86). The idealized blond boy at the back of the group was misidentified as Federigo Gonzaga by Vasari.

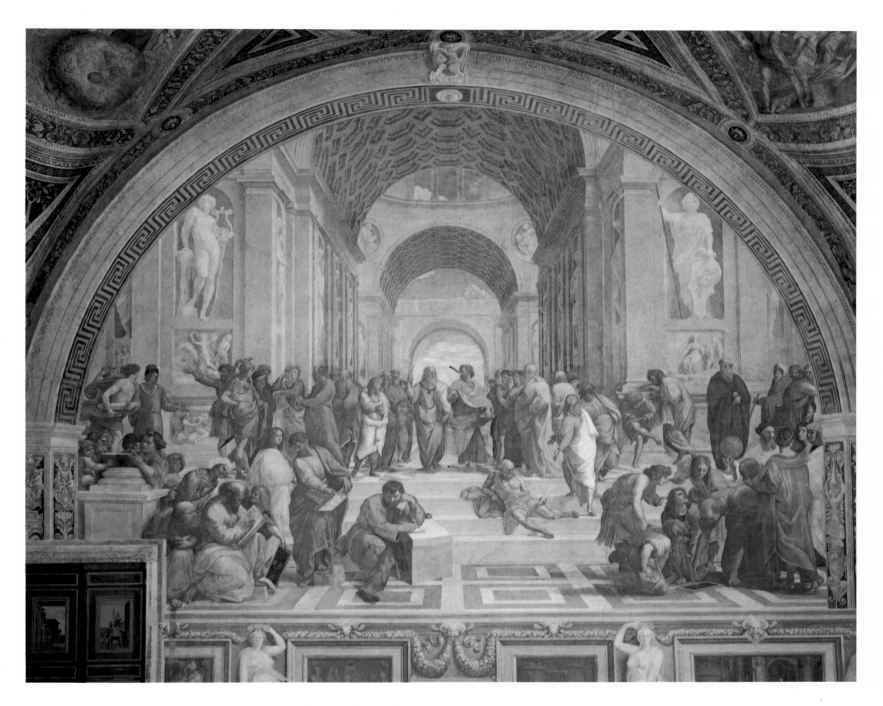

85. *The School of Athens*. Rome, Vatican Palace, Stanza della Segnatura.
Placed in monumental architecture inspired by ruins of the ancient Roman baths, Raphael created the first great allegorical picture in which figures and setting were fully integrated. The fresco is not just an allegory of Philosophy, but also a representation of the Seven Liberal Arts.

who was hanged for heresy in 1498. It must be remembered that this fresco is an allegory of theological learning, not a 'who's who' in religious life. This is made perfectly clear by the inclusion of Thomas and Bonaventura, who were scholars, rather than Dominic and Francis, the founders of their respective orders.

On the facing wall *The School of Athens*, also named in the seventeenth century, represents the theme of secular learning (Plate 85). In a spacious hall men from all branches of knowledge are engaged in writing, thinking, debating, and demonstrating their particular studies. Raphael has completely transformed the static arrangement traditional for such a scheme into a lively grouping of people, while at the same time preserving the theme of the seven liberal arts, which comprise Philosophy. The two greatest pagan philosophers, Plato and Aristotle, stand at the focal point of the fresco (Plate 88). Clearly identified by the titles on their books, *Timeo* (*Timaeus*) and *Etica*, Plato points upward to heaven while Aristotle reaches out with a gesture laid down by Quintilian for orators. They are surrounded by

eager students and historical figures, some of whom can be named. For example, Socrates, unmistakeable with his pug nose, instructs a group to the left. In the foreground on the same side, Pythagoras copies a tablet displaying his system of harmonies (Plate 84). Opposite is Euclid bent over a pair of compasses teaching geometry (Plate 89), and behind him stands a figure with a starry sphere usually identified with Ptolemy. Thus, the fresco can be divided into the Trivium, Grammar, Rhetoric and Dialectic, demonstrated by the figures engaged in disputations on the top of the steps, and the Quadrivium at the base: Arithmetic and Music to the left and Geometry and Astronomy to the right. Raphael has deliberately placed his self-portrait behind Geometry: it was a skill vital to artists for the accurate construction of perspective.

The impressive architectural setting testifies that Raphael had a complete command of perspective. It also demonstrates again his desire for historical accuracy as well as his powers of observation. The scholars of the Renaissance were

86. Leonardo da Vinci. *Adoration of the Magi.* Panel, 246 × 243 cm. Florence, Uffizi.
Begun in 1481, Leonardo appears to have abandoned work on this altarpiece after seven months. Despite its unfinished state it is a work of great beauty and had a profound influence on Raphael.

87. *Early design for the left half of 'The Disputa'*. Brush and wash, white highlights, squared in black chalk, 28 × 28.5 cm. Windsor, Royal Library.
Raphael's adaptation of the eldest Magus from Leonardo's *Adoration of the Magi* can be seen crouching in the centre. He was subsequently dropped from *The Disputa* and used in *The School of Athens*.

well aware that not only the Roman but also the Greek philosophers met for their discussions in the public baths. Remains of such buildings, of which the most famous were the Baths of Diocletian, could be easily found in Rome. These vast spaces, covered with grand coffered vaults, inspired the setting in which Raphael placed his figures from classical antiquity.

The increased monumentality of both figures and setting is a sign of Raphael's growing confidence in his handling of fresco technique. Again the influence of the large silhouettes of Fra Bartolommeo as well as of the intricate poses in Michelangelo's *Battle of Cascina* cartoon is readily apparent. Further inspiration came from Leonardo's unfinished altarpiece of the *Adoration of the Magi* (Plate 86). The figure writing behind Pythagoras's shoulder has been closely modelled on the eldest Magus. Drawings reveal that Raphael had first sought to incorporate him into the *Disputa* but dropped the idea as the design developed (Plate 87). With great economy he has been placed in a more successful niche among the philosophers.

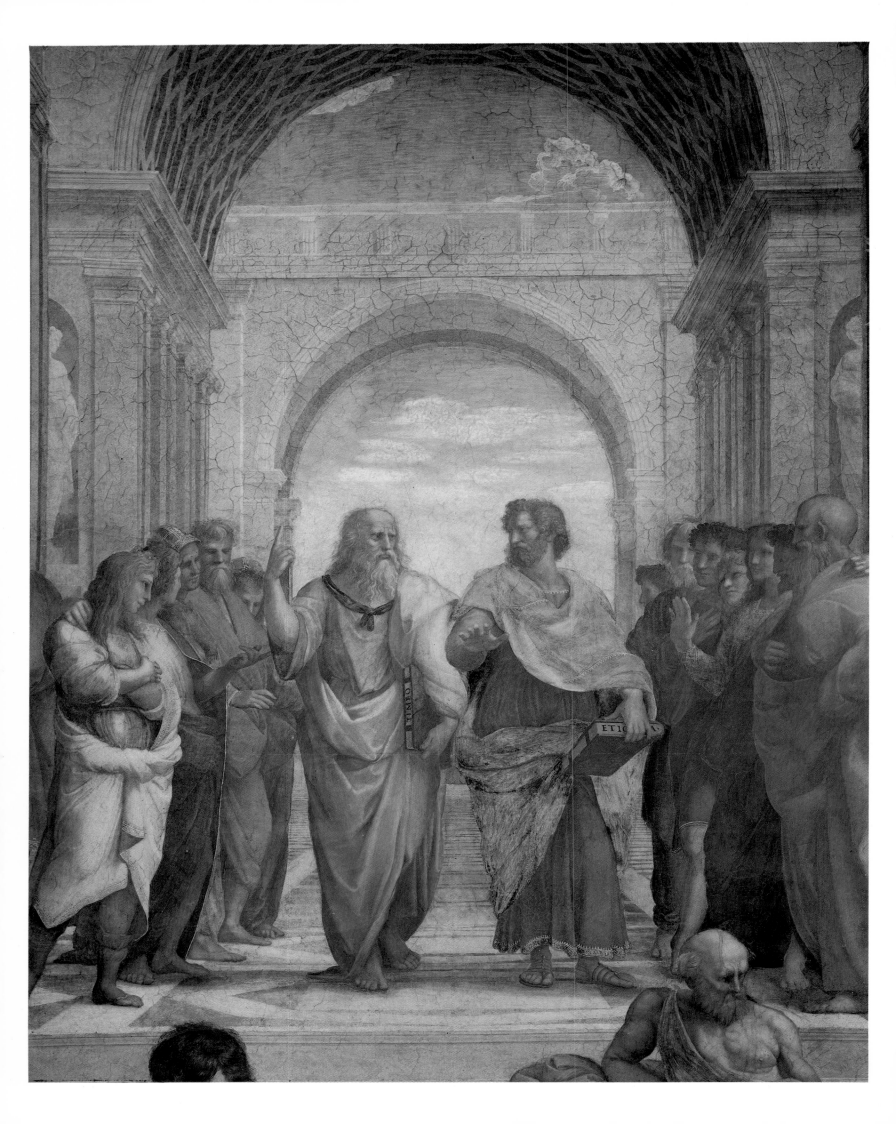

88. Detail of *The School of Athens*.
In the centre of the fresco are the two greatest pagan philosophers, Plato and Aristotle, identifiable by the titles of their books.

89. Detail of *The School of Athens*.
To the extreme right can be seen portraits of Raphael and Sodoma. Before them Euclid, representing Geometry, leans over a pair of compasses. On the neck of his tunic the gold initials R.V.S.M. (Raphael Vrbinas Sua Manu) can be seen. Representing Astronomy, Ptolemy holds a starry sphere.

Perhaps the most intriguing problem of artistic source is the group to the extreme right above the artists' portraits. It is copied almost exactly from one of Donatello's reliefs for the altar of Sant'Antonio in Padua (Plates 90,91). There are other instances in Raphael's paintings, among them the *Tempi Madonna* and the crouching group to the left of the altar in the *Disputa*, which indicate his fairly detailed knowledge of this work. While it cannot be proved, Raphael may have accompanied Fra Bartolommeo who went to Venice in spring 1508, perhaps travelling by way of Padua. Certainly there is much in Raphael's Roman art to suggest that he knew not only Donatello's Paduan reliefs but also Venetian composition and handling of colour at first hand.

It must not be inferred that because Raphael's sources can sometimes be easily traced he was merely a *pasticheur* who successfully copied and combined features from works by other artists. His innate sense of balance, his flowing graceful line, his extraordinary feeling for colour and tone transformed everything he used into something uniquely his own. He never portrayed extremely emotional scenes or

90. Donatello. Detail of the *Miracle of the Heart of the Miser*. Bronze relief. Padua, Sant'Antonio. Dating from the mid-fifteenth century, Donatello's bronze high altar was widely famous. The small size of the detail means that Raphael must have studied extremely close to it.

91. Detail of *The School of Athens.* This group is startling in its closeness to a group from Donatello's relief for the altar in Sant'Antonio in Padua. It is only one of several examples in the Stanze and supports strongly the hypothesis that Raphael visited Padua, perhaps in 1508 with Fra Bartolommeo.

achieved effects by depicting anything crude or ugly. He was not obsessed with only one theme as was Michelangelo with the human body. For Raphael the process of designing a painting involved him in reusing and reworking forms, combining them in new ways until he found one that satisfied all his criteria for that work. His success in achieving perfection was held up as an example to aspiring artists for centuries.

On the north wall of the Stanza della Segnatura is an allegory of Poetry known as *Parnassus* (Plate 92). Under laurel trees sits Apollo accompanied by the Nine Muses and by ancient and modern poets. Again, some are easily identified, such as the blind Homer and the hatchet-faced Dante to the left. Sappho, the only historical woman in the entire Stanze, carries a scroll with her name. The fresco is placed around a window, and the choice of this wall for the mountain of

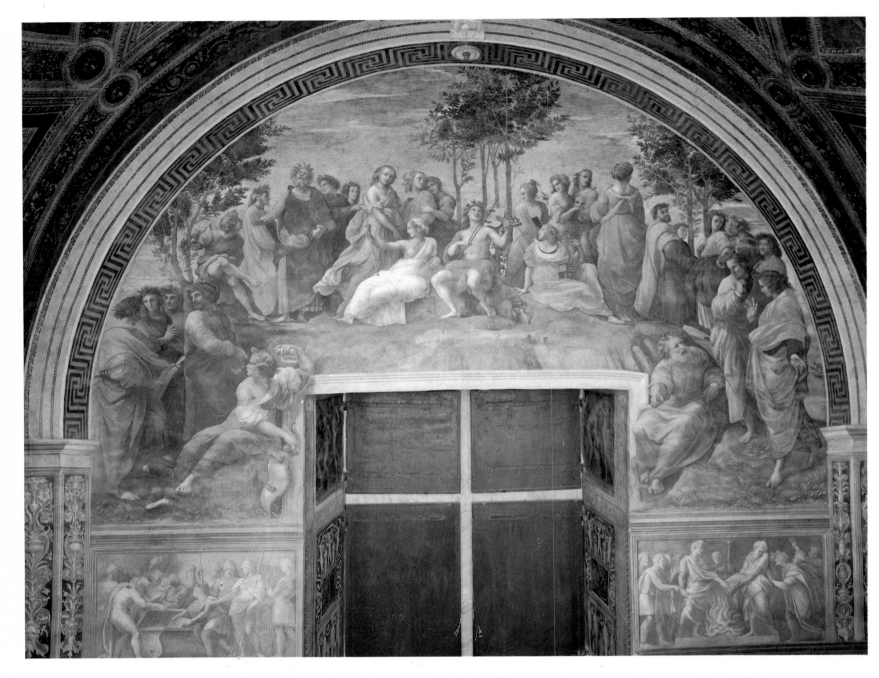

Parnassus is a nice instance of humanist playfulness. As John Shearman has observed, the window affords a beautiful view of the Mons Vaticanus, which in antiquity was sacred to Apollo. Julius, looking up from his desk, would have seen Apollo seated at the summit of this mountain.

Raphael's concern for historical accuracy can be seen in the stringed instruments of Sappho and the Muses, which are taken from an antique sarcophagus. The replacement of Apollo's traditional lyre with a modern viola da braccio is somewhat odd, but Raphael has taken great care to depict the correct bowing technique of his day.

On either side of the window under the main fresco are two scenes in grisaille. To the left is Alexander the Great ordering the works of Homer to be placed in the tomb of Achilles, and to the right Augustus Caesar preventing the burning of Virgil's *Aeneid.* Each scene demonstrates the preservation of a classic work through the wisdom of a great ruler. Furthermore, the antique epics had a bearing on Roman history. The Trojan War, the story of which is related in the *Iliad,* led to the

92. *Parnassus.* Rome, Vatican Palace, Stanza della Segnatura. The Nine Muses and famous poets accompany Apollo on his sacred mountain. Raphael here displays for the first time his ability to work around architectural impediments; Sappho with her stringed instrument leans on the frame so that the window is incorporated into the scene.

93. *The Justice Wall.* Rome, Vatican Palace, Stanza della Segnatura.
Originally planned as a Last Judgment, the programme for this wall was changed when Julius was defeated by the French in 1511. Above sit three of the four cardinal virtues. On either side of the window are historical scenes representing the codification of civil and canon law.

destruction of the city of Troy. Fleeing from there Aeneas went west to found the city of Rome, as told in the *Aeneid*.

Under the window embrasure of the *Parnassus* is an inscription giving the year of completion as 1511. The same year appears on the opposite wall of Jurisprudence, where political events necessitated a change of subject. On 26 June 1511 Julius II returned to Rome after being badly defeated by the French in the wars in northern Italy. Bologna, so coveted by the Pope, had been lost. This was in part because of the cruelty and maladministration of the papal governor, Cardinal Francesco Alidosi, whose misdeeds had led to open revolt among the already hostile citizens. The famous bronze statue of the Pope cast by Michelangelo and placed over the main door of the cathedral had been pulled down and destroyed by the mob. The *Last Judgment* originally planned for the Jurisprudence wall as an allegory of Justice was considered too disturbing and was replaced by the present tripartite division of the wall (Plate 93).

Because of this revision the structure and theme of the wall are entirely different

from those of the other walls. Rather than a single allegorical representation of one of the faculties, there are two historical scenes depicting the codification of law, and above in a lunette appear three of the cardinal virtues, Fortitude, Prudence and Temperance (Plate 89). The fourth, Justice, was already present in the ceiling under the guise of Jurisprudence. Although not conventional allegories, the two lower frescoes symbolize the division of Jurisprudence into civil and canon law, a division already made in the *Triumph of St. Thomas Aquinas* in Santa Maria Novella.

The fresco of Justinian receiving the Pandects from Trebonianus, on the left, was designed by Raphael after antique reliefs, but executed by his workshop. It was never finished and has suffered much damage over the centuries. Its magnificent counterpart, on the right, is certainly a work by Raphael. This shows the Dominican canonist Raymond da Peñaforte handing the Decretals to Gregory IX, who had ordered him to codify canon law (Plate 97). Dressed in a splendid cope embossed with the acorns and oak leaves of the della Rovere family, Julius had himself portrayed in the guise of Pope Gregory but surrounded by members of the modern curia. The cardinal to the extreme left of the Pope was identified, perhaps too enthusiastically, by the loyal Vasari as Giovanni de'Medici, the future Leo X.

94. *Three Cardinal Virtues*. Rome, Vatican Palace, Stanza della Segnatura.
Each carries an identifying attribute. Fortitude holds an oak branch referring both to strength and the arms of Julius II; Prudence gazes into a mirror and has a Janus-head so that she can see both the past and the future; and Temperance holds a bridle, symbol of restraint.

95. Medal of Cardinal Francesco degli Alidosi. Washington, D.C., National Gallery of Art.
Alidosi was made governor of Bologna by Julius II. His terrible cruelty contributed to the revolt of the town in 1510. He was subsequently killed by the Pope's nephew, to whom he tried to pass the blame for the loss of the city.

However, it can be seen from a medal (Plate 95) that the heavy-jawed face bears a striking resemblance to Cardinal Alidosi, whose intimate friendship with Julius had won him the governorship of Bologna. Rumours of sodomy between the two may not be based on fact, but Julius lavished much attention on him in spite of his unsuitability both as a cleric and a governor. So confident of his position was Alidosi that he dared to blame the loss of Bologna on the Pope's nephew, Francesco Maria della Rovere, who commanded the papal troops. Enraged, Francesco Maria ran the cardinal through with his sword outside the Pope's door. Raphael's ability to create convincing portraits from sculptures had already been shown in the *Disputa*, and it may be that what is depicted here is a slain papal favourite in close proximity to the man he served.

It was traditional in Renaissance art to represent the Seven Virtues in courts of justice as, for example, the panels executed by Piero Pollaiuolo and Botticelli for the Mercanzia in Florence. Four Virtues were already present in the Stanza della Segnatura: Faith, Hope, and Charity were symbolized by the colours of the raiment of Theology, and Jurisprudence stood for Justice. The remaining three were placed in the lunette with their conventional attributes, except for the replacement of the pillar of Fortitude by a sturdy oak branch as an allusion to the della Rovere oak (Plate 94). Julius had also ordered this modification when he commissioned the bronze tomb of Sixtus IV, on which some of the liberal arts carry oak branches.

The window embrasures on the Jurisprudence wall contain two small grisailles continuing the legal themes on the main walls. Next to the *Justinian* is a scene from Roman history, *The Judgment of Zaleucus*, and opposite on the *Decretals* side is *Christ Pointing to the Two Swords*, from Luke XXII:38. Important as the doctrine of the two swords was for the history of the Church, here, in this relatively inconspicuous location, the scene was intended more as a personal motif than as a statement of policy. As pointed out by Ernst Steinmann, *Ecce duo gladii hic* was the motto of Julius when he was a cardinal.

Stanza d'Eliodoro

Paolo Giovio, a contemporary humanist and close friend of Raphael's, claimed in his biography of the artist that the subjects of the frescoes in the Stanze were chosen by Julius himself. It would appear, therefore, that the theme for the second room to be decorated, the Stanza d'Eliodoro (Plate 96), was determined before the Pope left to wage war in August 1510. Inspired by political developments, the scenes were to depict examples of heavenly intervention against those who would challenge the Church's, and thus papal, authority. Raphael was probably already at work on the first fresco, *The Expulsion of Heliodorus* (Plate 99), from which the room takes its name, when the defeated Julius returned at the end of June 1511. The story from II Maccabees III:23-29 appealed to the pontiff so much that he ordered his portrait to be introduced on the left side of the work (Plate 100).

Heliodorus and his colleagues had attempted to rob the Temple in Jerusalem of its treasure. Unable to defend it, the High Priest prayed to God for succour, whereupon heavenly avengers appeared and drove the thieves out. The choice of this obscure story seems to have been made initially in connection with a revolt within the College of Cardinals in 1509 against the authority of the Pope and the call for another council to replace him. After the disastrous losses against the French the work took on additional significance for the schismatic council was proposed by the French cardinals and backed by the French king.

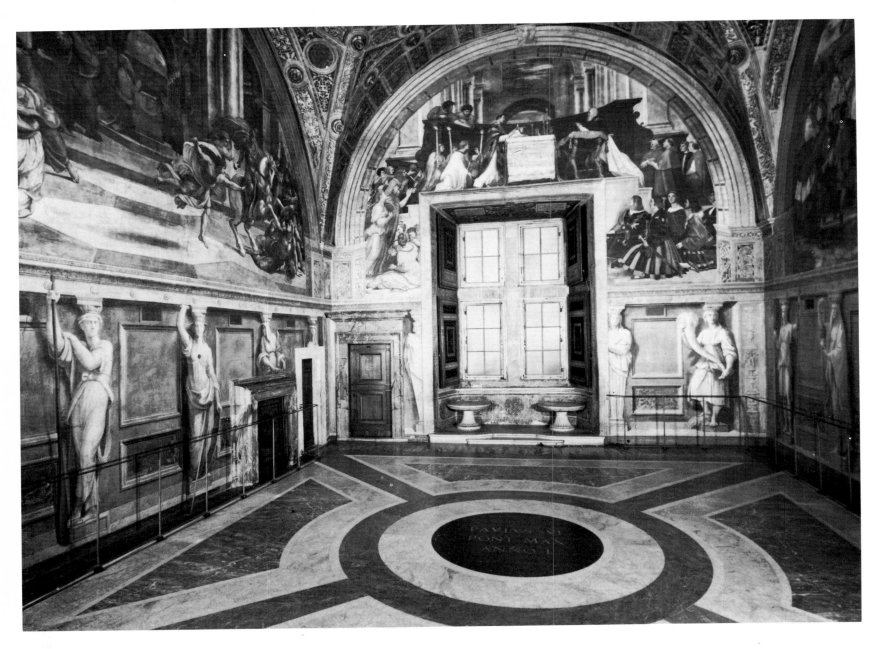

A copy of the now lost drawing for the preliminary design for the *Heliodorus* fresco shows that the papal party was not originally included (Plate 98). Technical evidence also indicates that the inclusion was the result of a later decision. On 16 August 1511, the Mantuan ambassador in Rome wrote to Isabella d'Este that Raphael had painted the pontiff 'from life with a beard' in one of the Stanze. This has long been taken as a reference to Julius as Gregory IX in the *Decretals* fresco. This is unlikely. Since the theme of the Jurisprudence wall was only changed when Julius returned to Rome at the end of June, it would mean that only a month and a half had elapsed in which a new topic was found, a new design planned and a large part of the fresco executed. Furthermore, the striking monumentality of the *Three Virtues* in the lunette above the *Decretals* indicates they were painted after Raphael saw the Sistine Ceiling, first revealed on 15 August 1511 when the scaffolding was removed briefly so that Mass could be celebrated on the feast of the Assumption of the Virgin, to which the chapel is dedicated. It would thus seem that the first portrait Raphael painted of Julius with a beard was that in the *Heliodorus* fresco, and that it was executed before the *Decretals* fresco.

In the story of Heliodorus Raphael at last had a subject which would permit him

96. Stanza d'Eliodoro. Rome, Vatican Palace.
Located next to the Stanza della Segnatura, the Stanza d'Eliodoro probably served as a small audience room. The door to the left led into an anti-chamber and the Pope's bedroom. This was the second and last room Raphael was to decorate for Julius II.

97. *Gregory IX Receiving the Decretals from Raymond da Peñaforte*. Rome, Vatican Palace, Stanza della Segnatura.
In 1230-4 the Dominican Raymond da Peñaforte codified canon law on the orders of the Pope. Julius II chose to have himself portrayed here as Gregory IX with the della Rovere oak leaves and acorns decorating his broad cope.

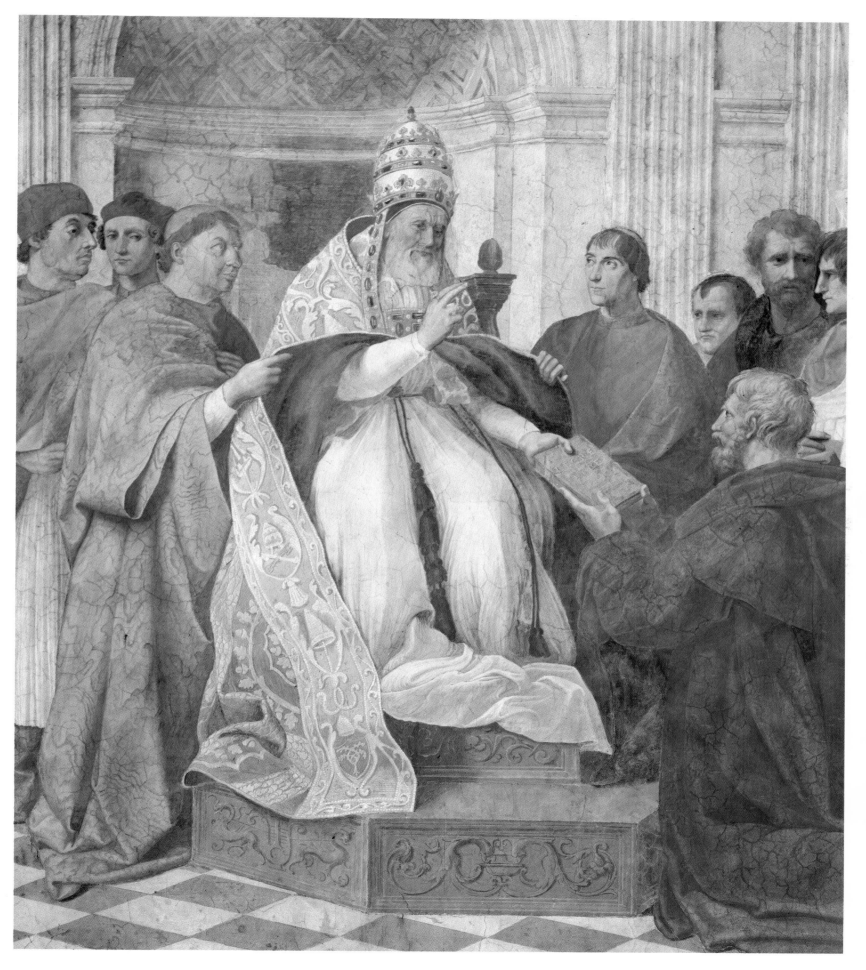

98. Copy of Raphael. *Preliminary design for 'The Expulsion of Heliodorus'*. Pen and brown ink, 25.2 × 41.5 cm. Vienna, Albertina. Raphael's first ideas for the architectural background drew on the fifteenth-century convention of representing the Temple as a centralized building.

to display his virtuosity in depicting violent action. The many drawings and studies of battles and conflicts came to fruition here. To the right a rearing horse mounted by a figure in golden armour tramples Heliodorus under foot (Plate 101). Bringing up the rear are two other avengers wielding whips as they fly forward to expel the robbers. The tremendous impact of Michelangelo's Sistine Ceiling is readily apparent in the massive arms and legs of figures on this side of the fresco. The man carrying the chest on his back is taken directly out of the Flood scene.

Raphael was not inspired only by Michelangelo. The woman protectively clutching two children was drawn from a classical statue of *Niobe*, and the two figures clinging to the pillar would seem to be derived from Donatello's Paduan

99. *The Expulsion of Heliodorus.* Rome, Vatican Palace, Stanza d'Eliodoro.
This was Raphael's first opportunity to paint a scene of violent action. The story from II Maccabees tells of the intervention of heavenly protectors to save the treasure of the Temple in Jerusalem from Heliodorus and his fellow robbers.

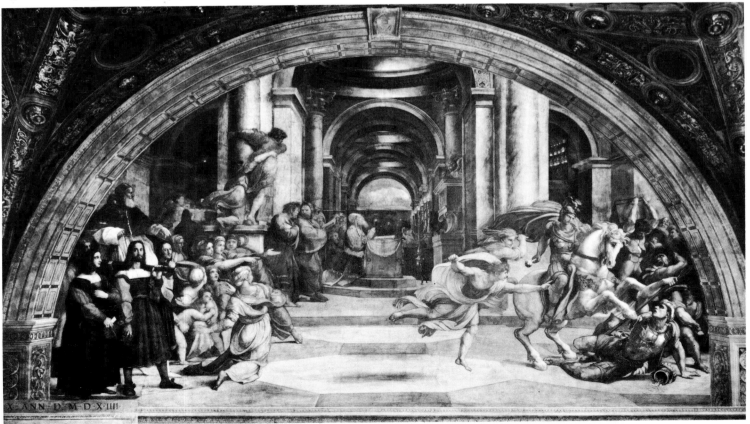

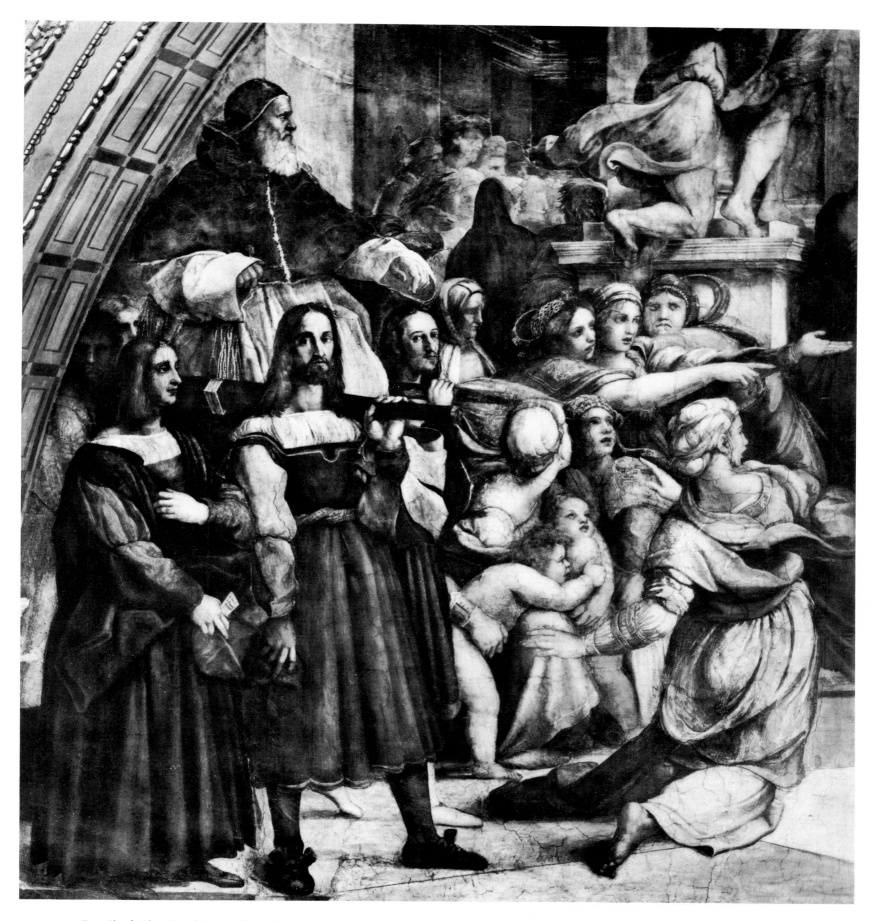

100. Detail of *The Expulsion of Heliodorus*.
The group of the Pope and his entourage was inserted on the orders of Julius II and was the first of several portraits that
Raphael painted of the Pontiff. The man in the foreground is a papal secretary, identifiable only because his name appears on
the paper he carries.

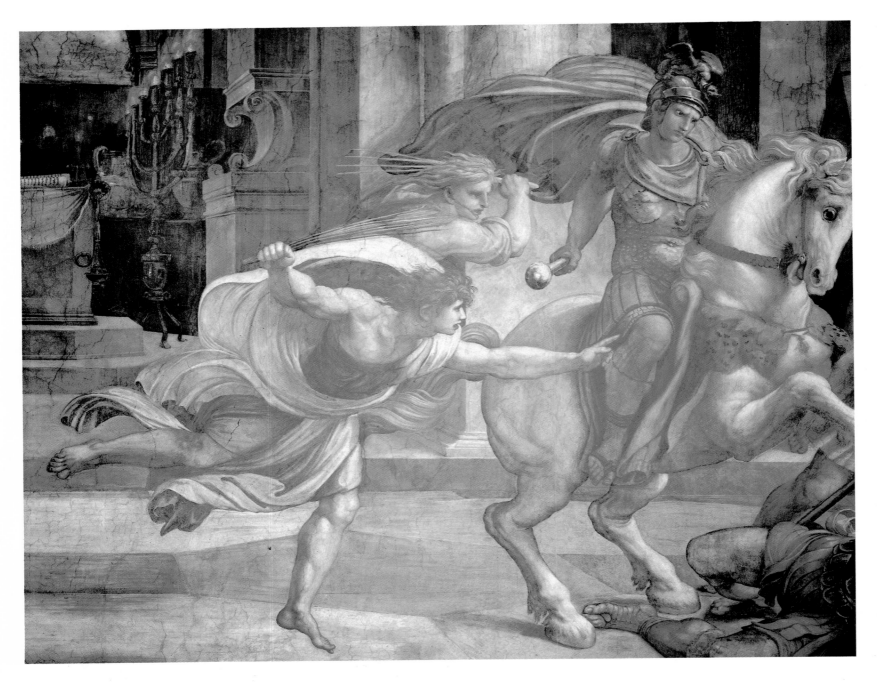

reliefs, while the rearing horse reflects study of Leonardo's drawings. Raphael's acuteness of observation is most obvious in the foot of the menorah (Plate 102). Traditionally, menorahs have a three-legged base. However, the classical relief on the Arch of Titus shows the menorah looted from the Temple in Jerusalem as having a solid octagonal stepped base, contrary to both religious practice and archaeological evidence. In choosing to paint a three-legged base Raphael shows that he has sought out an actual menorah instead of relying on the Roman relief.

The imposing architecture is another of Raphael's daring innovations. As can be seen from the copy of the preliminary drawing, he began by recalling the artistic tradition of depicting the Temple as a large centralized building (similar to the one he depicted in the *Marriage of the Virgin* of 1504). But the success of the monumental baths in the *School of Athens* encouraged him to attempt something more complex. The final result is a magnificent series of gleaming arches supporting golden domes. The contrast with the dusky candlelit side aisles truly evokes the mysterious atmosphere of the Holy of Holies.

101. Detail of *The Expulsion of Heliodorus*.
The right side of the fresco shows the impact of Michelangelo's Sistine Ceiling in that the muscularity and size of the figures have been enlarged. Leonardo's influence is also clear in the depiction of the rearing horse.

102. Detail of *The Expulsion of Heliodorus*.
Raphael used the series of golden domes to evoke the mystery and sanctity of the Holy of Holies. In depicting a three-legged menorah Raphael shows that he sought out a contemporary model.

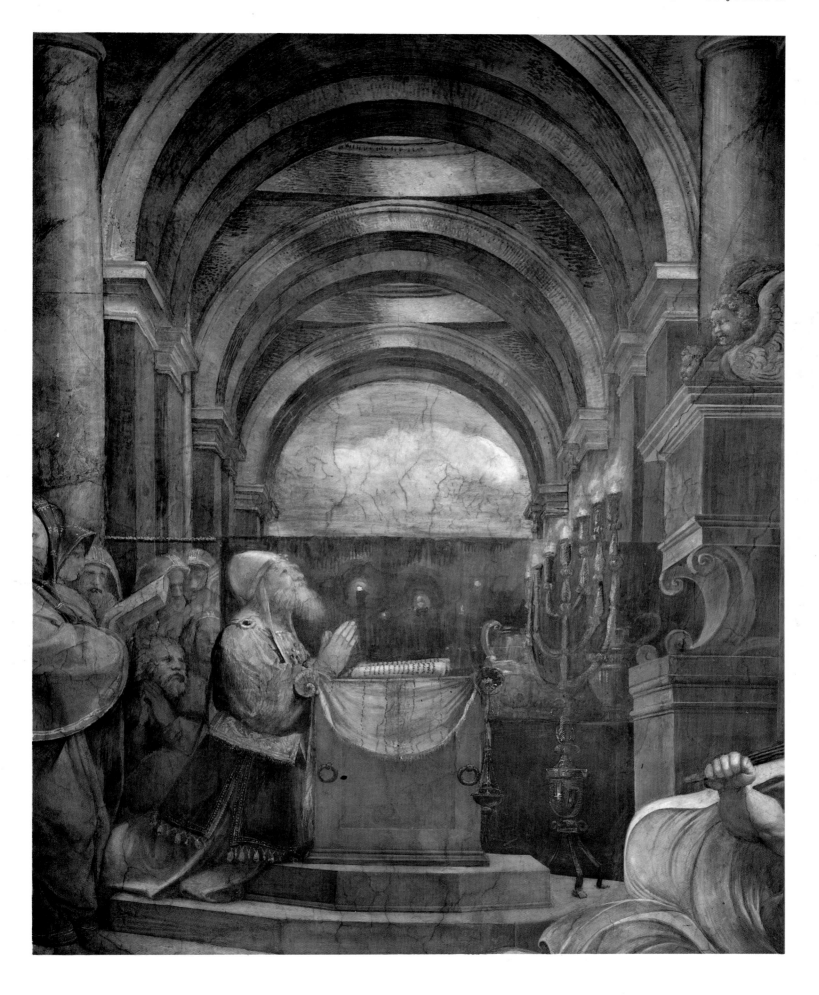

103. *Drawing of the Woman for 'The Expulsion of Heliodorus'.* Black chalk, 39.5 × 25.8 cm. Oxford, Ashmolean Museum. One of the most beautiful of all Raphael's creations, this kneeling woman is an outstanding example of the perfection and harmony for which he was renowned.

Not even the intrusion of the papal portrait group could destroy Raphael's splendid composition. The visitor entering the Stanza d'Eliodoro from the Segnatura is immediately confronted by the Pope being carried grandly in the *Sedia Gestatoria.* The group of women, some pointing, some recoiling, lead the eye naturally upward to the centre of the composition and the praying High Priest. The supernatural figures burst in upon the central space, and the tempo suddenly changes from the legato of the left to the powerful staccato on the right. (So often conventional visual terms seem inadequate for describing Raphael's art, and only the vocabulary of music is satisfactory.) Perhaps most harmonious of all the figures in this masterpiece is the woman to the left with her back to us, for which Raphael did one of his finest drawings (Plate 103). No words can easily describe the intricate rhythm of the lines of her drapery, the graceful curve of her body or the delicate balance of her arms. Her origins in the heavy, earthbound Virgin of Michelangelo's *Doni Tondo* (Plate 65) are hardly recognizable.

The tumbling figures of Heliodorus and his fellow robbers lead the eye to the next fresco, *The Mass at Bolsena*, dated 1512 on the window embrasure (Plate 105). It is one of the most subtle of all Raphael's works. The challenge of the difficult space with its intruding, asymetrically placed window has been resolved by an apparently simple and yet extremely sophisticated solution. The altar has been placed closer to the right, thus giving the illusion that the two halves of the picture are roughly equal. To reduce further the right-hand space Raphael has painted a dark grey strip between the frame and the ceiling arch only on this side.

The story, taken from the *Chronicles* of St. Antoninus, concerns a priest who doubted the dogma of Transubstantiation. One night in 1263, while celebrating Mass in the small town of Bolsena, he was astonished to see that the consecrated Host was bleeding, thus dispelling all doubts that the bread had indeed become the True Body and Blood of Christ. A miracle was proclaimed and the Host taken to the neighbouring city of Orvieto, where the Pope was in residence. It was installed in a special chapel in the cathedral where it is to this day. Raphael has portrayed the moment of revelation as the priest lifts the Host from the humeral and sees the Blood for the first time (Plate 104). A crowd of believers behind and below the priest presses forward at the sight of the miracle.

104. Detail of *The Mass at Bolsena*. As the priest lifts the humeral covering the consecrated Host, he sees that it is actually bleeding, thus proving to him that it has become the True Body and Blood of Christ. Similar miracles occurred several times throughout Europe during the thirteenth and fourteenth centuries.

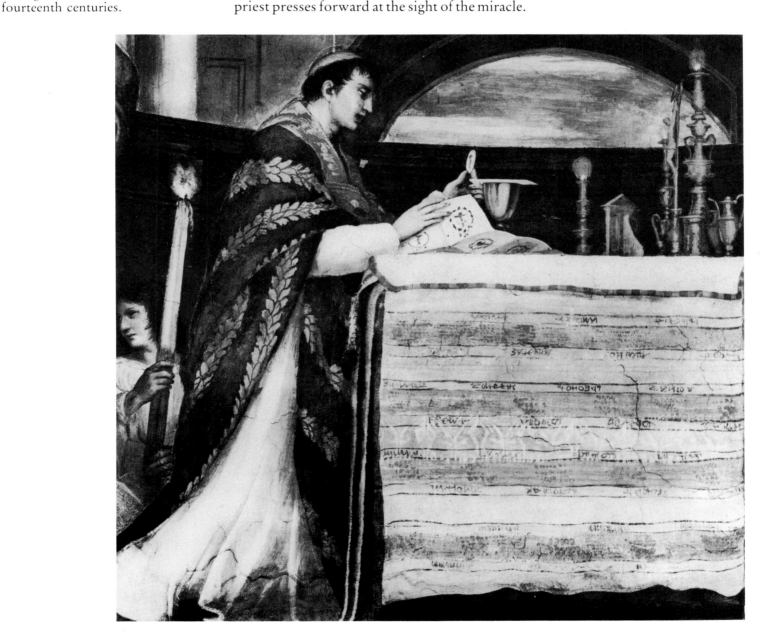

To the right on the other side of the altar are some of the finest portraits Raphael ever painted. Pope Julius is of course nearest to the Body of Christ (Plate 107). Behind him are members of the papal court and at the base of the stairs kneel members of the Swiss Guard (Plate 106). Their inclusion is another instance of an alteration imposed by Julius. In spring 1512 the Swiss troops soundly defeated the French army and gave Julius back his longed-for Bologna as well as most of central Italy. Out of gratitude the Pontiff proclaimed them official papal guardians. They were, incidentally, the predecessors of the colourful guards who still patrol the Vatican today. The lower part of the fresco could not have been painted before June 1512, when the Swiss arrived in Rome for the victory celebrations.

The extraordinary luminosity of the colours as well as the lively quality of the portraits has led to much speculation as to how Raphael would have known about Venetian techniques. Art historians have even suggested that the portraits were executed by other painters, for example Sebastiano del Piombo, who had recently arrived from Venice. The simple fact is that, whatever his inspiration, it was Raphael who painted these figures. Vasari stressed that he had learned his colour from Fra Bartolommeo whose art also influenced Titian and Sebastiano. We have seen that he may have visited Padua shortly before moving to Rome. Furthermore, Agostino Chigi had spent six months in Venice in 1511 and could have brought back examples of Venetian art for his new villa, where Raphael was working.

105. *The Mass at Bolsena*. Rome, Vatican Palace, Stanza d'Eliodoro. This scene refers once again to the miracle of Transubstantiation. The importance of the Corpus Christi in both this fresco and the *Disputa* indicates that the Dominican order which was particularly devoted to this feast, played a major role in determining the programme for these two rooms.

106. Detail of *The Mass at Bolsena*. The magnificent glowing colours and extraordinary lifelike quality of these portraits is a clear testimony to Raphael's knowledge of Venetian technique. The Swiss Guards were certainly added to the fresco after June 1512, when they arrived in Rome to join the victory celebrations over the French.

Opposite the *Mass at Bolsena* is *The Liberation of St. Peter* (Plate 108), the last fresco Raphael executed for Julius II. The subject, taken from Acts XII:4-10, was not just an instance of divine intervention on behalf of the first pope, who had been imprisoned by Herod. It was also a direct reference to Julius's title as Cardinal of San Pietro in Vincoli. This Roman church houses the chains that bound Peter in prison. Even after he became pope, Julius maintained a deep affection for the church and in June 1512 celebrated the thanksgiving Mass there for the expulsion of the French from the Papal States. Raphael was engaged on the *Liberation of St. Peter* when Julius died, for Julius's name appears on both sides of the framing lunette, while lower down on the left a putto carries the impresa of his successor, Leo X.

In this Stanza Raphael's inspiration never seems to have waned. First he created the dynamic forms of the *Expulsion of Heliodorus* and followed with the glowing colours of the *Mass at Bolsena*. In the *St. Peter* fresco he has painted an innovative night scene. To the left only the moon, half-covered by a cloud, and the feeble torch of one of the guards provide sources of light. By contrast, the scenes in the centre and on the right are entirely illuminated by the blinding radiance of the angel.

107. Detail of *The Mass at Bolsena*. Julius is seen here not just as a worshipper adoring the Host, but also as the embodiment of the Church, through whose sacraments all men may be saved. Such a concept was central to the defence of papal primacy in the early sixteenth century.

Peter's cell is filled with an unearthly light, which throws the dark shadows of the sleeping guards against the wall (Plate 109). The strength of the illumination is enhanced by the hard black grid of the prison bars. To the right the armour of the unconscious guards reflects the brilliance much more brightly than does that of their counterparts on the left side. The intensity of the angel's glory is emphasized in a more subtle way. Peter is led from his cell unseeing, for to behold such supernatural light would be too much for mortal eyes.

The fourth fresco planned for the Stanza d'Eliodoro, the *Repulse of Attila,* was not painted until the pontificate of Leo X. (The execution of the fresco will be discussed fully in Chapter 5.) Although the event is mentioned briefly in the *Liber Pontificalis,* a much fuller account is found in the *Chronicles* of St. Antoninus, which had also served as the source for the *Mass at Bolsena.* This version includes a detailed description of the Hun's ravages over northern Italy before he was confronted by Pope Leo the Great. Attila was so impressed by the Pope's holiness that he immediately withdrew north of the Alps. Julius and his contemporaries could hardly fail to notice the parallel with the French occupation of most of the same territory. To represent an occasion when an invader was repulsed simply by the presence of a pope must have seemed very attractive.

108. *The Liberation of St.Peter.* Rome, Vatican Palace, Stanza d'Eliodoro.
The story of Peter's miraculous liberation from prison was not just an example of God's favour to the first pope. It was also a direct reference to San Pietro in Vincoli, which was Julius's titular Church in Rome as a cardinal.

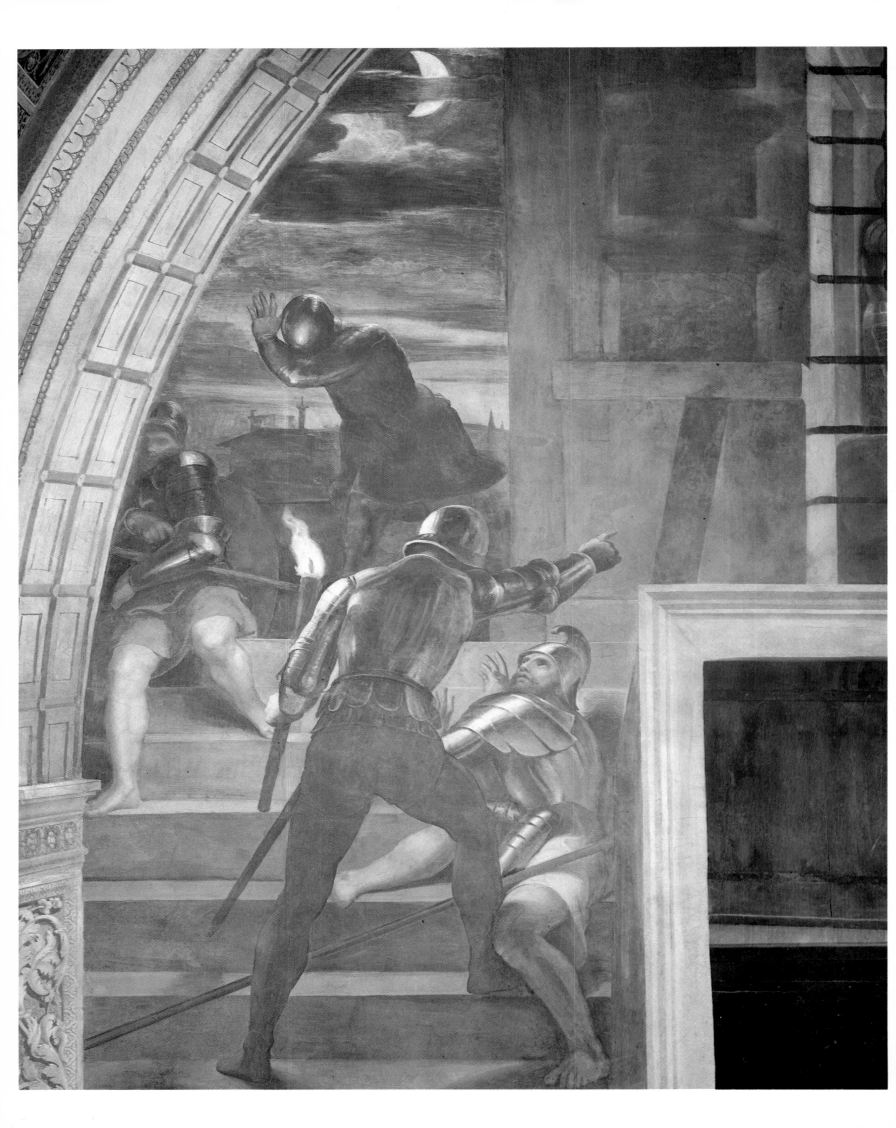

110. Copy after Raphael. *Early design for 'The Repulse of Attila'.* Brush drawing in brown wash, heightened with body colour (oxidized), 38.8 × 58 cm. Oxford, Ashmolean Museum.
The bearded pope shows that Julius intended to cast himself in the central role of Leo the Great. The boy hostage, Federigo Gonzaga, can be seen to the left.

For the version planned under Julius there exist only copies of drawings after Raphael's original conception (Plate 110). Once again Julius had cast himself in the role of the historic pope, but this time his entourage carrying him in his chair would have been fully integrated with the rest of the fresco. Above him are the two representatives of papal authority, St. Peter and St. Paul. Their role in the drawing is purely allegorical for Attila and his troops pay them no heed, but attend solely to the gesticulating Pontiff.

In this drawing can also be found the 'portrait' of Federigo Gonzaga, which has long puzzled art historians. The eleven-year-old son of Isabella d'Este had been sent to the papal court as a hostage in order to ensure his father's loyalty in the wars against the French. Precocious and talented, he soon charmed the entire court and became Julius's favourite. In the letter of 16 August 1511 previously mentioned, the Mantuan ambassador wrote that the Pope desired to have a portrait of Federigo included in the room in which Raphael had painted his Holiness with a beard. Because of the confusion over which of Julius's portraits this referred to, Federigo's face has always been sought in the Stanza della Segnatura. But here the only figure young enough to be the boy is a golden-haired, idealized head that peeps out from behind the group surrounding Pythagoras in the *School of Athens* (Plate 84), which was finished some time in 1510. This head is already present in the even earlier cartoon preserved in Milan and there is no other likely representation of him in the frescoes in the Segnatura.

In the copy of the preliminary drawing for the *Repulse of Attila*, however, there is a young boy walking in the foreground of Leo's (Julius's) entourage. (That the Pope is drawn with a beard proves that this drawing must date from after Julius's return to Rome in June 1511 when Raphael would have seen him with a beard for the first time.) This was apparently the place intended for Federigo, but he vanished from the fresco when it was redesigned under Leo X, by which time he had left the papal court. Because of the close friendship between the Gonzaga and the Medici, Federigo returned immediately to Mantua upon Giovanni de'Medici's election to the papal throne as Leo X.

There is a long tradition of identifying portraits in the Stanze, and already in 1883 Anton Springer published a chart listing the various names suggested for each figure

109. Detail of *The Liberation of St.Peter.*
This is one of the earliest night scenes in Italian art. Raphael has created a brooding sky with broken clouds across the moon. Such dramatic atmospheric effects bespeak a close knowledge of Venetian painting.

in the *School of Athens*. Ever mindful of his patrons Vasari had included as many Medici as possible. On the other hand, the gloomy figure leaning on a marble block at the base of the stairs in the *School of Athens* has been thought to be Michelangelo writing poetry on the stone he loved to carve, although why Raphael should have added the portrait of a man who was particularly antagonistic towards him is not clear. (It is interesting that Vasari, who worshipped Michelangelo and was generous in assigning the names of artists to figures in the Stanze, did not see here the portrait of his god.)

It should be remembered that of course neither Julius, nor Raphael, nor any of the advisors, in deciding which people would be represented in the frescoes, could know who would or would not be remembered by posterity. The members of the papal curia, so well known to one another in their own day, were forgotten already by the mid-sixteenth century. Yet sometimes their portraits have been assigned the names of artists who do not even appear in contemporary documents. Thus, Vasari identified the engraver Marcantonio Raimondi as a bearer of the papal chair in the *Expulsion of Heliodorus* although he may well not have been acquainted with Raphael at the time the fresco was painted. When portraits, particularly in the second room, have been successfully identified they are usually of members of the papal household or court. For example, the frontmost figure accompanying the pope in the *Heliodorus* fresco is Giovan Pietro de Foliari, a papal secretary, who carries his name on a piece of paper. A. Schiavo has shown with the aid of medals that the foremost cardinal kneeling behind Julius in the *Mass at Bolsena* is the Pope's cousin, Raffaele Riario. But without such comparative material or individual attributes, identification is at best tenuous and frequently silly. Not every figure in the Stanze with a beard is Julius and not every man with jowls and a five-o-clock shadow is Leo X. Raphael's extraordinary ability to create lifelike faces must be considered as part of his art, and not a planned rebus for future generations.

When Giovio said that the subjects of the rooms were determined by the Pope, he did not mean that Julius sat long into the night searching for acceptable subjects to be painted on his walls. The papal court contained theologians who could work out a programme according to the pontiff's desires. Of central importance were the Dominicans, as already pointed out by Ludwig von Pastor in his *History of the Popes*. This religious order provided the pope's official theologian, the Master of the Sacred Palace, who established official policy regarding all theological questions and problems. He chose the orators and approved all sermons given in the papal chapel; he even had the right to interrupt if theologically unsound material was presented.

Throughout the fifteenth and sixteenth centuries, the Dominicans proved the staunchest supporters of papal primacy, a subject particularly close to Julius's heart. The problem of whether a pope could be condemned and removed by a Council of Cardinals continued to worry every pontiff even after the Great Schism had been resolved at the Council of Constance in 1417. Attempts to depose the ruling pope were encouraged by secular rulers, most notably the kings of France, who sought to regain the control over the papacy, which they had enjoyed when the pope had been resident in Avignon. There were constant intrigues, and the threat of a conciliar challenge to papal authority in 1509 (an incident that determined the theme of divine intervention for the Stanza d'Eliodoro) had been preceded by many before. As the leading advocates of the divine character of the papal office, the Dominicans would be most likely to suggest a fresco cycle that depicted occasions of God's succour to His Church, as embodied by the person of the pope.

The Dominicans had also played the leading role in the development of the theology of the Host, which figures so prominently in the *Mass at Bolsena* and the *Disputa.* They succeeded in having the Feast of Corpus Christi instituted as a celebration for the Universal Church in 1264, for which the Mass at Bolsena was the ostensible reason. The greatest of all Dominican theologians, Thomas Aquinas, was reputed to have composed the office for this new feast at the behest of Urban IV. Thomas also wrote extensively on the dogma of the Trinity and the dogma of Transubstantiation, both of which are artistically symbolized by the central position of the Host in the *Disputa*, in which Thomas duly appears.

The Dominican bias in these two rooms is further seen in the fresco that commemorates the codification of canon law, a task carried out by a Dominican and mentioned in Antoninus's *Chronicles.* The artistic representation of the division of secular and religious law is first found in the Dominican church of Santa Maria Novella in Florence. The Roman seat of the Dominicans, Santa Maria Sopra Minerva, also provided intellectual and artistic inspiration for the Stanza della Segnatura. In Filippino Lippi's *Triumph of St. Thomas Aquinas* in the Carafa chapel, numerous heretical books are strewn underfoot while Thomas, accompanied by Grammar, Dialectic, Philosophy, and Theology, confounds those who would doubt or try to destroy the True Faith.

Finally, it is worth recalling that it was in the Dominican libraries of San Marco in Florence and the Badia in Fiesole that the future Nicholas V utilized the same system of division of the faculties as is represented in the Stanza della Segnatura. St. Antoninus, himself a Dominican, worked in both these libraries when he composed the *Chronicles*, which serves as the source for every post-Biblical scene in these two Stanze.

The Stanza della Segnatura and the Stanza d'Eliodoro were Raphael's first fresco cycles. His only previous experience with this medium as an independent artist had been the unfinished work in San Severo in Perugia although he must have been familiar with the technique from Perugino's workshop. It is a mark of his genius that within a year of his arriving in Rome he superseded older and more experienced artists. The increasing virtuosity with which he handled figures and settings allowed him to fulfil the very different requirements of both rooms in highly original ways. These masterpieces inspired and educated future generations of artists.

Raphael was the first fresco painter to assimilate figures into their surroundings. Settings in quattrocento frescoes served primarily as a backdrop against which an action was placed. Even in Leonardo's *Last Supper* the architecture functioned as a frame for the figures. Occasionally iconographic considerations would require the inclusion of buildings that had no place in the actual event: the Temple in Jerusalem was depicted in Perugino's *Charge to St. Peter* in the Sistine Chapel even though the event took place in Caesarea. In contrast, the figures in the *School of Athens* are genuinely integrated into their background, which itself relates accurately to the subject. Raphael has dared to place two main figures further back in the picture, and bring others nearer to the spectator. The result is a realistic scene rather than a posed arrangement or staged event.

This naturalism is also characteristic of Raphael's figure style. He has worked images from a variety of sources into a new and convincing whole. It is impossible to remove one figure from a group, or a group from the entire composition, without destroying the balance of the whole. By this Raphael has fulfilled the Aristotelian condition for perfection in art through the congruence of all parts. The addition after the fresco was completed of the seated philosopher in the foreground of the *School of Athens* attests to this aesthetic sensitivity. Without that figure the white

expanse of steps would dominate the foreground and separate the two sides of the fresco instead of forming a bridge between them. The dark figure has restored unity and symmetry.

One of Raphael's most dramatic innovations was to integrate his contemporaries as actual participants in the scenes. Formerly, portraits in fresco cycles had been grouped separately from the event or placed as onlookers in a crowd. For the *Receiving of the Decretals*, however, Julius was cast in the leading role, and contemporary members of the curia served as attendants. In the *Mass at Bolsena* the portrait of the pope is vital not only to the composition but also to the iconography. The inclusion of a living pope and his entourage as historical figures was continued in the *Repulse of Attila* and all the frescoes in the Stanza dell'Incendio executed under Leo X.

Although this extraordinary suite constituted Raphael's main work for Julius, he also did other paintings for the pontiff. The first of these was probably the so-called *Madonna di Loreto* for Santa Maria del Popolo (Plate 124). The subsequent fame of the picture was such that numerous copies were made, and only recently has the original painting reappeared after cleaning at Chantilly. (The composition, also referred to as the *Madonna del Velo* and called a 'Nativity' by Vasari, received its present name from the copy painted for the Loreto basilica in the eighteenth century.)

As mentioned earlier, the church of Santa Maria del Popolo occupies a particularly significant site in Rome, at the end of the Via Flaminia, just inside the Porta del Popolo. Each year thousands of pilgrims from the north streamed through this gate in search of indulgences and salvation in the holy city, and it was in this church that they began their Roman pilgrimage. Consequently Sixtus IV began to renovate Santa Maria del Popolo shortly after his election. The new marble high altar by Andrea Bregno, which may have been donated by Cardinal Roderigo Borgia (later Pope Alexander VI), housed a miraculous icon of the Virgin and Child, which was reputed to have been painted by St. Luke. The high altar, redesignated as a 'papal' altar, was dedicated to the Nativity of the Virgin. By raising its status, increasing the indulgences, and redecorating the church, Sixtus immediately impressed the magnificence of the Christian capital upon the weary travellers.

Sixtus's patronage of Santa Maria del Popolo has often been misinterpreted as an indication that he chose this church to serve as a family mausoleum. In fact, no close relatives of either Sixtus or his nephew Julius are buried there. The della Rovere brothers buried in the first chapel came from an unrelated noble family, whose arms Sixtus had stolen when he was elevated to the College of Cardinals. A brother-in-law to whom Sixtus had granted the privilege of adding della Rovere to his name built a tomb in another chapel. Indeed, the Borgia pope Alexander VI used the church much more as a family mausoleum, and buried his mistress with their murdered son in a chapel in the transept.

Julius understood the political power of architecture better than any of his predecessors. He dared tear down and rebuild St. Peter's, the most important church in western Christendom. One of his acts to aggrandize Santa Maria del Popolo was to transfer there all the indulgences connected with pilgrimages to St. Peter's, since this would be more convenient for the pilgrims. To enhance the small church still further, he commissioned a splendid new choir from Bramante. The grand monumentality of the choir arch, with its deep shell-like apse behind, dwarfed the Borgia marble altar completely. The della Rovere arms were raised to a more prominent position in the beautiful stained glass windows.

Julius's only interest in using the church as a burial place for his family was to

111. *Study for the Child in 'The Madonna di Loreto'*. Silverpoint on pink paper, 16.7 × 11.8 cm. Lille, Musée des Beaux-Arts.
Raphael has captured extraordinarily lifelike effects in the various poses of the Child.

employ one of the two great marble tombs in the choir for his distant cousin the Cardinal of Loreto. On the opposite wall of the choir he installed the tomb of one of his most hated enemies, Cardinal Ascanio Sforza, who had twice blocked Julius's succession to the papacy. Although the inscription on Sforza's tomb claims that Julius was acting out of charity, in fact he had seized Sforza's considerable fortune at his death in 1505, probably to help defray the costs of rebuilding the choir of the church, as Christof Frommel has suggested.

The *Madonna di Loreto* was another papal endowment to the church. The picture was hung on a pillar in the nave so that it was easily seen by everyone entering the church. On the basis of a thorough technical examination, Mme Sylvie Béguin has established a date of early 1509 for the *Madonna di Loreto*, which would accord with Julius's generous patronage of the church at that time. Drawings (Plate 111) demonstrate once again how much care Raphael took over a picture. He continued his practice, first established in Florence, of experimenting with a particular pose until he found the desired solution. In the final work the lively movement of the Child reaching upward from the bed to push away the veil is entirely natural and yet, in its iconographical context, foreshadows the Resurrection. The gesture of the Madonna is deliberately ambiguous. Does she remove the cloth from her Son as a revelation of the Incarnation or seek to cover Him as if with His shroud?

The year of 1509 was eventful for Raphael. He obviously had established himself as a favourite at the papal court very rapidly, for on 4 October he was appointed *Scriptor Brevium Apostolicorum*, that is, a secretary in the papal bureaucracy. Furthermore, although he received his post with 'all its honours and usual payments', he was relieved of actual duties. There was fierce competition for such

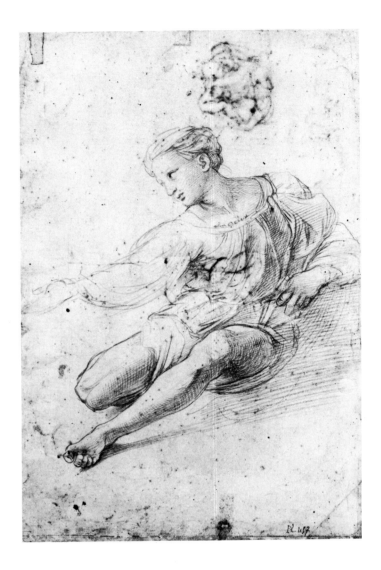

112. *Study for 'The Alba Madonna'*. Red chalk, 42.1 × 27.1 cm. Lille, Musée des Beaux-Arts. Raphael used one of his male assistants to pose for the Madonna. Once the pose had been worked out, he could change the features to meet his concept of ideal beauty.

posts because they were sought by itinerant scholars as sinecures. Raphael's appointment indicates the rising social status of the artist in the early cinquecento. Until the end of the fifteenth century painters and sculptors were considered primarily as artisans, that is, practitioners of the mechanical rather than the liberal arts. (Architects were regarded slightly differently.) A subtle shift had begun already in Florence when Lorenzo de'Medici took Michelangelo into his household in 1490. Under the tremendous impact of Michelangelo, Leonardo, and Raphael, the position of the artist altered from that of a skilled craftsman to the equivalent of a scholar. Raphael's famous grace and charm no doubt must have contributed to his swift change of status from being one of a team of painters to being a papal courtier, but it was his genius that set him apart. It is worth noting that even Perugino, in spite of his fame and long service to the della Rovere family, was never accorded a similar honour.

During his first two years in Rome Raphael seems to have worked exclusively for Julius. There is no evidence that he received any outside commissions before the pontiff's departure for war in August 1510. The following November Raphael agreed to furnish the designs for a pair of floral tondi to be cast in bronze and gilded for the banker Agostino Chigi. The tondi, now lost, are the first works that Raphael is known to have done for the man who became his greatest secular patron.

Also dating from about this period are two paintings whose patrons are unknown. One, *The Alba Madonna* (Plate 113), is reputed to have been in the possession of Paolo Giovio in 1528 when he became Bishop of Nocera near Naples. But Giovio did not come to Rome before 1514 whereas the painting is traditionally dated about 1510. The other, the portrait of *A Cardinal* (Plate 114), was unknown

in the literature until the nineteenth century. The sitter has never been convincingly identified although several implausible suggestions have been made. While most experts consider this a work of 1510-11, the names of Giulio de'Medici, Bernardo Bibbiena and Innocenzo Cybo have been put forward even though they all were made cardinals only in 1513.

The *Cardinal* is an arresting and fascinating picture. The portrait is unlike anything in Raphael's previous *œuvre* and supports the suggestion that he was directly acquainted with Venetian art and techniques. The silhouette is derived from Giovanni Bellini's portrait of *The Doge Leonardo Loredan* (Plate 115) in the way the head is set upon a broad base formed by the sumptuous cloth and turned at a slight angle to the picture plane. This is different from both the frontal poses of Raphael's earliest portraits and the sharper angle of the *Doni* portraits. Another Venetian feature is the textures of the buttons and the watered-silk *mozzetta*. But the incredible brushwork of the face, in which the eyes are softly lined with eyelashes and delicately highlighted, and the hairs of the eyebrows and head are painted individually, show a quality seen before this only in Giorgione's work (Plate 116). The portrait has become a presence rather than a likeness. From now on all Raphael's portraits have this added psychological dimension.

The *Alba Madonna*, on the other hand, continues the interest in the form of the tondo that Raphael had shown in Florence. The completely natural curve of the Virgin's body echoes the line of the frame. To achieve this Raphael has drawn the figure from a carefully posed live model, as can be seen from a drawing (Plate 112),

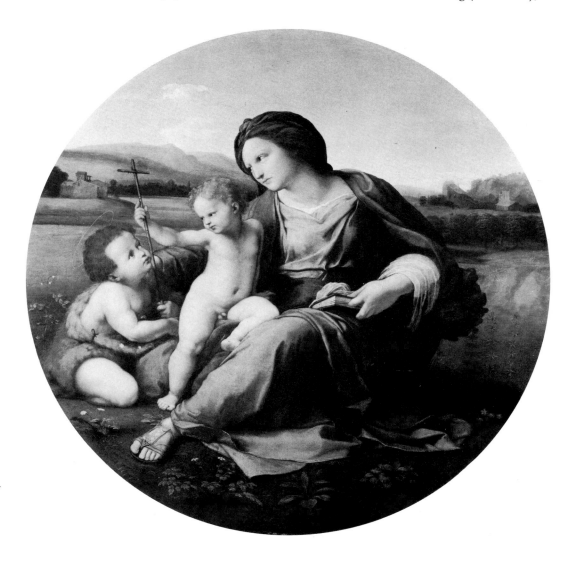

113. *The Alba Madonna*. Canvas, transferred from wood, tondo, diameter 95 cm. Washington, D.C., National Gallery of Art. Although the cross is the focal point of the picture, Raphael has placed it to one side. The carefully painted plants in the foreground were all selected for their iconographic meaning.

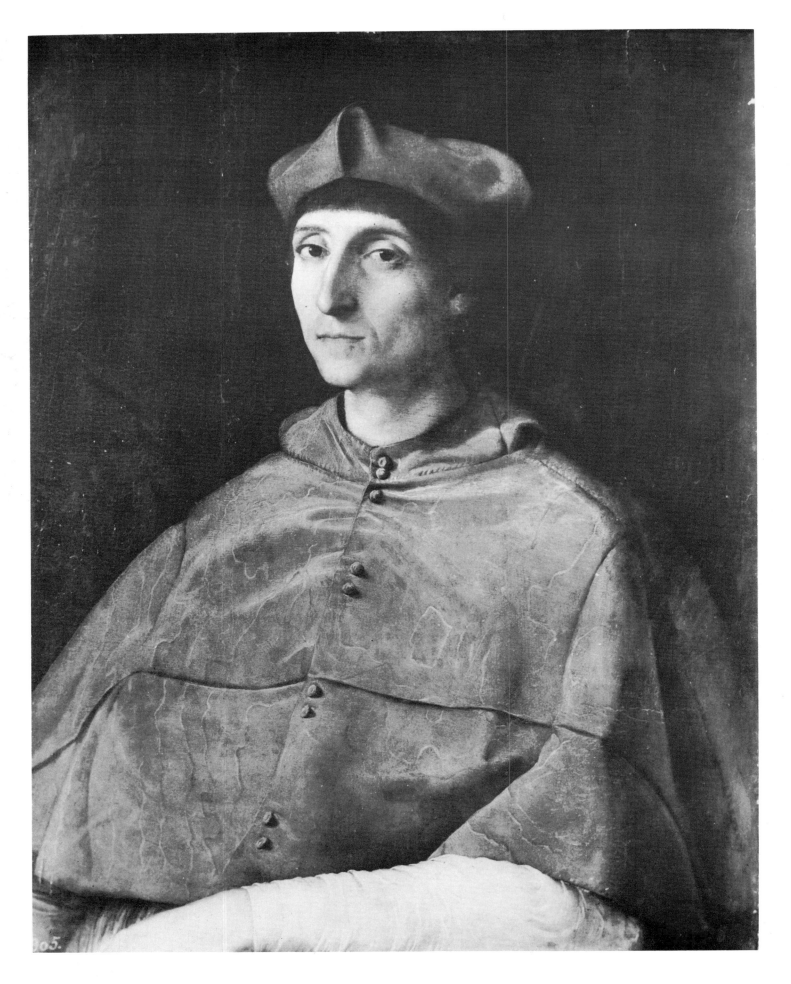

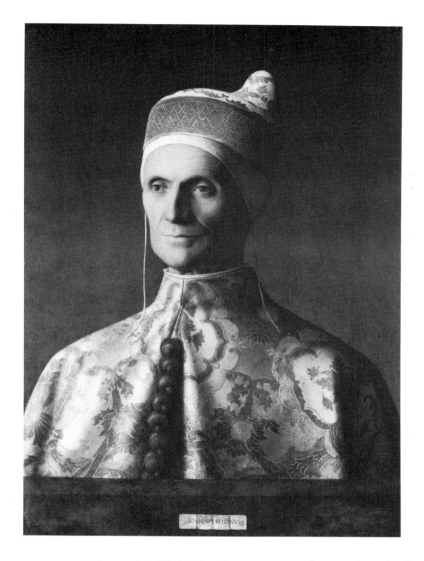

115. Giovanni Bellini. *The Doge Leonardo Loredan.* Panel, 61.5 × 45 cm. London, National Gallery.
Probably painted shortly after 1501, the placing of the sitter and the careful handling of the rich cloth are typical of Venetian portraiture.

116. Giorgione. *A Young Man.* Canvas, 58 × 46 cm. Berlin-Dahlem, Gemäldegalerie.
The subtlety of Giorgione's technique changed the course of painting in Venice. The delicate shading of Raphael's *Cardinal* portrait could have been the result of direct knowledge of Giorgione's works.

114. *A Cardinal.* Panel, 79 × 61 cm. Madrid, Prado.
This magnificent portrait was a radical departure from Raphael's earlier technique. The more brittle lines of the Umbrian school have given way to Venetian softness.

and yet, when the figure was painted, the forward movement appears spontaneous. Encircling the group are a number of plants, which must have been deliberately chosen for their symbolism. Those closest to the Virgin are all traditionally associated with her. According to legend the lady's bedstraw was found in the hay at the Nativity; the cyclamen symbolizes her love and her sorrows; and the violet and plantain refer to her humility. On the opposite side the flora refers to her Son: the dandelion prefigures the bitterness of the Passion, the ranunculus so prominent in the foreground His death, and the anemones in St. John's lap the Resurrection. These latter stress the focal point of the painting, which is the cross grasped by the two holy children. This was not the first instance of plant symbolism in Raphael's art. A similar selection appears in the foreground of the Baglioni *Entombment.*

It was probably in 1511 that Raphael received the commission for a fresco of *Isaiah* (Plate 117) from the papal protonotary and humanist Johannes Goritz. Goritz had concluded a contract with the canons of Sant'Agostino on 13 December 1510 that he should be buried in front of one of the nave piers. His tomb was to be in the floor, before a marble altar on which a sculptural group of St. Anne, the Virgin Mary and the Christ Child would stand. No mention was made of artists or a fresco. Andrea Sansovino, who had recently finished his work for Julius in the choir of Santa Maria del Popolo, was retained for the sculpture. The completed altar ensemble was unveiled on St. Anne's feast day, 26 July 1512.

The sculpture was separated from the fresco during restorations to the church in the eighteenth century, and only recently, thanks to the researches of V.A.

117. *Isaiah*. Fresco, 205 × 155 cm. Rome, Sant'Agostino. Commissioned by the Protonotary Johannes Goritz, the *Isaiah* was a companion piece to a sculptural group of St. Anne, the Virgin and the Christ Child. Painted in 1511-12, the figure's debt to Michelangelo's Prophets on the Sistine Ceiling led Vasari to allege that Raphael had entered the Sistine chapel surreptitiously.

Bonito, have the two been reunited in some semblance of their original relationship (Plate 118). The Greek inscription over Isaiah's head refers to the sculptural group and dedication of the altar below, and there is a slightly different inscription, in Latin, on the base of the statue. Isaiah holds an inscription, written in Hebrew, which appeals for admittance into Heaven (Isaiah XXVI:2-3), thus stressing the funerary purpose of the altar.

As Bonito has pointed out, Raphael, in designing his work, took into account the relationship between the statue group and the fresco. The *Isaiah* seems more like a painted statue than a pictorial representation, and has been so totally inspired by Michelangelo's prophets on the Sistine Ceiling that Vasari claimed that Raphael,

aided by Bramante, surreptitiously gained admittance to the Sistine Chapel. Certainly it is one of Raphael's less successful paintings, lacking the originality that is usually found in his work. Nevertheless, Vasari's charge may be discounted since Raphael could have seen Michelangelo's work quite openly on 15 August 1511 when Mass was celebrated in the chapel and still have completed the fresco before it was needed in the following summer. The work did not make a great impression on Raphael's contemporaries, for it is mentioned only rarely in the poems about the altar.

These poems were the products of the annual poets' contest organized by Goritz to commemorate St. Anne's day. Such 'contests', in which Goritz's friends and acquaintances celebrated him and his generous patronage in rhyme, were a typical humanist conceit and served as an opportunity to exhibit esoteric knowledge and verbal facility. Goritz himself obviously took great pride in his classical learning. Inscriptions in Greek are infrequent in Renaissance art, and Hebrew appears even more rarely. To have included in the fresco three inscriptions, two of which say almost the same thing, was a display of his own accomplishments. Furthermore, Goritz required that Sansovino carve the group of three figures from one piece of stone, a requirement that referred to Pliny's praise of the *Laocoön* for having been carved from one block. When this antique group was dug up in a vineyard in Rome in 1506 it created a sensation. Although it was, in fact, not carved in one piece, the idea of such an achievement was not diminished in the minds of the humanists. By including such a clause in the contract Goritz was casting himself in the role of an ancient patron. Not for nothing did his flatterers call him Maecenas.

The uninspired *Isaiah* is in sharp contrast to another altarpiece Raphael painted about the same time, also for a humanist and apostolic secretary. Sigismondo dei Conti, who had been in the papal service for thirty years, commissioned the work now known as *The Madonna di Foligno* (Plate 121) shortly before his death in February 1512. Originally placed on the high altar of the church of Santa Maria in Aracoeli, the seat of the Franciscan order in Rome, the painting was removed in the mid-sixteenth century to Sigismondo's home town of Foligno, from where it derives its present title.

The Virgin and Child floating on clouds before a large golden disk are a direct allusion to the name of the church. According to medieval legend, the emperor Augustus had sought advice from the Sibyl on the Capitoline Hill after learning that the Roman Senate wanted to deify him. She told him that he would remain a god until a greater god came and then showed him a vision of the Virgin with the new-born infant Jesus surrounded by a golden aura. The site of the church was traditionally the site of this miracle.

Basically the picture employs a conventional hierarchical arrangement. Adoring the Virgin and Child are St. John the Baptist and St. Francis on one side, St. Jerome presenting the kneeling donor on the other. Sigismondo has chosen this saint as his intercessor rather than, as more traditional, his name saint because, having been in the papal service himself, St. Jerome is the patron saint of all secretaries. However, the upper half of the picture departs from the usual type of the Madonna in Glory. No longer held aloft in a mandorla supported by angels, the Virgin is seated naturally as if the clouds were a throne. Her heavenly attendants have merged with the clouds so that, while at first glance Mary appears to be alone with the Child, she is in fact surrounded by an angelic host.

Some features of the picture have never been satisfactorily explained, for example, the putto in the centre holding a blank tablet. The lack of an inscription cannot be an accident, for Raphael completed the painting. Possibly Sigismondo died before he had selected or composed a text. Even more puzzling is the arc of

118. *The St. Anne Altar.* Rome, Sant'Agostino.
Newly restored to its original arrangement, the altar contains three inscriptions, one each in Latin, Greek, and Hebrew, all relating to the funerary context for which the chapel was intended. The texts were probably chosen by Goritz himself, who was an educated humanist.

119. Detail of *The Madonna di Foligno*.
The arc of light under the feet of the Virgin has long puzzled art historians but no satisfactory explanation has been found. The distant view of the town with its atmospheric effects is reminiscent of Venetian landscapes.

light under the feet of the Virgin, which seems to end in the town in the background. Various proposals have been put forward: ball-lightning, a meteor from which Sigismondo barely escaped, or even a half-moon, in reference to the Immaculate Conception of the Virgin, to which the Franciscans were particularly devoted. None of the explanations carries conviction, and the problem continues to puzzle beholders.

The landscape in this picture (Plate 119) is very different from Raphael's earlier Umbrian style of clear atmosphere and distinct distant views. Moreover, the *sfumato*, now so noticeable, is not the same as Leonardo's monochromatic rendering. Rather, the various shimmering colours are reminiscent of those used by Venetian painters, particularly Giorgione. The lowering sky cut through by an arc of light conveys much of the same mysterious atmosphere as the *Tempesta* (Plate 120). This is so unlike Raphael's previous style that the assistance of Dosso Dossi has been suggested. Technical examination by D. Redig de Campos has refuted this

121. *The Madonna di Foligno*. Canvas, transferred from panel, 301 × 198 cm. Rome, Vatican Pinacoteca.
The painting was originally placed on the high altar of Santa Maria in Aracoeli. It was Raphael's first monumental altarpiece after he arrived in Rome. The donor, Sigismondo dei Conti, is being presented to the Virgin and Child by the patron saint of secretaries, Jerome.

120. Giorgione. Detail of *The Tempesta*. Canvas, 82 × 73 cm. Venice, Accademia.
The mysterious atmosphere evoked by the lowering clouds cut through by lightning is strikingly similar to Raphael's later work, as in the *Madonna di Foligno*. Giorgione's style of *sfumato* and distant views had become characteristic of the Venetian school already by 1505.

theory, and we are thrown back once more on the hypothesis that Raphael travelled north with Fra Bartolommeo in 1508.

Raphael's close connection with Fra Bartolommeo is seen very clearly in the figure of the Virgin for this painting. From a drawing (Plate 122) there can be no doubt that Raphael was familiar with Fra Bartolommeo's altarpiece for the cathedral of Besançon, completed in 1511 (Plate 123). The figure of the Virgin has been reversed and the cherub that Fra Bartolommeo placed under her feet has been moved up to the left, but the essential pose has been retained. The influence upon each other of the two artists, who were close friends all their lives, has not been properly explored; but the exchange of drawings between artists was a common practice of the period, and it was probably from one of these exchanged drawings that Raphael gained his knowledge of this altarpiece.

The donation of a new painting for the high altar of the principal Franciscan church in Rome indicates that Sigismondo dei Conti had considerable wealth and influence. Appointed apostolic secretary by Sixtus IV in the 1470s, he may have felt that such a large gift to the order of which Sixtus had been a member, General, and Cardinal Protector, would demonstrate his gratitude for his good fortune. Sigismondo was a scholar and humanist, and is best known for his *Historiae dei Suii Tempi*, which provides important first-hand information about the popes under whom he served, and about the rebuilding of St. Peter's by Julius. Towards the end of Sigismondo's long life Julius wanted to reward him for his devoted service with a cardinal's hat. Unfortunately he was married, and his wife refused to enter a convent so that her husband could accept an honour for which celibacy was required. He was buried in the choir of the Aracoeli.

Raphael's new Roman patrons were completely different from those he had served previously. From the start of his work in Città di Castello to the end of his

122. *The Madonna and Child on Clouds.* Black chalk and pen, 24.8 × 37.5 cm. Frankfurt, Staedelsches Kunstinstitut. Raphael's close connection with Fra Bartolommeo can be seen from this drawing. The angel on the right holding his arm over his head corresponds to the angel under the Virgin's feet in Fra Bartolommeo's altarpiece for Besançon Cathedral.

123. Fra Bartolommeo. *Virgin and Child with Saints and Donor.* Panel, 260 × 230 cm. Besançon, Cathedral.
Because of its close affinity to the *Madonna di Foligno*, this work, finished in 1511, must have been known to Raphael from drawings. Fra Bartolommeo and Raphael were close friends until the former's death in 1517.

stay in Florence, his main clients were members of the bourgeoisie or religious houses. In Rome as his genius became apparent and he gained obvious favour within the papal court the clientele that approached him changed considerably. Raphael was now a member of a sophisticated society that demanded from artists not just competence but also a knowledge of theology and classical learning. His artistic eye, so quick to grasp the innovations of Leonardo and Michelangelo, also absorbed the archaeological wealth found in the remains of the ancient city. His understanding was not limited to visual matters, for his paintings for the Stanze show his comprehension of subtle points of theology, liturgy, and classical litera- ture. His outstanding ability to observe everything around him and synthesize it was certainly admired by these educated ecclesiastics, humanists, and connoisseurs. From now on Raphael moved among these people as a peer.

He still produced his best work for Julius. One of his greatest paintings, *The Sistine Madonna* (Plate 126), was commissioned by the Pope for the Benedictine church of San Sisto in Piacenza. This vision of the majestic Virgin and Child appearing in the clouds has led to many obscure interpretations of this picture. Curiously, it was not among Raphael's best known works in the sixteenth century, and Vasari, who had never seen it, only mentions that it was painted for the black monks and was very beautiful.

During the wars with France the town of Piacenza had remained loyal to the

papacy and even joined the States of the Church voluntarily after the French were expelled in 1512. At about that time the Benedictine monastery in Piacenza, one of the largest and most important in Italy, was rebuilding its church. Julius probably commissioned the new altarpiece in June 1512 as a gesture of gratitude during the victory celebrations in Rome to which Piacenza had sent a special delegation. In doing so the Pope would have served a personal interest, for among the holy relics kept in San Sisto were the bodies of St. Barbara, protector of Piacenza, and of St. Sixtus II, a martyred pope and patron saint of the della Rovere family. These two saints accompany the Virgin in Raphael's masterpiece. To make the della Rovere connection even more obvious the brocade pattern of St. Sixtus's cope is worked with oak leaves and acorns.

The composition of the *Sistine Madonna* derived from the recently installed *Madonna di Foligno*, but the sheer power of the new picture is overwhelming. The Virgin alone stands on the bank of clouds into which the two saints sink. Behind her is a brilliant glory of clouds comprising the heads of cherubim, who fade away around her and the Child, so that the central group seems to radiate an intense light. To emphasize the illusion of a heavenly vision two painted curtains are pulled back. The concept of the curtain of the Tabernacle symbolizing that which separates heaven and earth had been incorporated into Christian iconography at an early date. Subsequently the Virgin, as the bearer of the Godhead, became allegorized as the Tabernacle. Thus, what is being revealed is a glimpse into the Holy of Holies, the heavenly realm that lies behind the curtain of the sky.

It has been noted that the features of St. Sixtus (Plate 125) are remarkably similar to those of Julius, not least because of the beard. This beard, perhaps one of the best documented in history, has presented many problems for establishing the chronology of Raphael's paintings, as the discussion of the Stanze has already shown. Julius left Rome for his military campaigns on 17 August 1510 clean-shaven, but on his return ten months later he had a full beard. This transformation was occasioned by the loss of Bologna, which, according to the Papal Master of Ceremonies, Paris di Grassi, so upset the pontiff that he swore not to shave again until the town was retaken. A bearded pope was considered so unusual that six months after his return his appearance was still commented on in the correspondence of the Mantuan envoy. However, on 13 March 1512, Bernardo Bibbiena remarked in a letter to Cardinal Giovanni de'Medici that the Pope was once more clean-shaven.

All of Raphael's known portraits of Julius have a beard. It is hard to believe that they all were painted within these eight to nine months and that the Pope never sat to Raphael again. If we accept that St. Sixtus in the *Sistine Madonna* was intended as a likeness of Julius II, then it follows that the Pope continued to be represented with a beard even after he had been shaved. This preference by Julius shows not only that he wanted his appearance to be the same whenever he was depicted in art, but also that he valued the individuality that this feature gave him. It is amusing that he was represented with a beard in the fresco of the *Receiving of the Decretals*, for it was in this book that the prohibition against priests wearing beards became canon law.

Julius's beard is nowhere more obvious than in the great portrait from Santa Maria del Popolo (Plate 127). This painting had long been thought to be lost, but in 1970 a picture thought to be a copy after Raphael was discovered during cleaning to be the missing work. Its pedigree has been established beyond doubt by Cecil Gould. The work was first mentioned by the indefatigable Venetian diarist Marino Sanudo when it was displayed on the high altar of the church during the celebrations for the feast of the Nativity of the Virgin in 1513, six and a half months after Julius's

124. *The Madonna di Loreto.*
Panel, 121 × 91 cm. Chantilly, Musée Condé.
Formerly thought to be a copy, this painting was revealed as the 'lost' masterpiece after recent cleaning. It was a gift from Julius II to the church of Santa Maria del Popolo, but was removed at the end of the sixteenth century together with the portrait of Julius.

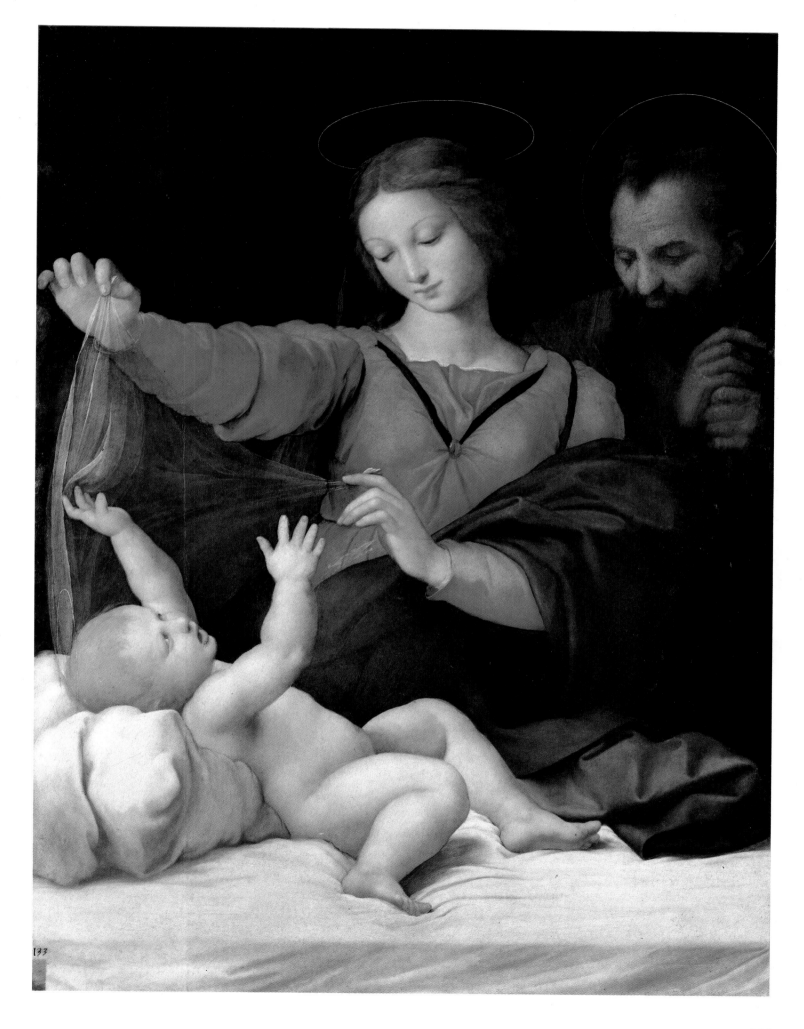

133

death. According to another contemporary, 'all Rome had flocked to see him again, as if for a jubilee', and Sanudo found it 'very similar to nature'. Such reactions indicate that this picture had not been seen before. This raises a very intriguing question. Did Raphael paint a posthumous portrait of the great pope who had done so much for him?

There is much to support such a hypothesis. To begin with, Raphael's personal attachment to Julius is revealed in a letter from the Mantuan ambassador to Isabella d'Este. The day before the pontiff's death he wrote to inform her that Raphael had returned the clothes of her son which were being used for a portrait of the boy. Raphael, he said, was too upset to paint. Secondly, Julius was deeply devoted to the Nativity of the Virgin and had intended to dedicate his own funerary chapel in the new St. Peter's to this feast; since no chapel was ready when Julius died, it would have been an appropriate gesture to place his portrait on the altar dedicated to the Virgin's Nativity on the day he had chosen for his memorial Mass. Subsequently, the portrait appears to have been hung on a pillar for special feast days and stored for the rest of the time in the sacristy. Finally, X-rays made during the cleaning have revealed that Raphael considerably altered the background of the portrait. Originally he painted a cloth of gold embossed with a repeating pattern of the papal tiara and crossed keys, but replaced this by a plain green background. Today pentimenti from the earlier background show through, particularly to the right. This change reduced the reference to the office of the pope.

Raphael had shown in the Stanze that he could create astoundingly lifelike images without any actual knowledge of the persons. However, he had not only drawn and painted Julius a number of times from life, but also was closely acquainted with him. There is nothing in this painting to match the vitality of the portrait in the *Mass at Bolsena* or the fiery glance of that in the *Expulsion of Heliodorus*. Rather, the fallen cheeks and sunken eyes with their unfocused stare convey the appearance of an old and weak man. Perhaps this was the last tribute from the artist to the patron he loved and served so well.

Whatever the case, this work totally changed papal portraiture, and set the standard for centuries to come. Sebastiano del Piombo, Titian, Velazquez, to name only the most famous painters, all turned to it for inspiration. The deceptively simple dignity of the scene enthrones the office while portraying the man. An armchair was the privilege of the very highest dignitaries; even cardinals sat on unbacked benches in the presence of the pope. The red velvet covering of the arms, the golden threads of the tassels and the gilded della Rovere acorns on the posts are all subtle indications of the elevated status of the sitter without their betraying unseemly splendour.

The choice of colour for the background demonstrates Raphael's artistic sensitivity at its best. The white and red of the papal garments had to be rendered accurately. To provide the greatest contrast and to set the image off so that it could be seen clearly at a distance, the background colour, green, is the complement of red. Even the rings conform to this colour scheme. Raphael's limited palette succeeds in displaying artistically his virtuosity as a painter.

With the death of Julius, a chapter closed in Raphael's life and work. The great spirit of the Pontiff, hated and feared by many, had drawn out the talents of the artist so that they acquired increasing force and intensity. In none of his work for Julius did Raphael produce anything less than the best. It was only during the pontificate of Leo X that he constantly reused figures without significant variation or delegated major tasks to the workshop. Under Julius, Raphael limited his outside commissions, and produced stunning masterpieces for a man who expected only excellence from him — although he enjoyed Julius's favour, Raphael was well

125. Detail of *The Sistine Madonna*.
The features of the bearded St. Sixtus bear a close resemblance to those of Pope Julius II. Sixtus II, a canonized pope, was the patron saint of the della Rovere family, and Julius's uncle, Francesco della Rovere, took the name when he became pope.

126. *The Sistine Madonna*. Canvas, 265 × 196 cm. Dresden, Gemäldegalerie.
The title of this famous work derives from the inclusion of Pope Sixtus II. Opposite kneels St. Barbara. The vision-like quality of the painting is emphasized by the pulled-back curtains that reveal the Incarnation.

127. *Pope Julius II*. Panel, 108 × 80 cm. London, National Gallery.
This is the first extant independent portrait of a pope and established a pose followed for papal portraiture to the present day. The unfocused gaze and the fallen facial muscles may indicate that it was done posthumously, a practice not uncommon in the Renaissance.

aware of how quickly other established masters had vanished from employment in the Stanze. The lyric lightness of the Segnatura, the awe-inspiring might of the Eliodoro, the sublime quality of the *Sistine Madonna*, and the quiet dignity of the papal portrait, are all greatly different and yet all the products of one hand for one man. With Julius, Raphael had a true meeting of both the mind and the eye.

4 Rome after Julius

The election of Giovanni de'Medici as Leo X in March 1513 to succeed Julius greatly changed the character of the papal court. Although Julius had been surrounded by prominent scholars, the accession of a Medici to the throne of St. Peter attracted the élite of Italian humanists as well as hopeful unknowns. Pietro Bembo, Baldassare Castiglione, Pietro Aretino, Ariosto, and Paolo Giovio gathered in an ambience that promised a reflowering of the patronage for which the Medici had been renowned.

As pope and patron Giovanni had much to live up to, for the mystique of being the son of Lorenzo il Magnifico involved him not only in culture but also in diplomacy. His great-grandfather, Cosimo il Vecchio, had been proclaimed *Pater Patriae* (Father of the country) after his death, and Lorenzo had spent much of his time promoting peace among the warring factions of the Italian peninsula. While the idea that the rule of the Medici was a golden age went back to the mid-fifteenth century, as Sir Ernst Gombrich has shown, Felix Gilbert has revealed how this myth gained new impetus during the Florentine Republic of 1500-12. Numerous laments came from the circle of disgruntled scholars and aristocrats surrounding the banker and intellectual Bernardo Rucellai. One claimed that the study of letters and arts had been extinguished and that Lorenzo had been 'a man of highest wisdom and magnanimity, who accorded men of letters the honours due them', while another compared Medicean Florence under Lorenzo to fifth-century Athens under Pericles. Rucellai wrote that Lorenzo was the 'master-mind whose wise policy maintained peace within Italy and successfully defended it against foreign encroachments'.

It was the aura of the Medici name that attracted scholars and sycophants from all over Italy to Rome. Many of them became intimate friends with Raphael, whose position was also greatly enhanced by Medici largesse. As will be discussed in the next chapter, he was showered with honours and offices by the new Pope and became the favourite artist of the Medici clan. But he found that much of the work from papal commissions could easily be given to his large studio and began to accept more and more commissions from outside the Pope's immediate circle. Leo had neither Julius's powerful personality nor the same grand vision of the role of the papacy.

The portraits that Raphael executed during these last seven years of his life reveal much about the people among whom he moved. In Florence he had painted bourgeois men and women. After his move to Rome, all his known portraits are of men connected with the papal court, except the beautiful *Donna Velata* (Plate 128) mentioned by Vasari as the *Donna Amata* of Raphael.

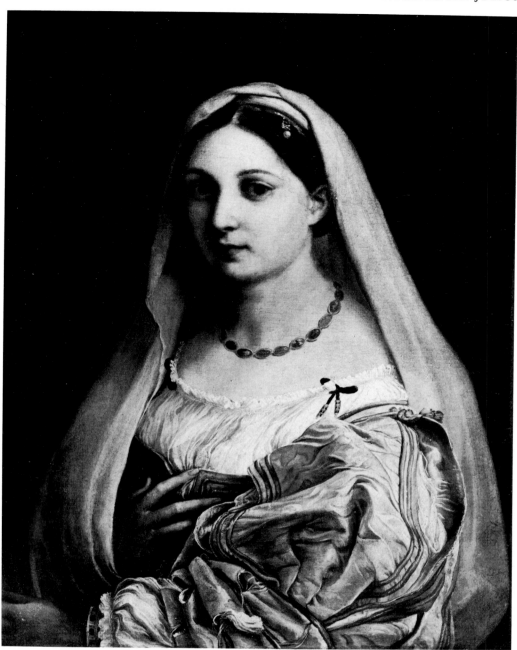

128. *La Donna Velata*. Canvas, 85 × 64 cm. Florence, Pitti. Vasari called this a portrait of Raphael's *donna amata.* Generally considered to have been executed between 1512 and 1516, it may be a portrait of Maria Bibbiena, whom Raphael intended to marry before her untimely death in 1514.

The attempt to trace the features of Raphael's legendary mistress La Fornarina in every female face that he painted distorts the recognition of his unsurpassed gift for idealizing female beauty (a subject about which he himself wrote to Castiglione). Raphael has striven to give *La Donna Velata* this perfect beauty without detriment to her individuality. Costume and veil suggest that she is a bride, an idea supported by the gesture of her right hand touching her breast to indicate fidelity.

The pose indicates that Raphael saw the *Mona Lisa* again when it was brought to Rome in 1513 by Leonardo, who was the guest of the Pope's brother. By moving the Velata's left arm forward along the bottom of the picture frame, Raphael has subtly combined the *Cardinal* (Plate 114) and the *Mona Lisa* (Plate 64). He also uses this picture to demonstrate his skill in colouring. Limiting his palette to whites and golds, he rivals Leonardo's narrow tonal range and at the same time manages to give the sleeve a liveliness and movement that is almost baroque in its swirls and shadows. The broad silhouettes of the costumes of the Swiss Guard have been transmuted into a grand conceit.

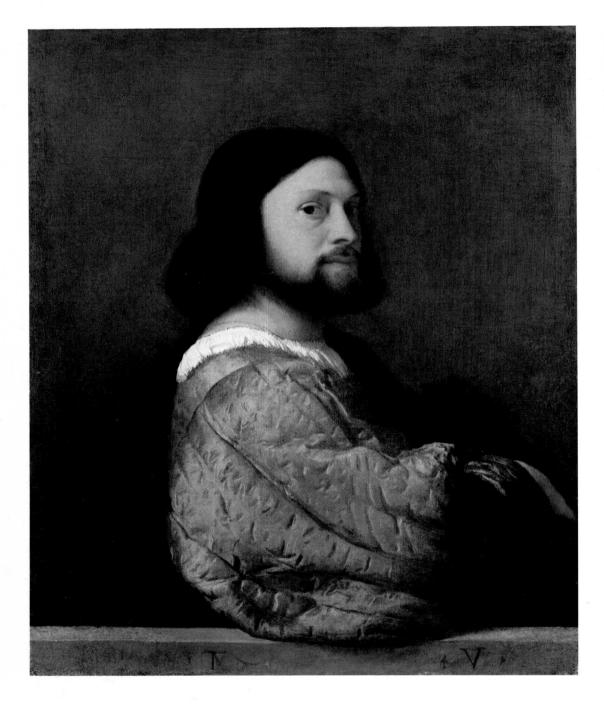

129. Titian. *Gentleman in Blue.*
Canvas, 81.2 × 66.3 cm. London,
National Gallery.
The prominence of the exquisitely
painted blue silk sleeve calls to
mind the sleeves in both *La Donna
Velata* and *Baldassare Castiglione*.

A similar display of luxurious fabric can be found in Raphael's portrait of his
friend, the diplomat and writer Baldassare Castiglione (Plate 130). Although the
velvets are much more restrained than the coquettish play of the Velata's silks, the
idea of wealth and elegance is equally well conveyed. Here the influence of the
Mona Lisa is stronger both in pose and in colour. But the symphony of greys
ranging from soft pearl to dark slate, uncovered by the recent cleaning, suggests
another source of inspiration, which is also evident in the prominent positioning
of the sleeves in both the *Castiglione* and *La Donna Velata*. Some two or three years
earlier Titian had painted the *Gentleman in Blue*, whose elegant grey-blue silk
sleeve dominates the composition (Plate 129). The cool colours are strikingly
similar to those of the *Castiglione*. Since there were many Venetians in Rome who
were constantly travelling between the two cities, it is possible that Raphael saw
this work or one similar. It may be no accident that the Titian portrait is first
documented in the same collection as the *Castiglione* in the seventeenth century.

130. *Baldassare Castiglione.*
Canvas, transferred from panel,
82 × 66 cm. Paris, Louvre.
This is one of Raphael's greatest
masterpieces. The pose of the sitter
shows his renewed acquaintance
with the *Mona Lisa* brought to
Rome by Leonardo in 1513. The
beautiful colours and subtle light
reveal that Raphael was familiar
with Venetian portraiture as well.

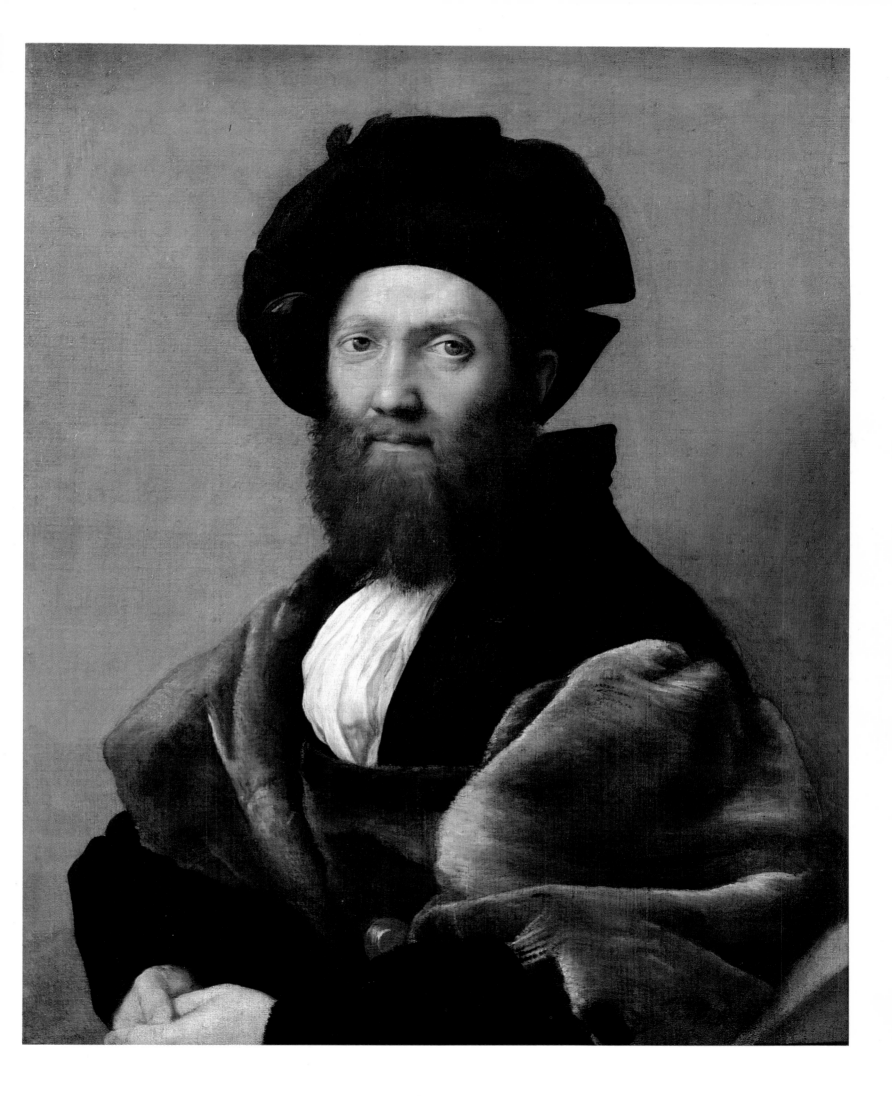

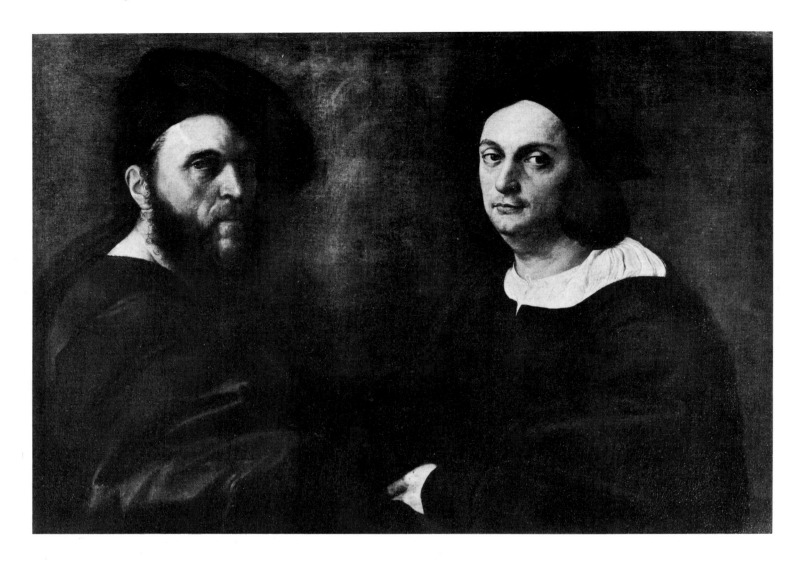

Raphael must have painted Castiglione in 1515 or 1516. Bembo speaks of the portrait in a letter of spring 1516 to Cardinal Bibbiena, commenting that in comparison with Raphael's more recent portrait of the poet Tebaldeo, that of Baldassare looks like a workshop product. A second portrait of Castiglione, about which nothing is now known, was mentioned by the Ferrarese envoy in 1519 when he informed his master that he had been unable to check on how Raphael was progressing on the Duke's commission because at the moment he called, Castiglione was with the artist sitting for his portrait.

The easy intercourse between Raphael and the intellectuals and courtiers in Rome that such letters reveal supports the description of his personality given by Vasari. Raphael was, according to him, 'endowed by nature with all modesty and goodness which can be seen in those who have a personality of gentle nature combined with a graceful affability, always showing itself sweet and pleasing under all circumstances'. Such qualities were the marks of a gentleman as defined by Castiglione. He himself was described as 'the living model of the courtier's elegance of taste and grace of manner', and his *Libro del Cortegiano* discussed what constituted a perfect gentleman. His friendship with Raphael probably dates from about 1506 when they were both in the service of Duke Guidobaldo of Urbino, and it was this period that Castiglione described so nostalgically in his book. During Leo's papacy he served in Rome as ambassador, first for Guidobaldo's successor Francesco Maria della Rovere, and, after 1516, for the Gonzaga of Mantua.

131. *Andrea Navagero and Agostino Beazzano*. Canvas, 76 × 107 cm. Rome, Galleria Doria Pamphili.
Raphael must have painted his humanist friends about the time they all went on an excursion to Tivoli in April 1516. Once again, strong Venetian influences in both light and colour can be seen.

Many of those who had been in Urbino with Castiglione and who appear in *Il Libro del Cortegiano* had moved to Rome during the Medici reign. Among the most prominent was Pietro Bembo. Born in 1470 to a Venetian patrician family, he was widely travelled and extremely sophisticated. His most famous work, *Gli Asolani*, a Neo-Platonic dialogue on the nature of love dedicated to Lucrezia Borgia, was published in 1505, shortly before he left Venice for Urbino. Here he encountered the young Raphael for the first time. His letter of 1516 quoted above mentioned that he too was considering having his portrait painted since all his friends were, but nothing seems to have come of this. After Raphael's death he sat for his portrait several times, notably for Titian.

Bembo, however, appears to have been one of the few of his circle who were not painted by Raphael. Another letter written to Bibbiena in the spring of 1516 describes an outing to Tivoli taken by himself, Castiglione, Raphael, and two other humanists, Andrea Navagero and Agostino Beazzano. Shortly after, Raphael depicted Navagero and Beazzano in a double portrait (Plate 131). Once again it is the Venetian air of the picture that is striking, particularly in the pose of Navagero. Raphael has placed his body at a right angle to the picture plane and turned his head so that the light strikes sharply on his right temple, leaving the rest of his face in shadow. These are variations on the innovations introduced by Giorgione in his so-called *Self-Portrait* of c.1510 (Plate 132). This *Self-Portrait* was first mentioned by Vasari, who recorded that it was in the Grimani palace in Venice. It may well be that the picture was already in the famous collection of the Venetian patrician and cardinal Domenico Grimani by 1516, where it could easily have been seen by Navagero, himself a patrician of the city as well as a historian and poet. But it might not have been necessary to go so far, for Grimani also maintained a palace in Tivoli. Furthermore, Grimani had sent a pupil of Giorgione's, Giovanni da Udine, to

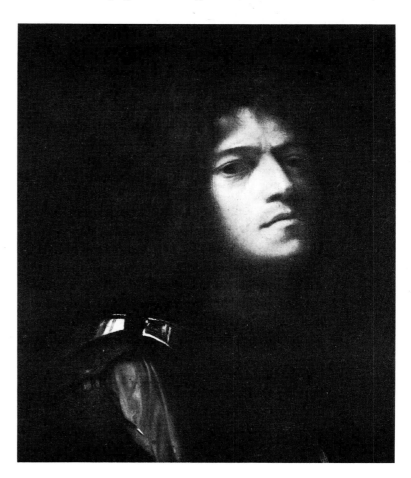

132. Giorgione. *Self-Portrait?* Canvas, 52 × 43 cm. Braunschweig, Herzog Anton Ulrich Museum. Whether this is actually a self-portrait by Giorgione is uncertain. The strong light from the left and the face painted half in shadow has much in common with Raphael's portrait of the Venetian Navagero.

133. The Loggia of Cupid and Psyche. Rome, Villa Farnesina.
This grand gallery was the entrance to the villa through which Chigi's guests arrived. Because the loggia was originally open to the air, Raphael's colourful frescoes have been much damaged. The door at the end on the right opens into the dining room.

134. *The Triumph of Galatea*. Rome, Villa Farnesina.
Representing the sea-nymph Galatea riding across the waves, this fresco was based on the same poem
that had inspired Botticelli's *Birth of Venus*. Raphael received the commission from Agostino Chigi
after the work by Sebastiano del Piombo in the same room was judged to be inadequate.

Rome the previous year with a letter of recommendation to Castiglione. Giovanni da Udine, whose father was, Vasari tells us, a 'most beloved friend' of the Cardinal, entered Raphael's shop and soon became one of its leading members.

Raphael made use of another pose first invented by Giorgione for the latter's portrait of the son of a German banker (Plate 135), c.1510. Giorgione's sitter has been placed with his back to the spectator, which forces him to turn in order to look out over his shoulder; this gives the figure a greater dynamic twist than the more conventional frontal or partially-frontal poses. It may be no coincidence that Raphael adopted this device for his portrait of a young Roman banker and collector, *Bindo Altoviti* (Plate 136). He has, however, employed the more brilliant colours he used a year earlier in the Julius portrait, such as the deep green background, which served so successfully as a foil for the silhouette. At the same time the subtle dark modelling of the face and the delicate rendering of the blond hair testify to Raphael's renewed acquaintance with Leonardo's *chiaroscuro*.

Bindo was an important member of the papal court. The Altoviti, one of the oldest and most aristocratic Florentine families, had close ties with the Roman curia. Bindo's mother was the niece of Pope Innocent VIII, and his father served as one of the numerous papal bankers. When Bindo became head of the bank at the youthful age of sixteen, he was also put in charge of the accounts for the rebuilding of St. Peter's, a job he held throughout Leo's pontificate. This portrait must have been painted about the time Leo appointed Raphael as architect of St. Peter's following Bramante's death in 1514.

135. Giorgione. *A Fugger Youth.* Panel, 70 × 54 cm. Munich, Alte Pinakothek.
Seated with his back to us, the young man is forced to turn to look at the spectator, a movement that makes his pose more dynamic.

136. *Bindo Altoviti.* Panel, 60 × 44 cm. Washington, D.C., National Gallery of Art.
Posing the young banker so that he is seen from the back, Raphael was working with ideas introduced by Giorgione. Nevertheless, the strong chiaroscuro in the face and the delicate rendering of the curls show the strong influence of Leonardo da Vinci, then present in Rome.

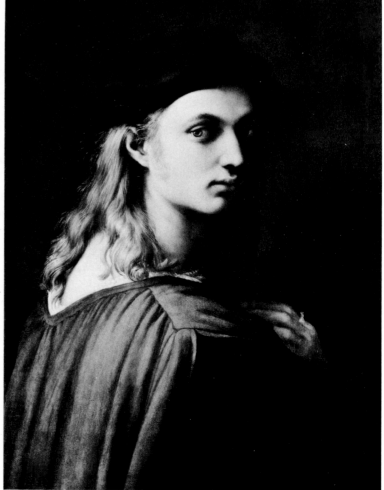

137. Cardinal Bernardo Bibbiena. Canvas, 86 × 65 cm. Florence, Pitti.

This portrait is generally held to be a copy after Raphael's lost original. Probably the most powerful man in Rome during Leo's pontificate, Bernardo Dovizi da Bibbiena had long served as secretary and confidant to the Medici. Sophisticated, witty, and highly educated, he commissioned Raphael to paint his bathroom with scenes from Ovid (Plate 188).

Bindo was a patron of the arts all his life. In addition to this portrait, he owned the *Madonna dell'Impannata* (Plate 152). He also employed Jacopo Sansovino, Salviati, and Vasari. About 1550 he commissioned a large bronze portrait bust of himself from Benvenuto Cellini, which today is in the Isabella Stewart Gardner Museum, Boston. Michelangelo gave him the cartoon of the *Drunkenness of Noah* on the Sistine Ceiling — a unique act on the part of the impetuous genius.

Two other members of the papal court painted by Raphael, Tommaso Inghirami and Bernardo Dovizi, were clerics with humanist interests. In fact, only Inghirami was truly a cleric, for Dovizi, better known as Cardinal Bibbiena, did not enter holy orders until he was rewarded for his long and faithful service by Leo X with a cardinal's hat. The portrait of Bibbiena, today in the Pitti Palace, is regarded generally as a copy after Raphael (Plate 137). Indeed, the hard and sneering glance denies the sentiment of remarks made about him by his contemporaries. Castiglione described him thus in *Il Cortegiano*: 'Your aspect is very agreeable and pleasant to all, although the features are not very delicate; it has something manly about it and yet is full of grace.' The Cardinal's wit and charm were renowned and his comedy, *La Calandria*, first performed in Urbino in 1513, introduced the figure of a girl in boy's dress into modern drama.

While Bibbiena's portrait only remains as a copy, that of Inghirami exists in two versions, both of which are judged to come from Raphael's hand (Plate 139, and Florence, Pitti). Here the inspiration derives from examples of northern portraiture as well as from the long-established convention of the scholar in his study. Inghirami is shown at his desk just at a moment when he has paused in his writing to glance up in thought. Although Raphael has not quite succeeded in capturing the spontaneity of this action, the idea of a man of learning at work is admirably conveyed.

143

138. The Cupola of the Chigi Chapel, Santa Maria del Popolo, Rome. Mosaic.
Clearly inspired by Michelangelo's creation scenes for the Sistine Ceiling, God holds up his hands in a gesture of command. The pieces of gold leaf inserted in the mosaic contribute to the effect that this is a view into highest heaven.

Inghirami must have become acquainted with Raphael soon after the painter's arrival in Rome. He was an established scholar and writer and was made Professor of Rhetoric in Rome in 1500, a Canon of the Lateran in 1503, and Prefect of the Vatican in 1508. He was close not only to Julius, serving as his secretary at the Fifth Lateran Council, but also to Leo, whom he had known since childhood in Florence.

Inghirami's erudition in Latin earned him the unusual nickname of Phaedra. One evening, while playing the lead in Seneca's tragedy at the palace of Cardinal Raffaele Riario, he was forced to improvise in Latin verse during a scenery failure. This achievement was greeted by cries of '*Viva Phaedra*', and thereafter he was always referred to by that name, even in the diaries of such a pedantic and humourless individual as Paris de Grassi.

Raphael's Roman sitters formed a homogeneous group. Sophisticated, witty, elegant, and cultured, they embodied the concept of the gentleman and scholar. Although many were in holy orders, they all openly enjoyed worldly entertainments and company. Certainly on an evening such as when Inghirami played Phaedra there would have been present some of the famous Roman courtesans who themselves often wrote verses or played music.

The behaviour of these men was in conscious imitation of antiquity. They took a deep interest in classical learning, adapted pagan philosophy to conform with Christian thought, and followed examples of ancient grammar and rhetoric in their own work. Roman drama was performed in the original language, but new works

139. *Tommaso Inghirami.* Panel, 89 × 62 cm. Boston, Isabella Stewart Gardner Museum.
Existing in two versions, this portrait derives from scenes of a scholar (for example, St. Jerome) at work in his study, so popular in northern European and Venetian art.

in both the vernacular and Latin were encouraged. Poetry contests, such as those held by the protonotary Goritz, were an example of the high intellectual level these amusements often attained. At the same time, this humanism was very different from the Florentine civic humanism of fifty to one hundred years earlier: rather than serving a city and the common good, these men sought patronage from individuals, and therefore appeared more concerned with flattery than with virtue, and were more self-serving than stoic.

In such society Raphael moved easily. He wrote poetry himself and designed stage scenery for performances of Ariosto's work. His love of and response to the glories of ancient Rome can be seen in his sketchbooks, and also in a long technical letter he wrote as Director of Roman Antiquities (discussed in Chapter 6). Raphael was certainly one of the first artists to move among intellectuals not simply as a painter and craftsman but as an equal and friend.

Of all Raphael's patrons, the Sienese banker Agostino Chigi holds the foremost place. One of the most fascinating personalities of early sixteenth-century Rome, he was immensely rich, highly educated, and well connected in the papal curia. He had skilfully secured from Alexander VI the concession for the papal alum mines at Tolfa, the only place this essential commodity was found outside the Middle East. Alum was vital to the dyeing of cloth and was not just sold to the large Italian textile towns of Florence and Venice but also exported to northern centres such as Flanders and London. During the quattrocento the alum monopoly was an important part of the Medici wealth, and the loss of the concession under Sixtus IV was a contributing factor to the ultimate collapse of the Medici bank in the 1490s. It was to prove as ephemeral for Chigi. Leo X withdrew his rights to the mines, and by 1526, only six years after Agostino's death, the Chigi fortunes were in ruins. However, the amount of money that Chigi had amassed before he lost the concession was more than sufficient to keep him in a very lavish style to the end of his life.

Chigi was not only the chief papal banker but also a close personal friend of Julius II, who even adopted him into the della Rovere family; after Julius's illness in the summer of 1512, Chigi was host at his villa to the pontiff during his recuperation. There Julius enjoyed the coolness of the famous gardens in the company of the young Federigo Gonzaga. A year earlier, Chigi had been to Venice both to pursue his own business and to negotiate on behalf of the pope. Felix Gilbert has shown, in a revealing study of Renaissance politics, that Chigi spent six months in the city from February to August 1511 working out a complex deal to persuade the Venetians to accept their former enemy the pope as an ally against the French, while at the same time himself offering the bankrupt city a loan in exchange for a guaranteed monopoly in the alum trade. It was through Venice that Turkish alum was shipped to northern Europe, and by forcing the Venetians to agree to cut the trade lines with the east and deal only with him, Chigi could corner the market with his control of the Tolfa mines.

From this trip Chigi brought back not only a monopoly, an alliance, and a mistress, but also the young painter Sebastiano del Piombo, a student of Giorgione's and an associate of Titian's. He was put to work decorating the walls of the dining loggia of the villa, but he proved inexperienced, and his inept artistic and technical execution must have displeased his exacting patron, for the lower portion with the classical story of the cyclops Polyphemus was left unfinished, and Chigi did not employ Sebastiano again. Instead, he secured the services of Raphael to execute the companion-piece of *Galatea*. It is quite possible that the well-known rivalry between the two artists stems from Raphael replacing Sebastiano as Chigi's favourite.

Chigi knew exactly what he wanted from an artist. In 1502 he had written to his father in Siena that Perugino should be commissioned to paint the altarpiece for the new family chapel because 'he is the best painter in Italy'. It was this altarpiece of the Crucifixion (Plate 3) that Raphael used as a model for his treatment of the same subject in 1503 (Plate 2).

Chigi selected the site of his new villa with the same care. Although it was located across the Tiber in an area that was outside the city proper, it was close both to the business quarter where the banks were located and to the Vatican palace. While not on the monumental scale of the greatest Roman *palazzi*, this graceful building, today known by its later name of the Villa Farnesina, was nevertheless quite splendid, with two loggie and about forty rooms. It immediately became the meeting-place of cardinals, scholars, aristocrats and courtesans who gathered for lavish entertainments and legendary banquets. Over their heads in the dining-loggia they would see the astrological ceiling fresco by Peruzzi, in the centre of which Fame blows her horn in the direction of the Chigi arms. Surrounding her are mythological figures representing the planets and depictions of the signs of the zodiac. Fritz Saxl has shown with great ingenuity that these are arranged to represent Chigi's horoscope, the sky over Siena around the date of his birth, 28 November 1466. Such jokes were intended as an erudite amusement for Chigi's sophisticated audience.

The ostentation of these feasts was intended to impress Chigi's guests with his wealth, generosity and social position. He even had Raphael design the new stables (now destroyed) for his show-place. Built between 1514 and 1518, they were the site of a great fête upon completion. The walls were hung with tapestries woven with golden threads, and Flemish silk carpets decorated the floor. Exotic delicacies such as fresh eels and sturgeon were served to the pope, fourteen cardinals and the foreign ambassadors in Rome. Presumably the ubiquitous courtesans were also present. But perhaps the most notorious of all these occasions was the party at which the banker invited the guests to cast their gold and silver plates into the Tiber. Unbeknown to them he had suspended nets in the river so that the precious vessels could be promptly retrieved. But such displays should not overshadow the fact that these evenings were gatherings of Rome's religious and secular intelligentsia. Music, plays, and poetry recitations in Latin and Italian were all performed in the splendid setting that Raphael's frescoes of stories from antiquity magnificently complement.

The first of these wall paintings was a continuation of the fresco begun by Sebastiano del Piombo. Galatea was a beautiful sea nymph with whom the cyclops Polyphemus fell in love. Raphael shows her being borne over the waves on a paddle-wheeled shell drawn by dolphins and surrounded by Tritons, Nereids, and other sea creatures indulging in mildly erotic sport (Plate 134). Above flutter *amorini* taking aim at the nymph with their arrows of love. The tale, though classical in origin, was in this instance drawn from a famous poem by the Florentine fifteenth-century poet Poliziano, which had also served as the source for Botticelli's *Birth of Venus*. The *Galatea* has been celebrated through the centuries as one of Raphael's most beautiful creations. Vasari spoke of the 'sweet style' and J.D. Passavant characterized her as 'filled with divine desire and abandoning herself to the guidance of the god of true love'.

Unfortunately, nothing is known about the other wall decorations planned for this dining-loggia. Christof Thoenes has linked the lack of a coherent theme with Chigi's thwarted attempt to contract a marriage with the Gonzaga family, for in 1511, when work in the room was started, he had begun negotiations to marry Margarita, the illegitimate daughter of the Duke of Mantua and half-sister of

Federigo Gonzaga. Thoenes proposed that for this room Chigi had planned, as a compliment to his intended bride, a series of stories portraying the loves of the gods, as described by Poliziano in his account of the palace of Venus. When the Duke's daughter absolutely refused to marry a mere banker, Chigi gave up his artistic celebration of *amore*. (Chigi continued to live with his mistress whom he had brought back from Venice in 1511 and who bore him four children. He finally married her in 1519, eight months before his death.)

Raphael referred to the fresco of Galatea in a famous letter of 1514 addressed to Castiglione. To portray a beautiful woman, he wrote, 'I use a certain idea which comes into my mind. Whether this is good art, I can't say.' This is, of course, the

140. *The Council of the Gods.* Rome, Villa Farnesina. The two central scenes of the Loggia (Plates 140 and 141) were painted as simulated tapestries and represent the happy end of the myth when Psyche is permitted to enter the assembly of the gods and marry Cupid. Raphael used many figures from antique sources as well as from his own works, but left the execution largely in the hands of his workshop.

141. *The Wedding of Cupid and Psyche.* Rome, Villa Farnesina.

simple expression of a Platonic concept, and it should be realized from this ingenuous statement that neither the *Galatea* (detail, Frontispiece) nor the *Sistine Madonna* could be portraits of Raphael's or Chigi's mistresses. Raphael's idea of perfect beauty shaped the features of every young female he ever painted whether the subject was mythological, religious, or real such as the Donna Velata. The same type is portrayed again and again not because it represented a particular beautiful woman but precisely because it is a vision of perfection.

Raphael also designed a fresco cycle of the story of Cupid and Psyche in the open garden loggia, which was the entrance to Chigi's villa (Plate 133). These lavish decorations cover the entire ceiling and most were executed by the workshop during 1518 in accordance with Raphael's drawings. The scheme appears to be incomplete, for only those parts of the story that take place in heaven are depicted, and some of the figures point down towards scenes that are not there. Furthermore, incidents central to the story, such as Psyche's discovery of her lover, are missing. These terrestrial episodes were probably planned for the lunettes.

The primary source for the version of the story used here was Apuleius. In the centre of the ceiling are painted two large simulated tapestries. The first shows the Council of the Gods (Plate 140), which considered whether to admit the mortal Psyche to Olympus. The second concludes the tale with the Wedding Feast of Cupid and Psyche (Plate 141). Around these run twenty-four episodes of the story framed by lush garlands. Replete with references to visual and literary classical sources, these vignettes would have amused the scholars of the Renaissance as much as they have art historians of the present day.

The well-endowed nudes (Plate 142) and rich colouring together give a gaudy effect that would have been in perfect keeping with Chigi's somewhat vulgar love of display. Because the loggia was originally open-air, the frescoes have suffered much damage, first from the elements and subsequently from restorers in the ensuing centuries. Nevertheless, it is clear that Raphael's interests were elsewhere. Designs from other works are frequently reused and the lack-lustre character of much of the execution bespeaks mainly studio participation. A contemporary judgment by Leonardo Sellaio, however, should be taken in context. In January 1519 he wrote to Michelangelo that it was 'a vile thing for such a grand master'. But both Michelangelo and his friend Sellaio hated Raphael, and Sellaio never lost an opportunity to denigrate Raphael when writing to Michelangelo in Florence.

Raphael's greatest works for Chigi were the decorations for the two chapels purchased by the banker in Santa Maria del Popolo and Santa Maria della Pace; both churches belonged to a branch of the Augustinians in Rome. Why Chigi should have desired two chapels is not known, but it is clear from documents that the one in Santa Maria del Popolo was designated from the beginning as his funerary chapel. Agostino continued the tradition of his family by his patronage of the Augustinian churches. He came originally from the parish of Sant'Agostino in Siena, had been named after the family's patron saint, and his family was buried in the local church. Perhaps the cagey banker felt it good policy to patronize both the Canons Regular of Santa Maria della Pace and the *Eremitani* of Santa Maria del Popolo.

Chigi acquired his funerary chapel in Santa Maria del Popolo in 1507, and rededicated it to 'the Blessed Virgin and her Church at Loreto', to St. Sebastian, and to Agostino's patron saint, St. Augustine. The rebuilding and decoration of the chapel does not seem to have begun before 1512-13, when Raphael was retained to design the chapel completely, from the architecture to the pictorial and sculptural decorations.

Chigi spared no expense to obtain a chapel that would testify after his death to the greatness of his wealth even as his villa did during his life (Plates 191,192).

Following Raphael's drawings the cupola was decorated in the expensive medium of mosaic, and bits of gold leaf were inserted to give a shimmering effect to the light and enhance the splendour of the whole. Smaller pictures were planned for the drum and pendentives, and in each pier a niche was built to house a large sculpture. Naturally, an altarpiece was also to be included. Chigi's tomb itself was a large white marble pyramid to the side of the chapel.

The death of both Raphael and Chigi within a week of each other in April 1520 put a halt to such grand designs. Although Chigi had tried to ensure that the chapel would be finished according to his intentions and Raphael's plans, the chapel was

142. *Cupid and the Three Graces.* Rome, Villa Farnesina.
Because several important incidents have been omitted and there are instances such as here when figures point and look downward, it has been suggested that additional scenes were planned for the lunettes, today filled with simulated window frames.

143. Lorenzetto, after a design by Raphael. *Christ and the Woman of Samaria.* Bronze relief. Rome, Santa Maria del Popolo, Chigi Chapel.
To the left the woman can be seen leading the people to Christ, who is seated on the well and admonishes the Apostles.

144. Lorenzetto, after a design by Raphael. *Jonah.* Marble. Rome, Santa Maria del Popolo, Chigi Chapel.
This singularly unimpressive work is one of the two sculptures Raphael designed for the Chigi Chapel.

not completed until the seventeenth century. As executor of Chigi's estate, the papal notary Filippo Sergardi attempted to follow exactly the banker's desires for both this chapel and that in Santa Maria della Pace, yet it is somewhat ironic that the altarpiece of the *Nativity of the Virgin*, which he finally managed to place in Chigi's burial chapel, was by Sebastiano del Piombo, whom Chigi had brought from Venice but subsequently rejected.

Rather than speculate about plans that were not executed, we shall confine our discussion to what was actually carried out after Raphael's designs. This includes the sculptures of *Jonah* and *Elijah*, a bronze relief for the foot of Chigi's tomb (today on the altar), and the spectacular cupola decorations. The architecture will be discussed in Chapter 6.

The two sculptures and the relief were executed by Lorenzetto after drawings by Raphael. The relief, representing Christ and the Woman of Samaria (Plate 143), shows the woman bringing the people to Christ rather than the more traditional moment when Christ and the woman first meet at the well. The suggestion that the subject is in fact the Woman Taken in Adultery is quite impossible: not only would it have been an insult to Chigi's widow and children, but the story has no place in a funerary context. The confidence with which the woman leads the crowd as well as the inclusion of other females within that group leaves no doubt that the story of the Samarian woman was the subject intended. Furthermore, this scene is particularly appropriate for a tomb chapel, for Christ has just promised salvation to all who drink from the well of living waters.

The two prophets represented by the statues continue this theme. Jonah (Plate 144) traditionally foreshadows Christ's death and Resurrection, and Elijah refers to the Ascension. Neither work is particularly inspired. In spite of his extraordinary sense of design, Raphael seems to have been unable to conceive of a figure in the round successfully. Lorenzetto's indifferent abilities did not improve upon the drawings.

Quite different is the exquisite mosaic in the cupola (Plate 138). Carried out by a Venetian craftsman, it is dated 1516 under the representation of the planet Jupiter. The scheme represents the cosmos. In the central oculus is God, and the way his arms are outstretched is similar to his gesture in Michelangelo's creation scenes in the Sistine Chapel (Plate 145). Encircling the oculus are eight sections, in seven of which are the pagan deities who personify the seven planets. Thus, Diana represents the moon, Apollo the sun, and Mercury, Venus, Mars, Jupiter, and Saturn the planets that bear their names. On an arc running through each section are the signs of the zodiac that the individual planet controls. In every section an angel is placed

above this group. The eighth section contains only a field of stars with an angel hovering over it.

This original depiction of the universe had no precedent in art, and it has been explained as an illustration of Dante's *Paradiso* or of a Neo-Platonic heaven. Rather, it depicts traditional Christian ideas. During the Middle Ages and the Renaissance the view was commonly held that the earth, as the centre of the universe, was surrounded by eight concentric spheres, each of which contained one of the seven planets and the appropriate signs of the zodiac. The outermost held the fixed stars, and beyond that was the Primum Mobile, or God. The movement of each heavenly sphere was directed by an angel guided by the will of God. In fact, the expression 'love makes the world go round' originated from this concept, for it was through the love that the angels bore God that the Divine Will for the movement of the universe was carried out.

Chigi's chapel was in the church of the Augustinian *Eremitani,* whose head was Giles of Viterbo. Celebrated for his oratory and esoteric learning, Giles also played an important role in the efforts at church reform in the sixteenth century. He felt that a beautifully decorated church was an encouragement to worship and he would have been very pleased that such a magnificent chapel was being added to the many works already glorifying Santa Maria del Popolo. But whatever counsel Giles may have contributed towards the programme, it is certain that Chigi had the final say.

There is no documentary evidence as to when Chigi acquired the rights to his second chapel, that in Santa Maria della Pace. This church, today sadly neglected and normally locked, had been built by Sixtus IV in 1482 to celebrate a peace treaty

145. *God, and the Planets,* Rome, Santa Maria del Popolo, the cupola of the Chigi Chapel.
Divided into eight pictorial fields around a central oculus, the cupola contains a representation of the universe. In the centre God commands the movements of the planets while around him the angels carry out his will. Each of the eight illustrative fields surrounding God show a planet being animated by an angel. Directly below God and positioned above the altar is the Planet Jupiter, which rules Chigi's birth sign, Sagittarius. See also Plate 138.

146. *Study for 'The Resurrection'.* Pen and red chalk, 40.6 × 27.5 cm. Bayonne, Musée Bonnat. This drawing indicates that the altarpiece planned for the Chigi Chapel in Santa Maria della Pace would have been truly awe-inspiring. The postures of the recoiling guards recall those in the *Liberation of St. Peter* in the Stanza d'Eliodoro.

with Milan. The building of the cloister was the first commission received by Bramante when he arrived in Rome at the end of the 1490s.

This chapel, like that in Santa Maria del Popolo, was unfinished at Chigi's death and underwent considerable alterations when it was completed in the seventeenth century. At that time it was believed that the altar had been dedicated to the Virgin and the decoration was completed accordingly. Michael Hirst, however, has shown that the original subject of devotion was the Resurrection. There are several drawings for the projected altarpiece of this subject by Raphael (Plate 146). The sketch for the whole design includes for the first time the dramatically soaring Christ that Raphael later adapted for the *Transfiguration*. Whether he intended to follow the innovative night scene which he had introduced in the fresco of the

Liberation of St. Peter cannot be determined, but the figures of the recoiling guards are similar to the various poses already employed in the Stanza d'Eliodoro.

The *Prophets* and *Sibyls* (Plates 147,148) on the outer wall of the chapel were executed about 1513-14 and thus also belong to the original dedication. In the upper register, on either side of a window, David and Hosea carry texts from the Old Testament, Hosea's predicting that the Resurrection would occur after three days. Accompanying them are Daniel and Jonah whose rescues from the lion's den and

147. *Prophets.* Rome, Santa Maria della Pace, Chigi Chapel.
The architecture of this chapel presented Raphael with a difficult challenge. In the upper zone he painted an architectural background that complemented the window frame.

148. *Sibyls.* Rome, Santa Maria della Pace, Chigi Chapel.
In the lower register Raphael had to deal with an even more awkward space. By making his figures recline against the arch of the lunette, he incorporated the architecture into the fresco and provided a solution that was widely imitated.

149. *Christ in Limbo.* Pen, 20.9 × 20.5 cm. Florence, Uffizi. This is the design for one of the two bronze tondi intended for the entrance to the Chigi Chapel in Santa Maria della Pace. Although the reliefs were executed by Lorenzetto, they were never placed *in situ.*

the whale, respectively, were interpreted by Christian exegesis as foreshadowing Christ's Resurrection. Below, around the lunette, are unidentified Sibyls holding Greek inscriptions. These writings come from Lactantius and refer not only to the Resurrection but also to the Last Judgment. Again this is consistent with the imagery. The *Dies Irae* in the Requiem Mass proclaims that the Judgment will come 'as foretold by David and the Sibyl'.

As very rightly pointed out by Vasari, these monumental figures were done in 'Raphael's new style, which was more magnificent and grand than the first', and that they resulted from his having seen Michelangelo's frescoes on the Sistine Ceiling. All this is indisputable but, characteristically, Raphael has taken over ideas and improved them. Michelangelo had painted blocks in each lunette of which his figures are seated. In contrast, Raphael allows his figures to lean on the curved frame of the lunette, so that the architecture is incorporated more completely into the composition. The experience Raphael had gained in the Stanze of painting with architectural obstructions has enabled him to master the difficult picture field with apparant ease. He paints with the architecture, not around it. Even the narrow space between the top of the arch and the entablature has been integrated into the composition. Where Michelangelo placed rectangular tablets, which are not in keeping with the curved forms, Raphael has seated angels whose legs are draped along the curve. On the keystone of the arch he has placed a cherub carrying the burning torch of Charity, the greatest of all virtues. The design of the figures was subsequently imitated by Sebastiano del Piombo in San Pietro in Montorio.

Beneath the Sibyls Raphael planned to place two bronze tondi representing Christ in Limbo on one side of the niche, and the Incredulity of Thomas on the other. Drawings for these exist (Plate 149), and the roundels were cast but never placed *in situ.* These subjects continue the theme of the chapel, for both events occurred after Christ's death.

It is tragic that the premature death of both artist and patron should have prevented the completion of such beautiful conceptions as these two chapels, and what is most odd is that although Chigi gave many commissions to Raphael, he never asked him to paint his portrait. (The only record of the features of this extraordinary showman is a medal struck in the first decade of the sixteenth century, which shows that he sported a beard.) But such an omission does not lower Chigi's place in the history of art as Raphael's greatest lay patron. His tapestries, silks, jewels, plate, and the bank itself have vanished. All that remains of his former spendour are his villa and his chapels.

Raphael's patrons were not only in Rome, however. He received several commissions for large altarpieces from private patrons as far away as Palermo and Bologna. The first of these commissions seems to have been for *The Madonna of the Fish* (Plate 151) of *c.* 1513-14. The painting is first mentioned as being in the del Duce chapel of San Domenico in Naples in 1524, but nothing is known about the commission. San Domenico was the church of the Neapolitan aristocracy during the Renaissance and housed many works of art and relics, among them the extensive tombs of the Carafa family and the Miraculous Crucifix, which spoke to St. Thomas Aquinas when he was living in Naples.

A lovely drawing for this work (Plate 150) shows that Raphael was using members of his workshop to pose for composition and figure studies. The picture

150. *Study for 'The Madonna of the Fish'.* Red chalk, with traces of black chalk and white highlights, 26.8 × 26.4 cm. Florence, Uffizi. This drawing demonstrates Raphael's working method. Once again he has posed members of his studio in order to work out the composition. The angle of the throne to the picture plane has been reduced in the painting.

151. *The Madonna of the Fish.* Canvas, transferred from panel, 215 × 158 cm. Madrid, Prado. The fish is the traditional attribute of Tobias who is here being presented to the Virgin and Child by the archangel Raphael. To the right is St. Jerome with his lion.

retains a traditional *sacra conversazione* format indicating either conservative taste on the part of the patron or expediency on the part of the artist.

The fish in the title of the work refers to that held by the young Tobias, who is being presented to the Virgin and Child by the Angel Raphael. Although the subject of Tobias and the Angel may refer to healing, it was also closely connected with travelling safely. Until more is known about the donor it is not possible to say why this pair was included; the church of San Domenico was not attached to a hospital; however, Naples was an important Mediterranean port.

Another altarpiece destined for southern Italy was the *Meeting of Christ and Mary on the Road to Calvary,* better known as *'Lo Spasimo'* (Plate 155). This powerful work, completed around 1516, was commissioned by an extremely wealthy Palermo lawyer, Giacomo Basilico, for a new church dedicated to Santa Maria dello Spasimo (that is, the fainting of the Virgin), which he was building in Palermo. Popular belief maintained that Mary, upon seeing Christ on the road to Calvary, fainted from grief. Because there was no feast in the church calendar dedicated to this apocryphal event, Basilico had petitioned for special permission to erect a church with such a dedication.

Even after the granting of this request by papal authorities, Basilico's difficulties were not over. Vasari tells us that the ship that carried Raphael's painting sank in a terrible storm, but the case containing the panal was washed up on the shore near Genoa undamaged. Only after the intervention of the Pope himself were the Genoese persuaded to part with their salvaged treasure. It was installed at last in Palermo, where it became, to quote Vasari, 'more famous than the mountain of Vulcan itself', that is, Mt. Aetna.

The powerful figures and heightened emotional treatment here make a telling contrast to the serene image of the *Madonna of the Fish.* Raphael was familar with German prints of *Christ on the Road to Calvary,* a subject much more popular in northern Europe than in Italy (Plate 154). With his usual resourcefulness he has adapted the subject to match the title of the church. In the northern examples Christ is led along by his tormentors while Mary, St. John the Evangelist, and the women of Jerusalem follow behind. In this painting, however, Raphael portrays the moment of meeting. On her knees, Mary reaches forward in mute grief to her Son who, fallen under the weight of the Cross, turns back to look at her. A strong light rakes across these figures in the foreground, focusing further attention on this dramatic scene. It seems as if Raphael has recalled the suffering he conveyed in the *Entombment* some nine years earlier. Even some of the motifs from the earlier work have been reused, most strikingly the kneeling woman with elegantly braided hair to the extreme right. Her gesture of delicately lifting the Virgin's veil had first been tried out in one of Raphael's studies for the *Entombment.*

There has been much debate about how much of this altarpiece Raphael painted himself. Certain figures, such as the ineptly painted soldier with a shield in the centre, are clearly by the workshop. Still, the massive forms and the daring diagonal thrusts of the Cross and Simon of Cyrene's arm are all of such mastery that there can be little doubt here of Raphael's hand. The story of the conflict over ownership after the shipwreck testifies to the high esteem in which the master's contemporaries held this work.

A painting in which studio participation clearly dominates is *The Madonna dell'Impannata* of c.1514 (Plate 153). A preliminary drawing (Plate 152) shows that Raphael worked out the original design, but the slickness of the Virgin's features and the saccharine quality of the young St. John lack the subtlety of the master's touch. Vasari praised the picture highly, but that may have been because of its recent purchase by his patron, Duke Cosimo de'Medici, from Bindo Altoviti.

Raphael's role in *The Santa Cecilia Altarpiece* of about a year later has never been questioned (Plate 157). This magnificent work was commissioned by Elena Duglioli d'Olio after she had a vision while praying before a reliquary in San Giovanni in Monte Oliveto in Bologna. This reliquary, incidentally, had been a gift during his governorship from Cardinal Alidosi, whose titular church had been Santa Cecilia in Rome. Elena Duglioli d'Olio, later beatified, contacted a relative, Bishop Antonio Pucci, who in turn got in touch with his uncle, Cardinal Lorenzo Pucci, a close friend of Leo X. It was in this way that Raphael's services were procured.

Raphael has stressed the visionary source of the commission. St. Cecilia turns her eyes upwards to the heavenly choir in the clouds. On the left are St. Paul and St. John the Evangelist, on the right St. Augustine and St. Mary Magdalene, all of whom are closely associated with heavenly visions. At their feet, battered and broken, lie assorted musical instruments. Even the pipes of the organ are beginning to slip. As pointed out by W. Gurlitt, this is an allegory of the Christian concept of music demonstrating 'the inferiority of all music perceived by the senses to what is absolute music in its religious sense, that is, the *Musica coelestis* . . . which can be played only by angels and can be heard only by saints'.

Cecilia's association with music and particularly with the organ came from a misunderstanding in her liturgy. Because of an elision made during the Middle Ages, the antiphon sung at Lauds and Vespers on her feast day implied that she had been playing the organ while praying to God to preserve her virginity when

152. *Study for 'The Madonna dell'Impannata'.* Silverpoint, 21 × 14.5 cm. Windsor, Royal Library.
Although the strong white highlights were added later, this drawing by Raphael shows that he was responsible for the composition of this picture.

153. *The Madonna dell'Impannata.* Panel, 158 × 125 cm. Florence, Pitti.
A radiograph examination has determined that originally St. Joseph was also included in this picture. Although designed by Raphael, workshop execution has given the picture a rather slick and sentimental quality.

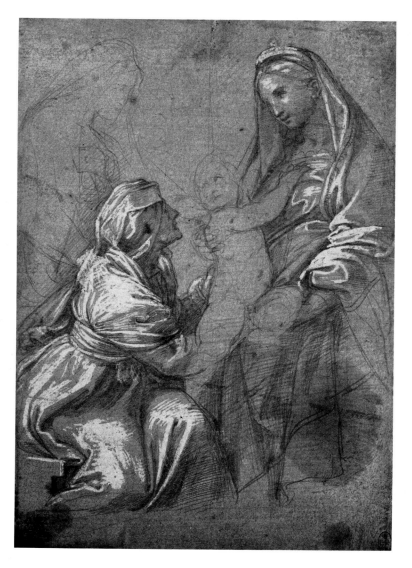

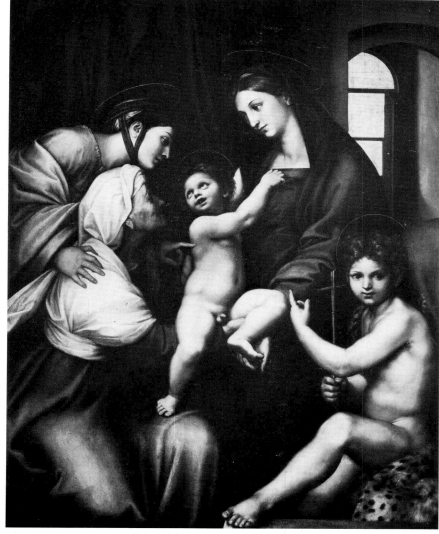

154. Dürer. *Christ Carrying the Cross* from *'The Large Passion'*. Woodcut, 38.4 × 28.3 cm. London, British Museum.
Although in this scene it is Veronica who kneels beside the fallen Christ, Raphael was obviously deeply influenced by this composition when he planned *'Lo Spasimo.'*

she was forced to marry. The representation of Cecilia with an organ became very popular in northern art during the quattrocento, but only gradually appeared in Italy. Raphael's image did much to foster this iconography.

The exquisite still life of instruments in the foreground was painted by Giovanni da Udine, who had recently arrived from Venice and joined Raphael's workshop. One of the most talented members of a largely uninspired group, he specialized in vegetative border decorations, grotesques, animals, and plants. Among his other works for Raphael were the garlands and birds in the *Cupid and Psyche* frescoes in the Villa Farnesina and large portions of the Vatican Loggie.

Also dating from this period is one of Raphael's finest and most famous pictures, *The Madonna della Sedia* (Plate 158). During the nineteenth century this work surpassed even the *Sistine Madonna* in popularity and still today is seen reproduced on tourist trinkets throughout Florence. It has inspired numerous myths, the most

155. *The Meeting of Christ and Mary on the Road to Calvary ('Lo Spasimo').* Canvas, transferred from panel, 318 × 229 cm. Madrid, Prado.
The alternative title for this work refers to the popular legend that Mary fainted when she saw Christ carrying the cross. Because this was not canonical Raphael showed her having fallen to her knees.

famous of which is that Raphael was so overcome by the beauty of a peasant girl with her children that he immediately drew them on the bottom of a wine barrel. In a more romantic vein are those who see in the Madonna's face Raphael's fabulous mistress. Alas, none of these tales is true. Nothing is known about this painting until the late sixteenth century when it appeared in the Medici collection. Vasari does not mention it.

Sir Ernst Gombrich in a brilliant and sensitive lecture on this work called it a 'self-sufficient masterpiece' and argued that it was precisely this quality that contributed to the creation of these myths. It is so difficult to describe the perfection of the picture that tourists demand, and guides supply, anecdotes as the means of approaching the picture. Thus, at the beginning of the nineteenth century, the Queen of Heaven with her Son, the Saviour, and His cousin the Baptist, were transformed into a family of peasants.

There is no need here to indulge in a formal analysis of curves and spirals. Instead, let us quote Jacob Burckhardt's famous evaluation of this work:

'It so clearly embodies what may be called the whole philosophy of the roundel as such, that nobody who comes to it with a fresh eye will fail to appreciate what this most difficult of all formats, and indeed what formats altogether, mean for the art of painting . . . Let the eye travel from the centre, the child's elbow, and follow the light as it spreads through the picture, the charm in the relation between draped and undraped parts, the unrestrained flow of lines, the right effect of the one vertical, the carved post of the chair. It is true that we may find a reference to these things somewhat irksome and pedantic besides the wonderful soul of the painting; but this soul unites with those apparently superficial excellences into one indissoluble whole.'

Raphael has finally achieved the perfection of balance and form in relation to format that he constantly sought. He never painted a tondo again.

It should be mentioned that the features that conveyed to the nineteenth century a romantic notion of peasant life are precisely what indicates the nobility of the person of the Virgin. The richly woven silk shawl was an item of great expense and elegance in the Renaissance, and the chair, with the backrest so prominently placed in the foreground, was a privilege for only those of the highest rank, as already discussed in reference to the portrait of Julius II. That the Virgin is seated in a chair with a back woven from golden threads testifies to her position as a queen.

Only brief mention can be made here of Raphael's involvement with one of the newer art forms of his day: engraving. According to Vasari, he first became interested when he learned that a Bolognese artist, Marcantonio Raimondi, was selling unauthorized engravings after his drawings. (This would be entirely in keeping with Marcantonio's character, for a few years earlier in Venice he had pirated some of Dürer's designs, even including the distinctive monogram.) However, they seem to have reached a satisfactory working arrangement, with Raphael providing material for Marcantonio to engrave, although he was careful to install one of his own *garzoni* to work alongside the Bolognese. The manufacture of prints after Raphael's designs rapidly grew as an industry, and other artists were quick to take part.

Raphael drew one of the most beautiful of all his drawings, *The Massacre of the Innocents* (Plate 156), precisely for this purpose. With his usual sensitivity to medium, he was careful to create large forms with clear individual strokes for the modelling. The engraver could then conform easily to Raphael's ideas.

Even more important, however, is the development of the scheme of producing engravings of paintings for dissemination to a wider audience. This development

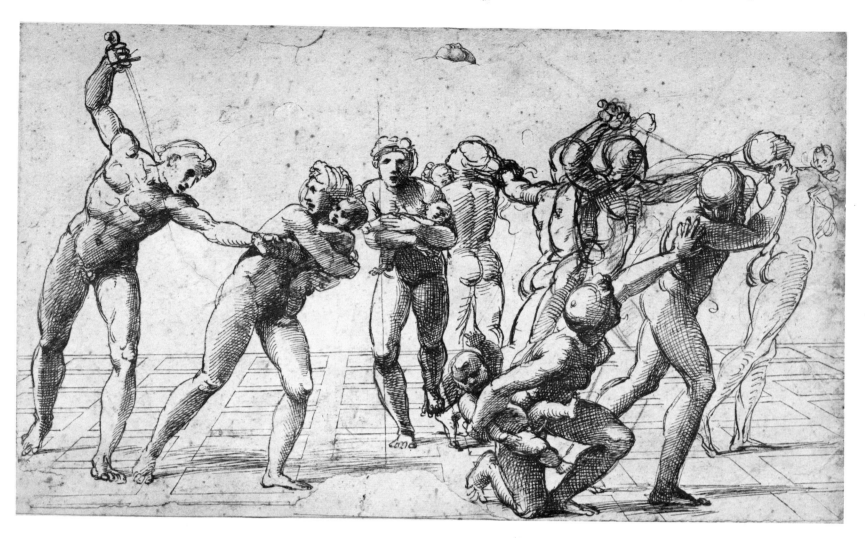

156. *Drawing for the central group for the engraving of 'The Massacre of the Innocents'.* Pen over red chalk, 23.3 × 37 cm. London, British Museum.
It is clear from this design that Raphael understood the requirements of designing for prints. The shading is done in clearly articulated strokes such as would be used on the plate by the engraver.

has never been properly examined, but it appears that Raphael was one of the first Italian artists to have his larger altarpieces specially copied. Earlier engravings freely adapting paintings existed already in the quattrocento, but there is no evidence that the painters themselves were involved. Certainly, however, it was Raphael who authorized the engraving of 'Lo Spasimo' dated 1517 (Plate 159) as well as of two of his other large altarpieces commissioned for places far distant from Rome. The *Madonna of the Fish,* with its straightforward layout, was copied almost exactly, but the *Santa Cecilia Altarpiece* underwent significant changes in the poses of the figures and the still life of instruments, possibly because the engraver found the painting too complex to translate successfully into a print and therefore simplified the format (Plate 160). The same reason probably accounts for the changes in the print after 'Lo Spasimo' where, for instance, the lances of the soldiers have been eliminated.

Raphael was among the first painters to grasp the potential of this new process as well as the importance of being involved with it himself. It was now possible for less wealthy people to afford to buy a product that came directly from the Raphael workshop. Paintings that were commissioned by patrons outside his immediate audience in Rome could still be seen in reproduction there, and he could experiment with formal problems taking into consideration the restrictions imposed by the new technique. Above all, his ideas and innovations would be available to a far wider following of fellow artists. The rapid growth in the dissemination of prints is one of the most important developments in sixteenth-century art.

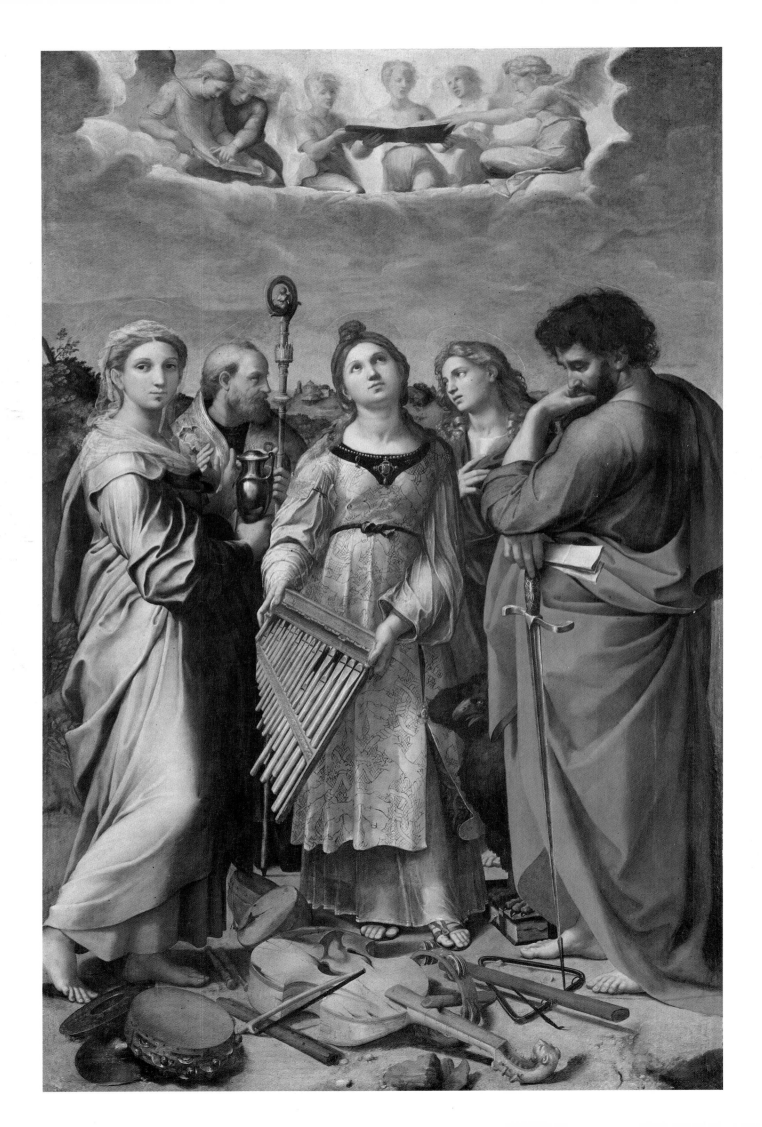

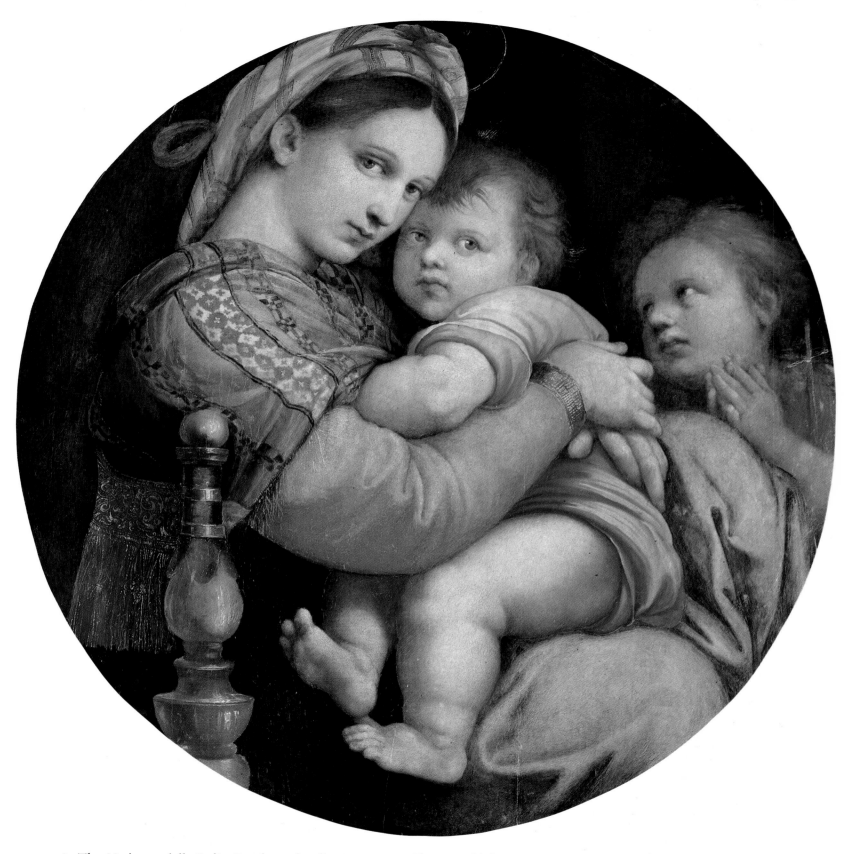

158. *The Madonna della Sedia.* Panel, tondo, diameter 71 cm. Florence, Pitti.
The incredibly subtle composition answers perfectly the challenges offered by the circular format while at the same time appearing completely natural. Having achieved this, Raphael never worked with the roundel again.

157. *The Santa Cecilia Altarpiece.* Canvas, transferred from panel, 238 × 150 cm. Bologna, Pinacoteca Nazionale.
One of the most serene of Raphael's works, this altarpiece popularized the association of St. Cecilia with music, specifically with the organ. The still life of instruments in the foreground was painted by Giovanni da Udine, who had arrived in Rome in 1515.

159. Agostino Veneziano.
Engraving after 'Lo Spasimo.'
42.1 × 27.9 cm. London, British
Museum.
The lances of the soldier and the
haloes of Christ, his mother, and
the other saints have been
eliminated for the sake of clarity in
this engraving. The date of 1517
provides a *terminus ante quem* for
the painting.

160. Marcantonio Raimondi.
*Engraving after 'The Santa Cecilia
Altarpiece'.* 26 × 15.5 cm.
Again several changes have been
made to simplify the composition.
The poses of both the angels and
the saints have been altered and
most of the musical instruments
removed. There is no longer any
background or an attempt to create
space.

We have seen that, after Julius's death, Raphael's circle of patrons grew much
wider. He did not try to confine his clientele to the curia or even to Rome. His
interest in studying and producing art required outlets other than large papal
commissions or vast fresco cycles. With his personal friends he was able to explore
the art of portraiture and the subtle effects possible with oil colours. The seemingly
unlimited wealth of Chigi gave him the chance to work with media other than paint.
The new art of engraving provided a unique opportunity to experiment and portray
subjects for which larger commissions were not available. But in spite of all this
activity, the Pope remained his principal patron, and it was because of the
commissions and offices awarded him by Leo X that Raphael could pursue his
broader interests. Under Julius he had been the court painter; under Leo he became
a courtier who, while following other pursuits, also painted.

5 Raphael and Leo X

Giovanni de'Medici, second son of Lorenzo the Magnificent, became a cardinal at the age of thirteen in 1489, a position determined for him at birth by his father. Already at the age of eight he had held numerous lucrative benefices, and Lorenzo managed, through clever and constant manipulation, to obtain from Innocent VIII his promotion to the Roman curia in the face of strong opposition from the cardinals to the appointment of so young a boy to such a high ecclesiastical office. Il Magnifico's real motive is clear from a letter he wrote to his son. Having a cardinal in the family was 'the greatest achievement of our house', but while serving the Church Giovanni was not to forget that 'it will not be difficult for you to aid the city and our house'.

Giovanni never forgot this admonition. Having succeeded to the papacy in March 1513, his main energies were from then on directed towards establishing the Medici as a major political force in Europe. When Julius restored the family to power in Florence in 1512, they were no longer only one of several leading families governing the city. As Pope Leo X, Giovanni immediately installed his younger brother Giuliano as governor of Florence and his cousin, Cardinal Giulio, as its archbishop, thereby ensuring that the Medici would retain close control of Florentine politics.

Leo's ambitions for his family were not limited to Tuscany. He first conceived designs on the Kingdom of Naples, which were quickly thwarted by the French. When his brother Giuliano refused to drive out Francesco Maria della Rovere who, as Duke of Urbino, had offered the exiled Medici hospitality at his court, Leo turned to his nephew Lorenzo. This ambitious young man was happy not only to usurp the dukedom but also to replace Francesco Maria as Commander of the papal troops. Both Giuliano and Lorenzo were married off to members of the French royal family in the hope of gaining both an alliance with the king and a coronet to be added to the Medici arms. Through nefarious deals Francis I and Leo managed to carve up much of Italy into proposed French and Medici areas of jurisdiction while on paper appearing to protect the rights of the Church. Unfortunately for Leo, his dynastic ambitions received a severe setback with the untimely death of Giuliano in 1516, followed by that of Lorenzo three years later. Furthermore, Leo's lack of interest in matters other than those that directly affected the Medici led to his fateful error of delaying the excommunication of Luther until it was too late, and thus provided the catalyst for the Reformation.

It is claimed that, upon his accession, Leo said, 'Since God has given us the papacy, let us enjoy it.' Whether or not this remark is apocryphal, his actions were in keeping with it. He enjoyed lavish banquets and entertainments as well as the

161. Detail of *The Repulse of Attila*.
The three men to the right are probably Francesco Maria della Rovere, Commander of the papal troops, Paris de Grassi,
Master of Ceremonies, and Andrea da Toledo, leader of the papal bodyguards. Leo's groom holds the head of the Pope's
favourite white horse.

princely sport of hunting. His love of music led him to play and collect instruments and patronize musicians generously. John Shearman has suggested that Julius's *studio* was converted into a music room at this time since beautiful wood intarsias (now destroyed) were made to line the bottom sections of the walls where bookcases would have previously stood.

As a Medici, Leo followed family tradition by collecting *objets d'art*, particularly jewels and manuscripts. His early education in the humanist tradition from the famous poet and Neo-Platonist Poliziano led him to be concerned with the preservation of antiquity. Raphael was duly appointed to the newly created office of Director of Roman Antiquities.

It is against this background that much of Raphael's work for Leo must be seen. As an artist he served not only the Pope but also the Medici family. Although Leo continued the rebuilding of St. Peter's and the Vatican palace, his interest in the imagery of the papacy was secondary to what he desired for the Medici. Raphael was employed in various projects for members of the family, so much so that for three months in 1518 his time was completely taken up by pictures the Medici intended to present to the French royal family. Indeed, Leo seemed loath to employ other artists and gave job after job to Raphael. Consequently some commissions were hardly begun, while many others were left to be carried out by the workshop.

Work on the Stanza d'Eliodoro had been suspended at Julius's death. Exactly when Raphael resumed his activities in the room is not known, but he must have started work again on the fresco of the *Liberation of St. Peter* (Plate 108), for the Medici impresa appears directly under the name of Julius II in the framing arch. This work was completed as it had been planned by Julius, but that was not the case with the decoration of the rest of the room. Leo made significant changes to both the iconography and the figures of the *Repulse of Attila*, and eventually even ordered the ceiling to be destroyed and redesigned by Raphael.

Completion of the Stanza d'Eliodoro

A comparison between the copy of the drawing for the *Repulse of Attila* that was done during Julius's lifetime (Plate 110) and a later drawing, widely accepted to be from Raphael's own hand (Plate 162), shows how the emphasis has shifted. It is no longer the pope who awes Attila into submission, as related by Antoninus, but rather the vision of Peter and Paul in the sky. The papal party has been relegated to the distant background and, while one figure in the centre foreground points to the pope, the majority of Attila's hordes are gesturing wildly at and recoiling from the heavenly apparition. In the fresco (Plate 163) the pope and his entourage have been restored to the foreground, but it is still to heaven that Attila looks, not at his earthly adversary.

The historic pope, Leo the Great, has been given here the features of Leo X. In 1512, while still a cardinal, Giovanni de'Medici had been briefly captured by the French at the Battle of Ravenna on the feast day of Leo the Great, who had been canonized. To commemorate his release and the successful outcome of his fortunes, Giovanni decided, after his election in March 1513, to postpone his coronation until Leo's feast day in April. In the fresco he is depicted much as he must have appeared at his coronation procession, riding his favourite white horse through the streets of Rome. This animal, which he had also ridden at the Battle of Ravenna, was freed from all further service by a papal dispensation after the coronation. The man holding the horse's head is probably an actual portrait of the papal groom, as D. Redig de Campos has suggested.

162. *Drawing for 'The Repulse of Attila'*. Silverpoint, brush, and wash, heightened with white, 36.1 × 59 cm. Paris, Louvre. This drawing shows major changes from the original plan for the fresco (see Plate 110). Attila now shields his eyes against the sight of the saints in the sky and a sword has been added to Peter's right hand. The Pope can be seen in the distance to the left.

Indeed, it seems clear that Leo, like Julius before him in the *Mass at Bolsena* on the opposite wall, chose to have himself accompanied by actual members of the papal household. For lack of comparative material the two cardinals behind the pontiff cannot be identified, but Redig de Campos has shown conclusively that the man in armour directly under St. Paul is Andrea da Toledo, a captain in the papal army. The large sceptre, *mazza d'argento*, in his hand is his badge of office. He was the head of the papal bodyguard, the *collegio de'mazzieri*, which had been set up by the emperor Constantine 'to defend the sacred person of the pope and indicate the dignity of the papacy'. Raphael has placed Andrea exactly where he would appear in this kind of procession, for a papal ceremonial of 1516 states that the guards should ride alongside the pope, near the crucifix.

The soldier holding the crucifix is probably the Commander of the papal troops, Francesco Maria della Rovere. His entirely black garb, mourning for his uncle Julius, is described in contemporary accounts of Leo's coronation. The third figure in this group may be the papal Master of Ceremonies, Paris de Grassi, whose diaries reveal so much about life at the courts of Julius and Leo. If it is the case, then this is a group portrait of three important members of the pope's entourage (Plate 161).

The drawings show that the principal change in the iconography of the fresco is that a sword has been placed in St. Peter's right hand. This departs from traditional representations where Peter holds the keys of authority given to him by Christ, while Paul carries the sword as a symbol of his martyrdom. This alteration, together with the fact that it is the saints rather than the pontiff who are routing Attila's troops, has given an entirely new meaning to the fresco.

During the Middle Ages the doctrine of the two swords was one of the most important grounds for the pope's claim to primacy in both spiritual and temporal matters. Simply stated, the argument, based on Luke XXII:38, claimed that Christ had given Peter two swords, one symbolizing the spiritual rule of the Church, the other the worldly rule of the Holy Roman emperor. Thus, although all Christian kings and princes were vassals to the emperor, he in turn was vassal to the pope as Peter's successor. The doctrine was significantly altered during the fifteenth century, as has been shown by Jeffrey Mirus. By the time Leo ascended the papal throne, the two swords were interpreted as representing the pope's dual role as spiritual leader of Christianity and temporal ruler of the States of the Church, thereby endowing the papal office with more worldly functions. As sovereign of an actual territory the pope had a stronger claim to leadership and was in a better position when dealing with other secular rulers.

This is the role that Leo perceived for himself: a prince and a pontiff. His interests lay not in securing the Church against outside interference from temporal rulers, but in establishing an earthly kingdom from which he could rule as the equal of, for example, the King of France. The Medici would thus be elevated from a family of wealthy merchants to the status of nobility and thereby enhance their chances of marital alliances with the royal houses of Europe. In other words, Leo saw in the *Repulse of Attila* not the great papal vision of Julius, but rather support for his claim to be both worldly prince and spiritual overlord.

This interpretation is continued with the *grisaille* figures (Plate 165) underneath the frescoes, planned by Raphael and executed by his assistants. Allegorical figures

163. *The Repulse of Attila*. Rome, Vatican Palace, Stanza d'Eliodoro. For the final version Leo had the papal party restored to the foreground. In the distance can be seen the ruins of Rome.

164. Detail of *The Fire in the Borgo*.
This side of the fresco (Plate 167) is dominated by the beautiful figure of the woman carrying water to quench the flames that are raging out of control among the buildings.

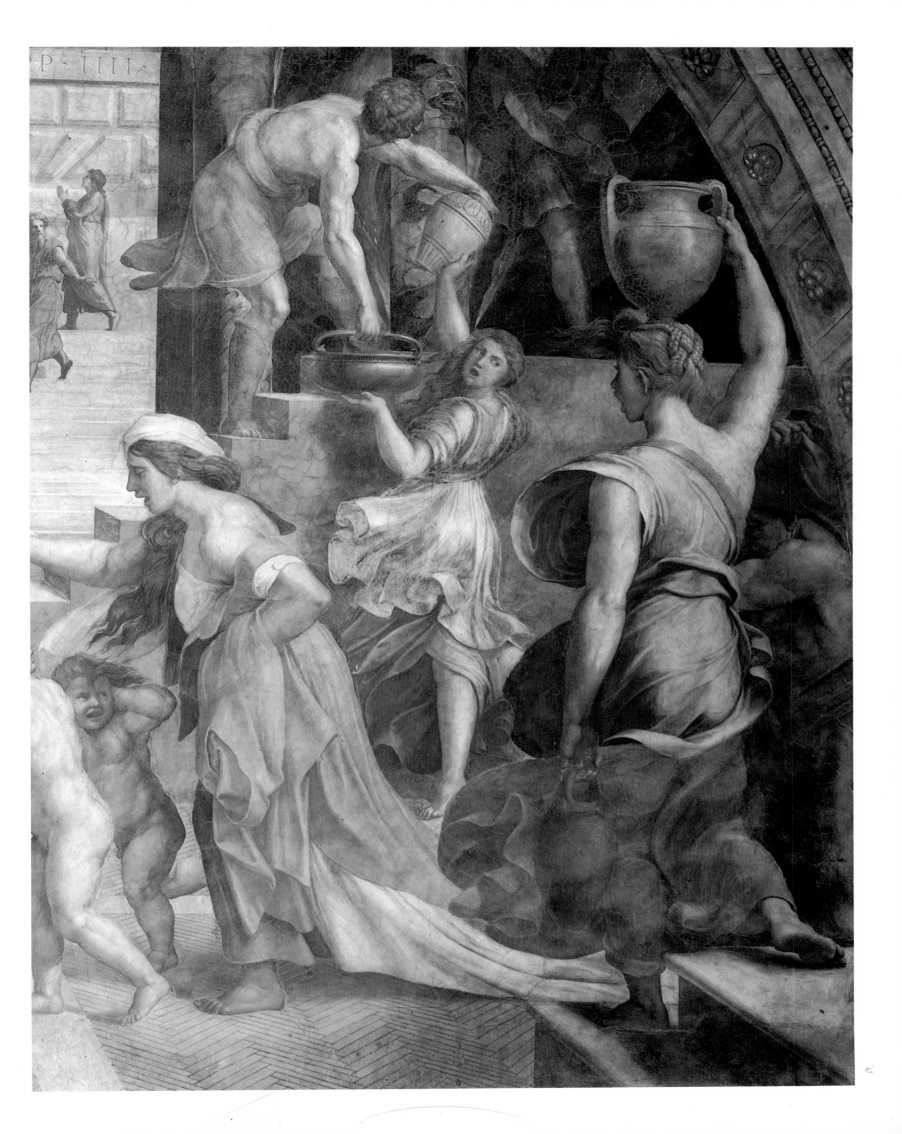

in the form of caryatids represent such themes as Abundance, Agriculture, Peace, Commerce, and Science; they pay tribute more to the benefits of good government, as in Ambrogio Lorenzetti's frescoes in the Palazzo Pubblico in Siena, than to the spiritual glories of the Church.

Originally, the ceiling of the Stanza d'Eliodoro seems to have been elaborately divided, as is that of the Stanza della Segnatura. Shortly after the completion of the *Repulse of Attila* in 1514 the entire structure was torn down so that Raphael could create a new design in keeping with Leo's philosophy. The crossed ribs form four large triangular fields, on which are painted simulated tapestries with scenes from the Old Testament (Plate 166). Taking God's manifestation to His chosen people as the common theme, the events represented are *Moses and the Burning Bush*, the *Sacrifice of Isaac, Jacob's Dream,* and *God's Appearance to Noah.* They are all instances of God's favour towards His selected leaders, while the theme of divine intervention in moments of extreme need is seen on the walls. Once again the difference between the concerns of Julius and Leo is clear. Julius selected examples which reflected God's protection of His Church; Leo preferred to think of himself as chosen by God to lead and govern His people.

There has been considerable debate about how much Raphael was involved in the design and execution of this ceiling. Modern critics seem to accept that he made designs, which were painted by his workshop. The strong influence of the Sistine Ceiling can be seen once again both in the muscular bodies and in the complete barrenness of the landscape. Some of the figures were reused with only minor alterations in the decorations of the Vatican Loggie five years later. More and more, Raphael imitated his master Perugino in letting the workshop carry out variations on old designs.

Stanza dell'Incendio

That Raphael relied increasingly on his assistants becomes obvious in the last of the rooms that he decorated, the Stanza dell'Incendio, the Pope's new dining-room. This was begun in 1514, shortly before he was appointed architect for St. Peter's and also received the commission for designing the tapestries to be hung in the Sistine Chapel. Given the importance of these two latter projects, it is

165. *Grisaille Caryatids.* Rome, Vatican Palace, Stanza d'Eliodoro. These figures, executed by the workshop after Raphael's designs, are allegories referring to the benefits of good government.

understandable that he turned over the execution of the decorations for the Stanza to his workshop.

The Stanza dell'Incendio had been first decorated during the pontificate of Julius in 1508 in a manner, it may be assumed, that befitted its function as the meeting-place for the supreme tribunal of the Church. All that remains of the original decoration is the frescoed ceiling by Perugino. Why this was not redone with the rest of the room is not known, but the romantic suggestion that Raphael wanted to pay tribute to his master is not tenable. Neither he nor Leo showed the slightest qualms about completely destroying wall frescoes in which such a leading master as Perugino must have participated. In any case, the decision would have been the Pope's. Perhaps he felt that such an elegant gilded and painted ceiling was equally appropriate for the room's new function.

The stories selected to adorn the walls are all taken from the *Liber Pontificalis*. Leo obviously enjoyed the idea of playing the roles of his predecessors who shared

166. Ceiling of the Stanza d'Eliodoro. Rome, Vatican Palace. Originally resembling that of the Stanza della Segnatura, the ceiling was altered after 1514 to a simplified arrangement of four large fields. The scalloped edges give the illusion that the scenes are tapestries rather than frescoes.

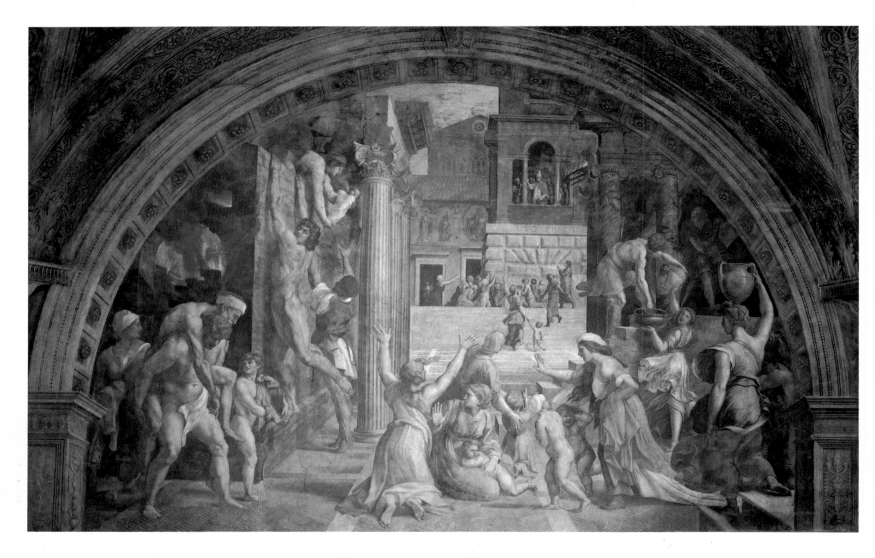

both his name and position, and therefore suitable events from the lives of Leo III and Leo IV were chosen. Julius's subtle and intellectual approach in selecting themes for papal propaganda was abandoned in favour of a more direct style. Both the historic popes were given Leo X's features so that there could be no mistake as to who was the real hero of the story in each case.

The fire, from which the room takes its name, is *The Fire in the Borgo* (Plates 164, 167). In 847 a fire broke out in the quarter of Rome which lay between St. Peter's and the Tiber, known as the Borgo. The conflagration raced unchecked until Pope Leo IV mounted the loggia in front of St. Peter's and made the sign of the cross, whereupon the flames were immediately extinguished. Raphael portrays the moment at which the Pope is raising his hand.

The terror of the citizens is in strong contrast to the priest's serenity. The heroism and bold deeds are of much greater visual interest than the Pope's actions. Raphael has conveyed the desperation and fear of the victims with his usual skill. From both sides the people are driven by the smoke and flames into the centre of the picture, which leads the eye towards the pontiff.

Raphael uses the architecture for this purpose with great effect. The ancient columns on both sides, painted with archaeological accuracy, serve to press the crowd inward. They form a tunnel, which opens onto the piazza and the gleaming white steps of the church with the blue sky above.

Once again, the extent of Raphael's involvement in this fresco, and indeed the whole room, has been widely debated, but Konrad Oberhuber has established that

167. *The Fire in the Borgo.*
Rome, Vatican Palace,
Stanza dell'Incendio.
Raphael's study of antique motifs can be clearly seen in this fresco. To the left he employed the famous sculptural group of *Aeneas and Anchises.* The Corinthian and Ionic columns of the burning buildings are archaeologically correct.

the master designed all four frescoes and executed a major part of the *Fire in the Borgo*. While there are a few obvious cases of borrowing from the work of other artists (the Cumaean Sibyl from the Sistine Ceiling appears as the old woman to the extreme left) some of Raphael's finest work can be seen here, for example, the dishevelled woman standing with her two frightened children or the magnificent amazon with the jar on her head, both on the right-hand side.

Various political events have been cited to explain the inclusion of this miracle in the room, but it seems more likely that Leo wanted to reiterate the idea of God's favour towards the pope. In contrast to the wall frescoes of the Stanza d'Eliodoro, where God's intervention is direct, here it is through the pope that God works.

The Sea Battle of Ostia (Plate 168) is an excellent example of papal invocation. The fresco depicts Leo IV's victory over the Saracens when they attacked the port of Rome in 849. It is the pope, with the features of Leo X, who invokes God's aid so that his troops may carry the day. In this case politics played a part in the choice of the scene. A Turkish invasion seemed imminent in the sixteenth century, and Leo called for a crusade against the infidel repeatedly throughout his pontificate.

The participation of the workshop has reduced the impact of this fresco. Although Raphael's creative abilities can be seen in such figures as the boatman to the extreme right or the Herculean warrior binding his enemy in the centre, much of the conflict has no urgency, as, for example, the group stepping out of the boat. Both captives and captors are posed stiffly and lack the variety Raphael always

168. *The Sea Battle of Ostia.* Rome, Vatican Palace, Stanza dell'Incendio.
Mostly executed by assistants, Raphael's carefully constructed battle has become lifeless and artificial. Leo X can be seen to the left as Pope Leo IV. Behind him stand the Cardinals Giulio de'Medici and Bibbiena.

introduced to give his figures balance and rhythm. The fortress in the background, a faithful reproduction of that built at Ostia by Julius II when he was still a cardinal, is out of proportion with the ships and men, who in turn are jumbled together in the sea battle. The ineptness of the fresco is shown at its worst by the totally lifeless papal party. Cardinals Giulio de'Medici and Bibbiena stare sightlessly at the Pope's back, and the functionaries stand like statues. Perhaps most unsatisfactory is the commander in the far left foreground whose pointing right hand disintegrates totally as a form, while his left hand seems severed from his body. The drawing for this figure (Plate 170), which Raphael sent to Dürer as an example of his style, shows the gulf between the master and the studio.

The execution of the last two frescoes, *The Coronation of Charlemagne* and *The Oath of Leo III*, was turned over to the assistants entirely (Plates 171,172). In these the inability of Raphael's workshop to translate the master's designs is obvious. The softly rippling flow of mitres and robes in Raphael's drawing for the *Coronation*

169. *Study of Eight Seated Bishops for 'The Coronation of Charlemagne'*. Red chalk over stylus, 26.1 × 31.8 cm. Düsseldorf, Kunstmuseum. This lovely drawing demonstrates the subtle variations Raphael could introduce even in two lines of seated figures. His studio was never able to achieve these effects, and the final fresco remains static.

1515

170. Study of Two Men for 'The Sea Battle of Ostia'. Red chalk over stylus, 40.3 × 28.1 cm. Vienna, Albertina.
The inscription to the right dated 1515 was written by Albrecht Dürer and says that Raphael sent him this drawing as an example of his art.

(Plate 169) has become static and stiff in the painted version. The *Oath of Leo III* is filled with figures unconcerned with the actions of the Pope. The strength of execution or boldness of design that is so readily apparent in the other two Stanze is sadly lacking in these two frescoes.

Both these scenes are related directly to contemporary political events. Relations between the papacy and the French monarchy had improved immediately after the death of Louis XII on 1 January 1515, and by spring negotiations were under way between the new king, Francis I, and Leo. On 13 October they signed a treaty, which stipulated that the King of France would take special care to protect Florence *and* the Medici in perpetuity. This was followed closely by a historic meeting between Francis and Leo in Bologna in December, where the agreement known as the Concordat was signed. In this document, which was ratified by the Fifth Lateran Council in 1516, the Pope turned over to the French monarchy both the absolute control of all major benefices in French territory (which at that time included Milan) and the right to try members of the ecclesiastical community before civil authorities. The only concession won by the papacy was the abrogation of the so-called Pragmatic Sanction, a policy adopted by the Schismatic Council of Basle in 1438 and subsequently invoked by the Gallic bishops and clergy to secure their independence from the papacy. Leo preferred to place control over ecclesiastical affairs in the hands of a secular authority that nominally recognized the pope's right

171. *The Coronation of Charlemagne.* Rome, Vatican Palace, Stanza dell'Incendio. Pope Leo III has been given the features of Leo X, and Charlemagne those of the French king, Francis I. The men bringing in a bench and pitchers to the left are described in the story from the *Liber Pontificalis.*

172. *The Oath of Leo III.*
Rome, Vatican Palace,
Stanza dell'Incendio.
Leo X once again plays the role of
the historic pope, seen here
swearing he was innocent of a
slanderous charge made by a
nephew of Hadrian I. Lorenzo
de'Medici, Leo's nephew, stands to
the right behind the deacons.

of final approval, rather than to preserve the independence of the Church. Francis was, of course, delighted to renounce the claims of the French clergy in exchange for the Pope's recognition of the monarch's authority over church matters. It is not surprising that shortly after this Francis suggested a further marital alliance between the Medici and the French royal house.

Thus, in a few days, Leo gave away the rights and independence for which his predecessors had fought for almost a thousand years. On the walls of his dining-room, however, he could pretend otherwise. There he can be seen as Leo III crowning Charlemagne (whose features are those of Francis I), an event that established the pope's primacy over secular authority in 800. On the adjoining wall, Leo swears his innocence before God. The inscription, in direct contradiction to the Concordat, reads, 'God, not man, is to judge bishops.'

The Cartoons and Tapestries for the Sistine Chapel

Raphael's diminishing role in executing the frescoes in the Stanza dell'Incendio was largely due to his preoccupation with the designs for the tapestries to be hung in the Sistine Chapel. This important commission, for which no contract survives, certainly came directly from the Pope, who wanted to continue the tradition, instituted by Sixtus IV and Julius II, of decorating the papal chapel. The Sistine

Chapel was used not only on high festivals and state visits but, most importantly, as the meeting-place for the conclaves to elect a new pope.

Only two documents concerning the cartoons for the tapestries exist. On 15 June 1515 Raphael was paid by order of Cardinal Bibbiena, the papal treasurer, three hundred ducats for designs, and another, smaller payment was recorded on 20 December 1516, possibly the final balance of a residue. But in fact Raphael was paid a great deal more. The Venetian connoisseur Marcantonio Michiel claimed that one thousand ducats were spent on the cartoons alone, and Paolo Giovio, in his biography of Leo X, claimed (perhaps exaggerating) that the tapestries were so costly that money destined for other purposes had to be diverted to pay for them.

The cartoons were painted in distemper on paper. Upon completion they were sent to the tapestry workshop of Peter van Aelst in Brussels, where they were cut into strips about one metre wide to be placed more easily under the looms. In the seventeenth century they were reassembled, mounted on canvas and, after quite a number of vicissitudes, seven — those that survived from the original set of ten — were acquired in 1623 by Charles, Prince of Wales, later King Charles I. Coveted by Cromwell, they were withheld from the sale of the matchless Royal Collection during the Commonwealth, and today hang in the Victoria and Albert Museum, London.

By late 1519 the first completed tapestries were placed on view. Michiel wrote on that occasion:

At Christmas the Pope showed in his chapel seven pieces of tapestry, the eighth being still unfinished, woven in Flanders. They are judged the most beautiful works of this type ever made up to our own day. The drawings of these tapestries were carried out by Raphael of Urbino, an excellent painter, who received from the Pope 100 ducats for each scene. A great quantity of silk and gold has been used in the tapestries. The weaving has cost fifteen thousand ducats apiece, or, as the Pope himself said, sixteen thousand ducats in all [sic]. It was rumoured that each had actually cost two thousand ducats.

Paris de Grassi speaks of the stunning effect of the tapestries and also claims that each was worth two thousand ducats.

The tradition of decorating churches and chapels with tapestries can be traced back to Carolingian times. Although elaborate pictorial cycles were rare, scenes from the Acts of the Apostles had been hung in the ninth century below the Old and New Testament cycles in the nave of Old St. Peter's. More recently, Sixtus IV had commissioned decorative hangings for the Sistine Chapel. When Julius ordered Michelangelo to replace the original star-covered ceiling with a fresco cycle, it left only the lowest zone of the chapel without figural representation.

The decorations of the Sistine Chapel, commissioned by four popes over a period of about fifty-five years, are remarkable for their cohesion of theme. The frescoes on the side walls painted for Sixtus, and dating from the early 1480s, establish the theme. Moses and Christ are juxtaposed as the founders of the Old and New Covenants and thus are represented as the foundation of papal authority, the doctrine of the *primatus papae,* which is clearly prefigured in these two cycles. The papal portraits in the clerestory between the windows promote this doctrine. Subsequently Julius added to the account of Christian world history by Michelangelo's ceiling fresco of the events before the Law, while Clement VII completed it with Michelangelo's *Last Judgment* fresco on the altar wall. Leo's two tapestry cycles fit neatly into this scheme. Peter and Paul, with whose lives the tapestries are concerned, appear as the founders of the Church. In this way all the decorations of the Sistine Chapel, frescoes and tapestries, give an account of the history of the

173. *'Feed My Sheep'*. Distemper on paper, 343 × 532 cm. London, Victoria and Albert Museum. Peter, holding the keys given to him earlier, kneels before the Risen Christ who commands him, 'Feed my sheep'. This was interpreted by the Church as the reaffirmation of Peter's role as the leader among the apostles.

world from the Creation to the Last Judgment. Raphael's designs must be understood not just as an opportunity for Leo to indulge his love of splendour, but as an integral part of the whole ensemble and its meaning.

There has been a great deal of discussion concerning the position and order in which the tapestries were intended to be hung in the chapel. The ten tapestries do not correspond to the fifteenth-century division of the wall into sixteen sections. On the other hand, there is no indication that any more tapestries were planned. The matter is further complicated by the fact that Raphael's two cycles appear to be divided unevenly, St. Paul having six scenes and St. Peter four. John White and John Shearman have proposed an arrangement whereby nine tapestries hung within the *Cancellata* in the space reserved for the pope and the clergy, and only one, *St. Paul Preaching in Athens*, hung outside in the area for the laity. Arguing mainly on the basis of the fall of light and shadow, they conjecture that the Peter scenes were hung underneath the Christ frescoes, and the Paul scenes opposite under the Moses cycle. Such an arrangement also seems probable on theological grounds, for Peter was Christ's successor as leader of the apostles and therefore is closer to Him than Paul.

All four cartoons survive for the Peter cycle, whose theme is Peter's primacy among the apostles. The first of these tapestries, *The Miraculous Draught of Fishes*, hung in all likelihood on the altar wall (cartoon, Plate 174). It depicts the occasion when Peter became the first apostle, a crucial moment in the history of the Church.

The theme is continued with Christ's appearance after His Resurrection when He admonished Peter, 'Feed My Sheep' (cartoon, Plate 173). This cartoon has sometimes been misinterpreted as representing Christ's Charge to St. Peter, but that event took place before the Crucifixion, and in this cartoon it is clearly the

Risen Christ with the wounds that is shown. The inclusion of *'Feed My Sheep'* is of great significance in the imagery of the chapel, for the episode was considered as confirming Peter's primacy among the apostles. The allusion to the popes' claim as leaders of the Church is obvious. According to a treatise by Leo's Master of the Sacred Palace, Silvestro Mazzolini, Peter's primacy was reaffirmed constantly after Christ's Ascension by the descent of the Holy Ghost, assisting Peter to perform miracles, as is shown on the last two tapestries of the group. On the occasion of the Death of Ananias (cartoon, Plate 176), it was through the power of the Holy Spirit that Peter was able to see through Ananias's deceit and call down his destruction. In the same way, it was with the help of the Holy Spirit that Peter was able to heal the lame man in the name of Christ (cartoon, Plate 177).

The Paul cycle has six tapestries, but for three of them — *The Stoning of St. Stephen, The Conversion of St. Paul,* and *St. Paul in Prison* — the cartoons no longer exist. They survive for *The Blinding of Elymas* (Plate 175), *The Sacrifice at Lystra* (Plate 178) and *St. Paul Preaching in Athens* (Plate 180). *St. Paul in Prison* was

174. *The Miraculous Draught of Fishes.* Distemper on paper, 319 × 399 cm. London, Victoria and Albert Museum.
This dramatic scene when Peter became the first apostle would have hung behind the altar under Perugino's fresco of the Nativity of Christ. The delicate *sfumato* of the landscape is lost in the tapestry.

Inscription on the throne base:

L·SERGIVS·PAVLLVS
ASIAE·PROCOS·
CHRISTIANAM·FIDEM
AMPLECTITVR
SAVLI·PREDICATIONE

175. *The Blinding of Elymas.*
Distemper on paper, 342 × 446 cm. London, Victoria and Albert Museum.
Also known as the 'Conversion of the Proconsul'; the fact that the theme is a conversion is made clear from the inscription under the throne.

intended merely to occupy a narrow space and need not concern us here. White and Shearman have proposed that, based on measurements, the *Stoning of St. Stephen*, the story marking the first appearance of the as yet unconverted Saul, hung on the altar wall. This was then followed by the *Conversion of St. Paul*.

That the theme of this series is preaching and conversion is made clear by the inscription below the throne in the so-called *Blinding of Elymas* which reads, 'Lucius Sergius Paulus, Proconsul of Asia, embraces the Christian Faith through the preaching of Saul.' Hence, it is the power of St. Paul's sermons rather than his ability to work miracles that is being stressed. In the episode represented in the *Sacrifice at Lystra,* the people believed at first that Paul was the pagan god Mercury because of his eloquence. Once he convinced the multitude that he was indeed mortal they were converted to Christianity. The final scene of *Paul on the Areopagus* sums up his office as preacher to the Gentiles. He addresses the Athenians on the subject of the Death and Resurrection of Christ, the *Mysterium Fidei.*

At first glance Paul's abilities as a preacher may not appear to fit in with the idea

of papal primacy, but an answer may be found in the treatise on this subject written by the Dominican Master General Tommaso de Vio, called Cajetan, in 1511. He compared Paul's role as a preacher with the role of bishops whose duty it is to preach. But just as Paul's position was defined by and subordinate to Peter's, so the duties of the bishops and their portion in governing the Church are under the complete jurisdiction of the pope. Had he so wished, Peter, because of his absolute power from God, could have excommunicated Paul, just as the pope can excommunicate any member of the Church, no matter how high he may stand in the hierarchy. The *Conversion of St. Paul* hung opposite '*Feed My Sheep*' for precisely this reason. Although Paul was chosen by the Risen Christ, Christ also confirmed Peter's primacy after His Resurrection. Thus the tapestries form a clear and coherent statement of hierarchy within the Church.

It is obvious from the extraordinary power of the cartoons that Raphael concentrated all his abilities on these designs. Working for the Sistine Chapel placed him in direct competition with both his old master Perugino and his current rival Michelangelo. This challenge brought Raphael's abilities to the fore. His sensitivity to the formal structure of the fifteenth-century frescoes under which his works were to hang caused him to design the cartoons in a manner that did not conflict with the older works. At the same time, he boldly incorporated the massive figures, the powerful gestures, and the strongly articulated bodies introduced by Michelangelo on the ceiling. Raphael was acutely aware that his designs were intended to be transferred into another medium, and so tried to ensure that each scene would remain clear and not be confused by the weavers. Eschewing,

176. *The Death of Ananias.*
Distemper on paper, 342 × 532 cm.
London, Victoria and Albert Museum.
This incident was used as an example of Peter's primacy by the pope's official theologian. He argued that because of Peter's unique position he was able to see through Ananias's deception and call down his destruction.

177. *The Healing of the Lame Man*. Distemper on paper, 342 × 536 cm. London, Victoria and Albert Museum.
Raphael has used extravagantly decorated twisted columns to recall the setting of the 'Beautiful Gate' of the Temple.

therefore, the complex architectural spaces he had constructed in the Stanze, he instead made use of unambiguous, simplified backgrounds with a straightforward perspective, and created an effect of stage-sets against which the actors are placed. This, together with the fact that the figures have extremely large proportions in relation to the architecture, enhances the dramatic event in each tapestry. The architecture becomes a device for sealing off the background rather than establishing a deep spatial recession.

Vasari states that Raphael himself made the cartoons and adds, in the life of Gianfrancesco Penni, that this assistant helped with the painting, particularly the border friezes. Giovanni da Udine, the specialist for flora and fauna, may have painted the superb catch of fishes in the *Miraculous Draught of Fishes* as well as the three cranes. The lateral borders with grotesques, virtues, liberal arts, and Herculean scenes could also be from his hand, while it is more likely that Penni worked on the narrative monochrome friezes.

These borders depict scenes from the life of Leo X on the Peter cycle, and further Pauline episodes from Acts for the story of Paul, with one inexplicable exception. Underneath the *Stoning of St. Stephen* is an event from the early life of Giovanni de'Medici whose rise through the cardinalate to the papacy is confined otherwise to the Peter tapestries. The introduction of so personal a theme as the life of Leo X is significant, for it is yet another indication of Leo's consuming desire to link his papal office with Medici fortunes. Included in the borders are ecclesiastical events such as his entry as a cardinal into Rome for the conclave that was to elect him pope; but there are as well family-connected affairs like the sack of the Medici

palace in 1494. The glorification of the Medici reaches its apex with the depiction of Giovanni's triumphal return to Florence in 1512.

The cartoons, precisely because the major part was executed by the master's own hand, are unrivalled in their display of Raphael's art at the height of his powers. They form a summary of everything Raphael had learned and hint at the new directions his art might have taken had he not died so young. From the *Battle of Cascina* and the Sistine Ceiling he had taken Michelangelo's sculptural forms and intricate poses. The influence of Fra Bartolommeo's monumental figures enveloped in their voluminous draperies is never more apparent than in these works. The delicate *sfumato* in the landscapes of the *Miraculous Draught of Fishes* and *'Feed My Sheep'* reveals his debt to Leonardo. Yet in every case the source has been transformed by Raphael's genius into something uniquely his own. To examine these masterpieces for the work of assistants is to fail to appreciate them as works of art. The sheer magnificence of the whole is in each one infinitely greater than the sum of its parts.

While he was engaged on the tapestry cartoons, Raphael painted two other works for the Medici, both now lost. One, a portrait of Duke Giuliano, is referred to in the same letter from Bembo that mentions the portrait of Castiglione. A copy after this picture shows that the design was that of a state portrait with the Duke posed before a view of Rome. The other painting was more informal and reveals Leo's love of exotic animals, a taste he inherited from his father. This was a portrait of

178. *The Sacrifice at Lystra.*
Distemper on paper, 347 × 542 cm. London, Victoria and Albert Museum.
Because of his eloquence in preaching, people believed that Paul was the pagan god Mercury. To emphasize this part of the story, Raphael has placed a statue of Mercury almost in the centre of the picture.

179. *Pope Leo X, with Cardinals Giulio de'Medici and Luigi Rossi.* Panel,154 × 119cm.Florence,Uffizi. Although the painting has darkened with age, the importance of the architectural setting for the cohesion of the whole can still be seen. The illuminated Bible was so accurately painted that it can be identified as the Hamilton Bible, today in the Berlin State Museum. The delicate painting of the reflection of the window on the knob of the chair is reminiscent of the detail work made famous by Flemish masters.

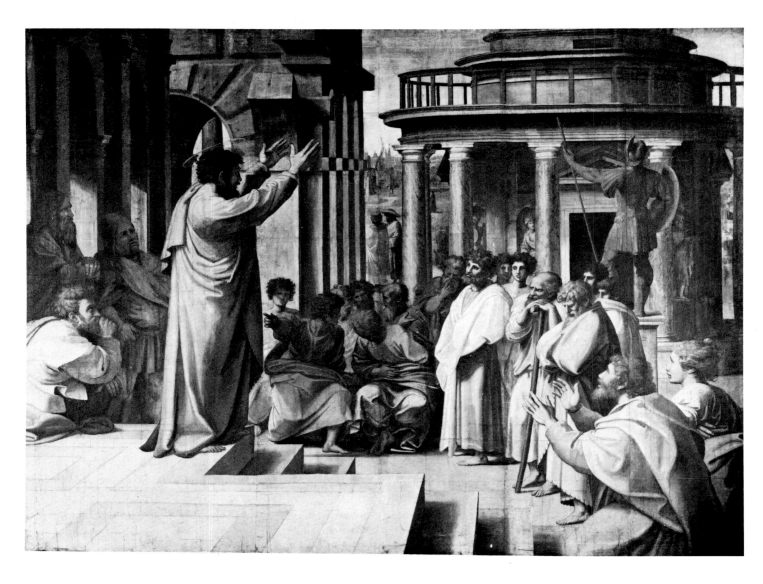

the Pope's pet elephant Hanno, which had been a gift from the King of Portugal in 1514. Hanno quickly became such a favourite that Leo had a scene of himself riding on the elephant's back included on the new intarsia doors for the Stanza della Segnatura, where it can be seen today. When the elephant died, a Latin epitaph was composed in its memory and it was buried in the Vatican gardens.

Leo does not seem to have commissioned more paintings from Raphael until the beginning of 1518, when Lorenzo de'Medici, by then Duke of Urbino and the only living male heir of Lorenzo il Magnifico not in holy orders, was engaged to Madeleine de la Tour, a relative of the King of France. Although the marriage was proposed by Francis I at the end of 1516, arrangements had been held up both by Lorenzo's war to capture Urbino and by his redoubtable mother Alfonsina who objected to the poor dowry the Medici were forced to accept in order to secure a marriage with royal connections. The announcement of the engagement was followed closely by the news that a son and heir had been born to the King of France, for whom Leo was asked to act as godfather. Such events involved sizeable gifts, and the Medici immediately turned to the most famous painter in Rome to provide something worthy of the occasions.

The first commissioned work was a portrait of the bridegroom, Lorenzo, which today exists only in copies. It was ordered in January 1518 as a gift for the bride with the expectation that she would reciprocate in kind. Cardinal Bibbiena, who had served as papal legate to France during most of 1517 and was a close friend of

180. *St. Paul Preaching at Athens.* Distemper on paper, 343 × 442 cm. London, Victoria and Albert Museum.
This cartoon was for the only tapestry that may have hung outside the *Cancellata*. It has been suggested that the plump man behind St. Paul is a portrait of Raphael's friend Tommaso Inghirami, who died while these cartoons were being executed.

the Queen Mother, requested a portrait of Giovanna, wife of the Vice-Regent of Naples. The other commissioned pictures included a *St. Margaret,* probably as a gift for the King's sister, Margaret of Valois, the godmother of the infant Dauphin and sister of the widow of Duke Giuliano de'Medici; for the King of France, Leo sent a large painting of St. Michael (Plate 181), the patron saint of the French chivalric order; and for the Queen, Duke Lorenzo commissioned the painting today known as *The Madonna of Francis I* (Plate 182). Raphael was expected to try to complete at least the latter two paintings before the baptism of the Dauphin and the wedding of Lorenzo at the end of April. The Ferrarese envoy Constabili reported that between March and the end of May the artist was forced to abandon all other projects in order to work on these pictures.

It is obvious that Raphael would have had to turn to his assistants to complete five large pictures within as many months. Bibbiena's commission seems to have been handed over to the workshop almost entirely, as it was necessary to send someone to Naples to make a drawing of the lady from which the painting could be done. That Raphael himself took no credit for this work is clear from a letter of Constabili's, for when he sent the cartoon to Ferrara at the Duke's request, Raphael wanted it understood that the drawing was from the hand of one of his *garzoni.* The painting of St. Margaret apparently was a product of the studio based on a Raphael design. The face, according to Vasari, was painted by Giulio Romano. Since both these pictures have suffered heavy damage it is difficult to judge them today.

Raphael concentrated his skills on the paintings for the King and Queen of France. Constabili wrote on 27 May, shortly before the pictures were dispatched, that both were most beautiful, but the hostile Sebastiano del Piombo reported differently to Michelangelo. 'The prince of the Synagogue', as he referred to Raphael, had painted two pictures, which could not be more at variance with the sculptor's opinions, for they appeared as though 'darkened by smoke or rather like figures of iron which shine all light and dark and [are] designed in the manner of Leonardo.'

Sebastiano intended his remarks to be derogatory but they are in fact a very fair description of Raphael's colouring in these pictures. He was fully aware that Leonardo, his old friend and mentor, was currently ensconced at the French court as the favourite of Francis I. Furthermore, Francis had recently made Leo the present of a large tapestry depicting the Last Supper copied from Leonardo's famous fresco in Milan. The tapestry today hangs in the Pinacoteca of the Vatican. (The choice of the Milan fresco was quite deliberate, for the Concordat of 1516 tacitly recognized the French king's claim to that city and the surrounding territories.) By choosing to emulate Leonardo's style Raphael was adopting a manner that he knew would be pleasing to the French monarch and at the same time pay homage to a great master.

It is difficult to write in detail about the *Madonna of Francis I* as it is currently being cleaned and restored. The smooth-faced, downward-glancing Virgin obviously derives from Leonardo's *Virgin of the Rocks* (Plate 37) and *Adoration of the Magi* (Plate 86), while the softly modelled muscles and wrinkles in the faces of the elderly St. Joseph and St. Elizabeth owe much to Leonardo's *chiaroscuro* technique and studies of old people. Perhaps most Leonardesque of all is the angel's head in the centre of the picture with its soft, liquid glance. The present cleaning will undoubtedly reveal new insights into this, the last of Raphael's monumental *Madonnas.*

In spite of being darkened with age, the magnificent *St. Michael* has retained much of its power, and is obviously a display of Raphael's virtuosity. The dramatic

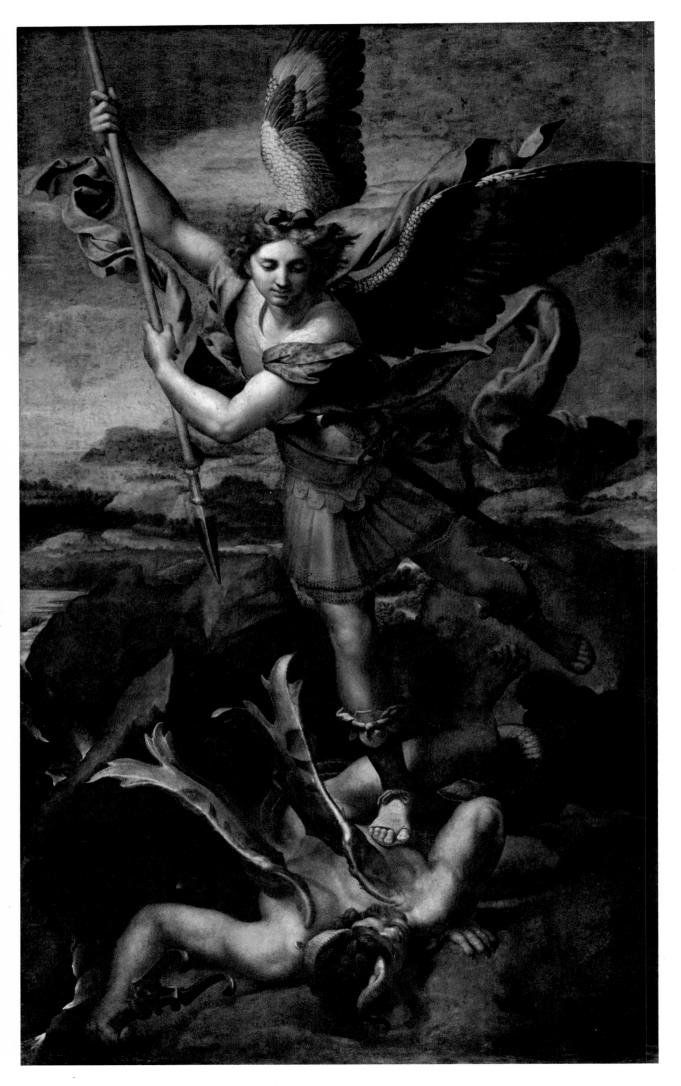

181. *St. Michael.*
Canvas, transferred
from panel, 268 × 160
cm. Signed and dated
on the hem of the
robe: RAPHAEL·
VRBINAS·PINGEBAT·
M.D.XVIII. Paris,
Louvre.
Painted as a gift for
Francis I, this
magnificent work had
a tremendous impact
on northern Baroque
art. For example,
echoes of it can be
found in sculptural
groups of the same
subject in Augsburg
and Munich.

182. *The Madonna of
Francis I.* Canvas,
transferred from panel,
207 × 140 cm. Signed
and dated on the
Madonna's cloak:
RAPHAEL·VRBINAS·
PINGEBAT M.D.X.VIII.
Paris, Louvre.
The theme of Mother
and Child was
particularly
appropriate as a gift to
celebrate the birth of
the Dauphin, for
whom Leo was asked
to be godfather. It was
the last of Raphael's
monumental
Madonnas.

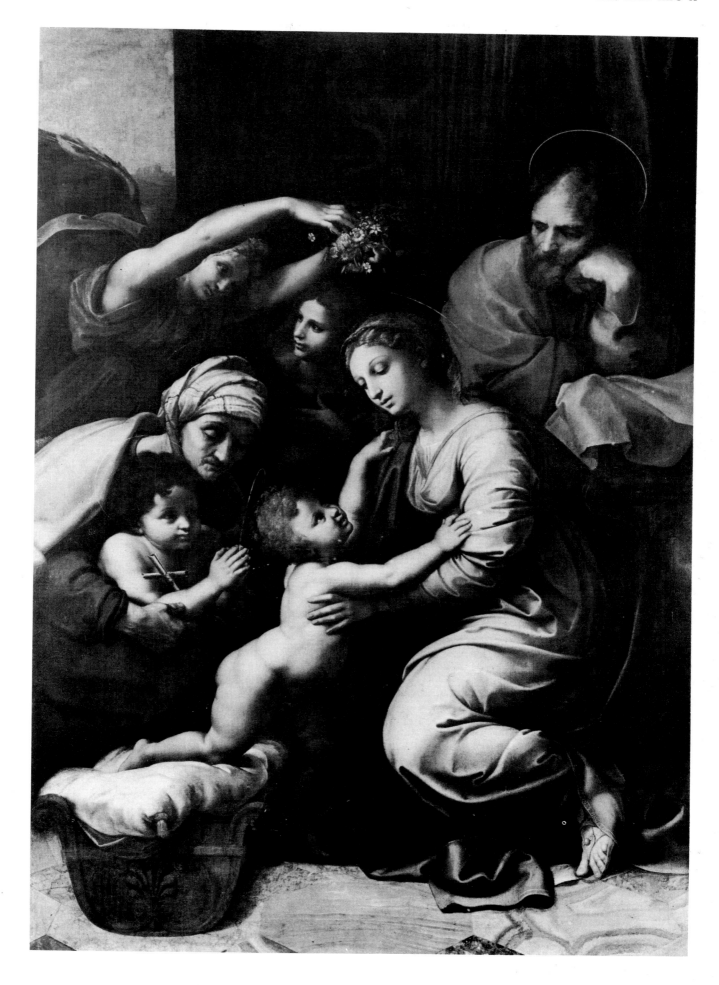

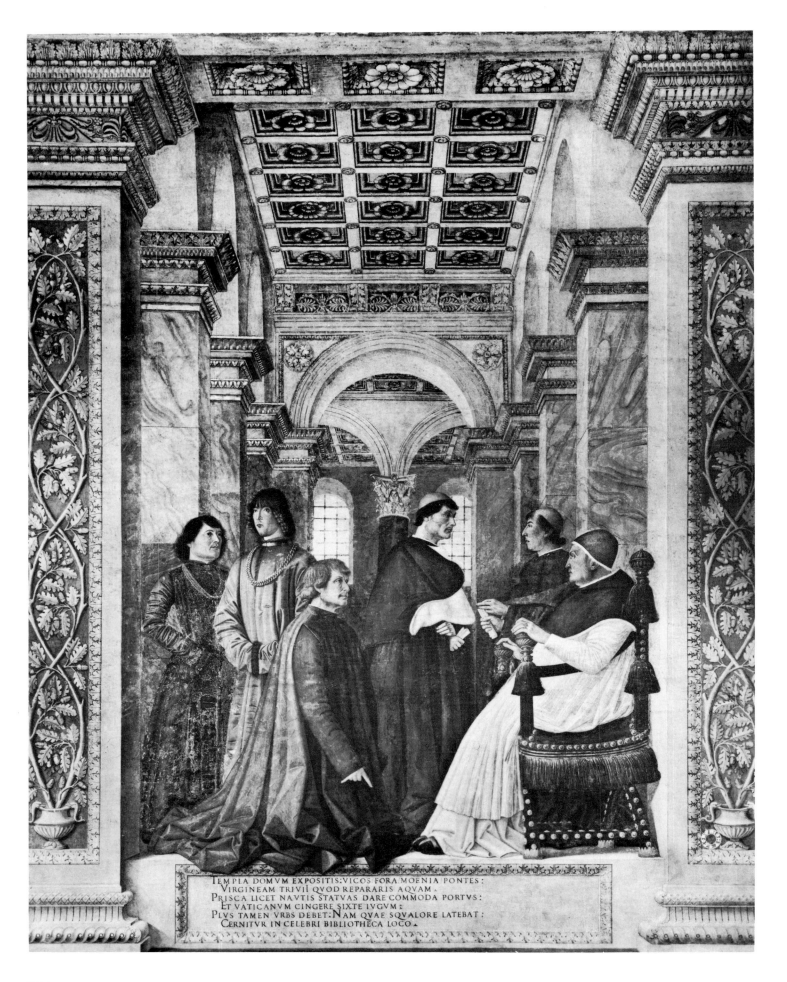

form of the archangel fills the picture and seems to leap out towards the spectator, an effect lost when reproduced in a photograph. The line of St. Michael's body is continued above his head by his right wing, so that the size of the figure appears to be much greater. The placing of this long line at a slight diagonal has given the figure dynamic movement without instability. The extended limbs and flying draperies spiral around this central axis, contributing to the feeling of great energy. Exaggerated or violent expressions were not necessary for describing the forceful effect of total victory over the Prince of Darkness. Raphael was certainly responding to the refined artistic taste of the King, whose connoisseurship even when he was a prince had earned him a mention in Castiglione's *Book of the Courtier*.

The last picture that Raphael painted for Leo was also one of his greatest: the portrait of the pontiff with two of his nephews, Cardinals Giulio de'Medici and Luigi Rossi (Plate 179); according to documents recently published by J. Beck and R. Sherr it was executed for Duke Lorenzo de'Medici's wedding in Florence in September 1518. Rossi was elevated to the College of Cardinals on 26 June 1517 with thirty others, an unusually large number to be created at one time. The impetus for this extraordinary and sudden expansion of the College of Cardinals was an assassination attempt on the pontiff plotted by some of the leading members of the Curia, including Raffaele Riario, cousin of Julius II, whose portrait had been included in the *Mass at Bolsena*. After executing or exiling his enemies, Leo decided to weigh the College in his favour, and among those he promoted were three of his nephews. The ceremony was followed by a 'sumptuous entertainment' in Raphael's newly completed Stanza.

When he was asked to paint the pope with two of his nephews, Raphael must have thought of the famous fresco by Melozzo da Forlì at the entrance to the Vatican library (Plate 183). To commemorate the re-establishment of the library after years of neglect, Sixtus IV had commissioned a painting of himself seated in a chair, with two of his cardinal nephews standing on either side. Before him kneels the librarian Platina together with two more of the pope's nephews. Such a group portrait was more than a celebration of the reopening of the library. It was also a dynastic portrait of the della Rovere family and an expression of their aspiration to remain a potent force in ecclesiastical politics. The Medici group portrait reflects similar hopes. Following the recent elevations Leo had five near relatives and many close friends in the Sacred College. He obviously had greatly increased the chances of a Medici succeeding him on the papal throne.

Impressive as Melozzo's fresco is, the figures are placed in a more or less linear arrangement. Raphael unifies his three sitters in space. The heights of the three heads are subtly varied. The two cardinals placed slightly behind and on either side of the seated pontiff establish the third dimension, which is then reinforced by the receding architecture that is articulated to complement the figures below. Above Giulio is a sharp corner, behind Leo a niche, and over Rossi an arch.

As with the *Madonna della Sedia* and the *Portrait of Julius II*, the chair establishes the pope's superior rank. Here, of course, the della Rovere acorns have been replaced with a more traditional golden knob, upon the highly polished surface of which Raphael has fancifully included the delicate reflection of the window. The chair is only one facet of the luxury depicted. Lorenzo il Magnifico had written to his son when he became a cardinal that it was better in his position to eschew rich silks and own instead a few beautiful manuscripts. In this portrait Leo clearly felt he could indulge in a lavish display of both. The heavy white silk brocade robe with its fur-lined sleeves is a far cry from the traditional papal *camicia* in which both Sixtus and Julius were painted. On the table before the pontiff are

183. Melozzo da Forlì. *Sixtus IV and his Nephews with the Librarian Platina*. Rome, Vatican Pinacoteca.
This fresco, originally located at the entrance to the Vatican Library, commemorated the re-establishment of the library after years of neglect. Platina points to the inscription. Beside the seated pope stands Cardinal Giuliano della Rovere, the future Julius II.

placed a richly illuminated Bible and a finely wrought gold bell topped by a red silk tassel. Personal vanity too is present. Contemporary sources reveal that Leo was extremely proud of his elegant white hands, posed here devoid of rings so as not to distract attention from their beauty. The same sources tell us that the Pope was very near-sighted and could only read with the aid of a magnifying glass. Here this necessity has been turned into the mark of a connoisseur of fine art.

Both as a pope and a person Leo differed greatly from his predecessor. Popular, jovial, and cultured, he preferred to surround himself with the pleasures rather than the duties of office. His flatterers were many, his detractors few. Yet in spite of his patronage of the arts, he never managed to inspire Raphael with the same fervour that Julius had. The grandeur of the tapestry cartoons was a response to the challenge posed by Michelangelo's ceiling, and the *St. Michael* was created for the King of France. That Raphael, however, had lost none of his abilities is demonstrated again and again in the works he did for other patrons. Judging from the *Transfiguration*, it is probable that, had he lived to work for Clement VII, he might have transcended all his previous efforts. Perhaps he felt that Leo's interests lay more in the direction of music or antiquities. But it was precisely because of this latter concern that Raphael was able to pursue his own studies of ancient Rome. As we shall see in the next chapter, the artist was becoming a scholar.

6 Raphael and Antiquity

Raphael's activities as an architect are closely related to his growing fascination with the antiquities of Rome, which gained an almost obsessive hold over him in the last years of his life. It has already been noted that in the later parts of the Stanze and in other work after 1515, his participation in the actual execution was much reduced. Although this was partly because the number of his commissions was rapidly increasing, it is also noticeable that his interests had changed. Architecture and the remains of ancient Rome took up much more of Raphael's time and energy. When he was appointed Bramante's successor as architect of St. Peter's in 1514, he took his post very seriously, and in 1519 the Ferrarese ambassador reported that he had met Raphael on the building site of St. Peter's 'playing the part of Bramante'. Unfortunately, very few architectural drawings from Raphael's hand survive, and while some of his ideas for St. Peter's are known from copies made by assistants (Plate 184), there are, for example, no clues as to how he worked out the complex spatial problems presented by the Chigi chapel of 1512-15. Not surprisingly, his architectural drawings that do remain, such as a copy of someone else's drawing of an interior view of the Pantheon (Plate 185) or his rapid sketches for St. Peter's, are as superb as everything else he did. Moreover, his famous letter to Leo X about the antiquities of Rome shows not only his interest in architectural drawing, but also his understanding of the technical problems encountered by architectural draughtsmen.

Raphael's approach to architecture was first set out in a letter addressed to Castiglione in 1514, written shortly after he became architect of St. Peter's: 'I want to find the beautiful forms of antique buildings if this is not the flight of Icarus. I get a good deal of light from Vitruvius but not enough.' Such a statement indicates that he was interested in theory as well as in structural forms. The best Latin version of Vitruvius had been published in 1511 by Raphael's collaborator on St. Peter's, Fra Giocondo, and it was from this text that he had an Italian version prepared by the humanist and translator Marco Fabio Calvo. This codex with marginalia by Raphael, which still exists, reveals how carefully the artist studied classical concepts. Since his remarks are mostly of a technical nature he may have read Vitruvius under the guidance of Fra Giocondo himself, whose fame as an outstanding engineer was widespread. As Raphael wrote to his uncle, 'He is a man with a great reputation for knowledge from whom I can learn; he has some beautiful techniques in architecture from which I can become most perfect in this art . . .'

Raphael's study of the antique can be seen best in his famous unsigned letter of 1519 to Leo X. While its authorship has been much debated, there can be little doubt that it was written, with the help of Castiglione, by Raphael in his capacity

as *Commissario dell'Antichità,* an appointment he had received in 1517. The papal brief naming him to this post stated explicitly that he was to prevent the destruction of inscriptions; however, no provisions were made for preventing ancient stones from being used for the rebuilding of St. Peter's. Nevertheless, Raphael was in a position to prevent wanton destruction since he held the joint posts of Architect of St. Peter's and Director of Antiquities.

That Raphael could write so much about highly technical matters is the result of his long study, which he had begun some five years earlier under Fra Giocondo. The letter is a key document to understanding his outlook during the last years of his life. At the same time it is a unique synthesis of the two traditions of investigating ancient Rome which had begun in the fifteenth century: although there are no drawings accompanying the letter, it is written by an artist, and edited by a humanist, and thus fuses both the artistic and the literary traditions.

Artists had begun to take an interest in recording actual ruins at the beginning of the quattrocento. Brunelleschi and Donatello are reputed to have drawn among the ruins, thereby breaking with the tradition of relying on patternbooks for depicting architecture. Surviving architectural sketchbooks of the fifteenth century testify to the widening appeal of such studies and 'on-site' observations and, by the

184. Copy after Raphael. *Project for St. Peter's: Elevation and Section.* New York, Pierpont Morgan Library.
Raphael planned his architecture as carefully as he planned his paintings. He felt it was necessary to draw detailed elevations and sections, as seen here, in addition to ground plans.

185. *Interior View of the Pantheon.* Pen, 27.7 × 40.7 cm. Florence, Uffizi.
Because this drawing is a duplicate of one from the *Codex Escurialensis*, which was already in Spain by 1508, before Raphael is known to have arrived in Rome, it is probable that both go back to a common source, thus demonstrating the continuation of the pattern book tradition.

1480s, even a painter such as Botticelli who had little interest in architecture or recreating antiquity could produce an archaeologically acceptable rendering of the Arch of Constantine.

With the return of the popes to Rome at the beginning of the quattrocento, various humanists began to examine and write about the architecture of ancient Rome. The need for the city to be considerably rebuilt after the long years of neglect was readily apparent. The hostility of the populace to the papacy did not diminish the latter's determination to recreate a great capital, modelled on old imperial Rome, and worthy of the spiritual leader of western Christendom. The first literary efforts reached fruition during the reign of Nicholas V. Leone Battista Alberti compiled a *Descriptio Urbis Romae,* which gave the distances between important ancient buildings, and Poggio Bracciolini used the ruins to support his moral argument about the vagaries of fortune in his *De varietate utriusque fortunae.* Most important for Raphael was the *Roma instaurata* of Flavio Biondo, which, based on visual and literary sources, has been described by Roberto Weiss as a 'vision of ancient Rome'. It remained until the sixteenth century the best evocation of the grandeur that had once been the ancient capital.

Raphael's letter is the product of these two traditions. In it he advises Leo as to what has to be done to reconstruct ancient Rome accurately and how to do it. Raphael asserts that he has eagerly measured the monuments while constantly

199

reading the good (that is, ancient) authors and comparing the remains with the texts, a method learned from the humanists. As a result of his inspections, he says, he has learned that Rome has three kinds of architecture: the ruins of the imperial capital, the unprepossessing structures from the days of the 'Goths', and the modern buildings, which are comparable to those of antiquity and of which those erected by Bramante are particularly fine examples. He discusses ancient architecture again, making special reference to Vitruvius, whom he clearly held in great esteem, and stresses that it was this style that survived *'con bona ragione'* until the end of the empire. These ancient buildings are the ones he wishes to record in accordance with the Pope's instructions. He then embarks on a fascinating technical discussion about the best method of measuring and drawing them. To avoid error he proposes using a complex compass but, because an architect's drawings differ from those of a painter in that an architect must show not only all measurements but also all parts of a building without error, he deems it necessary to make three drawings of every building: a ground-plan, an elevation showing all details, and a section. Specimens of such drawings, which were to be added to the letter, do not survive. In a kind of postscript he adds that he will also draw some buildings in perspective, so that he may show 'grace, good proportion, and symmetry, because a properly foreshortened view cannot be shown in purely architectural drawings.'

The suggestion of making three drawings for every building was novel, and Paolo Giovio wrote that Raphael had invented a new method of presenting architecture. C.L. Frommel has shown that this kind of accurate drawing of buildings had originated, in all likelihood, in Bramante's workshop with drawings for the cupola of St. Peter's, but Raphael can still be credited with the significant innovation of combining an architect's method with the archaeologist's recording of ancient structures.

Despite Raphael's inclusion of the often-repeated complaint that the antiquities were constantly being destroyed, the letter was clearly intended not as an archaeological report, but as an investigation into how the Rome of the past was a prelude to the Rome of the future. In seeking such information the artist did not confine himself only to buildings or even to Rome. Vasari tells us in the life of Giovanni da Udine that Giovanni and Raphael went together to study the recently discovered decorations of the Golden House of Nero and were overwhelmed by the 'freshness, beauty, and quality' of what they saw. Raphael's visit to Tivoli in the company of four humanists in 1516 was partly to visit the ruins of Hadrian's villa. After his death Castiglione wrote, 'You had to die just when your lofty spirit was on the point of wakening to life Rome in her ancient beauty, mutilated in limb and ravaged by war, fire and the lapse of centuries.'

Another of Raphael's interesting projects concerning the ancient city was cut short by his untimely death. Marcantonio Michiel wrote, 'scholars have the most reason of all to lament and after them painters and architects, for he intended in a book . . . to represent the ancient buildings of Rome and in this work to show their proportions, their forms, [and their] decorations so clearly that everyone who saw these pictures could justly say that he had seen ancient Rome.' No longer extant, Raphael's work dealing with the 'first region of the city' had met with general admiration. What is clear from Michiel's description is that it was intended not just as a pictorial map (Plate 186), but as a complete plan (insofar as that was possible) of Rome and her edifices. Such a work is conceptually very different from the crude schematic maps included in Mario Calvo's *Antiquae urbis Romae cum regionibus simulacrum* of 1527, which is sometimes considered a reflection of Raphael's work but in fact follows the more traditional plans of the previous century. Similarly, the *Antiquitates urbis Romae* by Andrea Fulvio (also published

186. Alessandro Strozzi. *Rome.*
1474. Pen and ink. Florence,
Biblioteca Medicea-Laurenziana.
Typical of the plans provided for
pilgrims, this drawing illustrates
with a rather free topography the
main monuments tourists would
have expected to visit. To the right
is the Vatican. Santa Maria del
Popolo is visible at the bottom to
the left.

in 1527) is the work of an erudite antiquarian rather than of an observant artist.
In the preface Fulvio states that he directed Raphael's drawing of classical remains
shortly before the artist's death, but in his text the historian fails to note that the
reliefs on the Arch of Constantine belong to two different eras, a fact of which
Raphael was aware.

One other document testifies to Raphael's involvement in town-planning.
Monsignor Angelo Mercati discovered a command of Leo X, unfortunately not
dated, ordering the *maestri delle strade,* together with Raphael and Antonio da San
Gallo, to develop the quarter and piazza by Santa Maria del Popolo. Since the
maestri were not architects but administrators concerned with the proper main-
tenance of streets and buildings, this can only mean that Raphael and San Gallo had
prepared some plan for this important part of Rome, for the execution of which
the collaboration of the *maestri* was needed. It is impossible to say how much was
done in compliance with this order, but an inscription of 1525 attributes the
threefold entrance into Rome from the Porta del Popolo to the two Medici popes,
Leo X and Clement VII.

How deeply Raphael was affected by his discovery of classical decoration is best
and most charmingly shown in the work he designed for Cardinal Bibbiena's
residence in the Vatican palace. What inspired Raphael and Bibbiena was the

pictorial decoration of the Golden House of Nero. The walls in this enormous palace were covered with very delicate and sophisticated paintings of floral and ornamental motifs in which fabulous little beasts and mythological figures intermingled. Since by the fifteenth century the rooms were underground they were referred to as *grotte* (caves) and so the decorations found in them acquired the name *grotteschi* (grotesques), which has become the generic term for this kind of ornamentation.

A small loggetta (Plate 187) opening out from Bibbiena's rooms was painted in imitation of a garden pergola covered with plants and birds. In between are mythological scenes and allegorical figures, and on the ceiling a veritable bestiary of both real and fabulous animals. Painted in 1519, it conveys the feeling of a light and airy retreat. More striking is the bathroom painted in 1516 (Plate 188), for

187. Loggetta, Vatican Palace, Rome.
This small gallery was painted in imitation of a garden pergola with birds, plants, and statues. In between were interspersed scenes from classical myths.

188. Cardinal Bibbiena's Bathroom ('*La Stuffetta*'), Vatican Palace, Rome.
This small room, measuring 2.5 meters square, was covered with frescoes on the walls and ceilings. The motifs, some of which are erotic, were chosen by the Cardinal himself, designed by Raphael, and executed by the workshop.

which the programme was suggested by Bibbiena himself, as we know from letters. Set against a background of Pompeian red are scenes from Ovid's *Metamorphoses*, some lightly erotic, others simply playful. The walls are further adorned with grotesques and putti driving chariots drawn by snakes, turtles, snails, or dolphins. While the choice of scenes involving Venus and her influence may seem odd for a cardinal, it should be remembered that Bibbiena received his hat as a reward for long and devoted service to the Medici, not to the Church. There is no evidence that he ever took priestly vows, which were not required for the office of cardinal. In fact, Leo himself was not ordained a priest until the day before he became pope. Furthermore, taking the vow of celibacy did not entail renouncing worldly

knowledge. Bibbiena was an urbane scholar and humanist, and Latin literature was an integral part of his life.

The artist mainly responsible for painting these rooms was Giovanni da Udine, who specialized in this kind of decoration, but other assistants of Raphael's were involved as well. The result is that of an excellent yet imaginative adaptation — not an imitation — of what Giovanni and Raphael had seen in the Golden House. The tastes of the patron and the inventive artists were in perfect harmony, all fascinated by the richness of the classical heritage. The bathroom, although on a small scale, is a fine example of the re-creation of Roman splendour, which was the ideal of Raphael and his patron.

Such striving for splendid and lavish decoration is even more obvious in the Loggie (Plate 193), the long gallery running along the papal apartments. While Raphael's hand can be found only in the preliminary designs, there is no doubt that the idea of combining Biblical scenes with grotesques all'antica is his. The Loggie are, in a way, the Golden House brought up to date.

The building history of the Loggie, like that of the whole Vatican palace, is complex. Although Bramante began work in 1509, the entire structure was far from finished at the death of Julius, and, after Bramante's death in 1514, Raphael undertook first the completion of the building and finally, in 1517, the decorations. It is unlikely that this latter work began before the Stanza dell'Incendio was finished in May of that year, after which the workshop was available for new work. The decorations were completed by June 1519.

The long gallery is made up of thirteen bays divided by arches. At the centre of the middle vault are the arms of Leo X; at the centre of the others are either the Medici imprese or the crossed papal keys. Placed around these in each vault are four rectangular panels with scenes from the Old and New Testaments, the majority of scenes being taken from the former. In many of them Raphael's study of his predecessors' work is obvious: the Creation scenes (Plate 189) transform Michelangelo's monumental renderings of the Sistine Ceiling into more lyric narratives; the Expulsion is a gentler version of Masaccio's fresco in the Brancacci Chapel, and the landscape of the Jacob and Rachel panel is taken from a Dürer print. Raphael borrowed freely from his own paintings as well, in particular using the ceiling of the Stanza d'Eliodoro. But the exotic flavour of the whole scheme depends on the illusionistic architecture, rich grotesques, and stucco reliefs spread all over the walls and ceilings. A riot of forms and colours, in character antique and in its mythological allusions often pagan, it gives the impression that Raphael wanted to show how Christian imagery could be combined with classical splendour without detriment to either. But it must be stressed that these decorations are not meaningful in any iconological sense; rather, they are intended to be admired as art for art's sake.

Because the Loggie were originally open to the air the paintings have unfortunately much deteriorated. Originally they must have been stunningly sumptuous with their rich pigments, gilding, stuccos, and brightly coloured floor tiles. Raphael and his school gave Leo a gallery worthy of the pontiff who wanted to be considered the social peer of secular rulers. The work done for Cardinal Bibbiena has culminated in this grandiose scheme of decoration.

Vasari was right when he claimed that Raphael conceived and supervised the project but that it was carried out by his assistants. Once again Giovanni da Udine led with his fine sense of colour and knowledge of the antique decorative motifs. Another important collaborator was Gianfrancesco Penni who drew the majority of the extant drawings for the Biblical scenes. The boast of Giulio Romano to Vasari that he alone was responsible for painting the Loggie has long been disproved, and

189. *The Creation.* Rome, Vatican Palace, Loggie.
While drawing on Michelangelo's Sistine Ceiling for the creation scenes, Raphael has filled in this ceiling with a lattice work sprinkled with tiny angels. In other bays he also used grotesques or *trompe-l'oeil* architecture.

Nicole Dacos has shown that his share was certainly no greater than that of other members of the Raphael shop such as Perino del Vaga or Tommaso Vincidor. A scene of the workshop was included by Giovanni da Udine in one of the stuccos as a group 'signature' (Plate 190).

But the search for individual hands must not be allowed to interfere with the admiration for the central concept: an evocation of the antique by bringing endlessly varied motifs together. In this Raphael certainly succeeded. There is nothing antiquarian or archaeological about his use of antique prototypes. The classical motifs are never 'quotations' chosen to show off the artist's erudition. Instead they are instances of an imaginative reshaping of a certain type of decoration. Raphael's preoccupation with antiquity becomes perfectly com-

prehensible once we realize the creative role his archaeological studies played in many of his later works.

These same studies played a central role in his work as an architect, an activity still much neglected. His employment in this specialized vocation is not surprising. Architecture in the early sixteenth century was not yet an established profession, and the genius of a designer was often sought in preference to the ability of a competent practitioner. Throughout the fifteenth century and into the sixteenth century the 'inventing' architect was assisted by a mason or another similarly experienced craftsman. Leo X and Agostino Chigi, Raphael's two most significant patrons for architecture, wanted ideas from him and expected that they would be properly translated by a technical assistant into buildings that would not fall down.

As far as we know, the commission of about 1512 for Chigi's mortuary chapel in Santa Maria del Popolo was the first involving architecture that Raphael received. The pictorial and sculptural decoration was discussed in Chapter 4, but it must be realized that the decorations form only part of the whole, which, as John Shearman has said, brings together 'all the visual arts in a most unusual integration'. Raphael had to build the chapel in an extremely confined space, bounded by, in fact, the walls of Rome and two earlier chapels. He brought to this task an astounding architectural imagination. To obtain the maximum floor area, he made the interior walls extremely thin, while resting the dome on four enormous corner piers. The disparity of thickness between the walls and the piers was masked by a marble

190. Giovanni da Udine. *Raphael's Workshop.* Rome, Vatican Palace, Loggie.
Most of the Loggie were designed and decorated under Raphael's supervision by the workshop. By including a scene of them working, Giovanni da Udine was providing the same type of 'signature' that Raphael had when he painted his self-portrait in the *School of Athens* (Plate 89).

191. The Chigi Chapel, Santa Maria del Popolo, Rome.
This chapel was perhaps Raphael's first architectural commission and he used it as an opportunity to unify in a spectacular way both the different visual arts and the lessons he had learned from studying antique remains. The paintings in the lunettes were done by Salviati in the mid-16th century and the tombs of the Chigi were completed by Bernini in the 17th century.

facing articulated so as to break up all the surfaces into pilasters and niches. The gradual transition from the cube of the chapel to the hemisphere of the dome is accomplished by making the frames of the pendentives (Plate 191) stretch across to touch the top of the wall lunettes. This gives the effect of four pieces of tautly stretched skin, which are held in place by the two cornices, the bottom one angular, the one above round. Unfortunately, as so often happens with architecture, no photograph can give an adequate idea of the energy created by this solution. It must be experienced *in situ*.

Already at this early stage Raphael was incorporating into his architecture what he had observed in the ruins of ancient Rome. The entrance of the chapel (Plate 192) is framed with a magnificent arch, and the various decorative motifs have been carefully translated from ancient to modern usage. He does not follow the strict hierarchy of the ancient orders as set forth by Vitruvius, but uses different parts freely so that his architecture is a reminiscence rather than a re-creation of ancient Roman buildings.

192. Entrance arch to the Chigi Chapel, Santa Maria del Popolo, Rome.
The magnificent entrance arch to the chapel recalls Roman triumphal arches. Raphael's innate sense of design enabled him to synthesize many antique motifs into a modern work of art.

It is known that Raphael received commissions to build palaces or villas from several members of Leo's inner circle, but little of this work survives. The Palazzo dell'Aquila was pulled down to make room for Bernini's colonnade; the original appearance of the palace of Leo's surgeon, Antonio da Brescia, is known only from a Heemskerck drawing; and the Palazzo Vidoni was spoilt by a nineteenth-century façade. The Villa Madama, never completed, was severely damaged during the Sack of Rome in 1527, when Clement VII's old enemy Cardinal Colonna used the opportunity of the Pope's seclusion in the Castel San Angelo to burn the building. Part of it was later repaired. The Palazzo Pandolfini in Florence does survive, but it is only a tradition started by Vasari that attaches Raphael's name to the design, and the execution was certainly directed first by Francesco da San Gallo and after 1530 by Aristotile da San Gallo.

Classical elements and Roman decoration are found in all these buildings; the most impressive in this respect, although much of the building was destroyed, is the Villa Madama (Plate 194). A letter from Raphael reveals that he wanted to

193. General view of the Loggie, Vatican Palace, Rome.
The building was begun by Bramante during the reign of Julius II, and this grand loggia of thirteen bays was completed and decorated under Raphael. The brilliant colours, stucco-work and lavish decorations are directly inspired by antique examples, particularly those in the Golden House of Nero.

recreate here a villa *all'antica,* and C.L. Frommel has shown that he began by modelling the villa on a similar one by Bramante, which itself had been based on Roman models. Further inspiration was derived from Pliny's description of his villa at Laurentium near Ostia, from Vitruvius, and Nero's Golden House.

The patron for whom the villa was to be built was Cardinal Giulio de'Medici. (It received its present name when it belonged to 'Madama', Margaret of Parma, a daughter of Charles V.) If the villa had been completed in accordance with Raphael's ideas, it would have been a modern version of a Roman imperial palace. Situated on a hillside above the Tiber near the Milvian Bridge, it was planned to have not only lavish living quarters and stables for two hundred horses, but also a theatre and a hippodrome. The large gardens between the Vatican and the Monte Mario were to have been adorned with statues and ornamental waters. Such a fusion of nature and architecture, intended to vie with the grandest imperial villas, was truly in the spirit of the classical revival.

The rich interior decorations (Plate 195), some of which still exist, further contributed to this effect. Fischel has observed correctly that, 'on the showing of Vasari, Giulio Romano appears to have assigned to himself somewhat too large a share in the architectural conceptions; the paintings by him . . . are unfortunately unmistakeable in their crudity.' This is of course because they were painted by Giulio after Raphael's death and lack his restraining influence. On the other hand, the ever-delightful Giovanni da Udine has kept beautifully the light-hearted touch of the classical grotesques that he had executed under the master.

Raphael's largest architectural project was the rebuilding of St. Peter's. As a novice he turned, as we have seen, to the master engineer Fra Giocondo, who had first been called in to help in 1513. His skills were needed to correct the structural

194. Exterior of the Garden Loggia, Villa Madama, Rome. Begun around 1516 for Cardinal Giulio de'Medici, this villa was planned as a deliberate re-creation of the glories of ancient Rome, bringing together elements from Pliny, Vitruvius, and Nero's Golden House.

195. Interior of the Garden Loggia, Villa Madama, Rome. These lavish decorations were directly inspired by remains of antique wall decorations and were carried out by Giovanni da Udine and Giulio Romano after Raphael's death.

failures caused by Bramante's ignorance of technical matters. After Fra Giocondo's death in 1515, the responsibility for this side of the project was given to Antonio da San Gallo.

It seems that Bramante himself recommended to the Pope that Raphael be made his successor, an appointment of which the painter was particularly proud. He wrote to Castiglione, 'Honouring me the Pope has laid a great burden on my shoulders, that is, the care for the fabric of St. Peter's.' To his uncle he reported his appointment by saying that nothing could be a worthier task than being made architect of the *'primo tempio del mondo'*, the first temple of the world.

In spite of the fact that Raphael's contribution has been absorbed into the work of his successors and is therefore difficult to distinguish, it is clear from drawings

(Plate 182) that he intended to continue St. Peter's in the spirit of Bramante. He planned a longitudinal church with ambulatories and five bays in front of the large space under Bramante's dome. While the details of the interior employed many classical elements, the outside, as proposed by Raphael, would have been made even more 'Roman' in character, by translating an ancient temple front into a modern façade using columns and a pediment. There was also to be a two-storied portico reminiscent of Old St. Peter's.

Work progressed slowly under Raphael's directorship. Leo X, true to his strong Medicean roots, lacked interest in St. Peter's and preferred instead to expend his energies and monies on a plan for adding a façade to the family church of San Lorenzo in Florence (a project for which Raphael was requested to submit a design) and the national church of his fellow Florentines in Rome, San Giovanni dei Fiorentini.

Raphael's studies of antiquity had a profound influence on his architecture. The impact of the ancient Roman structures can already be seen in the fresco of the *School of Athens.* The Chigi chapel, the purest example of Raphael's architecture still standing, shows a sensitive fusion of the decorative and the functional elements derived from antiquity. On the other hand, the Loggie, with their light and extravagant flavour, recall the elegance of a Roman palace. His two main architectural projects, Villa Madama and St. Peter's, today scarcely show what Raphael had planned, but it is in these two buildings — the one secular, the other religious — that he probably would have come closest, as Castiglione would have it, to reawakening Rome.

7 The Last Years

Such large projects as the Vatican Loggie or the Farnesina *Cupid and Psyche* obviously required considerable participation by his workshop but, in addition, as Raphael's fame grew, he began to rely more and more on his assistants to execute the smaller works such as altarpieces or private devotional panels. Much in the same manner as Perugino, he became essentially the head of a firm that followed his designs and adapted standard types to fill the necessary functions. That the finished product was usually far inferior in quality to anything the master himself would have produced did not matter. Just the association with the name Raphael was sufficient for most of his patrons.

There was no deception in this. Michelangelo was unique in his dislike of assistants. The system whereby a busy and successful master employed assistants served also to train aspiring artists during their apprenticeship, and in most cases it worked extremely well. It was the subtlety of Raphael's work, with its rhythmical designs and delicate modelling, that made copying difficult and imitation impossible. The absence of these qualities from paintings produced in Raphael's name was due to the transcendence of his work in comparison with that of his competent but uninspired followers.

Nowhere is this more obvious than in the series of *Madonnas* painted after 1518, such as Plates 196 and 197. Raphael seems to have had no interest in exploring further the formal problems of grouping the Virgin and Child with the young Baptist and St. Elizabeth or St. Joseph, but it was a subject with which his name was irrevocably connected and which his patrons demanded from him. His practice was to provide a basic design and pass it on for execution to his workshop, which in turn made use of the facial types from the *Madonna of Francis I* (Plate 181).

In spite of this procedure, these works commanded large sums and were treated with great respect. *The Visitation* (Plate 198), a pastiche made up from parts of the Loggie and of the *Madonna of Francis I,* cost the donor, the father of one of Raphael's close friends who was an executor of his estate, three hundred scudi. It was installed in a chapel of San Silvestro in Aquila in April 1520, and there can be no doubt that Raphael's involvement in this mediocre work was limited to the most cursory design. Yet such was the fame of Raphael's name that four days before his death the city council of Aquila forbade the copying of this altarpiece.

Such cavalier treatment was not reserved for patrons in the remote provinces. The *St. John in a Landscape* (Plate 199) was commissioned, according to Vasari, by Cardinal Pompeo Colonna as a gift for his Florentine physician Jacopo da Carpi. Although the Colonna were one of the most powerful Roman families, Raphael provided only the composition, and again left the execution to his assistants.

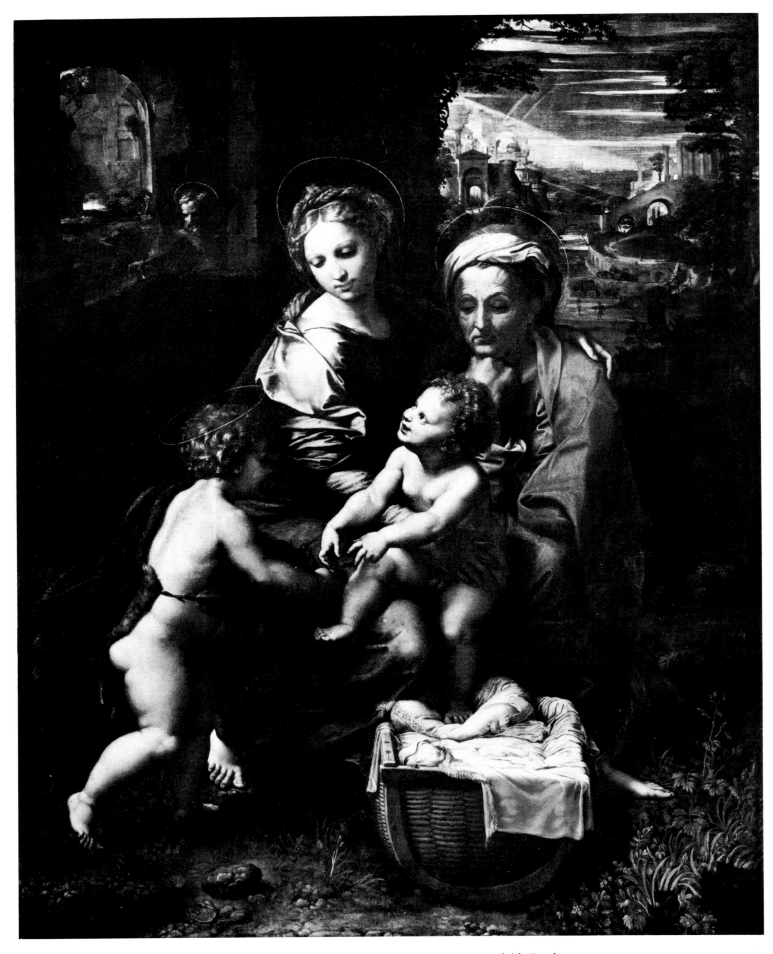

196. *The Madonna della Perla*. Canvas, transferred from panel, 144 × 115 cm. Madrid, Prado.
This picture, which may have been painted after Raphael's death, has been generally ascribed to Giulio Romano. It acquired
its nickname when Philip IV of Spain exclaimed that it was the 'pearl' of his collection.

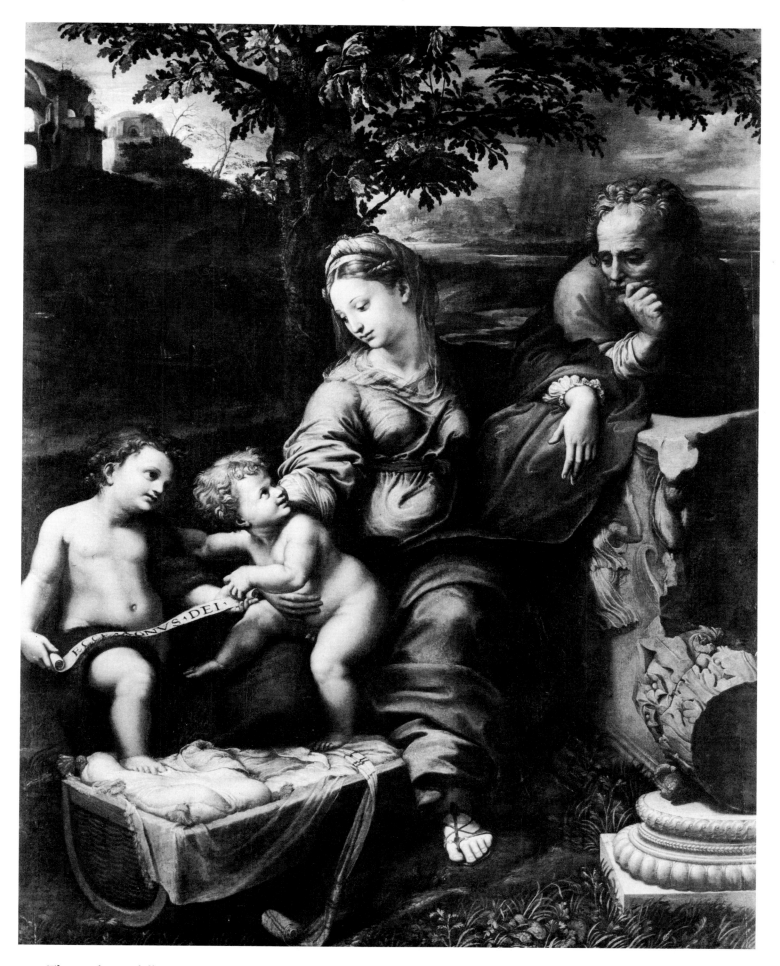

197. *The Madonna della Quercia*. Panel, 144 × 110 cm. Inscribed on the cradle: RAPHAEL PINX.
Madrid, Prado.
Experts generally consider this to be a workshop product after Raphael's designs. The master's interest
in Roman remains can be seen in the various antique ruins in the painting.

198. *The Visitation*. Canvas, transferred from panel, 200 × 145 cm. Madrid, Prado.
The inscription along the bottom of the picture, RAPHAEL VRBINAS F. MARINVS BRANCONIVS F.F., was certainly not by
Raphael, as his signature is always incorporated into the body of the painting. The Virgin's face conforms to the
same type as those of the *Madonna della Quercia* and the *Madonna della Perla*.

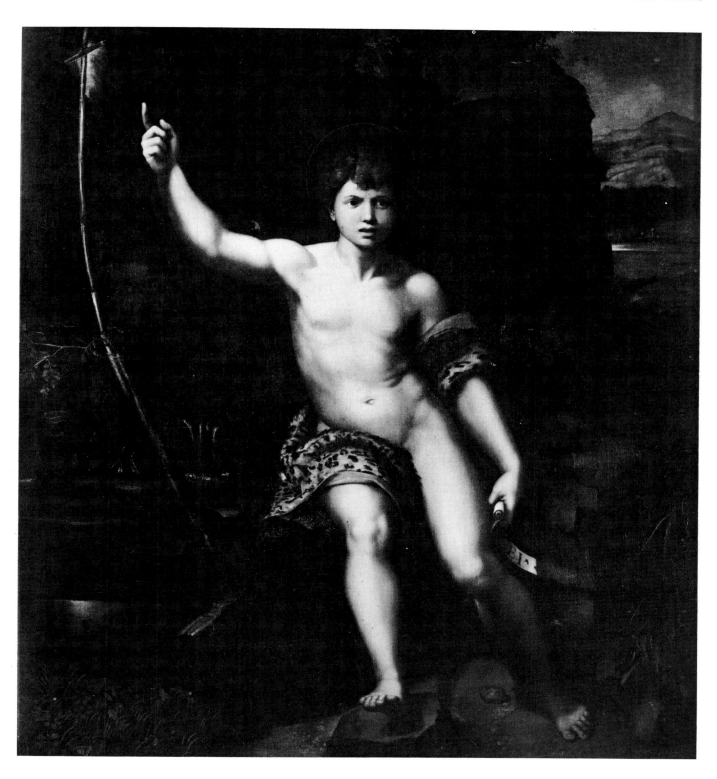

199. *St. John the Baptist in a Landscape.* Canvas, 165 × 147 cm. Florence, Uffizi.
Although it is agreed that Raphael did not paint this work, it is not known which of his assistants was responsible for the execution after his design.

The most informative source for Raphael's activities in his last three years is the correspondence between the Ferrarese ambassadors to the Vatican and Alfonso d'Este, Duke of Ferrara. In March 1517, the Duke ordered a *Triumph of Bacchus* from Raphael, a commission that was accepted but never executed. Because the painting appears to have been planned but not begun, the various envoys, constantly harassed by Alfonso for progress reports, were forced to explain away the continuous procrastination. What emerges from these letters is an artist who has accepted too much work, is anxious to remain on good terms with powerful and important nobility, and finds his time constantly being taken up by the demands of the Pope.

Alfonso and his sister Isabella d'Este, Duchess of Mantua, were great rivals for the services of outstanding artists. While her son had been hostage at the court of Julius II, Isabella had tried to procure a portrait of him by Raphael, but this commission came to an end with Julius's death. Not easily discouraged, she tried for another panel in 1515, again without result. Alfonso, for all his efforts, was equally unsuccessful. He intended the *Triumph of Bacchus* to hang with other paintings of mythological subjects by prominent artists in his *studiolo*. Already in place were a *Bacchanal* by his court artist Dosso Dossi and the *Feast of the Gods* by Giovanni Bellini. Raphael's old friend Fra Bartolommeo had been retained to provide a *Children's Bacchanal*, a commission transferred to Titian after Fra Bartolommeo's death in 1517. Eventually works by Titian dominated the room, including the *Bacchus and Ariadne* as a substitute for the panel Raphael never painted.

Six months after the initial contact, the project began to run into trouble. Raphael informed the Ferrarese ambassador that one of his assistants, probably Battista, the younger brother of Dosso Dossi, had returned from Ferrara with the news that another artist had already painted the *Triumph of Bacchus*. Raphael was implying that his design had been plagiarized. Nevertheless, he said, he was still desirous of serving the Duke and would be happy to paint another subject. In November the Duke paid a retainer of fifty ducats and, as a gesture of good will, Raphael sent the cartoon for one of the histories of Leo IV from the Stanza dell'Incendio to Ferrara. The monetary side of the transaction was handled by Raphael's old friend and patron, Bindo Altoviti.

In June 1517 the ambassador had already begun the long stream of letters assuring the Duke that Raphael would start the Duke's commission as soon as his current work for the Pope was completed. As these projects included the last stages of the Stanza dell'Incendio, the planning and decoration of the Loggie, and various architectural and archaeological projects, no progress was made on the Ferrarese panel. Letters in December 1517 and throughout spring 1518 continue this theme: Leo was blamed for monopolizing Raphael's time to the detriment of other clients. No mention was made of the Loggia of Cupid and Psyche for Chigi, which was being carried out at this time, perhaps because the ambassador preferred to leave his master in ignorance of the fact that the banker whom his niece had refused to marry was being given precedence over nobility. However, Alfonso was not alone. In July 1518 Sebastiano del Piombo wrote to Michelangelo that the *Transfiguration*, commissioned by Cardinal Giulio de'Medici in the latter part of 1516, was still not begun.

In September 1518 Raphael sent the Duke, as a substitute for the promised work, the cartoon for the large *St. Michael* he had painted for the French court. The carrier was probably Battista Dossi, this time on his way to Venice to buy colours. Once again the ambassador assured the Duke that Raphael would soon begin his project, now a *Hunt of Meleager*. The projected starting date was immediately after Christmas.

Throughout 1519 the same story was repeated except that now part of the delay was said to be due to the *Transfiguration*. In addition, there were the excuses of Raphael's duties as architect of St. Peter's and as Director of Antiquities, and the project to redevelop the area by Santa Maria del Popolo. Documents indicate that at this time Raphael was further engaged on the completion of the Vatican Loggie, a design for a funerary monument for Federico Gonzaga (Alfonso's brother-in-law), and a proposal for removing a newly discovered obelisk from the mausoleum of Augustus to the piazza of St. Peter's, a task that would have required considerable engineering skills.

200. Sebastiano del Piombo. *The Raising of Lazarus.* Canvas, transferred from panel, 381 × 289 cm. London, National Gallery. Sebastiano and Michelangelo considered this commission as being in competition with Raphael's *Transfiguration*. Drawings show that the Lazarus group was designed by Michelangelo. Kneeling at Christ's feet is Mary Magdalene, whose relics were preserved with those of Lazarus in Narbonne Cathedral.

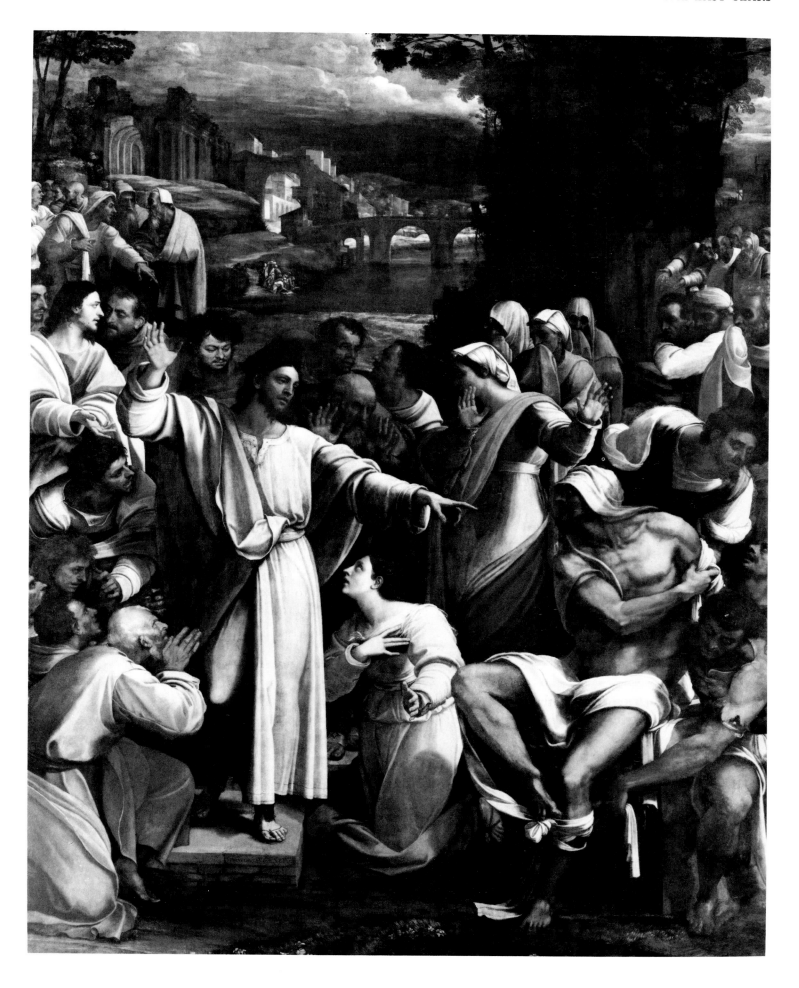

By now, the Duke was employing his third ambassador since the beginning of the whole affair. Alfonso Paolucci, a man determined to give his master satisfaction, attempted to enter Raphael's house to see if any progress had been made on the Duke's commission. Once, he reported, Raphael was designing stage scenery; on another occasion he was busy painting a portrait of Castiglione and could not be interrupted.

By January 1520, Alfonso felt that things had gone on long enough and ordered his ambassador to appeal to Cardinal Cybo to bring pressure on Raphael to complete the painting. In February Paolucci informed the Duke that he had at last seen a drawing for the work and Battista Dossi was confident that Raphael would begin work on the *Hunt* as soon as the *Transfiguration* was finished, probably around Carnival. Such optimism was not to be rewarded. On Good Friday, 1520, Raphael died after a brief illness. The unfortunate Duke then spent two years attempting to recover his deposit of fifty ducats from Raphael's heirs.

Paolucci's letter of 3 September 1519 shows that Raphael was devoting much of his time to the *Transfiguration* (Plate 201). The commission had assumed the nature of a competition after Cardinal Giulio de'Medici had followed his order to Raphael with a request to Sebastiano del Piombo to paint a *Raising of Lazarus* (Plate 200). This was probably at the behest of Michelangelo, who was expected to supply designs from which Sebastiano was to work. Both Michelangelo and Sebastiano loathed Raphael, and the letters sent to Michelangelo in Florence by Sebastiano and his friends reporting on Raphael's progress in Rome are filled with sneering and scornful remarks as well as a good deal of paranoia.

It is ironic that most of the documentation on the progress of the *Transfiguration* should come from hostile witnesses. The first reference to Raphael receiving this important commission is in Leonardo Sellaio's letter to Michelangelo of 19 January 1517, which shows, as Michael Hirst has argued, that the commission for a second altarpiece came only after Michelangelo met Cardinal Giulio in December 1516 and sought support for his protegé against their hated rival. Giulio de'Medici was sufficiently shrewd quickly to appreciate the advantages of such rivalry. He must have been well aware of the results of a similar competitive spirit between Michelangelo and Leonardo some ten years earlier in the Palazzo Vecchio in Florence. Not only would he be getting an altarpiece a great deal of which was designed by Michelangelo, but he would also be sure that Raphael painted his picture with his own hand, for his reputation would be at stake.

These monumental altarpieces were destined for the cathedral of Narbonne, of which Giulio had been made archbishop in 1515 through the good graces of Francis I's mother. At the same time, he had become Cardinal Protector of France as part of the Medici policy of encouraging closer ties with the French royal house. The commission coincided with the completion of four new apsidal chapels in the cathedral. A gift of such largesse as the two new altarpieces was aimed at making a favourable impression upon the local inhabitants, in the same manner as Julius's gift of the *Sistine Madonna* to the city of Piacenza had done.

Because Giulio was taking advantage of the competition between the artists there have been attempts to show that he deliberately chose related subjects for them. However, this is unlikely since it seems that he did not originally intend to send two altarpieces to Narbonne. Furthermore, not only are the two panels of different dimensions, but the light falls from opposite sides, indicating that they were never intended to be placed near each other. A typological relationship between the two subjects does exist as both the Transfiguration and the Raising of Lazarus were considered as prefigurations of the Christ's Resurrection in Biblical exegesis. This tradition, brought together in the famous Bible commentaries by Nicholas of Lyra,

201. *The Transfiguration*. Panel, 405 × 278 cm. Rome, Vatican Pinacoteca.
Recent cleaning has revealed the stunning brilliance of the colours Raphael used in his final masterpiece. The monumental work, over twelve feet high, was placed at Raphael's head as his body lay in state. It was never sent to its original destination, the Cathedral of Narbonne, but was kept in Rome.

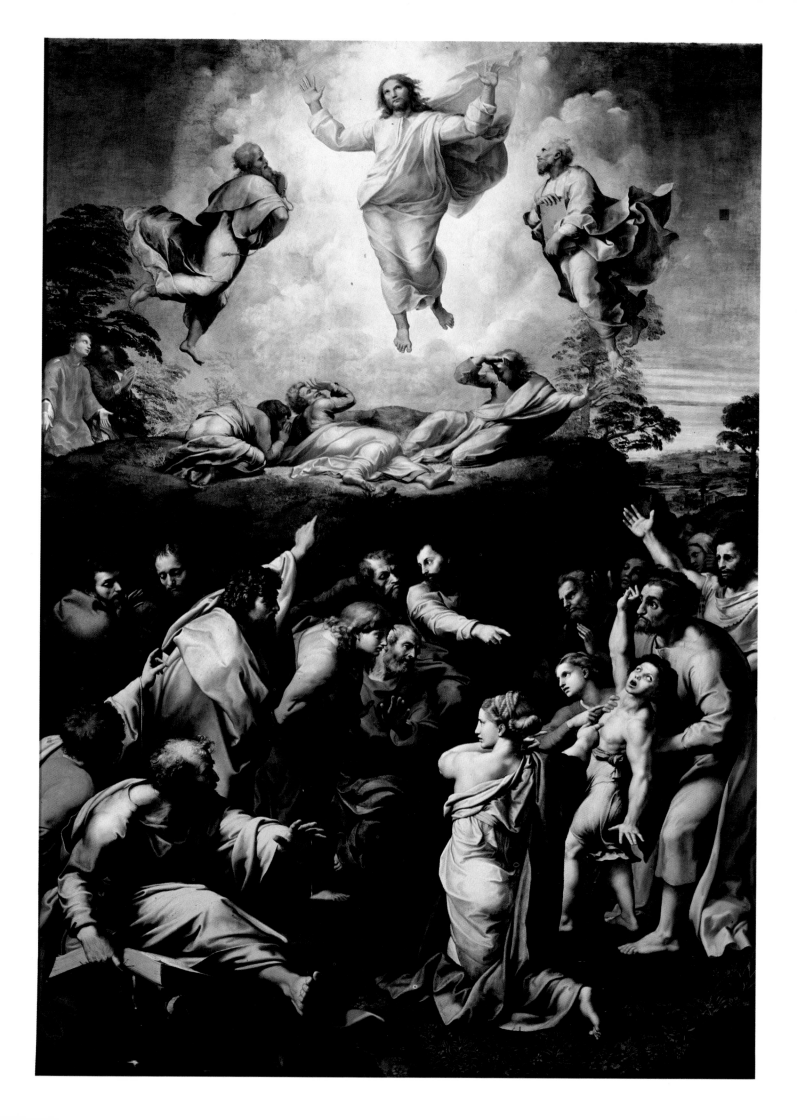

202. Raphael School. *Modello for 'The Transfiguration'*. Brush and wash with white heightening, 39.8 × 26.8 cm. Vienna, Albertina. This copy of Raphael's preliminary design shows Christ standing on the ground addressing Peter. To the extreme right can be seen the two patron saints of Narbonne Cathedral, who appear on the mountain to the left in the final painting.

was well known in the sixteenth century, not least because of the publication of Thomas Aquinas's commentaries by Cajetan. But since Narbonne cathedral claimed to have relics of Lazarus and Mary Magdalene (at that time believed to be Lazarus's sister), it is possible that one of the new large chapels was planned to house these precious objects. Sebastiano's picture would then have been directly related to the dedication of the altar.

The choice of the subject of the Transfiguration presents a complex problem. The feast had been instituted by Pope Calixtus III to celebrate the defeat of Mehemet II and the Turks in 1456. The office of the new feast was composed by the Dominican Jacobus Gil, then Master of the Sacred Palace. By August 1516, the fall of Egypt had made a Turkish threat seem imminent once more, and Leo had tried to raise support for a crusade. This has led to the suggestion that the subject was initially chosen to recall the importance of resisting the infidel.

203. Gianfrancesco Penni. *Modello for 'The Transfiguration'*. Pen and bistre washes with white highlights, 41.3 × 27.4 cm. Paris, Louvre.
Dated 1518 on stylistic grounds this second stage in the planning shows the addition of the scene with the possessed boy at the foot of the mountain. Note that Christ is still earthbound.

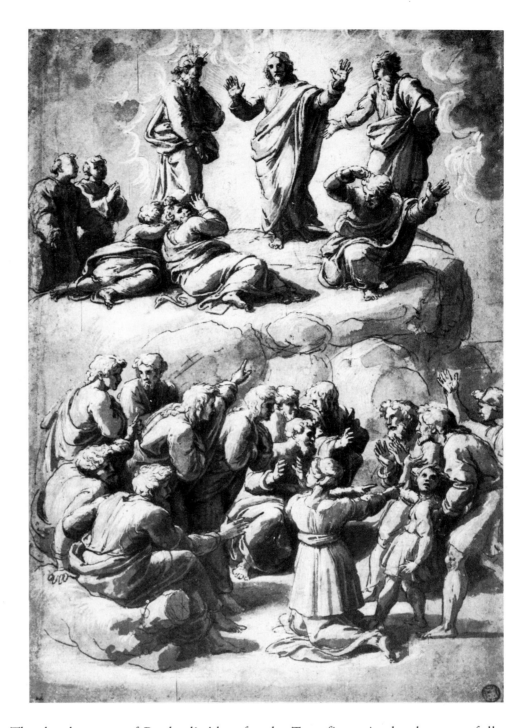

The development of Raphael's ideas for the *Transfiguration* has been carefully worked out by Konrad Oberhuber from the studio copies after Raphael's drawings. Raphael began with the traditional composition of Christ standing on the ground flanked by Moses and Elijah, the three apostles Peter, John, and James below, and God the Father in a glory above (Plate 202). The second stage shows several significant alterations: the story of the possessed boy, which follows the Transfiguration in the Bible, now occupies the lower half of the picture and God the Father no longer appears. Christ is still earthbound but the apostles recoil from His splendour, and two observers, kneeling in prayer, have been moved to the left (Plate 203). The copy of this modello by Penni shows the influence of designs for the Loggie in the drapery and figure style, and therefore Oberhuber dates it from some time in 1518.

Sebastiano's paranoia about Raphael caused him to stop work on the *Raising of*

Lazarus. On 2 July 1518 he wrote to Michelangelo, 'I do not want Raphael to see mine, because he has not yet furnished his design,' which suggests that Raphael was still at the drawing stage. Since it is most unlikely that Raphael had already begun painting, the pigments that Battista Dossi bought in Venice at the end of September were in all probability oil colours intended for the *Transfiguration.* At that time the only other large projects on which the Raphael studio was engaged were frescoes, for which pigments would not have been sought in Venice. The *Transfiguration* was alone in being of sufficient import to merit the expense of sending to Venice for colours.

More important than the purchase of paints, however, is that a member of Raphael's workshop, while in Venice, would have seen Titian's overwhelming *Assumption of the Virgin* in Santa Maria dei Frari, unveiled in May 1518 to universal acclaim (Plate 204). It may have been the influence of this work, with its central figure soaring upward in a glory of cloudlike cherubim, that led Raphael to alter his design for Christ's pose so considerably. Although he had experimented earlier for the Chigi *Resurrection* with the idea of a Risen Christ floating similarly in a glory above His sarcophagus, there is no indication in the first stages of the design for the *Transfiguration* that he had intended to employ this device.

By making Christ rise in an explosion of radiance, Raphael has endowed the image with the mystical significance that surrounds the event in the Bible. The sheer energy of the Transfiguration lifts the garments of the two Old Testament prophets. Raphael has departed from earlier paintings of the subject in that the apostles do not simply recoil but are forced back, shielding their eyes against the blinding effect of the light; they seem to be experiencing a supernatural vision rather than merely witnessing an event. Raphael's interpretation of the Bible is fuller and more convincing than his predecessors'. While Fra Angelico and Perugino placed Christ in an old-fashioned golden mandorla, and Bellini stood Him in open countryside with a cloud-filled sky in broad daylight, Raphael has surrounded Christ and the two prophets with the clouds from which, in the Bible, God's voice emanates. These clouds also define the extent of the miracle, so that neither the kneeling men to the left nor the apostles at the foot of the mountain participate in it. The dawn, which is mentioned allegorically in Peter's letter that refers to the Transfiguration (II Peter I: 16-19), and which forms part of the liturgy for the feast, is breaking to the right.

The two young men to the left are in poses of supplication, traditional to donors or figures intended to witness mystically but not take part in the events that transpire. They have been identified as two obscure martyr deacons, Felicissimus and Agapitus, because of their costumes, but it is more likely that they are the two patron saints of Narbonne cathedral, Justus and Pastor.

A unique addition to this picture is the story of the possessed boy, which Cardinal Giulio rather than Raphael must have decided upon. The apostles, unable to work miracles in Christ's absence, were forced to wait until He came down from the mountain. Jesus then cast the demon out of the boy and chided the apostles for their lack of faith.

This scene first appears in the 1518 drawing and may have been intended as an exhortation to unquestioning and unswerving faith in the Church at the very moment that the unity of western Christianity was disintegrating. On 31 October 1517, in his *Ninety-five Theses,* Martin Luther denied both the power of the pope as Peter's successor 'to loose and to bind' and the efficacy of the sacraments. His assertion that 'every truly penitent Christian is released from his offences without the formality of absolution' challenged the central role of the Church in the doctrine of salvation. The document was sent to Leo, and on 7 August 1518 Luther was

204. Titian. *The Assumption of the Virgin.* Panel, 690 × 390 cm. Venice, Santa Maria dei Frari. Titian studied the light in the apse of the Frari very carefully so that he could achieve the extraordinary effect of the Virgin soaring heavenward. It may have been the impact of this work, unveiled in 1518, that led Raphael to levitate his figure of Christ in *The Transfiguration.*

summoned to Rome for questioning. At the same time Silvestro Mazzolini, the Master of the Sacred Palace, was instructed to write yet another treatise on papal authority, *De potestate Papae dialogus.* At the beginning of November, after Luther had met Cardinal Cajetan in Augsburg, a bull was issued that reaffirmed the pope as the sole successor to Peter and, as such, able to grant indulgences to both the living and the dead. Luther countered this with a call for a council.

As has been stressed throughout this book, popes responded strongly to councils that challenged their position. Again and again, as we have seen, they had affirmed the primacy of Peter, from whom all papal power descended, over the other apostles. Supporters of the conciliar theory, on the other hand, argued that the power had been distributed equally among the apostles. Raphael's *Transfiguration* completely refutes this latter position. Without the aid of Christ the apostles cannot save the boy; without the aid of the mystical body of Christ, that is, the Catholic Church, with the pope at its head, mankind cannot find salvation; and without belief in the sacraments of the Church the soul cannot be healed. Those members of the Church who sought to work without the leadership of the pope or who doubted the efficacy of the sacraments could not offer succour to humanity.

The choice of Peter as a witness to the Transfiguration was based on his position as the recipient of the keys and had long been established in Biblical exegesis. The

occasion on which he received the keys had occurred immediately before the vision on Mt. Tabor (Matthew XVI). Peter's importance is already evident in the first drawing for this altarpiece. Raphael depicted the moment when Peter proposes to Christ that they should build three tabernacles, one to Him, one to Moses (at whom Peter points) and one to Elijah. Christ turns towards Peter alone, ignoring the other apostles. The addition of the story of the possessed boy eliminated the need to emphasize Peter's position because it demonstrated the inability of the apostles to act in concert without the leadership of Christ, a role passed on to Peter with the keys. Thus, the decision in 1523 to place the *Transfiguration* on the high altar of San Pietro in Montorio in Rome was not arbitrary, as it might first appear, for the church is built next to the reputed site of the first Pope's martyrdom. Peter's position was further stressed by the inscription that Cardinal Giulio de'Medici placed on the frame: 'Blessed Peter, Prince of the Apostles'.

Various identities have been suggested for the nine apostles who wait at the foot of the mountain. John Shearman was probably correct when he suggested that the foremost figure with a book is Matthew, as it is in his gospel that the most detailed accounts of the Transfiguration and the possessed boy are to be found. The scowling bearded disciple in the centre has been thought to be Judas. The two apostles below him, for whom a beautiful drawing from Raphael's own hand exists (Plate 205), are sometimes erroneously called John and Peter. These two apostles are on the mountain witnessing the Transfiguration, and therefore the lower figures remain unidentified. This is equally true of the kneeling woman in the foreground. The final manifestation of Raphael's much repeated twisting figure, she has been seen as the mother of the possessed boy, Mater Ecclesia, a Sibyl, and even a portrait of the famous courtesan Imperia, who had been dead for eight years. Her presence has never been satisfactorily explained, but her debt to the Delphic Sibyl in the Sistine Ceiling is unmistakeable.

Artistically, the predominant influence in the lower half of the picture is that of Leonardo da Vinci, whose manner, as we have seen, Raphael had employed in his pictures for the French court. For the *Transfiguration*, Raphael turned once again to Leonardo's *Adoration of the Magi* (Plate 86), which had served so often as a source of inspiration. The balanced arrangement of the apostles and the strong play of light and shadow across their features come directly from Leonardo.

The use of strong *chiaroscuro* by Raphael was a direct challenge to Michelangelo, as has been discussed by Kathleen Weil-Garris. One of the most famous Renaissance debates, known as the *Paragone,* was the question of whether painting or sculpture was the superior art. Not surprisingly, Leonardo espoused the first cause, Michelangelo the second. Employing oil paints and the *oscurità* of Leonardo, Raphael endowed his forms with a plasticity that demonstrated his ability to make painting surpass sculpture in conveying a life-like impression. This effect was enhanced by the careful positioning of the foreground figures. Originally placed with his back to us, Matthew has been rotated so that he now lunges out of the picture towards the spectator. The kneeling woman, on the other hand, gestures back into the picture, thus forcing the eye to bring her forward in relation to the other figures. By placing her in full light, Raphael has thrown her into stark relief against the shadowy background.

The upper half of the picture, with its soft brushwork and Venetian luminosity, is very different from the deep *chiaroscuro* and sculptural forms of the lower part. This had led many art historians before the painting was recently cleaned to attribute much of the work in the bottom zone to Giulio Romano and Gianfrancesco Penni after Raphael's death. It has now been established beyond doubt by Fabrizio Mancinelli that Raphael executed almost the entire panel, and

205. *Studies of the Heads of two Apostles and their Hands for 'The Transfiguration'.* Black chalk, touched with white over pounced outlines, 49.9 × 36.4 cm. Oxford, Ashmolean Museum.
This drawing is an auxiliary cartoon, the function of which was to establish the final details in form and shading before painting.

that the participation of his assistants was negligible. Such a strong contrast in styles suggests that Raphael deliberately chose to exhibit his complete command of the techniques of the Venetian painter Sebastiano and the sculptor Michelangelo.

Raphael's death came just as he was about to complete this masterpiece. Marcantonio Michiel recorded in his diary on 6 April 1520, 'Raphael of Urbino, excellent painter and architect of St. Peter's, has died, to the great sorrow of everyone, and of the Pope . . . He died at the third hour of the night (that is, three hours after the Avemaria) between Good Friday and Holy Saturday, on the day of his birth.' Although Vasari insinuated that Raphael caught a fever after an excess of love-making, comtemporary sources offer no support for such a claim. Sebastiano makes no mention of it to Michelangelo; he writes he is sure that Michelangelo will be sorry about the news and adds piously, 'May God forgive him [Raphael].' Michiel wrote to a friend in Venice five days later that the painter had been ill for fifteen days during which time the Pope himself had been to visit.

The size and disposition of Raphael's considerable estate caused great comment. He left his palazzo in the Borgo to Cardinal Bibbiena, and his practice and shop to Gianfrancesco Penni and Giulio Romano. There was, in addition, the enormous sum of 16,000 ducats, which eventually became the object of a lawsuit brought by his uncle Simone and the family in Urbino since the artist had neglected to prepare a written will.

According to Vasari, on the day after Raphael's death his body lay in state in his studio with the *Transfiguration* at his head before he was interred in the Pantheon, the church of Santa Maria Rotunda. He had left 1500 ducats for the construction of a tomb chapel and 600 ducats to be invested to pay for a weekly Mass for his soul. The funeral was attended by the entire papal court, and Leo wept publicly during the burial rites for his beloved artist. The pomp and circumstance that accompanied the death and burial of Raphael were unprecedented for an artist and testify to the unique status he had attained in his short life. Not even for Leonardo, who had died in France as the favourite of Francis I the previous year, had there been such a public display of grief.

Raphael himself had chosen to be buried in the Pantheon, a privilege previously reserved for the canons of the church. With his usual sensitivity he had designed a chapel to fit into one of the original Roman niches of the interior. On the altar he intended to place a statue of the Virgin and Child, which drew its inspiration from a pose used in antiquity for nymphs or Hygeia, as has been shown by Tilmann Buddensieg. Unfortunately the tomb does not survive as Raphael planned it and, once again, the work of Lorenzetti in executing Raphael's design for his statue has resulted in an indifferent sculpture. What is significant, however, is that Raphael's original ideas bear out the contemporary testimonies after his death of his great concern and love for Rome. The subtle use of the ancient architecture for a Christian chapel and the antique source for a group of the Madonna and Child display that ability for using varied sources to forge something uniquely his own that is so characteristic of his work. From his earliest known works deriving from the Perugino workshop, through the first intimations of his unique talents in Florence, to the final flowering of his genius in Rome, Raphael took and transformed everything he learned. It is truly fitting that the Pantheon, an ancient temple transmuted into a Christian church in the heart of Raphael's beloved city, should be the resting place of the man whose art was to define 'classic' for generations to come.

Epilogue

Raphael's death in April 1520 came at a turning point in the history of Rome. Agostino Chigi died a week after him, Cardinal Bibbiena in November, and by December of the following year, Leo too was dead. Duke Lorenzo de'Medici had died in the spring of 1519, thereby extinguishing the legitimate male line of Lorenzo the Magnificent. Pietro Bembo left Rome for Padua, Castiglione for Mantua. The brilliant circle of writers and scholars, which had provided so much patronage and stimulus, was no longer the centre of Roman intellectual and artistic life. Leo with his love of splendour was succeeded by the dreary puritan Hadrian VI, during whose brief pontificate the arts in Rome languished. His successor Clement VII attempted to continue the Medici tradition of patronage, but was forced to turn his attention increasingly to the challenge of the rising Reformation in northern Europe. Rome's nadir was reached with the Sack of Rome in 1527 when the Vatican palace was occupied by the troops of the Emperor Charles V. Raphael's Stanze were defaced by German graffiti, and the name of Luther was scratched into the *Disputa*. The unthinkable had happened. The Holy City had been pillaged by Christians.

Raphael's workshop also dispersed within a few years of his death, having worked on only some of the projects that it inherited: the *Monteluce Altarpiece*, the Villa Madama, and the Sala di Costantino in the Vatican palace. The contrast between the Sala di Costantino, for which Raphael's pupils designed and painted the history of the Emperor Constantine, and the earlier Stanze is depressing. Confusion reigns: the walls are overcrowded with too many incidents and with figures in exaggerated or artificial poses that totally abandon Raphael's principles of clarity and balance. The close control that Raphael maintained even when he left the execution largely to the workshop is, through its very absence, best shown up by this vast hall. Although overburdened with too many tasks during his last years, his authority was such that he always directed his workshop and gave its product the unmistakeable imprint of his style.

Raphael's pupils tried to continue in the footsteps of the master. Giulio Romano reused many of Raphael's ideas in his work for Mantua, where the master's charming *Cupid and Psyche* cycle for Chigi was reduced to the much coarsened version in the Sala di Psiche in the Palazzo del Té. Gianfrancesco Penni remained the most faithful, even painting an excellent copy of the *Transfiguration* for Naples in 1524. Marcantonio Raimondi and his followers continued to engrave Raphael's designs or to make up pastiches from left-over drawings, and Giovanni da Udine went on painting light decorations, most notably for the cupola of Michelangelo's New Sacristy for San Lorenzo in Florence.

Raphael had the ability to infuse his pupils and collaborators with his ideas and

make them produce work of a quality that they were unable to match once his guidance had gone. For it was Raphael himself who made the difference, not tricks of his trade that his pupils had failed to master. In fact, Raphael's assistants are his worst followers. Other contemporaries, such as Correggio, learned much more from his work. The artists of the seventeenth century — from the Bolognese Carracci to the French Poussin — studied him assiduously. Even in the twentieth century, his power can be felt. Picasso's *Guernica* of 1937 owes much to the *Fire in the Borgo.* Of all the great Renaissance masters, Raphael's influence is the most continuous. Perhaps as we retreat from the brutalism of the twentieth century, we can once more embrace his values and seek perfection and beauty in art.

Bibliography

This bibliography is intended to direct the reader to sources that will then lead him further. Not every book or article we have consulted is listed but only those that proved most important to our work or presented interesting material. A nearly complete bibliography on Raphael up to 1970 can be found in L. Dussler, *Raphael: A Critical Catalogue*, London, 1971.

General Bibliography

CAMESASCA, E., *Tutta la Pittura di Raffaello*, Milan, 1962 (2 volumes).
DUSSLER, L., *Raphael: A Critical Catalogue*, London, 1971.
FISCHEL, O., *Raphael*, London, 1948.
FREEDBERG, S., *Painting of the High Renaissance in Rome and Florence*, Cambridge, Mass., 1961 (2 volumes).
GOLZIO, V., *Raffaello nei documenti, nelle testimonianze dei contemporanei e nella letteratura del suo secolo*, Città del Vaticano, 1936.
OPPÉ, A.P., *Raphael*, London, 1970.
PASSAVANT, J.D., *Raphael d'Urbin*, Paris, 1860.
POPE-HENNESSY, J., *Raphael*, London, 1970.
REDIG DE CAMPOS, D., *Raffaello e Michelangelo*, Rome, 1946.
VASARI, G., *Le Vite de' più eccellenti pittori, scultori, e architettori*, ed. Milanesi, Florence, 1878-85.

Drawings:

FISCHEL, O., *Raphaels Zeichnungen*, Berlin, 1913-41, vols. I-VIII.
FISCHEL, O., and OBERHUBER, K., *Raphaels Zeichnungen*, Berlin, 1972, Vol. IX.
JOANNIDES, P., *The Drawings of Raphael*, Oxford, 1983.
MIDDELDORF, U., *Raphael's Drawings*, New York, 1945.

Catalogues:

GOULD, C., *The Sixteenth Century Italian Schools, London: National Gallery*, London, 1975.
PARKER, K.T., *Catalogue of the Collection of Drawings in the Ashmolean Museum: Italian Schools*, Oxford, 1956.
POUNCEY, P., and GERE, J., *Italian Drawings in the Department of Prints and Drawings in the British Museum: Raphael and His Circle*, London, 1962 (2 volumes).
SHAPLEY, F.R., *Catalogue of the Italian Paintings, National Gallery of Art*, Washington, D.C., 1979.

History:

PASTOR, L., *History of the Popes*, London, 1901-8, vols. 6-8.

Chapter 1: The Young Artist

SHEARMAN, J., 'Raphael at the Court of Urbino', *Burlington Magazine*, CXII, February 1970, 247ff.
WITTKOWER, R., 'The Young Raphael', reprinted in *Idea and Image: Studies in the Italian Renaissance*, London, 1978, 151-60.
Vespasiano dei Bisticci: VESPASIANO, *Renaissance Princes, Popes and Prelates: Lives of the Illustrious Men of the Fifteenth Century*, Santa Fé, 1970.
Melozzo da Forli: SCHMARSOW, A., *Melozzo da Forlì*, Berlin, 1886.
Joos van Ghent: SCHMARSOW, A., *Joos van Ghent und Melozzo da Forlì in Rom und Urbino*, Leipzig, 1912.
 JACQUES LAVALLEYE, *Juste de Gand, Peintre de Frédéric de Montefeltre*, Louvain, 1936.
 JACQUES LAVALLEYE, *Le Palais Ducal d'Urbin*, Brussels, 1964.
Perugino: CANUTI, F., *Il Perugino*, Siena, 1948.
 CAMESASCA, E., *Tutta la Pittura di Perugino*, Milan, 1959.
Raphael and Padua: VÖGE, W., *Raffael und Donatello*, Strasbourg, 1896.
Raphael and Bologna: FILIPINI, F., 'Raffaello a Bologna', *Cronache d'Arte*, 1925.
Coronation of St. Nicholas of Tolentino: BÉGUIN, S., 'Un Nouveau Raphael: un ange du retable de Saint-Nicholas de Tolentino', *La revue du Louvre et des Musées de France*, 2/1982, 99ff.
Vision of a Knight: PANOFSKY, E., *Hercules am Scheidewege*, Studien der Bibliothek Warburg, 1930, 37ff.
St. George and St. Michael: ETTLINGER, H., 'The Problem of St. George's Garter', *Burlington Magazine*, CXXV, January 1983, 25-8.
Coronation of the Virgin: LUCHS, A., 'A Note on Raphael's Perugian Patrons', *Burlington Magazine*, CXXV, January 1983, 29-31.

Chapter 2: The Florentine Period

GRONAU, G., *Aus Raphaels Florentiner Tagen*, Berlin, 1902.
Leonardo da Vinci: CLARK, K., *Leonardo da Vinci*, Cambridge, 1952.
Michelangelo: TOLNAY, C. DE., *Michelangelo*, Princeton, 1945-60 (5 volumes).
Fra Bartolommeo: KNAPP, F., *Fra Bartolommeo della Porta und die Schule von San Marco*, Halle, 1903.
Canigiani Madonna: SONNENBURG, H. VON, Report on restoration, forthcoming.
Entombment: BURCKHARDT, J., *Civilization of the Renaissance*.
Madonna del Baldacchino: RIEDL, P.A., 'Raffaels "Madonna del Baldacchino"', *Mitteilungen des Kunsthistorischen Instituts in*

231

Florenz, VIII, 1957-9, 223-46.

Holy Family with Lamb and St. George: SCHUG, A., Review of L. Dussler, *Raffael, Kritisches Verzeichnis, Pantheon*, XXV, 1967, 470ff.

Chapter 3: The Rome of Julius II

Sixtus IV: ETTLINGER, L.D., 'Pollaiuolo's Tomb of Sixtus IV', *Journal of the Warburg and Courtauld Institutes*, XVI, 1953, 239-74.

ETTLINGER, L.D., *The Sistine Chapel before Michelangelo*, Oxford, 1965.

Stanze: REDIG DE CAMPOS, D., *Raffaello nelle Stanze*, Milan, 1965.

SHEARMAN, J., 'The Vatican Stanze: Functions and Decorations', *Proceedings of the British Academy*, LVII, London, 1972.

Segnatura: SCHLOSSER, J. VON, '"Giusto" Fresken in Padua und die Vorläufer der Stanza della Segnatura', *Jahrbuch der Kunsthistorischen Sammlungen des Allerhöchsten Kaiserhauses*, VII, 1896, 13-100.

WICKHOFF, F., 'Die Bibliothek Julius II', *Jahrbuch der Preussischen Kunstsammlungen* XIV, 1893, 49ff.

Throne of Gregory the Great: FEHL, P., 'Raphael's Reconstruction of the Throne of St. Gregory the Great', *Art Bulletin*, 55, 1973, 373-9.

Pythagoras and musical harmonies: WITTKOWER, R., 'The Changing Concept of Proportion', reprinted in *Idea and Image*, London, 1978, 109-24.

Musical Instruments: WINTERNITZ, E., *Musical Instruments in Western Art*, New York, 1967.

Change in Programme: SHEARMAN, J., 'Raphael's Unexecuted Projects for the Stanze', *Walter Friedländer zum 90. Geburtstag*, Berlin, 1965, 158ff.

Two Swords: STEINMANN, E., 'Chiaroscuri in den Stanzen Raffaels', *Zeitschrift für bildende Kunst*, N.F., X., 1899, 169ff.

Eliodoro: ETTLINGER, H., 'Dominican Influence in the Stanza della Segnatura and the Stanza d'Eliodoro', *Zeitschrift für Kunstgeschichte*, forthcoming.

REDIG DE CAMPOS, D., 'Julius II und Heliodor: Deutungsversuch eines angeblichen "Anachronismus" Raphaels', *Zeitschrift für Kunstgeschichte*, XXVI, 1963, 166ff.

Portraits: REDIG DE CAMPOS, D., 'Dei ritratti di Antonio Tebaldeo e di alcuni altri nel Parnaso di Raffaello', *Archivio della Società romana di Storia patria*, LXXV, 1952, 3. Serie, Vol. VI, 51ff.

SCHIAVO, A., 'Profilo e Testamento di Raffaele Riario', *Studi Romani*, July-Aug. 1960, Vol. 8, No. 4, 414-29.

SPRINGER, A., 'Raffaels "Schule von Athen"', *Die Graphischen Künste*, V, 1883, 53ff.

Dominicans: MIRUS, J.A., *The Dominican Order and the Defense of the Papacy in the Renaissance*, Princeton dissertation, 1973.

Madonna di Loreto: Musée Condé, Chantilly, *La Madonne de Lorette*, Paris, 1979.

Santa Maria del Popolo: BENTIVOGLIO, E., and VALTIERI, S., *Santa Maria del Popolo*, Rome, 1976.

Alba Madonna: FRIEDMANN, H., 'The Plant Symbolism of Raphael's "Alba Madonna"', *Gazette des Beaux-Arts*, Vol. XXVI, 1949, 213ff.

Isaiah: BONITO, V.A., 'The St. Anne Altar in Sant'Agostino in Rome: a New Discovery', *Burlington Magazine*, December 1980, 805ff.

BONITO, V.A., 'The St. Anne Altar in Sant'Agostino: restoration and interpretation', *Burlington Magazine*, May 1982, 268ff.

Madonna di Foligno: EINEM, H. VON, 'Bemerkungen zu Raffaels "Madonna di Foligno"', *Studies in Late Medieval and Renaissance Painting in Honor of Millard Meiss*, ed. I. LAVIN and J. PLUMMER, New York, 1978, 131-42.

REDIG DE CAMPOS, D., 'La "Madonna di Foligno" di Raffaelo', *Miscellanea Bibliothecae Hertzianae*, Munich, 1961, 184-97.

SIGISMONDO DEI CONTI DA FOLIGNO, *Le Storie de'Suoi Tempi dal 1475 al 1510*, Rome, 1883.

Sistine Madonna: EINEM, H. VON, 'Raffaels "Sixtinische Madonna"', *Särtryck ur Konsthistorisk Tidskrift*, 1968, 97ff.

KANTOROWICZ, E., *The King's Two Bodies*, Princeton, 1957.

PUTSCHER, M., *Raphaels Sixtinische Madonna*, Tübingen, 1955.

Julius Portrait: GOULD, C., *Raphael's Portrait of Pope Julius II: The Re-emergence of the Original*, London, 1970.

OBERHUBER, K., 'Raphael and the State Portrait: I: The Portrait of Julius II', *Burlington Magazine*, 113, March 1971, 124ff.

PARTRIDGE, L. and STARN, R., *A Renaissance Likeness: Art and Culture in Raphael's Julius II*, Berkeley, 1980.

WEISS, R., 'The Medals of Julius II', *Journal of the Warburg and Courtauld Institutes*, 25, 1965.

Chapter 4: Rome After Julius

Medici and Golden Age: GOMBRICH, E.H., 'Renaissance and Golden Age', and 'The Early Medici as Patrons of Art', both reprinted in *Norm and Form: Studies in the Art of the Renaissance*, London, 1966.

GILBERT, F., 'Bernardo Rucellai and the Orti Oricellari: A Study in the Origin of Modern Political Thought', *Journal of the Warburg and Courtauld Institutes*, 12, 1949, 101ff.

Titian: WETHEY, H., *The Paintings of Titian*, London, 1969-75 (3 volumes).

Giorgione: PIGNATTI, T., *Giorgione*, Venice, 1969.

Brief biographies of Raphael's Roman clients with further bibliography: HALE, J.R., ed., *A Concise Encyclopedia of the Renaissance*, London, 1981.

Bindo Altoviti: AVERY, C., 'Benvenuto Cellini's Bronze Bust of Bindo Altoviti', *The Connoisseur*, CXCVIII, May 1978, 62ff.

Agostino Chigi: Associazione Bancaria Italiana, *Il Magnifico Agostino Chigi*, Rome, 1970.

FROMMEL, C.L., *Die Farnesina und Peruzzis architektonisches Frühwerk*, Berlin, 1961.

GILBERT, F., *The Pope, His Banker, and Venice*, Princeton, 1980.

SAXL, F., 'The Villa Farnesina', *Lectures*, London, 1957.

Sebastiano del Piombo: HIRST, M., *Sebastiano del Piombo*, Oxford, 1981.

Galatea fresco: THOENES, C., 'Zu Raffaels "Galatea"', *Festschrift für Otto von Simson*, ed. L. Grisebach and K. Rengen, Berlin, 1977, 220ff.

Loggia of *Cupid and Psyche:* SHEARMAN, J., 'Die Loggia der Psyche in der Villa Farnesina und die Probleme der letzten Phase von Raffaels graphischem Stil', *Jahrbuch der Kunthistorischen Sammlungen in Wien*, XXIV, 1964, 59ff.

Chigi Chapel, Santa Maria del Popolo: ETTLINGER, H., 'Christian Concepts in the Chigi Chapel', forthcoming.

SHEARMAN., J., 'The Chigi Chapel in S. Maria del Popolo', *Journal of the Warburg and Courtauld Institutes*, XXIV, 1961, 129ff.

Chigi Chapel, Santa Maria della Pace: HIRST, M., 'The Chigi Chapel in S. Maria della Pace', *Journal of the Warburg and Courtauld Institutes*, XXIV, 1961, 161ff.

ETTLINGER, L.D., ' A Note on Raphael's Sibyls in S. Maria della Pace', *Journal of the Warburg and Courtauld Institutes*, XXIV, 1961, 322ff.

'*Lo Spasimo*': ETTLINGER, H., 'Raphael's "Lo Spasimo": Its Historical and Iconographic Background', *Source: Notes in the History of Art*, Summer 1982.

Santa Cecilia: GURLITT, W., 'Die Musik in Raffaels *Heiliger Caecilia*', *Jahrbuch der Musikbibliothek Peters für 1938*, Leipzig, 1939, 88ff.

Madonna della Sedia: GOMBRICH, E.H., 'Raphael's *Madonna della Sedia*', Charlton Lecture, Durham University, Oxford, 1956. Reprinted in *Norm and Form: Studies in the Art of the Renaissance*, London, 1966, 64-80.

Engravings: DELABORDE, H., *Marc-Antoine Raimondi*, Paris, 1888.

LEVENSON, J.A., OBERHUBER, K., and SHEEHAN, J., *Early Italian Engravings from the National Gallery of Art*, Washington, D.C., 1973.

OBERHUBER, K., *Marcantonio Raimondi and His School; The Illustrated Bartsch*, Vols. 26 and 27, New York, 1978.

Chapter 5: Raphael and Leo X.

Leo X: HALE, J.R., *Florence and the Medici*, London, 1977.

ROSCOE, W., *The Life and Pontificate of Leo X*, Liverpool, 1805.

Repulse of Attila: REDIG DE CAMPOS, D., 'Il ritratto di Andrea da Toledo dipinto da Raffaello nella Stanza d'Eliodoro', *Rendiconti della*

Pontificia Accademia Romana d'Archeologia, XXXII, 1959/60, 163ff.
Stanza dell'Incendio: OBERHUBER, K., 'Die Fresken der Stanza dell'Incendio im Werk Raffaels', *Jahrbuch der Kunsthistorischen Sammlungen in Wien*, Band 58 (N.S. XXII), 1962.
Concordat: THOMAS, J., *Le Concordat de 1516*, Paris, 1970 (3 volumes).
Tapestry Cartoons: POPE-HENNESSY, J., *The Raphael Cartoons*, London, 1950.
 SHEARMAN, J., *Raphael's Cartoons in the Collection of Her Majesty the Queen and the Tapestries for the Sistine Chapel*, London, 1972.
 WHITE, J., and SHEARMAN, J., 'Raphael's Tapestries and Their Cartoons', *Art Bulletin*, XL, 1958, 193ff, 299ff.
Medici portraits: OBERHUBER, K., 'Raphael and the State Portrait: II: The Portrait of Lorenzo de'Medici', *Burlington Magazine*, 113, August 1971, 436ff.
Elephant: WINNER, M., 'Raffael malt einen Elefanten', *Mitteilungen des Kunsthistorisches Instituts in Florenz*, XI, 1963-5, 71ff.

Chapter 6: Raphael and Antiquity

Classical revival: WEISS, R., *The Renaissance Discovery of Classical Antiquity*, Oxford, 1973.
Bramante drawings: FROMMEL, C.L., 'Die Peterskirche unter Papst Julius II im Licht neuer Dokumente', *Römisches Jahrbuch für Kunstgeschichte*, 16 (1976), 59ff.
Raphael and the *Maestri della Strada*: MERCATI, A., 'Raffaello d'Urbino e Antonio da Sangallo, Maestri delle Strade di Roma sotto Leone X', *Rendiconti della Pontificia Accademia Romana d'Archeologia*, I, Rome, 1923, 121-9.
Raphael as architect: FROMMEL, C., *Der römische Palastbau der Hochrenaissance*, Tübingen, 1973 (3 volumes).
 HOFFMAN, T., *Raffael in seiner Bedeutung als Architect*, Zittau, 1904-14 (4 volumes).
 LOTZ, W., 'Das Raumbild in der italienischen Architekturzeichnung der Renaissance', *Mitteilungen des Kunsthistorischen Instituts in Florenz*, VII, 1956, 193ff.
 LOTZ, W., Chapter 15 in L. H. Heydenreich, and W. Lotz, *Architecture in Italy, 1400 to 1600*, Harmondsworth, 1974.
 SHEARMAN, J., 'Raphael as Architect', *Journal of the Royal Society of Arts*, CXVI, 1968, 388ff.
Loggie: DACOS, N., *Le Loggie di Raffaello*, Rome, 1977.
 FROMMEL, C.L., 'Eine Darstellung der "Loggien" in Raffaels "Disputa"? Beobachtungen zu Bramantes Erneuerung des Vatikanpalastes in den Jahren 1508-1509', *Festschrift für Eduard Trier zum 60. Geburtstag*, ed. J. Müller-Hofstede and W. Spies, Berlin, 1981, 103ff.
Chigi Chapel architecture: FROMMEL, C.L., 'Das Hypogäum Raffaels unter der Chigi Kapelle', *Kunstchronik*, 27, 1974, n. 10, 344ff.
Villa Madama: COFFIN, D.R., 'The Plans of the Villa Madama', *Art Bulletin*, LI, 1967, 111ff.
 FROMMEL, C.L., 'La Villa Madama e la tipologia della villa Romana nel Cinquecento', *Bolletino del Centro Internazionale di Studi di Architettura Andrea Palladio*, XI, 1969, 47ff.

Chapter 7: The Last Years

Battista Dossi: GIBBONS, F., *Dosso and Battista Dossi*, Princeton, 1965.
 MIDDELDORF, U., 'Die Dossi in Rom', *Festschrift für Herbert von Einem zum 16. Februar 1965*, Berlin, 1965, 171f.
Transfiguration: EINEM, H. VON, 'Die "Verklärung Christi" und die "Heilung des Besessenen" von Raffael', *Abhandlungen der Wissenschaften und der Literatur, Mainzer Akademie*, 1966, n. 5, 299ff.
 OBERHUBER, K., 'Vorzeichnungen zu Raffaels "Transfiguration"', *Jahrbuch der Berliner Museen*, IV, 1962, 116ff.
 WEIL-GARRIS, K., *Leonardo and Central Italian Art, 1515-1550*, New York, 1974.
Raphael's tomb: BUDDENSEIG, T., 'Raffaels Grab', *Kunsthistorische Studien: Hans Kauffmann zum 70. Geburtstag*, Berlin, 1968, 45ff.

List of Plates

186. Alessandro Strozzi. *Rome*. 1474. Florence, Biblioteca Medicea-Laurenziana.
187. Loggetta, Vatican Palace, Rome.
188. Cardinal Bibbiena's Bathroom (*'La Stuffetta'*), Rome, Vatican Palace.
189. *The Creation*. Rome, Vatican Palace, Loggie.
190. Giovanni da Udine. *Raphael's Workshop*. Rome, Vatican Palace, Loggie.
191. The Chigi Chapel, Santa Maria del Popolo, Rome.
192. Entrance Arch to the Chigi Chapel, Santa Maria del Popolo, Rome.
193. General view of the Loggie, Vatican Palace, Rome.
194. Exterior of the Garden Loggia, Villa Madama, Rome.
195. Interior of the Garden Loggia, Villa Madama, Rome.

196. *The Madonna della Perla*. Madrid, Prado.
197. *The Madonna della Quercia*. Madrid, Prado.
198. *The Visitation*. Madrid, Prado.
199. *St. John the Baptist in a Landscape*. Florence, Uffizi.
200. Sebastiano del Piombo. *The Raising of Lazarus*. London, National Gallery.
201. *The Transfiguration*. Rome, Vatican Pinacoteca.
202. Raphael School. *Modello for 'The Transfiguration'*. Vienna, Albertina.
203. Gianfrancesco Penni. *Modello for 'The 'Transfiguration'*. Paris, Louvre.
204. Titian. *The Assumption of the Virgin*. Venice, Santa Maria dei Frari.
205. *Studies of the Heads of two Apostles and their Hands for 'The Transfiguration'*. Oxford, Ashmolean Museum.

Acknowledgements

The Publishers are grateful to all museums, institutions and private collectors who have given permission for the works of art in their possession to be reproduced. They have endeavoured to credit all known persons holding copyright or reproduction rights for the illustrations in this book.

Plates 33, 87 and 152 are reproduced by Gracious Permission of Her Majesty the Queen; 29, 43, 154, 156 and 159 by Courtesy of the Trustees of the British Museum; 30 by courtesy of Viscount Coke; 2, 15, 25, 36, 57, 115, 127, 129 and 200 by courtesy of the Trustees, The National Gallery, London.

The following sources have been very helpful in providing photographs: Berlin, Staatliche Museen zu Berlin, Kupferstichkabinett und Sammlung der Zeichnungen, Plate 24; Berlin, Staatliche Museen Preussischer Kulturbesitz, Gemäldegalerie, 17, 35, 46 and 116; Cambridge, Mass., courtesy of the Fogg Art Museum, Harvard University, Gift – Friends of the Fogg Art Museum, 26; Dresden, Staatliche Kunstsammlungen, Gemäldegalerie Alte Meister, 125 and 126; Florence, Alinari, 1, 3, 4, 5, 12, 13, 28, 31, 32, 39, 41, 44, 56, 59, 60, 67, 68, 70-2, 74-7, 91, 94, 100, 108, 117, 121, 128, 142-5, 165, 168, 183, 189, 191, 192 and 194; Florence, Foto Scala, 19, 62, 73, 121, 133, 134, 142, 157, 158, 193 and 201; London, courtesy of the Courtauld Institute, 30; London, Victoria and Albert Museum, Crown Copyright, 173-8 and 180; Marburg, Bildarchiv Foto Marburg, 120; Munich, Bayerische Staatsgemäldesammlungen, Alte Pinakothek, 42, 54 and 135; Paris, Clichés des Musées Nationaux, 11, 51, 52, 146, 162 and 203; by courtesy of the Musée du Louvre, 11 (Cabinet des Dessins), 20, 21, 37, 51, 52, 64, 130, 162, 181, 182 and 203; Paris, Lauros-Giraudon, 124; Rome, Gabinetto Fotografico Nazionale, 147 and 148; Vatican City, Musei Vaticani, Archivio Fotografico, 96, 188 and 190; Vienna, Graphische Sammlung Albertina, 49, 98, 170 and 202; Washington D.C., National Gallery of Art, Washington, Samuel H. Kress Collection, 18 and 136, Andrew W. Mellon Collection, 34 and 113, Widener Collection, 40; and Virginia Anne Bonito, January 1981 (photograph V. Bonito) for detail of restoration of St. Anne Altar, Plate 118.

Index